Lee Mingwei and His Relations

李 明 維 與 他 的 關 係

The Art of Participation 參 與 的 藝 術

透過觀照、對話、贈與、書寫、飲食串起和世界的連結
Seeing, Conversing, Gift-giving, Writing, Dining and Getting Connected to the World

主辦 臺北市立美術館
Organized by TAIPEI FINE ARTS MUSEUM MORI ART MUSEUM

策展人 片岡真實
Curator Kataoka Mami

目錄

Contents

序言

身為台灣當代藝術發展的核心機構與交流平台，本館的重要工作項目是策劃辦理國際及台灣現當代藝術展覽的推動與交流，期能透過多元的藝術交流形式，分享亞洲文化經驗與發展現況。此次首度與日本東京的森美術館合作辦理「李明維與他的關係：參與的藝術」亞洲巡迴展，即為台日聯手拓展台灣藝術家於亞洲藝壇的案例，此次的館際交流也展現了台日長期以來的密切關係與深厚情誼。

本展由森美術館主任策展人片岡真實策展，從重新審視「關係」、「連結」等關鍵字在藝術創作上扮演角色的觀點，集結了李明維 15 個重要計畫，包括藝術家為家鄉台灣的展出所發表的新作，讓我們首次有機會在同一展覽中看到李明維 20 年間創作生涯的全貌。1964 年生於台灣的藝術家李明維，在其藝術發動進程中，突破文化與國家疆界，成為活躍的國際藝術家。他曾參展本館 2000 台北雙年展及 2003 威尼斯雙年展台灣館，以不同的藝術參與計畫，透過簡單的參與模式如贈與、交談、用餐及睡寢等日常生活行為，使陌生的參與者逐漸熟悉彼此，探索信任與親密等議題；展場冥想式的空間體驗，以及帶有儀式性及表演性質的行為演出，也豐富和擴大了觀眾的知覺形態和藝術認知。

此次針對台灣的展出，以徵人徵件的方式擴大公眾參與範疇，例如《織物的回憶》向大眾徵詢個人紀念物，經藝術家挑選後於美術館大廳展出；藝術家也為《聲之綻》及《如實曲徑》甄選為觀眾獻唱與演出的表演者；而諸多計畫除了需要社會大眾的參與，也需要擔任「主人」的館員與義工的參與，例如《晚餐計畫》和《睡寢計畫》由館方擔任主人，與參與者成為計畫的一部分；《補裳計畫》由本館義工大隊擔任主人，為觀眾送來的衣裳作縫補；《客廳計畫》每週由館員或義工擔任駐站主人，向觀眾介紹自己提供的收藏等等。從觀看到參與，李明維的作品形式各異，或徵選、或抽籤、或代替接待、或憑機緣偶遇，觀眾的親身體驗，讓作品充滿

活力。整個展覽如同生命歷程一般，在為期三個月的展期中產生變化。

為了對李明維創作的精神脈絡有更深一層的理解，策展人挑選在東京展出的「關係區」之藝術家、宗教家和思想家的作品與文獻資料、以「思考『關係』的作品」為題展出之餘，更特別邀請在台灣各世代對參與式創作議題有涉獵的當代藝術家吳瑪悧、林明弘、楊俊、吳建瑩提出作品，闡述他們對「關係」和「連結」的見解與探討，與李明維的計畫相互參照。

本次展覽得以成功呈現，實為台北、東京長年文化交流的成果，在此感謝森美術館館長南條先生、主任策展人片岡女士的借展交流，藝術家李明維的合作展出，與所有熱心出借作品的藏家及機構；也感謝藝術家吳瑪悧女士、林明弘先生、楊俊先生、吳建瑩先生的參與展出；更要感謝此次熱烈參與徵件、甄選以及參與計畫的民眾，以及協助館方執行諸多計畫的館方同仁、義工大隊與導覽義工老師在展期間無私的參與及付出；最後除了日方原文書的作者，也特別感謝陳�怡老師為本展專輯撰寫專文。透過以上的借展合作與交流，以及展覽籌備期間各方熱忱的付出，才能讓展覽與專輯順利完成，謹代表本館致上最誠摯的謝意。

台北市立美術館館長
林 平

Foreword

The principle tasks of Taipei Fine Arts Museum, as a core institution for promoting the development of contemporary art in Taiwan, are organizing art exhibitions and actively engaging in exchange with the international community. The aim of this broad range of interactions in the arts is to share the Asian cultural experience and the current state of Asian culture. For the first time our museum has joined forces with the Mori Art Museum in Tokyo to present "Lee Mingwei and His Relations: The Art of Participation," the first time Taiwan and Japan have worked together to promote a Taiwanese artist in the Asian art world. This collaboration between museums has demonstrated the long, close relationship and strong amity between Taiwan and Japan.

Curated by Mami Kataoka, chief curator of the Mori Art Museum in Tokyo, the exhibition re-examined the roles that such key words as "relations" and "connections" play in art. It brought together 15 major projects by Lee Mingwei, including a new work the artist developed for this exhibition in his homeland of Taiwan. For the first time we were able to see the results of Lee Mingwei's entire career spanning two decades, all in the same exhibition. Born in Taiwan in 1964, Lee has broken through barriers of culture and nationality to become a vibrant international artist. He has taken part in the 2000 Taipei Biennial and the 2003 Taiwan Pavilion at the Venice Biennale, both organized by TFAM. In a variety of participatory art projects, he has employed ordinary activities of life such as gifting, chatting, dining or sleeping as simple models for participation, making complete strangers become gradually familiar with one another, and exploring such themes as trust and intimacy. The meditative spatial experience of the galleries and the enactment of ritualistic and performative behaviors also enrich and broaden viewers' perceptual states and their understanding of art.

For this exhibition in Taiwan, the artist expanded the scope of public participation by recruiting people to make their own contributions. For example, in *Fabric of Memory* he invited people to share garments bound up with their personal memories. In *Sonic Blossom* and *Our Labyrinth*, he introduced singers and performers. Many of his works required the active participation of not only community members, but also museum staff or volunteers. In *The Dining Project* and *The Sleeping Project*, for example, staff members played "host," and the public became part of the artwork. In *The Mending Project*, museum volunteers took turns hosting and repairing visitors' clothing. And in *The Living Room* a different staff member or volunteer played host each week, introducing visitors to the collections they provided. Whether experienced through viewing or participation, Lee Mingwei's works came in a wide array of forms – selected contributions, lotteries, surrogate hospitality, or chance occurrence. The public's personal experiences filled the works with life. And like the journey of life itself, the entire exhibition went through changes throughout its three-month existence.

To give an extra level of understanding to the spirit and context of Lee Mingwei's art, the curator organized the section "Works for Relationality," showcasing a number of artists, religious thinkers and philosophers first featured at the Tokyo exhibition, as well as local Taiwanese artists from different generations whose work entails participation – Mali Wu, Michael Lin, Jun Yang, and Wu Chien-ying. Their interpretations and explorations of "relations" and "connections" provided points of mutual reference with the projects of Lee Mingwei.

The successful presentation of this exhibition was the fruition of a long relationship of cultural exchange between Taipei and Tokyo. At this time I express my sincere gratitude to the Mori Art Museum, its director Fumio Nanjo and its chief curator Mami Kataoka, for lending this exhibition to TFAM. I also wish to thank the artist Lee Mingwei for his personal engagement, and all the collectors who enthusiastically lent artworks for this exhibition. On behalf of Taipei Fine Arts Museum, I thank the artists Mali Wu, Michael Lin, Jun Yang, and Wu Chien-ying; all the members of the public who submitted works, cast ballots and participated in these projects; as well as the colleagues, volunteers and guides for their selfless contributions throughout the exhibition. Finally, I am grateful to the authors of the original Japanese texts, as well as Professor Kuangyi Chen for the contribution of her scholarly monograph for this exhibition. The collaboration and passionate contribution of all these parties has made this exhibition and this catalogue possible.

Ping Lin
Director of the Taipei Fine Arts Museum

序言

這次能在台灣舉辦台灣藝術家李明維的展覽，令人備感欣喜。

李明維於 1964 年生於台灣，14 歲赴美，目前以紐約為據點從事國際性活動。他的作品根底，有著一貫直視人心內在的東方觀點。1990 年代，李明維正式以藝術家的身分開始活動時，觀眾參與作品創作過程及展示空間而成立的新藝術備受注目，而他也繼承了那個脈絡。

另一方面，日本在 2011 年經歷了東日本大地震後，人們之間的「連結」與「牽絆」成了心靈支柱。進而在今日社會，透過多樣化的社群媒體，以個人與社會連結的新型態登場。人與人連結的多樣化關係與個別經歷，是今日社會的新現象，想必也是其價值所在。森美術館基於這樣的認知，舉辦了以關聯與關係性作為藝術重心的藝術家李明維的個展。如今這種關聯由台北市立美術館接續，並加以發展，實為可喜之事。

本展「李明維與他的關係」，從他 20 年來的活動中，選出包括新作在內的 15 件計畫齊聚一堂，讓人首次有機會同時親身體驗。有的作品是場內人人皆可參與，有些作品必須事先報名與抽選才能參與，與觀眾的連結方式也很多樣化，亟盼各位能積極參與。

又及，為了探討李明維作品背後的歷史脈絡，也加入了東京展出的藝術家、宗教家、思想家（包括白隱、鈴木大拙、伊夫·克萊因、約翰·凱吉、亞倫·卡布羅、里克力·提拉瓦尼），以及出於台灣脈絡的吳瑪悧、林明弘、楊俊、吳建瑩的作品與言論。透過與李明維作品的對照，想必又可發現另一種關聯。

最後，本展舉辦時，承蒙李明維及李工作室的各位大力協助，還有合辦、協辦的各位，以及大力幫忙促成本展的台灣支持者，在此要衷心致謝。同時，對於欣然應允提供作品展出的藝術家、收藏家、收藏機構，以及給予有形與無形協助的企業、機構、個人，在此也要一併鄭重致謝。

森美術館館長
南條史生

Foreword

To join in organizing an exhibition of the Taiwanese artist Lee Mingwei in Taiwan is for me a true delight.

Lee Mingwei was born in Taiwan in 1964 and relocated to the United States at the age of 14. He is currently based in New York, where he engages in many projects at an international level. His works are rooted in an Eastern perspective that looks straight into the inner minds of people. In the 1990s when Lee first became formally active as an artist, a new form of art, founded on audience participation in the creative process and exhibition space, was receiving broad attention, and his work has always been grounded in this milieu.

In 2011 the east coast of Japan was struck by the Tōhoku earthquake, and in its aftermath many people found relationships and connections to be a vital source of psychological support. Furthermore, in today's society, a wide variety of social media has given rise to a new form of connection between individuals and groups. The diversity of relationships and distinct experiences to be found in interpersonal connections are something to be treasured. It was based on this realization that Mori Art Museum organized the solo exhibition of Lee Mingwei, whose art is centered on connections and relationality. Today, we are truly happy to see Taipei Fine Arts Museum carrying on with these connections and developing them even further.

The exhibition "Lee Mingwei and His Relations" brought together in one venue 15 works spanning over two decades, including a completely new project, which visitors had the opportunity to personally experience for the first time. Many of the projects allowed members of the public to participate upon arrival, while others required reservation in advance, or selection by lottery. The ways in which the art connected with the viewer varied widely, in the hope that everyone could actively take part.

In addition, in order to explore the context surrounding Lee's art, we also presented the works and words of other artists, spiritual leaders and thinkers, both those featured in the original Tokyo exhibition (Hakuin, D. T. Suzuki, Yves Klein, John Cage, Allan Kaprow, and Rirkrit Tiravanija) and several fellow travelers from Taiwan (Wu Mali, Michael Lin, Jun Yang, and Wu Chien-Ying). Through comparison and contrast with the works of Lee Mingwei, they afforded the discovery of many new connections.

Finally, at the successful completion of this exhibition, we express our gratitude to the artist Lee Mingwei and his studio, who were unsparing in their assistance, to our co-organizers and sponsors, and to all those who offered their support in Taiwan. To the artists, private collectors and institutions that readily consented to share the works in their collections, and to all the enterprises, organizations and individuals that provided assistance, either tangible or intangible, we extend our sincerest thanks.

Fumio Nanjo
Director of the Mori Art Museum

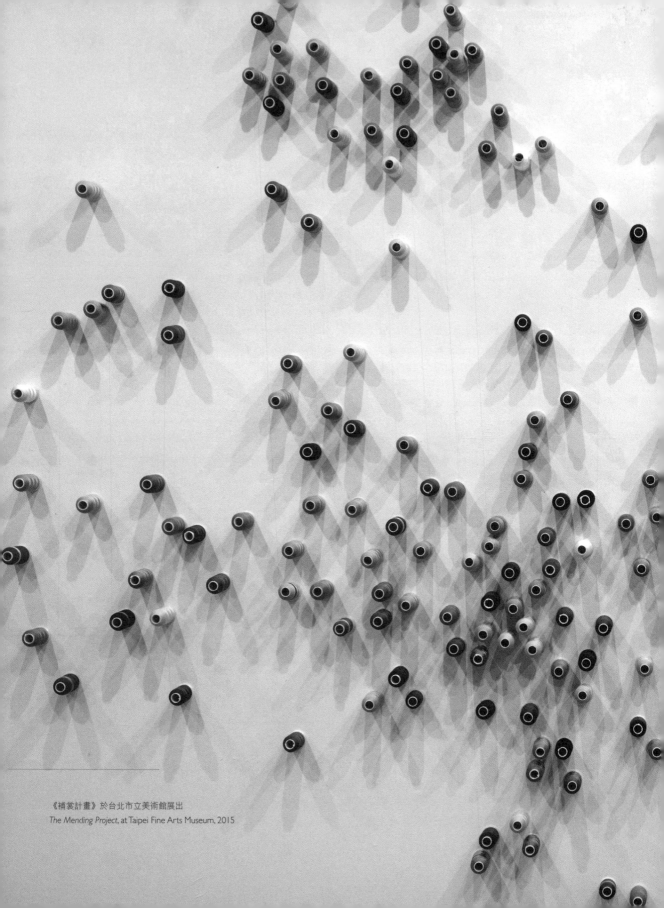

《補裰計畫》於台北市立美術館展出
The Mending Project, at Taipei Fine Arts Museum, 2015

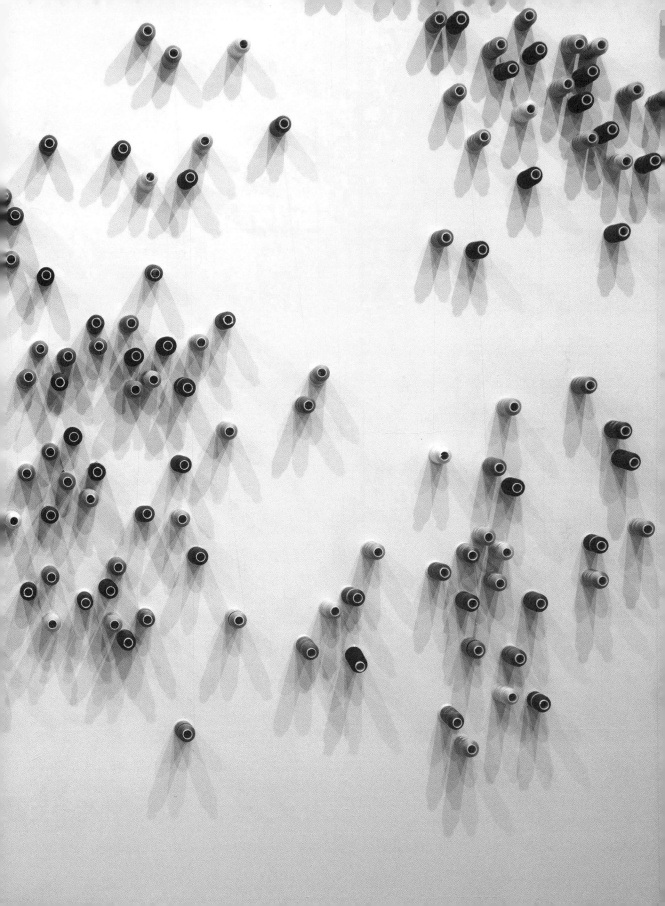

無形之線的價值：
李明維與他的關係

片岡真實

森美術館主任策展人

至少在這十年間，透過觀眾參與為基礎的藝術——所謂的「參與式藝術（participatory art）」已經獲得了廣泛的認可和明確的正當性。同時，不受美術館體制與空間限制，藝術家走上街頭進行各種社區計畫（community project）也不再是罕見之事。李明維（1964 年生於台灣，現居紐約）長達 20 年的藝術創作發展，經常被置於「參與式藝術」的脈絡中討論，藝術評論家荷朗德・寇特（Holland Cotter）也曾稱李是「社會型觀念藝術家（social conceptualist）」。[1] 這對於我們檢視李明維的創作是個耐人尋味的詞彙。如果從美術館走入真實社會執行計畫就是「社會參與（social）」，那麼李明維並非激進的社會參與型藝術家（social artist）。他既不是那種正面設法解決或改善某種特定社區議題的藝術家，也不是集合一群孩童大搞工作坊的那種類型。

但是，他透過生物學、建築、織品等發展養成的「當代藝術」，和繪畫與雕刻這些傳統類型藝術也不同。1990 年代初，李明維在加州藝術學院在學期間認識了馬克・湯普森（Mark Thompson）與蘇珊・雷西（Suzanne Lacy）二位教授。身為哲學家及養蜂人的湯普森，帶著李明維從養蜂的生活事務上，體會藝術的想像如何深入到生活的層面；而雷西則讓他更加意識到生活周遭與女性主義的議題。雷西師事於 1950 年代末期提倡「偶發藝術（Happening）」的亞倫・卡布羅（Allan Kaprow）。卡布羅不斷質疑「藝術是什麼」這個探究精神，想必與雷西提倡的「新類型公共藝術」也有關連。她的論點是：「有別於過去的公共藝術，新類型公共藝術使用傳統或非傳統媒介，皆是一種為了與更廣大且多樣的群眾生活直接相關的課題進行對話和相互交流的視覺藝術，那是以入世（engagement）作為基礎」。[2]

在前述的環境下，產生了李明維早期創作《金錢計畫》（1994）。李坐在咖啡館將十元美鈔摺成紙「雕塑」，然後送給感興趣的人，條件是要對方提供電話號碼，以便讓他每隔半年打去詢問作品的狀況。實際上他真的半年打一次電話給作品擁有者，其中曾經是越戰退役軍人的遊民約翰與他維持了長期關係，雖然十美元對約翰所處的環境而言非常好用，約翰卻一直保有那件作品，每次與李見面就會驕傲地把

摺紙雕塑拿給他看。李在今年（2014）春天還與他見過面，這20年來約翰從李那裡收集到的雕塑已多達14件。這個計畫探索的是藝術的非金錢價值，那給了約翰尊嚴。這種無法量化的價值，透過「交流」、「贈與」以及「個人的生命經歷」等行為促使我們重新思考，而此正是李明維的創作核心。

即便如此，我仍無法將李明維完全歸類於激進的社會參與型藝術家，乃是因為他的作品計畫幾乎都在美術館或畫廊這種為藝術而存在的體制內進行。觀眾造訪美術館，參與李設定好的簡單規則或儀式化行為，並以實際的回應令作品成形。這個「成形」代表的意義，不是形成肉眼可見的形體，而是建構如同絲線的關連性，並且，讓每位參與者意識到非物質的無形價值。就此意義而言，李的作品較為接近觀念藝術（conceptual art）。無論來到展間的觀眾是否有所侷限，只要它是公眾形式，某種程度上代表「社會」，那麼我們對於向社會提出觀念架構的李，或許便可稱之為「社會型觀念藝術家」。實際上，他自己認為作為這種非物質藝術的觀念基礎、理論前提，畫廊與美術館的體制是有效的。

以下，本文首先針對「參與式藝術」如何邀請觀眾參與的諸面向進行考察，其中包括發展歷程的分析，再進而從歷史和社會的脈絡來審視李明維的藝術實踐。

一、參與式藝術的諸面向

從物質性的作品到關係性的作品

1990年代以後，當我們談論到在國際間已相當普遍的「參與式藝術」時，很難不提及法國藝評家及策展人尼可拉·布西歐（Nicolas Bourriaud）所提倡的「關係藝術」或「關係美學」。這個理論首次反映他於1996年在波爾多CAPC當代藝術館策劃的「交流」（Traffic）展中，1998年更出版了法文散文集《關係美學》（Esthétique relationnelle），接著在2002年出版該書英文版，將其推廣至國際間。[3] 布西歐最早使用這個詞彙是在他自己創辦的雜誌《藝術文獻》（Documents sur l'art）1995年春季號，他在文中如此定義：

金錢計畫 #4
1994

「不管是在理論或實踐上，從人際關係這個領域出發的藝術實踐形式」。[4] 幾位曾經參與「交流」展，之後也被視為象徵關係藝術的藝術家，例如菲利浦·帕雷諾（Philippe Parreno）、多明尼克·貢札雷斯·佛斯特（Dominique Gonzalez-Foerster）、利亞姆·吉立克（Liam Gillick）、安傑拉·布洛克（Angela Bulloch）等人，他們也是布西歐於 1980 年代末至 90 年代初期策劃展覽的參展藝術家。就某種意義上來說，對於還沒有理論基礎的新世代藝術家而言，布西歐賦予了他們架構與語言。至於這次「交流」展，他稱之為「在波爾多這個城市暫時形成微型社區的展覽」。[5] 從長達四天的開幕酒會，便可窺知自家人共襄盛舉的盛況。對於 28 名參展藝術家的共同點，布西歐說：「他們的作品強調交流的社會性方法（social method），藉由向他／她展示美學經驗來達到與參觀者的交互作用以及溝通的過程，他們以有形（tangible）的次元作為人們與團體相互連結的管道」。[6] 如同布西歐認為 30 年前的普普藝術自「消費」的領域誕生，極簡主義自「工業」的領域誕生，這個世代的藝術家則是自「關係性（relationships）」的領域誕生。[7]

布西歐宣告藝術的本質改變了，從肉眼可見的物質性作品，轉向人們互動、或社會脈絡的「關係性」，這就是新型態的藝術。布西歐的觀點所具有的洞察力，是其應該被高度評價的理由之一。這點，觀察同時代藝術家的具體創作後也會有同感。關係藝術如此廣泛滲透，布西歐指出的趨勢在世界各地——包括日本及亞洲在內——的當代藝術家身上皆可觀察到，我回想起來，當時這無從捉摸的新藝術的確在尋求一個理論架構。對此，布西歐本人也說，「最早回應這個理論的是北歐，1996 年瑞典的藝術雜誌《Paletten》針對關係美學做了一期專題報導，這些概念便從『周邊』諸國開始散播」。[8]

如今，《關係美學》一書已被翻譯成多國語言，以歐美為中心，在藝術類大學也被奉為教科書，[9] 另一方面，以這個理論為基礎也展開了種種議論。其中尤為知名的，是美國評論家克萊爾·畢曉普（Claire Bishop）2004 年在《OCTOBER》發表的〈敵對與關係美學〉（Antagonism and Relational Aesthetics）。[10] 畢曉普的批判標的，集中在布西歐的理論及藝術家里克力·提拉瓦尼（Rirkrit Tiravanija）與利亞姆·吉立克，她的論點之一是「關係美學中的民主狀態」。把觀眾帶進作品的一部分，促使彼此可以對話，這點肯定讓藝術家視自己的作品為「民主的」，布西歐論及的多數藝術家作品，乍看之下似乎是開放的，但事實上並非展望更美好未來的烏托邦，而是只考慮那一瞬間的「微托邦」（microtopia），畢曉普指稱那是在打造封閉的社區形式。實際上，民主社會要求的「敵對（antagonism）」——辯論及對談的場域——在布西歐的理論中付之闕如。[11] 對此，布西歐以提拉瓦尼及吉立克以外的藝術家作品為例，說明關係藝術中含有的政治性。而畢曉普的批判，也針對作品在公開展覽時因觀眾參與而變化的性質。「像這種作品，似乎是來自後結構主義理論的創造性誤讀。換言之，不是對藝術作品一再重覆評價的詮釋，而是藝術作品本身在永續的流動中被評論」。[12] 對此，布西歐提出反駁：「『交流展』的展出作品多半是一種流動體，拒絕意義的明確化，因此是對評論家無法放棄的安定性議論作出挑戰」。[13] 關係美學也在 2008 年被法國哲學家傑克·朗榭爾（Jacques Rancière）的著作《被解放的觀眾》（Le apectateur émancipé）批判，翌年布西歐又提出反駁，可說是提供了一場令人興味盎然的長期議論。[14]

即使在學術界這樣的議論持續展開，但「參與式藝術」讓觀眾更主動參與作品的創作過程，或是成為空間裝置的一部分，此趨勢已經開始穩步地滲透進美術館這個藝術現場。雖然「關係美學」可適用於當代的全球化運動，但後續的議論焦點卻集中在個人的理論，以及特定的藝術家和藝術作品。並且，隨著它的範疇擴大至民主、政治、美學等普遍的概念，議論似乎也逐漸偏離作品本身以及實際參與者的心理。如果「關係美學」被定義為藝術家的實踐中「關係性」的意識化這個理論層面，那麼它的某些批判似乎對「社會參與式藝術」及「社區藝術」寄予期望，希望它能積極參與特定地域的社會問題及政治課題。「社會參與式藝術」與前述的「新類型公共藝術」在理論架構上有點近似，從藝術家具體介入當地社區的課題謀求環境改善的計畫，乃至根據這種社會政治性的研究，將成果在美術館展出。它的本質可說是廣泛地

針對社會的藝術參與，邀請公眾成為計畫的一部分，因此也可被視為「參與式藝術」。此外，經常以觀眾參與的空間或身體經驗為前提的「裝置藝術」，也是汲取 1960 年代以後的「偶發藝術」與「環境藝術」趨向，在 1990 年代以後廣泛滲透的藝術形式之一。它不是概念性或社會性的參與，而是身體的參與，就此意義而言，它應該也被歸類於「參與式藝術」的範疇。因此，在這裡，除了「關係藝術」與「關係美學」，再加上「社會參與式藝術」、「社區藝術」和「裝置藝術」，作為這些實踐的總稱，有必要以廣義的「參與式藝術」為前提去思考。

談到重新思考這個發展趨勢的展覽，可舉 2008 年紐約古根漢美術館舉辦的「任意空間」（theanyspacewhatever）展為例。在這次由「交流展」十名主要參展藝術家參與的展覽中，策展人南西·史佩克特（Nancy Spector）提供觀眾對於之前的藝術動向一個更廣泛的概觀，同時指出 1990 年代大半藝術發展的共通點：「意圖迴避表象，並積極尋求與更大世界的連結」[15]。同年，在舊金山現代美術館舉辦的展覽「參與的藝術：1950 年代至現在」（The Art of Participation: 1950 to Now），更試圖賦予此動向一個歷史的脈絡。[16] 這次展覽廣泛網羅了 43 組藝術家，包括早期的偶發藝術、表演藝術、激浪藝術（Fluxus）到今日的「參與式藝術」。如果將視野進而擴大到「社會參與式藝術」及「社區藝術」，以冷戰結構瓦解後社會政治體系急劇變化的地域為首，這 20 年來，當代藝術家參與地域特定課題的例子不勝枚舉。對藝術與社會的關聯長年提出革新觀點的非營利組織「Creative Time」（紐約），於 2012 年，將這些趨向整合成「Living as Form: Socially Engaged Art from 1991-2011」這項展覽。展中介紹了世界各地超過一百位藝術家的計畫案例，凸顯每個國家與地域面臨的社會政治課題，以及與種族、宗教、性別有關的議題，可以看到這些藝術家在必然性（necessity）趨動下所展現的熱情。

1990 年代參與式藝術的發展背景

美術館與展覽的架構向來被視為靜態，把各種立場的人們透過「參與式藝術」納進這種架構，對於實際負責運作的人而言是很大的挑戰。即便如此，它還是被廣泛接納的背景究竟是什麼？布西歐認為，「如果對這種現象作出社會學的解釋，那就是經濟衰退的 1990 年代，幾乎不可能孕育煽情、炫耀的企畫」。[17] 另一方面，策劃「任意空間」展的史佩克特就美國的社會、文化背景分析如下：「1980 年代初，藝術界出現了極其分歧又相互共生的諸流派，各自滿足急速成長的市場需求。（中略）在美國，1980 年代是雷根政權的時代，新富階層興起，基督教右派鞏固團結，在文化方面，藝術與商業也前所未有的緊密連結。同一時期也產生了一股藝術創作的潮流，挑戰藝術權威的概念，並審視表象呈現的透明性。那被後現代理論冠上 Neo-Geo、Neo-Conceptual、Appropriation art 等種種稱呼的藝術動向，暴露了西方思想——包括宗教、哲學、心理學——敘述的正當性，作為意識型態的建構，以維持西方文化長久以來被視為理所當然的優勢」。[18] 實際上，她策劃的展覽名稱「任意空間（theanyspacewhatever）」，也是利亞姆·吉立克的作品名稱，二者都是引用後現代思想家吉爾·德勒茲（Gilles Deleuze）提出的名詞「任意空間（any-space-whatever）」（電影用語，指場景轉換時流動的、日常性且高度匿名性的影像），可以窺知德勒茲的多樣性與差異的哲學被拿來與藝術的多樣化潮流對照。此外，史佩克特指出的藝術與商業的親密化，想必也與「參與式藝術」的發展背景不無關係。許多「參與式藝術」，把比重放在參與體驗及社區共有課題的改善，不見得會留下物理性的形式。因此，要鎖定作為市場對象的作品所有權，或從非物質的體驗中找出價值都很困難。實際上，最早對布西歐的理論作出反應的北歐諸國，也是對藝術的支援制度比較充實的地區，這種環境想必也是「參與式藝術」得以發展的原因之一。

另一方面，畢曉普雖基於自己的論點批判提拉瓦尼的實踐，但她也曾指稱泰國為「關係美學」的精神故鄉。實際上，「參與式藝術」在日本及泰國等亞洲地區也廣泛受到 1990 年代

以後的新世代藝術家所接納。在此時期，許多亞洲藝術家被國際性的藝術傳媒介紹，其中尤以泰國藝術家格外受到注目，這想必與里克力‧提拉瓦尼有直接或間接的關係。分析「參與式藝術」在亞洲發展的社會背景時，或許有必要找出異於布西歐及史佩克特的視點。

上述背景的主要特徵之一，就是畫廊及美術館等當代藝術展覽空間的制度化，還有畢曉普刻意提及的民主化問題。要充分論析這些問題只能留待下次機會，不過在此想提出其共通點，首先，是亞洲各地當代藝術的歷史，一方面與二次世界大戰後的去殖民地化、國家與社會的現代化及民主化的歷史並行，同時也在與歐美有時間落差的形式下各自發展。其中含容了由歐美所帶動的現代藝術史，同時與各國傳統的藝術形式對照，孕育出複雜的多重性。從這個角度來看，各國固有的文化、宗教習俗，也是我們在探討參與及關係性這種概念時不可忽視的要素。

至於藝術在制度方面的議題，1990 年代邁向國際藝壇的泰國清邁藝術家納文‧羅旺柴庫爾（Navin Rawanchaikul）的說法極有象徵性。他最知名的作品為包下一輛計程車與司機一個月，把車內轉化成畫廊的計畫《納文‧畫廊‧曼谷》（1995-），他說那單純只是「因為沒有其他的場所可以展出當代藝術」。這種必然性在亞洲其他地區同樣也可看到，日本的「參與式藝術」先驅小沢剛（Ozawa Tsuyoshi）最具代表的系列作品《茄子畫廊》（1993-）亦然。這是對年輕藝術家只能租借畫廊發表作品的現狀作出的批判性提案，他在街頭展出用牛奶盒做成的世界最小型移動畫廊，邀請各式各樣的藝術家舉辦世界最小的展覽。小沢也將他人的意見反映在作品的創作過程，於 1991 年提出「相談（Sodan，諮商）藝術」，其中原委，他敘述如下：「某日，我覺得大部分藝術作品都是藝術家把自己的想法單方面地向觀眾輸出的自我中心主義。於是我思考自己是否能做出與其他藝術家相反的事」。[19] 然後，基於自己辦個展時除了友人幾乎無人光顧的真實經驗，「我主動把畫布搬到街頭，請路人直接對創作中的作品提出建議，而開始這套新的模式」。[20] 若說 20 年前的現代藝術界本身是微托邦，那麼，開始意識到不特定多數

觀眾的存在，與現代藝術更加制度化、一般化的過程有著密不可分的關係。被畢曉普批判為微托邦的「關係藝術」，可以說也只有在藝術作品發表的場所是商業畫廊或替代空間這類以藝壇人士為前提的場所才能成立，當它進入為更廣大觀眾開放的美術館或機構空間，恐怕這個針對微托邦的疑問很快就會化為現實問題出現了。

事實上，日本在 1990 年代，展示當代藝術的場所，有段時期是自私人或企業出資經營的場地轉至公立美術館。1970 至 90 年代，把當時優秀的歐美當代藝術介紹到日本的私人慈善家或企業提供的場所相當多，但多半在泡沫經濟崩潰後關閉。[21] 彷彿是要繼承它們，在景氣好的時期所規劃的各地公立美術館，於 1980 年代末期如雨後春筍般紛紛開館。[22] 介紹當代藝術的場域急速向一般市民擴展，迫使館方開始主動尋求讓身為納稅人的市民參與的對策，以及令「難懂的」當代藝術與觀眾連結的機制。這十年來也有森美術館及金澤 21 世紀美術館等大型當代藝術館開館，以全球化為背景，從越來越複雜的脈絡產生的當代藝術，該如何更廣泛地與觀眾連結？對於眼前這個問題，不可否認的，「參與式藝術」已成為一個有效的手段。這個潮流也與 1990 年代以後遍及全球的雙年展或三年展有共通之處。以特定美術館與展場為中心的「橫濱三年展」（2001-）模式，乃至作為過疏化地區再生的原動力，靈活利用自然環境及廢屋、廢校的「越後妻有藝術三年展」（2000-）與「瀨戶內國際藝術祭」（2010-）模式，雖然營運方式各不相同，但尋求居民參與的模式已逐漸確立。實際上，里克力‧提拉瓦尼與納文‧羅旺柴庫爾、小沢剛、李明維等人這 20 年來都是國際展的常客，由此應該也可看出這種需求。

另一方面，2011 年東日本大地震發生後，日本無論在物理或心理層面上都經歷了巨大的失落與衝擊，在這樣的環境下，藝術在社會扮演的角色再次被強烈質疑，以災區為中心，進行了許多社會參與式藝術及社區藝術計畫。

此外，觀眾能參與作品的創作過程及展示，的確有其民主的一面。不是參照藝術史的解釋或一個獨立作品內在的意義，

而是透過介入身體的、感覺的體驗，讓人們感到平等的歸屬意識。這點，與亞洲地區的民主化過程也有所關連。例如，經濟發展突飛猛進的東南亞，在「當代藝術館」這個制度不發達的情況下，許多年輕的藝術家與策展人，活躍地進行著表演、街頭藝術、現場演唱等各種橫跨藝術領域及政治性的活動。雖然除了新加坡與曼谷外，常設性展出國際性當代藝術的公共設施之設立與成熟目前仍在發展中，倘若換個角度看，在東南亞，比起當代藝術館，首先更強烈需要的是社會本身的民主化、現代化與安定，何況在當代藝術的社群中，「公眾」意識也極高。在經濟成長的背景下，受到國際藝壇關注的是，新富階層成了藝術市場的新顧客，年輕世代的策展人與藝術家可說是面臨了「自己的觀眾是誰？」這個緊迫的課題。

1998 年，提拉瓦尼自言「不是對美學而是對關係感興趣」，他在清邁與卡明・拉恰普拉沙特（Kamin Lertchaiprasert）合作進行「The Land」計畫。建造由藝術家與建築家設計的展覽館，一面從事有機農業一面持續駐地藝術等長期計畫。對此，泰國策展人克利提亞・卡維翁（Gridthiya Gaweewong）表示：「（這個）計畫是作為另類模型（alternative model）的構想，為了向藝術界提示嶄新創造的可能性。實際上，此項計畫也批判了具有特權性、排他性傾向的藝壇。從藝術制度的中心遷往清邁郊外的聖芭東，這個舉動本身就是一種強烈的聲明。然而這個宣言只是針對國際藝壇，並未與當地的藝術傳媒或觀眾連結」。[23] 據卡維翁表示，藝術實際走向社會是在提拉瓦尼之後的世代。2001年塔克辛政權的誕生與 2006 年的軍事政變，以及之後政治、社會的混亂，令國民的意識覺醒，步向真正的民主化，在朝向這種烏托邦的階段，藝術扮演的角色被重新質疑。[24] 對民主化的意識，進而攸關人類尊嚴與存在的意識，在前述震災後的日本，以及馬可仕政權瓦解後的菲律賓，蘇哈托政權後逐漸民主化的印尼，還有民主化與經濟發展突飛猛進的緬甸等地，都同樣可看到這種關注。在這種社會政治環境中探究藝術扮演的角色，對於還在成長中的亞洲而言，想必需要更廣泛的研究。

東方思想中的「關係性」

思考亞洲的「參與式藝術」時，我想探討的另一點，是從文化、宗教的觀點看「關係性」，尤其是與佛教思想的關係。在這方面，除了布西歐曾經指出提拉瓦尼的實踐具有遊牧生活及佛教的性格之外，其他被檢視的機會還很有限。不過，就像畢曉普批判藝術作品的流動性及可變性、只注重「此時・此地」的微托邦式思考，這些都是佛教思想的核心部分，可見東方思想在我們探究「關係性」時極有意義。

思考人類相互關係及社會脈絡時，意識會自然集中在「關係」、「關聯」這種狀態，以及「之間」這種時間與空間的概念上，佛教所說的「緣起」、「空」、「無」、「諸行無常」等觀念，與它們自然地產生共鳴。實際上，李明維幼年接觸的禪宗思想，尤其是日常的慈悲、自覺、內省的視點，可說是為他日後的藝術實踐立定方向的意識基礎。毋庸贅言，佛教是始自釋迦牟尼的教說，在他死後，分為上座部佛教與大乘佛教這二大派別，日本自印度經由中國傳來大乘佛教。相較於印度佛教的高度理論性、分析性，今天日本的佛教主流是鎌倉時代普及的，注重實踐與體驗，它們超越宗教的框架，滲透到日常的習慣、語言及文化中。

這些普及的佛教思想之一是「緣起」的概念。我們平常會說「緣起好或緣起不好」（即好預兆或壞預兆），但在佛教中，它其實是指原因與結果這個時間軸上的因果關係，進而也包括自然法則及人類的相互關係，所有的主體皆因彼此的依存關係而存在。那種依存關係就是「緣起」。發展這套思想的是印度的佛教僧侶 Nagarjuna（龍樹），[25] 在他的代表作《中論》中可以看到精闢的分析。書中他指出，若諸事萬物皆有依存關係，那就沒有本質上存在的事物，一切都是「空」的關係。因此，緣起與佛教的基本概念「空」也息息相關。把禪學推廣到全世界的鈴木大拙，對於「空」的說明如下：「我們是站在重重無盡、無止無窮的網絡關係中，可以說只有那個關係，除此之外別無他物。那就是佛教主張的一切皆空」。[26] 意識到萬物的相互依存性，也就等於意識到「關係性」、「之間」及時間的因果關係，同

時「無常」、「苦」、「無我」這些佛教的基本概念也是以相互依存性為前提。

所謂「諸行無常」，認為一切存在都會不斷變動，不會停留在同一個地方。執著於社會地位及物質擁有等事物的恆常性，只會令人類感到「苦」。因此，理解「諸行無常」等於是自「苦」解脫。禪宗汲取大乘佛教的傾向，同樣重視實踐甚於教義。正因萬物無常，才要對「此時·此地」的當下瞬間秉持自覺而活。17 至 18 世紀的禪僧白隱慧鶴，因確立日本臨濟宗的禪學而知名。白隱注重坐禪與公案（禪問答），同時也注重在灑掃庭院及種田勞務等日常生活各種瞬間的自覺。對此白隱有句名言廣為人知：「動中工夫勝過靜中百千億倍。」中國唐末至五代的禪僧雲門也有句著名的禪語「日日是好日」，同樣是教人要意識「此時·此地」度過日常，這也是 20 世紀最具代表性的作曲家約翰·凱吉（John Cage）所喜愛的一句話。

禪學以美國西岸為中心，自 1950 年代以後，被所謂「垮掉的一代（beat generation）」接受。1950 年，80 歲的鈴木大拙在普林斯頓大學、紐約大學等地作禪學演講，1952 年起在哥倫比亞大學授課。他的英語演講及著作對禪學的遍及全球有莫大的貢獻，小野洋子及約翰·凱吉等多位藝術家也曾聽過大拙的演講，深受他的思想所影響。二次世界大戰後的美國，謳歌著伴隨韓戰所帶來的軍需工業發達，以及冷戰結構下的核能開發、大量生產、大量消費等經濟與科學的發展。在這種環境下，禪學被廣泛接納，不難想像是因為人們開始重新質疑生存的根本意義。如今，禪學再度在歐美與日本受到關注，這或許也暗示，在 21 世紀全球的政治亂局、快速變化的無常世界觀中，人們又重新探究生存的根本意義。「自己在世界的何處？」這個根本問題，也讓意識自然地集中到存在的相互依存性與關係性上。以佛教觀點重新思考「參與式藝術」，將會再度開啟大門，尤其是在探究亞洲的「參與式藝術」的發展上，應會是意義深遠的嘗試。

二、從李明維的藝術實踐看關係性

至此，看過了「參與式藝術」的諸面向，如果具體整理每個創作計畫中的「是誰、何時、何處、什麼目的、如何參與」，想必可清楚看到在一把語言的傘下形形色色之藝術表現。李明維的藝術實踐把這些面向多樣融入，在本展（編者：本文提到的本展皆為森美術館展覽）「李明維與他的關係」第一次作為廣泛而全面性的展出。標題中的「他的關係」，彰顯他與參加展出計畫的觀眾之間編織出的關係性，同時，也指出從歷史與文化的脈絡解析他的創作所構成的「思考『關係性』」的作品」。展覽中，探討他與古今東西 11 位包括藝術家、宗教家、思想家（白隱、今北洪川、鈴木大拙、九松真一、伊夫·克萊因、約翰·凱吉、李禹煥、亞倫·卡布羅、里克力·提拉瓦尼、小沢剛、田中功起）作品的共鳴。這些人不見得都對李明維有直接的影響關係，本展區的企圖，毋寧是期待他們的思想與實踐能深化「關係性」衍生出的多樣化概念，並與李明維的作品產生有趣的對話。同時，也試圖將李的創作自「1990 年以後的參與式藝術」這種既定的說法解放，從包括東方思想在內，更寬廣的世界來俯瞰他的創作。

本展及專書，將李明維的作品計畫以「一、對『關係』、『連結』和『之間』的思考」、「二、行、住、坐、臥——日常經驗的再認識」、「三、從個人的記憶為起點，思索與歷史、文化、社會的連結」這三大觀點構成，為了與李的作品產生共鳴，也特地穿插了「思考『關係』的作品」。各自的詳細內容請參閱本書的圖版頁，在此主要以這三大縱軸，織入歷史、傳承、交換與贈與、儀式、信賴、個人成長經歷這些橫軸，以便與「思考『關係』的作品」適切對應，藉以綜觀李明維作品展現的關係性。

對「關係」、「連結」和「之間」的思考

若就時間的觀點看「關係性」，不只是人類歷史，一切歷史都以各種時間軸相連。若就空間的觀點來看，不只是與周遭的人際關係及地域社會的關係，更廣及自古以來人類

懷抱的天地關係、大宇宙（macrocosmos）的太空與小宇宙（microcosmos）的身體「之間」的關係性。

禪畫代表主題之一「圓相」也是以一筆畫出宇宙的真理，在本展可以看到白隱的《圓相》（江戶時代中期），及鈴木大拙師事的今北洪川所畫《圓相》（明治時代）。另一方面，也會介紹集中在 1950 年代後半至 60 年代前半發揮過人才華的伊夫‧克萊因（Yves Klein），這位藝術家不斷探求構成宇宙的要素（第一物質、prima materia）之一「空氣」，或非物質性的繪畫空間「空」。克萊因自窗口向「空」縱身一躍的蒙太奇照片《躍入虛空》（1960）是最知名的作品之一，另外還有 1958 年在巴黎的艾瑞絲‧克勒特藝廊舉辦的個展「將原料狀態的感性特化成為穩定的圖像感性」（通稱「虛空展」），還有只用單一和弦與寂靜構成的交響曲《單調－寂靜交響曲》（1949-1961），皆可看到他對「空」的關注。從意識到「空氣」與「空」這種非物質領域的角度而言，他與 1960 年代末期至 70 年代，在日本以新雕刻運動而受矚目的「物派（以木、石、紙等未加工的自然物質‧物體，作為藝術舞台主角的創作流派）」基本觀念也有共通點。其中，「物派」代表藝術家之一李禹煥在 1970 年代開始的繪畫系列《從點開始》、《從線開始》，令人感到與禪畫「圓相」共鳴的宇宙真理。畫筆吸飽的顏料，自有至無一再重覆，透過極低限的（minimal）行為，傳達出永恆循環不已的宇宙能量與無限的世界。

在這樣的潮流中，李明維被墨西哥詩人奧塔維歐‧帕斯（Octavio Paz）的同名詩作觸動，創作出的《去留之間》（2007），可視為親身體驗宇宙與身體、天與地之間不斷對話的裝置藝術。在漆黑的空間中，宛如巨大沙漏般自破裂燈泡靜靜流瀉的沙子，令我們思考與天空的關係，加上蒙古的弦樂器馬頭琴演奏的音色，創造出冥想的空間。此外，中國古代的洪水傳說及開天闢地神話中流傳的女媧，是用五色石補天的女神，畫有女媧模樣的風箏《女媧計畫》（2005）中，持有者會在風箏上寫下自己的心願，在某一刻剪斷繫線讓女媧飛上天，藉此祈求天地平安。

女媧（離騷圖）
出自瀧本弘之編《中國神話‧傳說人物圖典》
遊子館出版，2010 年

另一方面，《補裳計畫》（2009），起因是 2001 年瞬間奪走許多人命的美國 9-11 恐怖攻擊事件，當時在世貿中心工作的李的伴侶也失去了 400 名同事。瓦解、喪失的關係要如何修復？經過了八年產生的這件作品，請觀眾帶來需要縫補的織物，由藝術家或扮演主人的工作人員一邊縫補，一邊與每位觀眾分享個人的故事。補好的織物，與裝置在牆上的線軸所延伸出的五彩絲線連結，將空間整體當作關係性與關聯的視覺象徵，讓作品不斷繁衍。此舉，一邊與象徵自瓦解與喪失中重生的女媧補天產生共鳴，同時也讓我們聯想到與

宇宙的連結。曾經專攻紡織藝術的李明維，在他的作品中，線與布是頻繁使用的素材之一，那就像是「無形之線」的隱喻，或者就像鈴木大拙把我們的存在比喻為網眼之一，象徵森羅萬象的連結。

若就歷史關聯與承繼的觀點來看，李把中國清初畫家石濤的畫作，分別邀請一群台灣藝術家及在亞洲以外地區活動的藝術家們連續臨摹的《傳移摹寫》（2004），明顯傳達出東方與西方在傳承這個價值觀上的差異。

交換與贈與

伊夫・克萊因為了讓非物質的價值可視化，進行的表演之一《「讓渡非物質繪畫感性區」的儀式》（1962），透過收藏家，把「非物質繪畫感性區」這個不可視的空間，不是用錢幣而是與象徵最高物質價值的純金交換，然後把證明交換的收據燒掉，另一方面，克萊因把收到的純金一半扔進塞納河，令該領域無法再繼續讓渡，完全歸持有者所有。這正是以「交換」行為作為媒介，讓我們認識非物質的價值。

在李明維的作品計畫中，「交換」的行為同樣也扮演了重要的角色。《石頭誌》（2009）中，李把他從紐西蘭的波羅拉里河撿來的 11 顆石頭用銅翻鑄，原件與複製品成一對。買下的藏家，在某一時間點必須在自然原石和翻銅複製品之間選擇一個扔掉。若照克萊因式想法，透過捨棄，或許會得到無法讓渡給任何人的永恆價值。另一方面，因冰河期地殼變動而成形的石頭，把 7 千年時光傳到今天。如果這麼想，等於把自然原石與經藝術家之手的翻銅複製品放到天秤上，令人思考有形無形的價值。前述的《女媧計畫》中，持有者也需放開風箏，如果將該行為視為補天、恢復天地秩序，那麼放開作品的行為本身堪稱遠遠凌駕於該作品的市場價值之上。

文化人類學家馬瑟・牟斯（Marcel Mauss, 1872-1950）的《禮物》（*Essai sur le don* / The Gift, 1925），關注的不是以競爭或利益為優先的市場經濟，而是古代文化與印地安贈禮（potlatch）等先住民文化中的贈與及交換儀式，對後世造成極大影響。進而，美國評論家路易斯・海德（Lewis Hyde, 1945-），把這種贈與經濟的想法與藝術家被稱為天賦（gift）的靈感或直覺重疊，「對我們最重要的藝術——若要形容那種體驗，可以說它會打動心靈、讓靈魂重生、讓感覺愉悅、帶給我們生活的勇氣——我們就是把帶來那種感動的藝術作品當成贈禮收下」。[27] 他如是說。

這種「贈與」的概念，在李明維的作品中也一再令人意識到。在 2009 年里昂雙年展首次發表的《移動的花園》（2009）中，觀眾在展間拿到的一朵鮮花，回程必須把花轉送給某人。在展間拿到的鮮花若是藝術家的贈與，透過匿名觀眾之手又轉到未知的某人手上，形成了再次贈與。在此產生的贈與循環，是替代市場經濟的贈與經濟系統。另一方面，「送花給不知名的人」這個行為沒有腦袋想得那麼簡單，它其實會產生心理的糾葛，令我們向內凝視脆弱的自我。同樣基於贈與概念的作品還有《聲之綻》（2013）。在這個作品中，展間內某位突然被選中的觀眾，會獲贈舒伯特的藝術歌曲。曾在母親做完心臟手術的療養期間，與母親一起聆聽舒伯特的歌曲而感受到嶄新能量的李明維，將如此禮物在這件作品中透過年輕歌者的才華（gift），贈與不知名的某人。隔著數公尺距離只贈與自己一個人的歌聲，就像是上天透過演唱者的身體賜與某種東西，想必會是感受到強大能量循環的神秘體驗。

行、住、坐、臥——日常經驗的再認識

禪宗思想注重「此時・此地」，意識集中在每日重覆的行為，這點前面已提到過，例如激浪藝術就是如此，在 1960 年代做了許多融合藝術與日常生活的嘗試。約翰・凱吉也常被放在該藝術流派中，但他的思想背景其實有亞洲藝術思想及禪學等東方思維。在紐約的社會研究新學院（The New School for Social Research）向約翰・凱吉學習的亞倫・卡布羅也承繼此觀念。卡布羅在 1949 年學習哲學時，

邂逅約翰‧杜威（John Dewey）的《藝術即經驗》（Art as Experience）（1934），後來透過凱吉認識了禪。1978 年在加州大學聖地牙哥分校任教後，也實際前往禪宗道場。卡布羅提倡的「偶發藝術」，正如《六個部分的十八個偶發》（1959）所見，讓觀眾按照詳細的指示參與演出，但凱吉似乎認為卡布羅的作品缺少偶然性與自由度。另一方面，凱吉自己於 1952 年在南卡羅萊納州的黑山學院進行的《Theater Piece No.1》被稱為最初的偶發藝術，其中，藝術家羅伯特‧羅森伯格（Robert Rauschenberg）、舞蹈家摩斯‧康寧漢（Merce Cunningham）、鋼琴演奏家大衛‧都德（David Tudor）等不同領域的藝術家，在凱吉的演講時間內，藉由 chance operation（完全交給偶然性決定）各自進行演出。

卡布羅提倡的「偶發藝術」，本該是與繪畫、雕塑截然不同的新型態藝術，但它很快被捲入以紐約為中心的藝壇漩渦，相較之下卡布羅卻漸漸與畫廊、美術館這些藝術場域拉開距離。其中尤以發展「偶發藝術」的「活動（activity）」最偏離過去的藝術，極為接近日常行為本身。卡布羅將它定義如下：「這一類型直接關連到日常世界，無視劇場和觀眾，是一種行動而非冥想，它在精神上更接近於身體運動、典禮、慶典、登山、戰爭遊戲和政治示威。它也和每天無意識的日常儀式有類似的性格，像是在超市購物、在尖峰時刻乘坐地下鐵、每天早上刷牙等。『活動型』偶發藝術選擇了多種狀況加以組合，讓大眾不單是鑑賞或思考其內涵，還能親身參與」。[28] 在完全沒觀眾的日常時間，可以與伴侶一對一進行的活動，乍看像禪宗公案一樣無厘頭，卻也是令人對日常意識覺醒的儀式。這些，被視為對當時美國的美術館及藝術界制度化的批判，另一方面，卡布羅自認，把藝術與日常行為幾乎完全重疊之舉，對於包括自己在內的藝術家而言也是極大的挑戰。「藝術一旦悖離傳統模式，並開始融入社會的日常表現後，藝術家不僅失去自以為擁有『才華』的權威性，對於眼前發生的事也將無法再單純基於『那是藝術』的理由主張其價值」。[29] 他這個質疑，在半世紀後的今天，或許依然值得我們反省。

相較於卡布羅把日常生活中的「無意識儀式」透過活動這個儀式而意識化，李明維則是把日常行為再次放進美術館或展覽這種體制內，藉以令人有所意識。李的早期作品《水仙的一百天》（1995）中，為了替曾給他許多創作靈感的外祖母服喪，他抱著一盆水仙，或置於身旁，一面閱讀、進食、書寫、睡覺、自我療癒，將這持續一百天的行為當作表演記錄下來。若是把水仙從發芽到成長、開花、凋萎等此種由生到死的循環過程，當作李的個人活動，那麼《晚餐計畫》（1997）與《睡寢計畫》（2000）便可說是與陌生人的一對一活動。前者，始自他就讀耶魯大學研究所時邀請某人到他的工作室一對一用餐；而後者，則是根據他去歐洲旅行時在夜行列車上與陌生老紳士徹夜對談的體驗。這些，作為概念架構非常簡單，但藉由在美術館此種非日常空間與素昧平生的人共餐、睡在同一個空間，令人意識到日常的無意識儀式。例如《晚餐計畫》中，對食物的偏好、用餐順序、拿筷子的方法、談話方式等，在《睡寢計畫》中，何時更換睡衣、何時脫襪，這些原本都是我們日常進行的無意識儀式，但在陌生對象面前卻會重新有所意識。這些只能一對一進行的計畫，會以抽籤方式自現場觀眾選出有限的參與者。因此，「參與式藝術」能夠期待的平等性與民主性很低，但獲選者的美術館體驗也因此格外特別。那裡有的，不是市場經濟的入場人數理論，而是重新審視藝術體驗的品質。

在美術館內用餐或過夜的計畫，也是提拉瓦尼及小沢剛相當知名的作品。用餐計畫方面，有提拉瓦尼的代表作——招待泰式咖哩的計畫（1992-），以及小沢剛的《蔬菜武器》系列（2001-）；至於過夜計畫，可舉出提拉瓦尼在畫廊裡重現自己的公寓，24 小時人人皆可使用的《無題 1999（明天可以安靜走開）》（1999），以及小沢剛的《相談藝術旅館》（2001），在畫廊內展出膠囊旅館，讓投宿的觀眾根據體驗不斷提出改善方案。李就讀耶魯大學期間的 1995 年，舉辦《晚餐計畫》的前身活動時，教授發現「以食物為媒介創造關係性」這點與提拉瓦尼有相似之處，據說還邀請提拉瓦尼來當了一學期特別講師。提拉瓦尼的計畫是用大鍋煮咖哩招待不特定的多數人，李的計畫則是為一個人而烹調餐點。乍看之下，提拉瓦尼的計畫是極為開放的宴會，而李的計畫

則比較內省，但提拉瓦尼曾對李如此說明：「我的作品雖然招待許多人吃咖哩，但我自己只在舞台後面煮咖哩，那是非常內向的。相較之下，你的計畫為準備餐點的人敞開心房，透過對話去理解對方，所以其實非常外向。」另一方面，小沢剛的《蔬菜武器》系列中，他與當地女性去買菜，請她抱著用買來的菜做成的槍，再替她拍下肖像照，之後，計畫的相關人士與觀眾一起煮菜共餐。透過那一連串過程，試圖接納超越文化、社會的差異。這個系列因 2001 年美國 9-11 恐怖攻擊事件而開始，自最初的作品《蔬菜武器——秋刀魚丸火鍋／東京》以來，到目前為止已在 17 個國家、33 個城市製作展出，最新版本的《蔬菜武器——煮芋頭／福島》於 2012 年在日本福島舉辦。買菜回來料理，一起用餐，融入這種無意識的日常生活的行為儀式化，因 2011 年的日本大地震及福島第一核災事故這個意外，被迫加強了完全不同層級的意識化。

還有，田中功起的《種種一切》（どれもこれも）（2003），是在居酒屋廚房側拍一名廚師作業的影像作品。令人矚目的與其說是「食」這個脈絡，毋寧是從廚師連續的熟練作業中並沒有產生任何具體料理。從中可以想像的是不斷持續的複雜作業片段，透過與廚房裡其他廚師們的複雜關係性、連帶作業構成整體的這種構圖。近年來，田中嘗試將這種多人構成的「複雜關係性」視覺化，《種種一切》似乎就已凝縮了那樣的本質。

從個人的記憶為起點，思索與歷史、文化、社會的連結

《晚餐計畫》與《睡寢計畫》能夠建立起一對一的關係性，是基於「親密」與「信賴」，或是以性善說為前提。近年流行的社群媒體，透過以信賴為前提的「朋友」作為媒介擴大人際網絡，但它所建構的友情與關聯的品質被不斷質疑。李明維的計畫內含親密性的另一把鑰匙，是個人的記憶與成長歷程。共享每天的個人經歷，並作出回應，也是滲入社群網絡時代的日常行為，這種光景暗示的是，在已無法掌握整體像的今日，或許唯有透過一個個的私人經歷片段，才能理解

歷史、社會、文化這些更大的故事。

李明維的家族歷史傳承下來的個人經歷，為日本與台灣在政治面的關係性上帶來新的視點。中日甲午戰爭結束後簽定馬關條約，自 1895 年至 1945 年，日本統治了台灣 50 年。李的祖父母與父母皆生在那個時代。尤其是母親的祖先出身自台灣原住民中的平埔族，李的外曾祖父還做過南投縣埔里鎮（日治時期為台中州能高郡埔里街）的「街長」，是位政治家。外祖父母都在 1920 至 30 年代留學東京，外祖父在明治大學專攻法學，外祖母在東京女子醫學專業學校（現在的東京女子醫科大學）學習西洋醫學。回國後，外祖父擔任學校校長，外祖母開診所實踐西洋醫學。「李明維」這個名字就是來自明治維新，據說也與外祖父母學習的日本精神有很大的關係。現代化以後的日本對亞洲諸國的殖民政策，從政治、歷史的觀點往往強調其負面影響，但若將焦點放在透過日本產生對西方現代文明的憧憬、學習，進而對後世作出極大貢獻的個人身上，他們每個人的故事並不單純。從當時的照片，可以感到李的外祖父母抱著背水一戰的決心赴日留學的迫切感，以及戰後仍與恩師和同學保持聯絡的情景，再次讓我們感到超越政治關係性的人際關係。

前面也提到過，李對外祖母抱著特別的憧憬，《魚雁計畫》（1998）就是他把想對過世外祖母說的話寫在信上而得來的靈感。在設計精美的三座小驛亭內，觀眾把無法傳達的感謝、悔悟、原諒等言語寫在信上。在那裡以或站、或坐、或跪的姿勢寫信，據說那是禪宗實踐中的三種冥想姿勢。寫好的信留在現場，封緘寫上收信人的信會由美術館工作人員寄出，但是未封起的信就任由其他觀眾打開閱讀。雖是陌生人寫的信，但裡面描寫的個人經歷與感情，卻有打動讀者的強大力量。尤其，震災發生後的 2012 年，日本社會籠罩在難以言喻的失落感中，在東京資生堂畫廊展出本作時，我也曾在不經意間差點落淚。還有《織物的回憶》（2006），源自不肯參加幼稚園入學典禮的小李明維，穿上母親親手做的外套而得到安撫的這段回憶。為了本展，特地向一般民眾募集有特殊回憶的織物，連同織物背後的故事，一起放入美麗的木盒，在簡單的平台上展出。觀眾就像欣賞茶道的茶碗

般，一邊閱讀盒中的各種個人故事，一邊凝望著那些織物。

實際上，《魚雁計畫》與《織物的回憶》中，藝術家製作的其實只有引導觀眾如何參與的解說，以及設計洗練的裝置而已。但是當人們的個人記憶與經歷介入其中，觸動另一位觀眾的心靈時，每件作品就會開始綻放出鮮活光彩。

另一方面，引用畢卡索名作《格爾尼卡》（1937）的《如沙的格爾尼卡》（2006），源自美國於 2003 年轟炸伊拉克之舉。《格爾尼卡》是畢卡索因 1937 年西班牙內戰時，納粹轟炸格爾尼卡城造成大批市民死傷而製作，同年在巴黎萬國博覽會的西班牙館展出，之後直到 1981 年歸還西班牙之前一直陳列在紐約現代美術館。14 歲的李在歸還前夕看到這件作品，據說那是他首度意識到藝術作品具有的政治面。用沙描繪的《如沙的格爾尼卡》，展期間，李將擇一日完成其中未完成的部分，同時容許觀眾一一走在沙上，最後包括李自己在內的參與者一同拿掃帚把沙子掃成一堆，讓圖像徐徐消失。藏傳佛教的沙曼荼羅，也是以五彩的沙子來表現宇宙的構造，耗費多日完成的沙曼荼羅，待完成後再一口氣毀壞。創造與毀滅的重覆循環，傳達出大自然的法則。進行一整天的《如沙的格爾尼卡》表演，令人意識到這世間的虛無縹緲與無常，但同時它也可能是一種慰藉，撫慰無所不在的政治紛爭中犧牲的無數生命，以及痛失所愛者的心靈。

無形之線的價值

本展最後出現的是《客廳計畫》（2000）。這件作品，本來是受 1903 年創立於波士頓的嘉德納美術館委託，李於 2000 年進行的計畫。嘉德納夫人曾支援當時在波士頓美術館當研究員的岡倉天心，是知名的藝術贊助人。《客廳計畫》在公開展出她私人收藏的嘉德納美術館中，由館員或當地民眾代替已過世的夫人，將他們自己珍貴的收藏品拿來，與來到房間的觀眾展開對話，分享藏品背後的故事與插曲。現在這個客廳，在 2012 年嘉德納美術館新館開設之際成為永久設置，再度藉由揭開個人的經歷，讓人一窺背後的歷史、社會、文化。在本展中，會有志願者扮演客廳的主人接待觀眾，敘述與森美術館及六本木地區有關的個人經歷還有他們個人的收藏。

以上，我們從參與式藝術的諸面向檢驗探究李明維的創作計畫。這次，透過「當代藝術館的展覽」這個架構展出他的作品，藉由各種藝術裝置提供多樣化的「參與」來構成整個展覽。作為主幹的概念架構，透過現實中的行為及體驗的積累、記憶的共享而開花結果。迥異於固定式展覽所面對物質性的「物」，李的作品則每天的狀態都在變化、繁殖。因此，展覽成了為這種行為及體驗、對話及共鳴而存在的時間與空間，唯有實際身歷其境才能鑑賞。李的作品，想必要透過參與後被刺激的直覺與感覺、想像與聯想才能體驗，因此，本文的上述說明純屬次要。那麼，觀眾能從展覽現場帶回什麼呢？但願透過在那裡的體驗被喚起的感覺、意識、記憶，可作為非物質性的價值，也就是「無形之線的價值」，形成新的記憶層，在今後的每一天讓每個人的無意識儀式熠熠發光。

本展同時也試圖探討「當代藝術館的展覽」是什麼，在各個不同的歷史與社會中被如何定位，應該扮演何種角色等議題。廣義的「參與式藝術」，在這日益複雜化的當代藝術及其環境、制度中，或許是用來不斷探究「藝術是什麼」的無形贈禮。

1. Cotter, Holland, "Art in Review; Lee Mingwei—'Project 80'," *The New York Times, November* 21, 2003.

2. Lacy, Suzanne, "Cultural Pilgrimages and Metaphoric Journeys," *Mapping the Terrain—New Genre Public Art*, Suzanne Lacy(ed.), Seattle, WA: Bay Press, 1995, p.19.

3. Bourriaud, Nicolas, *Esthétique relationnelle*, Dijon: Les presses du reel, 1998 (French Edition). Bourriaud, Nicolas, *Relational Aesthetics*, Dijon: Les presses du reel, 2002 (English Edition).

4. Bourriaud, Nicolas, "Pour une esthétique relationnelle (première partie)," *Documents sur l'art* 7, Spring 1995, pp. 88-99. (Bourriaud. Nicolas, "traffic : The Relational Moment," trans. Molly Stevens, *theanyspaceewhatever*, New York: The Solomon R. Guggenheim Museum, 2008, pp. 172-173.)

5. 同上註，p. 173。

6. Bourriaud, Nicolas, "An Introduction to Relational Aesthetics," *TRAFFIC*, Bordeaux: CAPC musée d'art contemporain de Bordeaux, 1996.

7. Bourriaud, Nicolas, *op.cit.*, theanyspacewhatever, p. 173.

8. 尼可拉・布西歐（訪談）〈關係美學與今日的策展〉（採訪者：松井綠），《季刊 ARTiT》，22 號，2009 年冬季／春季號，頁 50。

9. 本書在 2014 年現在，已翻譯成世界各國版本，簡體中文版也在 2013 年於中國出版。提倡至今已快 20 年，準備出版中的日文版也令人期待。

10. Bishop, Claire, "Antagonism and Relational Aesthetics," *OCTOBER*, Cambridge, MA: The MIT Press, No. 110, Fall 2004, pp. 51-79.（日文版：克萊爾・畢曉普〈特集｜敵對與關係美學〉，星野太譯，《表象 05｜特集：對話的藝術》，表象文化論學會，2011 年，頁 75-113。）

11. 在此畢曉普參照的，是政治理論家艾內斯特・拉克勞（Ernesto Laclau）與政治學者項塔爾・穆夫（Chantal Mouffe）的以下論點：「充分發揮機能的民主社會，不是指一切敵對皆已消失的社會，而是不斷描繪新的政治疆界（frontier），並把它帶進辯論的社會。換句話說，所謂的民主社會，是維持其中的對立關係，而不是消去。（中略）他們〔拉克勞與穆夫〕主張，沒有烏托邦的概念就沒有激進假想的可能性。〔對我們而言的〕課題是在不陷入極權主義之下，讓介於想像的理想與務實的社會積極營運之間的緊張關係達到平衡。」（同上註，p. 90）

12. 同上註，p. 76。

13. Bourriaud, Nicolas, *op.cit.*, thranyspacewhatever, p. 175.

14. Jacques Rancière, *Le spectateur émancipé*, Paris: La fabrique editions, 2008. 此外，這一連串的發展，請參照星野太的詳細分析〈Relational Aesthetics and After｜閱讀布西歐 × 朗榭爾爭議〉，（筒井宏樹編《EOS Art Books Series 001：Contemporary Art Theory》，2013，頁 36-70。）

15. Spector, Nancy, "theanyspacewhatever: An exhibition in ten parts," *op.cit.*, theanyspacewhatever, p. 15.

16. *The Art of Participation: 1950 to Now*, London: Thames & Hudson (November 17, 2008), published in association with the San Francisco Museum of Modern Art.

17. Bourriaud, Nicolas, op. cit., *TRAFFIC*.

18. Spector, Nancy, *op. cit.*, theanyspacewhatever, p. 14.

19. 引自作者透過電子郵件所作的訪談，2014 年。

20. 同上註。

21. 包括西武美術館（後來的 SEZON 美術館、SEZON 現代美術館）、原美術館、佐賀町展覽空間、ICA 名古屋、東高現代美術館等。其中現在仍維持開館當時型態的，只有原美術館。

22. 1989 年橫濱、名古屋、廣島設有市立美術館（其中廣島是日本首座公立現代美術館），1990 年在水戶成立正式的當代藝術畫廊，1995 年東京都現代美術館開館。

23. 引自克利提亞・卡維翁〈無法回頭的地點（為了「超越『關係美學』」）〉，平芳幸浩譯，「第七屆亞洲次世代策展人會議」，於國際交流基金 JFIC「櫻」廳（東京），2011 年 9 月 29 日開幕（Session 1，發表 1）時的資料。

24. 提拉瓦尼在 2010 年的曼谷個展「誰怕紅、黃、綠」（Who's afraid of red, yellow and green），畫家在牆上畫下泰國自 1970 年以後的政治史，在畫廊中央招待大家吃象徵不同政黨顏色的咖哩。

25. 印度佛僧。年代不確定，應是生於西元 2-3 世紀。

26. 鈴木大拙，〈第五講 從心理學看到的禪〉，《禪是什麼》（改訂版）角川書店，1999 年，頁 130。

27. 路易斯・海德，《禮物——情色的交易》，井上美沙子・林廣美譯，法政大學出版局，2002 年，序論 viii。

28. Kaprow, Allan, "Pinpointing Happenings," *Essays on the Blurring of Art and Life* (Expanded Edition), Jeff Kelly (ed.), Berkeley, Los Angeles and London: University of California Press, First Edition: 1993, Expanded Edition: 2003, p. 87.

29. Kaprow, Allan, "Success and Failure When Art Changes," *op. cit.*, *Mapping the Terrain—New Public Art*, p. 158.

Value of Invisible Threads: Lee Mingwei and His Relations

Kataoka Mami
Chief Curator, Mori Art Museum

Over the past ten years at the very least, so-called "participatory art" that relies on the participation of an audience has gained broad acceptance and a definite sense of legitimacy. In addition, artists who go into the space of the city in order to execute various forms of community projects, rather than limiting themselves to the spaces and structures associated with the art museum, are no longer an uncommon sight. Although the career of Lee Mingwei (born in Taiwan in 1964, and now based in New York), which spans a period of some twenty years, has also often been discussed within the context of this "participatory art," he was once described as a "social conceptualist" by the art critic Holland Cotter.[1] Cotter's choice of words proves particularly apt in beginning to inquire into Lee's artistic practice. Assuming that the act of leaving the museum and entering into actual society in order to carry out art projects can be termed "social," Lee Mingwei is not a particularly proactive social artist. He is, for instance, neither an artist who tries to grapple squarely with the problems of a specific community in an attempt to ameliorate them, nor someone who brings a big group of children together to run large-scale workshops.

That being said, the brand of "contemporary art" that Lee has arrived at by way of such varied disciplines as biology, architecture, and textiles is also entirely different from traditional art forms like painting and sculpture. In the early 1990s, while studying at the California College of the Arts, Lee met two professors called Mark Thompson and Suzanne Lacy. Thompson, who was also a philosopher and a beekeeper, deepened his appreciation of what an artwork was, in the context of living together with bees and being conscious of the ecologies of the natural world. Lacy, for her part, made him more aware of problems surrounding the issues of community and feminism. Although Lacy had studied under Allan Kaprow, who advocated an entirely new form of art called "Happenings" during the late 1950s, Kaprow's sustained devotion to the fundamental question of what art is perhaps also resonated with the "new genre public art" that Lacy herself proposed. "Unlike much of what has heretofore been called public art, new genre public art — visual art that uses both traditional and nontraditional media to communicate and interact with a broad and diversified audience about issues directly relevant to their lives — is based on engagement."[2]

This was the environment that gave rise to Lee's early work, *Money for Art* (1994). In this piece, Lee sat in a café folding ten-dollar bills into paper sculptures. In exchange for the gift of these paper sculptures to people who were interested in them, Lee asked for their telephone numbers so that he could call them every six months to ask what had become of the bill. Although Lee actually called the owners of these artworks every six months, one of the participants with whom he has maintained a longstanding relationship is a homeless man called John, an ex-soldier who served in the Vietnam War. In spite of the fact that John lives under a set of circumstances in which ten dollars means quite a lot, he has continued to hold on to the paper sculpture, proudly showing it off to Lee each time they meet. Earlier this spring, Lee met John again, and found that he has now collected 14 of these sculptures over twenty years. *Money for Art* is a project that explores the non-monetary value that art embodies while also giving John a sense of dignity. It is this non-quantifiable value, which we are encouraged to reconsider through personal narratives and the acts of exchange and giving, that stands at the core of Lee's practice.

Despite this quality of his work, the reason why I wouldn't entirely classify Lee as a proactive social artist is because most of his projects are carried out from within the inside of systems associated with art, such as galleries and museums. Visitors enter these spaces and participate in ritualistic frameworks or simple instructions that Lee has prepared, whereupon artworks come into being by actually executing a series of actions. The significance of how these works emerge resides not within the act of giving a visible form to them — rather, it consists in the construction of relationships that resemble invisible threads. Furthermore, each participant becomes conscious of the immaterial, intangible value of these constructions. In this sense, Lee's practice is akin to conceptual art — if it is a form of public that somehow represents "society," whether or not the audiences that visit his exhibitions are a limited demographic or not, then perhaps we can characterize Lee, as someone who proposes conceptual frameworks with a social objective, as something of a "social conceptualist." In fact, Lee himself considers the institutional framework that includes art galleries and museums to be effective as a kind of theoretical prerequisite for the conceptual underpinnings of this sort of immaterial art.

Money for Art #4
1994

In the following essay, I hope to first examine various aspects of the notion of "participatory art" in terms of how it elicits the participation of viewers, including a historical analysis, before exploring the entire arc of Lee Mingwei's artistic practice based on its historical and social contexts.

1. Various Aspects of Participatory Art

From Material Artwork to the Artwork-as-relationship

Since the 1990s, whenever the notion of a now globally disseminated "participatory art" is discussed, it has proven difficult to leave out the "relational art" or "relational aesthetics" first advocated by the French art critic and curator Nicolas Bourriaud. This theory was reflected within an exhibition for the first time in 1996, at the *Traffic* exhibition that Bourriaud had curated at the CAPC musée d'art contemporain de Bordeaux. In 1998, they took the form of a book in the French edition of a collection of essays called *Esthétique relationnelle*, which was followed in 2002 by the publication of an English version, *Relational Aesthetics* that enabled them to spread on an international level.[3] Bourriaud had first deployed the term in the spring 1995 issue of *Documents sur l'art*, a magazine that he founded in 1992. In it, the term was defined as a "set of artistic practices that draws from the sphere of human relationships as a point of departure, whether theoretical or practical."[4] Several of those who participated in *Traffic* and would later come to symbolize relational art, such as Philippe Parreno, Dominique Gonzalez-Foerster, Liam Gillick, and Angela Bulloch, were also artists who showed their work in exhibitions curated by Bourriaud from the late 1980s through the early 90s. In a sense, it was Bourriaud who provided a framework and a terminology for a new generation of artists and their practices that still suffered from a lack of theoretical underpinnings. Bourriaud has said that *Traffic* was "a communal exhibition that involved forming a temporary microcommunity in Bordeaux."[5] The extent of this insiderish excitement could also be seen in how the opening reception stretched on for four days. For Bourriaud, what united the 28 participating artists was the fact that "their works highlight social methods of exchange, interactivity with the onlooker within the aesthetic experience proposed to him/her, and communication processes, in their tangible dimension as tools for linking human beings and groups to one another."[6] At the same time, Bourriaud situated these artists as part of a generation that emerged out of the realm of "relationships" — similar to how the Pop Art of thirty years earlier was born out of the world of consumerism, and how Minimalism emerged from the realm of industry.[7]

Bourriaud was essentially declaring that the essence of art had been shifted from an artwork as a visible substance to a mutual "relationship" between human beings, or a social context — this was the new form that art had taken. Here was the one insight, more than any other, that gave Bourriaud's viewpoint the acclaim it deserves. In addition, this interpretation of relational art also aligned itself with the lessons gleaned from the concrete, practical explorations of other artists from the same generation. In fact, the reason that relational art had managed to permeate the art world so deeply was this: the tendency that Bourriaud had pointed out was also being simultaneously observed in the practices of contemporary artists from all over the world, including those from Japan and Asia. I myself also sympathize with his perspective, as I recall the way in which a theoretical framework was demanded of this new, ungraspable art. Bourriaud himself notes that "Scandinavia was the first to really respond to the theory. The Swedish art magazine, *Paletten*, did a special issue on relational aesthetics in 1996. So the diffusion of those ideas came from 'peripheral' countries first."[8]

Today, *Relational Aesthetics* has been translated into languages all over the world, and has acquired textbook status at art universities mainly in Europe and America.[9] On the other hand, various critical arguments based on it have also been developed. One of the most well known is American critic Claire Bishop's 2004 essay "Antagonism and Relational Aesthetics,"[10] which appeared in *OCTOBER*. Although the target of Bishop's criticism was focused on Bourriaud's theory along with artists Rirkrit Tiravanija and Liam Gillick, one of the things that she pointed out was the state of being democratic in the art of relational aesthetics. The act of incorporating the audience into a portion of the artwork and facilitating a process of dialogue was an affirmative one that allowed

artists to see their works as democratic. What Bishop pointed out was that most of the works by the artists that Bourriaud discussed, although seemingly open at first glance, were not in fact utopian situations that envisioned some brighter future — they were "microtopias" that only offered up a momentary instant of consideration, constructing a rather closed form of community. Effectively, Bishop was criticizing the fact that Bourriaud's theory lacked a certain "antagonism" that might serve as a site of debate and discourse required in democratic society.[11] In response, Bourriaud explained the politics entailed by relational art by drawing on examples of works by artists other than Tiravanija and Gillick who had been demonstrating more discursive aspects. Bishop's criticism was also directed at the way in which these artworks tended to shift and alter themselves over the course of the exhibition in response to the participation of viewers. "Such work seems to derive from a creative misreading of poststructuralist theory: rather than the *interpretations* of a work of art being open to continual reassessment, the work of art *itself* is argued to be in perpetual flux."[12] Bourriaud countered that "many of the works in *Traffic* exhibit a kind of fluidity, refusing to be pinned down, and thus challenging a discourse of stability that critics do not seem ready to give up."[13] Relational aesthetics had also been criticized by the French philosopher Jacques Rancière in his 2008 book *Le spectateur émancipé (The Emancipated Spectator)*. Just as Bourriaud had refuted Rancière's criticism the following year, Bourriaud's theory provided an intriguing, long-term argument.[14]

Even as these debates unfolded within the world of academia, the "participatory art" that allowed visitors to an exhibition to become more actively involved in the process by which a work developed, or the space in which it was created as a part of an installation, began to steadily infiltrate the setting of the museum. Although "relational aesthetics" could be applied to contemporary global movements happening elsewhere in the world, the focus of subsequent arguments somehow became summarized by individual theories, as well as specific artists and artworks. Furthermore, because the scope of relational aesthetics expanded towards more universal notions of democracy, politics, and aesthetics, the arguments seem to have gradually strayed away from the artworks themselves, and the

psychology of those who actually participated in their making. If "relational aesthetics" is defined as a theoretical horizon that acknowledges the "relationality" of an artist's practice, then several criticisms of it seem to have been constructed in expectation of the "socially engaged art" and "community art" that seeks active involvement in the social problems or political issues specific to a certain location. As a framework, "socially engaged art" is not far removed from the "new genre public art" mentioned earlier. Its instances span a whole gamut, from artists who make concrete interventions that engage issues facing local communities, to exhibits in museums that showcase findings based on research into social or political issues. Its essence can be said to consist in a certain engagement through art that is broadly directed at society. Because the majority of the public are naturally invited to be a part of the project, this kind of art can also be seen as "participatory." Furthermore, the spatial or bodily experience of an "installation" that is often premised on the participation of the audience also takes its cue from the "Happenings" and "environmental art" of the 1960s and beyond, while also accounting for a form of art that has gained wide traction since the 1990s. "Installation," in terms of how participation is physical and bodily rather than conceptual or social, can also be classed within the realm of "participatory art." Accordingly, in addition to "relational art" and "relational aesthetics," I would like to consider the nature of "participatory art" broadly defined — a general, all-encompassing term for practices that include "socially engaged art," "community art," and "installation art."

An example of an exhibition that reconsidered this tendency was *theanyspacewhatever*, held at the Guggenheim Museum in New York in 2008. Nancy Spector, who curated this exhibition made up of works by ten of the main artists who featured in Bourriaud's *Traffic*, offered audiences a wide-ranging overview of artistic movements from previous generations while pointing to the fact that much of the art from the 1990s was united by its "desire to circumvent representation in favor of an engagement with the world at large."[15] That same year, the San Francisco Museum of Modern Art organized an exhibition entitled *The Art of Participation: 1950 to Now*, which attempted to give this movement a historical context.[16] *The Art of Participation* covered a wide swathe of 43 artists/groups ranging

from early Happenings, performances, and Fluxus art to the so-called "participatory art" of today. If the scope of the discussion was extended to "socially engaged art" and "community art," the number of instances in which contemporary artists became engaged in regionally specific issues over the last two decades, including regions in which social and political systems have undergone dramatic transformations after the collapse of Cold War structures, would be too numerous to mention. Creative Time, a New York-based non-profit organization that has proposed innovative perspectives on the relationship between art and society for many years, summed up these tendencies in a 2012 exhibition entitled *Living as Form: Socially Engaged Art from 1991–2011*. The selection of more than 100 artists' projects from around the world introduced here highlighted the political and social issues confronting each country or region and specific problems related to race, religion, and gender, conveying something of the enthusiasm of these artists driven by the force of necessity.

How Participatory Art Developed during the 1990s

Frameworks like art museums and exhibitions were originally seen as static structures. The act of bringing a "participatory art" that entails the involvement of people from all walks of life into these frameworks, however, actually forced institutions into taking on this considerable challenge. Even so, what were some of the reasons that led to the widespread acceptance of participatory art? For Bourriaud, "possible sociological explanations for this phenomenon exist, given that the 1990s, marked as the decade has been by recession, hardly bode well for sensational and conspicuous undertakings."[17] Spector, on the other hand, who curated *theanyspacewhatever* exhibition, analyzes the phenomenon in the following way, from the perspective and background of American society and culture. "At the beginning of the 1980s, the art world witnessed drastically divergent, yet coexistent tendencies, each feeding the demands of an exponentially growing market. (…) In the United States, the 1980s coincided with the age of Ronald Reagan, an age which garnered the rise of a new monied class, the consolidation of the Christian Right, and, in culture, the unprecedented linkage of art and commerce. Concurrently,

an oppositional strain of art-making emerged that challenged the notion of artistic authority and scrutinized the seeming transparency of representation. Variously known as Neo-Geo, Neo-Conceptual, and Appropriation art, it was informed by postmodern theory, which exposed the legitimizing narratives of Western thought — including religion, philosophy, and psychology — as ideological constructs designed to sustain the presumed superiority of Western culture."[18] In fact, the title of Spector's exhibition, *theanyspacewhatever*, which is also a title of the work by Liam Gillick, suggests a term used by the postmodern philosopher Gilles Deleuze — "any-space-whatever," a film-specific expression that he used to refer to quotidian, highly anonymous images that circulate onscreen whenever the setting of the film changes. Here, we catch a glimpse of how the Deleuzian philosophy of diversity and disparity is being contrasted with the gradual diversification of art. In addition, the increasingly intimate relationship between art and commerce to which Spector draws our attention is surely not entirely unrelated to the development of participatory art. Seeing as how a lot of "participatory art" assigns a relatively heavier importance to the experience of participation and the amelioration of how the community shares with each other, it does not necessarily leave behind a physical trace of its presence. As a result, it becomes difficult to assign specific ownership rights for artworks that go on to become products of the market, or to ascertain the value of non-material experiences. In fact, the Scandinavian countries that gave Bourriaud the earliest reactions to his theory were also regions with comparatively extensive support systems for art. Perhaps it was this environment that accounts for one of the reasons behind the development of "participatory art."

In contrast, although Bishop raises criticisms of Tiravanija's practice in her own writings, she also refers to Thailand as the spiritual home of "relational aesthetics." In fact, "participatory art" also came to be widely accepted during the 1990s among a new generation of artists from Asia, including Thailand and Japan. During this period, the work of many of these artists was introduced in the global art scene. Although the attention paid to Thai artists in particular may have been due in part to the direct or indirect influence of Tiravanija, the social background surrounding the development of "participatory art" in Asia

demands the incorporation of a viewpoint that differs from either Bourriaud's or Spector's.

One of these background factors is the institutionalization of galleries, museums, and other spaces dedicated to contemporary art, as well as the issue of democratization that Bishop so aptly touches on. A more in-depth examination of these questions will have to be left to another occasion, but the point I wish to emphasize here is this: the history of contemporary art throughout Asia, while dovetailing with various historical movements including the postwar decolonization process and the modernization and democratization of countries and societies, actually developed in a specific manner that entails a time lag when compared to Europe and the US. And in contrast to the art history of the modern era and beyond that was driven by the West, each Asian country has embodied an ambiguous multiplicity of traditional art forms and Western modernism. Within this perspective, the particular cultural and religious customs of each country, too, cannot be ignored in any consideration or analysis of concepts like participation and relationality.

When it comes to the issue of institutions and systems that surround art, Navin Rawanchaikul, the Chiang Mai-born artist who made his international debut during the 1990s, is a symbolic presence. Although Rawanchaikul is known for a body of work that includes *Navin Gallery Bangkok* (1995–), where he hired a taxi and a driver for a month and converted the interior of the cab into a gallery, the reason why he started the project was plain and simple: "because there was no other place to show contemporary art." This inevitability is a sentiment that seems to be shared in other Asian regions, and is also found in the representative *Nasubi Gallery* series (1993–) by Ozawa Tsuyoshi, a pioneer of "participatory art" in Japan. Conceived as a proposal that criticized the way in which exhibition spaces for young artists were limited to rental galleries, *Nasubi Gallery* consisted of an exhibition of the world's smallest mobile galleries made using milk delivery boxes in the streets of the city — the world's smallest exhibition featuring a group of international artists. In 1991, Ozawa also proposed the idea of "Sodan Art," in which the opinions of other people were reflected in the process of producing his artwork. "One

day, it occurred to me that most artworks are just a bunch of egoists that confront viewers with the artists' own thoughts in a one-directional fashion. If that was the case, then I wanted to see how far I could go in terms of doing something that would be the exact opposite."[19] Based on Ozawa's experience of holding solo exhibitions to which almost nobody except his friends would come, "I began working in a style that involved taking a canvas out into the street and soliciting direct advice from passers-by about a work-in-progress."[20] If we accept that the so-called contemporary art world of twenty years ago was a microtopia, the act of taking into account the presence of members of the general public also has an inextricable relationship to the process of the institutionalization of art — meaning that its microtopia had to be opened up to the wider public. The "relational art"-as-microtopia that Bishop criticizes can occupy commercial galleries, alternative spaces, and other venues that cater to members of the art world. When this art enters into a museum or other institutionalized space that is open to a larger audience, this microtopia may start to encounter real world issues.

In fact, the 1990s in Japan were also a period in which spaces for showing contemporary art shifted from private venues or spaces operating mostly on corporate funds, and towards public museums. From the 1970s through the 1990s, the majority of art spaces funded by corporations or individual benefactors that introduced the work of leading Western contemporary artists found themselves forced to close their doors after the collapse of the bubble economy.[21] As if to inherit the mission and spirit of these spaces, public museums all across Japan that had been planned during the economic boom opened in great numbers starting in the late 1980s.[22] Undoubtedly, the dramatic expansion of contemporary art spaces that reached out to ordinary citizens naturally led to a demand for policies that allowed the participation of citizen taxpayers and programs that would connect audiences to "difficult" contemporary art. Among the large-scale contemporary art museums that have opened over the past ten years, including the Mori Art Museum and the 21st Century Museum of Contemporary Art, Kanazawa, how many are able to connect a wide-ranging audience to contemporary art that emerges from an increasingly complex set of contexts,

set against a backdrop of globalization? It cannot be denied that "participatory art" has become an effective means of dealing with this imposing question. This trend can also be found in the biennials and triennials that have spread all across the globe since the 1990s. Despite the diversity of operating models — from the Yokohama Triennale (2001–), which focuses on particular museums or exhibition facilities, to the Echigo-Tsumari Art Triennale (2000–) and Setouchi Triennale (2010–), which make use of the natural environment and abandoned buildings as a dynamic way of revitalizing neglected, depopulated regions — there is now a definite demand for the creation of programs and frameworks that facilitate citizen participation. In fact, this demand can be inferred from the way in which artists like Tiravanija, Rawinchaikul, Ozawa, and Lee Mingwei have become regular fixtures who have participated in many international exhibitions over the past two decades.

In contrast, Japan in the wake of the 2011 Great East Japan Earthquake has experienced a tremendous shock and loss that is both physical and psychological. Under these conditions, the role of art in society has once again been called into question, leading to many socially involved, community art projects being held mainly in areas affected by the disaster.

To be sure, there is a democratic aspect to audience members being able to participate in an exhibition or the production of an artwork. Participatory art makes one feel an equal sense of belonging or identification, not through art history or the meaning of a particular artwork, but rather through a bodily or sensory experience. This fact can be related back to the process of democratization in Asian countries. In Southeast Asia, for instance, where economic development proceeds apace, many young artists and curators are energetic proponents of activities such as performance, street art, and live music that straddle both the artistic realm and the space of political activism, all conducted outside of the system of "contemporary art museums." Except for countries or cities like Singapore and Bangkok, public institutions where one can regularly see international contemporary art are still in the process of being developed. On the flip side, however, what has been urgently demanded in Southeast Asia, more than contemporary art museums, is the democratization, modernization, and stability

of society itself. Even within the contemporary art community, a consciousness of the "public" is extremely high. Thanks to economic development, the art market has even attracted the attention of the international art world, with members of the new rich becoming a source of new audiences. As such, curators and artists from this younger generation are now faced with the urgent question of who their own "public" is.

Saying that "I'm not interested in aesthetics, only relations," Tiravanija founded a collaborative project together with Kamin Lertchaiprasert in Chiang Mai called *The Land* in 1998, a long-term ongoing endeavor that does organic farming while also organizing residence programs housed in pavilions designed by artists and architects. For Thai curator Gridthiya Gaweewong, "the project was designed as an alternative model, to point out other possibilities of creativity to the art world. In fact, it actually criticized the art world for being introvert and privileged. Just moving away from the center of the art institution to San Pa Tong, a suburb of Chiang Mai, was a strong statement in itself. However, this discourse was centered on the international art world; it did not engage the local art scene or the audiences."[23] According to Gaweewong, it was the generation of artists following Tiravanija that actually led art to orient itself towards society. She points out that the advent of the Thaksin administration in 2001, the coup d'etat of 2006, and the political and social chaos that ensued all awakened the consciousness of the Thai citizens. The renewed questioning of what role art should play came at the stage when the country was heading towards a potential utopia — a shift towards real democracy.[24] This consciousness of democracy, as well as the dignity and existence of human beings, is a concern that can be found in any number of other situations: the post-disaster situation in Japan as mentioned earlier, the Philippines after the collapse of the Marcos government, a newly democratic post-Suharto Indonesia, or even a Myanmar that is seeing rapid democratization and dramatic economic growth. In a region that is still in the process of development, the role of art, called into question under such political and social conditions, surely demands further wide-ranging research.

Relationality in Eastern Thought

Another important consideration when thinking about "participatory art" in Asia is the relationship between Buddhist thought and the notion of "relationality" as seen from a cultural or religious perspective. Discounting what Bourriaud has said about how elements of nomadism and the Buddhist temperament can be found in Tiravanija's practice, this particular aspect has only rarely been examined. And yet the fluidity and versatility of these works that have become the target of Bishop's criticism, for example, and the ideals of a microtopia that only privilege the "here and now," are part of a body of Eastern philosophy that promises to be extremely useful in thinking about the idea of relationality — just as they are a central part of Buddhist thought.

In thinking about the interdependent relationships between human beings and social contexts, we naturally turn our attention to the state of our "relations" and "connections," as well as temporal and spatial concepts like the "in-between." Buddhist concepts like *pratitya-samutpada*, emptiness, nothingness, and the impermanence of worldly things, however, resonate naturally with them. In fact, the Zen philosophy that Lee Mingwei came into contact with during his youth, especially its self-awareness of the everyday, compassion, and introverted disposition, might be said to form the foundations of a consciousness that would subsequently give direction to his artistic practice. Buddhism, of course, began with the teachings of Gautama Buddha. After his death, however, his philosophy became divided into the two schools of Theravada Buddhism and Mahayana Buddhism, and it was the Mahayana school that was transmitted to Japan from India, via China. In contrast to the ethical and analytical rigor of Indian Buddhism, the strain of Buddhism in present day Japan is mainly focused on an interpretation that became disseminated during the Kamakura era, which privileges practical deeds and experience. These acts, however, have transcended the framework of religion, and permeated the realm of daily customs, language, and culture in Japan.

One of these concepts, *pratitya-samutpada*, is often used in daily life as fairly interchangeable with the idea of good and bad luck. In Buddhism, however, it implies a causal relationship connected along a temporal axis of cause and result: all subjects only exist thanks to a relationship of mutual interdependence, including the laws of divine providence and reciprocal human relationships. It is this mutual interdependence that *pratitya-samutpada* refers to. The figure who developed this line of thought was the Indian Buddhist monk Nāgārjuna,[25] who expounds on it with subtle analysis in his representative work *Madhyamakasastra*. In it, he argues that if all things exist within a relationship of mutual interdependence, then essentially nothing "exists," and all is emptiness. As such, the concept of *pratitya-samutpada* is also linked to the fundamental Buddhist concept of emptiness. D. T. Suzuki, who spread the philosophy of Zen throughout the world, explains the concept of emptiness in the following way. "We exist in a net of relationships formed out of our eternal passing from one thing to another. We stand on the relationships between all these knots in that net; all that exists are those relationships, and nothing else exists apart from them. Buddhism teaches us that all of this is but emptiness."[26] To be conscious of the mutual interdependence between all things is also to be aware of the temporal relationships of cause and effect, such as relationality and the in-between. At the same time, this mutual interdependence is a founding premise of such fundamental Buddhist notions as impermanence, suffering, and self-renunciation.

The impermanence of worldly things holds that all existences in this world are in constant flux, never stopping in the same position. Fixating over the constancy and permanence of social position and material belongings, for instance, causes human beings to experience suffering. As such, an understanding of this transience also represents a release from this suffering. Zen, which picks up on the teachings of Mahayana Buddhism, places greater emphasis on practical action rather than doctrine. Because all existence is impermanent, it is imperative to go about one's life by being self-aware of the present moment in the here and now. The Zen monk Hakuin Ekaku, who lived in the 17th and 18th centuries, is known as the figure who established the Rinzai school of Zen philosophy in Japan. While placing emphasis on Zazen practice and koan training, Hakuin also considered it important to be self-aware of each and every moment in everyday life spent tidying the garden

or working the fields. This philosophy is well known in his own phrasing: "Meditation in activity is a hundred thousand million times superior to meditation in stillness." The Zen saying "every day is a good day," known as a Zen utterance spoken by Zen monk Unmon from the end of the Tang until the Five Dynasties period, implores us to live by being aware of the here and now of everyday life. It was also one of the favorite sayings of the leading 20th century contemporary composer John Cage.

Zen found acceptance mostly on the West Coast of the US from the 1950s onward, especially among the so-called Beat Generation. In 1950, the 80-year-old D.T. Suzuki was lecturing on Zen at Princeton University and New York University, later also giving lectures at Columbia University starting in 1952. While his lectures and writings in English made a profound contribution to the dissemination of Zen philosophy at a global level, many artists including Yoko Ono and John Cage also audited Suzuki's lectures, becoming deeply influenced by his philosophy. Post-WWII America exulted in economic growth and scientific progress, including the development of the defense industry following the Korean War, nuclear development under the Cold War, and mass production and consumption. The widespread acceptance of Zen philosophy under these circumstances, one imagines, stemmed from how it called the fundamental meaning of life into renewed question. Of late, Zen has once again been enjoying a spate of attention in the West and Japan — perhaps suggesting that the fundamental meaning of life is once again being questioned against a backdrop of global political malaise and the vertiginously shifting, transient worldviews of the 21st century. The basic question of "where do I stand in this world" also naturally shifts one's consciousness towards thinking about the mutual interdependence and relationality that accompanies our existence. The reassessment of "participatory art" from a Buddhist perspective promises once again to reopen its discussion to a wide context. In particular, this approach promises to furnish a fascinating experiment in examining the development of "participatory art" in Asia.

2. Relationality in the Practice of Lee Mingwei

The previous sections have examined "participatory art" from a variety of angles. If one were to offer a concrete analysis of who, when, where, how, and for what purpose the participants got involved in each project, it would become clear that an extremely variety of phenomena have been discussed under a single, blanket term. Lee Mingwei's artistic practice, which has incorporated all these disparate aspects within it, is being presented for the first time as a wide-ranging mid-career retrospective. The phrase "his relations" that appears in the title is a reference to the relationships that emerge among audience members who participate in each of the projects proposed at his exhibitions. At the same time, however, the phrase alludes to the "Works for Relationality" section that has been organized in order to provide a historical and cultural context for his practice. This section, consisting of works by 11 artists, religious leaders and thinkers from both East and West and across all eras — Hakuin, Imakita Kōsen, D.T. Suzuki, Hisamatsu Shin'ichi, Yves Klein, John Cage, Lee Ufan, Allan Kaprow, Rirkrit Tiravanija, Ozawa Tsuyoshi, and Tanaka Koki — will look for points of resonance with Lee's work. Although all of them are not necessarily figures who have had a directly influential relationship with Lee Mingwei, their philosophies and practices, which have served to deepen and intensify a variety of concepts derived from the idea of "relationality," promise to produce a fascinating dialogue with Lee. It is also an experimental attempt to break away from the restricted discourse surrounding participatory art since the 1990s, and to gain an overview of Lee's practice from the perspective of a wider world that includes the insights provided by Eastern thought and philosophy.

While both the exhibition and this catalogue are organized around three viewpoints — "1: Thinking Relations, Connections and In-between Space," "2: Walking, Eating and Sleeping — Rethinking Everyday Action," and "3: Thinking Connections of History, Culture, Society through Personal Memories" — the "Works for Relationality" section has been inserted along the way in a bid to encourage the different works to resonate more with each other. Explanations of each section and individual works will be left to the catalogue entries: instead,

what I hope to do here is to weave together a number of horizontal themes including history, inheritance, exchange and giving, ritual, trust, and personal narrative among these three vertical axes, looking at the entirety of Lee Mingwei's idea of relationality by making appropriate references to the "Works for Relationality" section.

Thinking Relations, Connections and In-between Space

From a temporal perspective, the concept of "relationality" is not limited to the course of human history — all sorts of histories are connected to each other through a variety of time axes. And in terms of spatiality, relationality is something that does not stop at the level of human relationships with those around you, or local communities — it extends to the relationship between heaven and earth embraced by ancient humans, and the "in-between" relationship that resonates with the universe as a macrocosmos and the body as a microcosmos.

Ensō (Circle), one of the most representative motifs of Zen painting, expresses the principles of the universe with a single brushstroke. At this exhibition, viewers can see *Ensō* (18th century) by Hakuin and *Ensō* (19th century) by Imakita Kōsen, whom D. T. Suzuki had studied under. In contrast, Yves Klein, who developed his singular talent over a focused period from the late 1950s through the 1960s, is introduced as an artist who devoted himself to the sustained exploration of "air," one of the *prima materia* that make up the universe, or the "emptiness" of the immaterial space of painting. The photomontage *Leap into the Void* (1960) in which Klein leapt through the window of a building into the "void," is one of his most well known images, but his interest in the idea of emptiness can also be seen in *The Specialization of Sensibility in the Raw Material State of Stabilized Pictorial Sensibility [The Void]*, shown at Galerie Iris Clert in Paris in 1958, or the orchestral piece *Monotone-Silence Symphony* (1949–1961), made up of a single chord and silence. The act of becoming conscious of the immaterial realms of air and emptiness also resonates with the fundamental ideas associated with Mono-ha that began attracting attention in Japan as a new sculptural movement from the late 1960s through 1970s.

Nuwa
From Takimoto Hiroyuki (ed.), *Chugoku shinwa densetsu jinbutsu zeten (Chinese myths and legends, illustrated book of figures)*, Yushikan, 2010.

The *From Point* and *From Line* series of paintings that leading Mono-ha proponent Lee Ufan began creating in the 1970s also demonstrates certain principles of the universe that resonate with the Zen *Ensō* paintings. Through extremely minimal means, the repeated shifts between presence and absence performed by the pigment contained in the brush convey something of the cosmic energy of the universe that circulates in perpetuity, and the infinite expanse of the universe.

Seen in this light, Lee Mingwei's *Between Going and Staying* (2007), which was inspired by the poem of the same title by the Mexican poet Octavio Paz, can be understood as a kind of device for experiencing the tireless negotiations that unravel between universe and body, and between heaven and earth. The sand that trickles quietly from the broken light bulb in a pitch-black room, like a giant hourglass, invokes our relationship with the heavens. Together with the strains of the *matouqin*, a Mongolian stringed instrument, a meditative space is created. Elsewhere, the figure of Nuwa , which appears in ancient Chinese tales of flooding and earth-creation myths, is known as a goddess who mended the broken heavens using five-colored stones. Lee's *Nu Wa Project* (2005), in which the likeness of this goddess is depicted on kites, asks the owner of each kite to inscribe his or her own memories onto it before cutting the thread at some point in time to release Nuwa to the heavens — a gesture that represents a wish for peace on both heaven and earth.

The Mending Project (2009), on the other hand, originated from the multiple acts of terror that occurred in the US in 2001, where many lives were lost in a single instant. Lee's partner, who was working at the World Trade Center at the time, also lost some 400 colleagues to these attacks. How can one repair connections that have been dissolved and lost? This project, which emerged after 8 years, invites visitors to bring with them a cloth item that they wish mended. As the artist or the person playing the role of the host mends the item in personal stories are shared and exchanged with each visitor. The mended items are displayed connected to colorful threads pulled from spools attached to the gallery walls, allowing the entire space to expand and proliferate in a way that visually symbolizes these relationships and connections. While appealing to a certain commonality with how Nuwa symbolizes the process of recovery from disintegration and loss, *The Mending Project* puts us in mind of our connection to the universe. Although threads and cloth are frequently employed as materials in the work of Lee Mingwei, who has studied textiles in depth, they serve as an emblem for all the connections in the universe — just as they function as a metaphor for "invisible threads," or how D.T. Suzuki likened our existence to a single knot in a net.

In terms of historical connection and the notion of inheritance or succession, Lee's *Through Masters' Eyes* (2004), which asked groups of artists from Taiwan and various other countries outside of Asia to each produce a copy of a painting by the early Qing dynasty Chinese painter Shitao, clearly conveys the difference in values with respect to the idea of artistic inheritance in Asia as opposed to the West.

Exchange and Giving

During *Rituals for the Relinquishment of the Immaterial Pictorial Sensitivity Zones* (1962), a performance that Yves Klein carried out in an attempt to give visible form to non-material values, collectors exchanged not money, but pure gold — the highest symbol of material value — for "immaterial pictorial sensitivity zones." The receipts that certified those exchanges were then burned, while half of the pure gold that Klein received was thrown into the Seine river. As a result, the zone is no longer transferable, and becomes the property of the owner. Using the act of exchange as a medium, this work surely triggered the participants' consciousness of immaterial value.

The act of exchange also plays an important role in Lee Mingwei's projects. For *Stone Journey* (2009), Lee took 11 stones that he had gathered from the Pororari River Valley in New Zealand and had bronze casts made of them, so that the originals and the replicas formed a series of pairs. Those who purchased a pair were obliged to discard either the natural stone or its replica at some point in time. Seen in light of Klein's own work, the act of throwing one or the other away is equivalent to obtaining a form of eternal value that cannot be transferred to anyone else. By contrast, these stones, shaped by tectonic activity during the last glacial age, have come down to the present day after a period of some 7,000 years, by placing the natural stone side by side with the bronze replica that bears the mark of the artist's hand on a scale, we are forced to consider the notion of both tangible and intangible value. In the case of the aforementioned *Nu Wa Project*, the owner of the work must also relinquish the kite. However, if we consider that this act will allow the heavens to be mended and order on heaven and earth to be restored, then it would appear that

the significance of relinquishing the work itself far exceeds the market value of the work.

Cultural anthropologist Marcel Mauss' book *Essai sur le don* (*The Gift*) (1925), which focuses not on principles of the market economy, such as competition and profit, but rather on the ritual of gift giving and exchange seen in ancient aboriginal or indigenous cultures, such as the potlatch gift giving feast, would go on to leave a profound influence on later generations. American critic Lewis Hyde went further, layering this philosophy of the gift economy with ideas of mystical inspiration and the natural endowment of gifted artists. "That art that matters to us — which moves the heart, or revives the soul, or delights the senses, or offers courage for living, however we choose to describe the experience — that work is received by us as a gift is received."[27]

The notion of this gift-giving is repeatedly invoked in the practice of Lee Mingwei. For *The Moving Garden* (2009), which was exhibited at La Biennale de Lyon in 2009 for the first time, visitors each took a fresh flower from the exhibition venue: in return, they were obliged to give that flower as a gift to a stranger on their way home. The fresh flower picked out from the exhibition venue is a gift from the artist that then passes into the hands of an anonymous visitor, establishing a link to the next gift by being further passed into the hands of an unknown stranger. The circulation of gifts that thus emerges is a gift economy system that represents an alternative to the market economy. On the other hand, the act of giving a flower to a stranger is not as simple as merely thinking about it in one's head: a psychological conflict arises that may naturally prompt us to gaze inwards at our brittle, frail self. *Sonic Blossom* (2013), too, is an artwork that is based on this notion of gift-giving — Franz Schubert's Lieder is delivered or "gifted" to an audience member at the venue who is suddenly chosen. Lee, who derived a fresh dose of energy while listening to Schubert's music together with his mother while she was recovering from heart surgery, presents this gift to a stranger through the talent (gift) of a young singer. The reverberations of the song being proffered exclusively to oneself at a distance of only a few meters produces something akin to a mystical experience that makes one sensible to an intense circulation of energy, almost

as if one was receiving something from the heavens through the medium of the singer's body.

Walking, Eating and Sleeping — Rethinking Everyday Action

The privileging of the "here and now" in Zen philosophy, and the way in which it directs our consciousness towards actions repeated on a daily basis, are issues that have already been touched upon. The 1960s, however, saw many attempts to fuse art with daily life, just as Fluxus did, for instance. Although John Cage is often positioned within this scheme, his own philosophy in fact stems from certain strains of Eastern thought, including the philosophy of Indian art and Zen. This stance was also taken up by Allan Kaprow, who had studied under Cage at The New School for Social Research. While studying philosophy in 1949, Kaprow came across John Dewey's *Art as Experience* (1934), and subsequently encountered Zen by way of Cage. After taking up a teaching position at the University of California at San Diego in 1978, Kaprow in fact also started attending a Zen meditation hall. As can be seen in works like *18 Happenings in 6 Parts* (1959), the Happenings that Kaprow proposed were essentially performances that involved the participation of viewers according to detailed instructions. Cage, however, apparently felt that Kaprow's Happenings lacked a certain element of chance and freedom. On the other hand, Cage's own *Theater Piece No.1*, which was performed at Black Mountain College in 1952, has been called the first ever Happening. For this piece, artists working in different disciplines, including Robert Rauschenberg, Merce Cunningham, and David Tudor, each gave a performance made up of chance operations within the period of time that Cage spent giving his lecture.

The Happenings that Kaprow proposed were supposed to have been a completely new form of art different from either painting or sculpture. When this art form quickly became drawn into the vortex of the art world centered on New York, however, Kaprow gradually started to maintain a distance between himself and art spaces such as museums and galleries. His "Activities," which were an extension of Happenings, were most detached from the typical realm of art, taking the form of a situation that was almost indistinguishable from everyday

actions. Kaprow defines an Activity as something that "is directly involved in the everyday world, ignores theaters and audiences, is more active than meditative, and is close in spirit to physical sports, ceremonies, fairs, mountain climbing, war games, and political demonstrations. It also partakes of the unconscious daily rituals of the supermarket, subway ride at rush hour, and brushing one's teeth every morning. The Activity Happening selects and combines situations to be participated in, rather than watched or just thought about."[28] Activities, which could be a one-to-one act performed with a partner during an everyday period of time with no audience whatsoever, seem to be nonsensical acts akin to a Zen koan. However, they are also rituals that sharpen our consciousness of everyday phenomena. Although Activities could be read as a criticism of the institutionalization in the American art world and museums at the time, the act of combining art with acts that were almost purely quotidian made Kaprow realize that this would go on to pose a significant challenge for artists, including himself. "Once art departs from traditional models and begins to merge into the everyday manifestations of society itself, artists not only cannot assume the authority of their 'talent,' they cannot claim that what takes place is valuable just because it is art."[29] Almost half a century later, Kaprow's line of questioning deserves to be mulled over.

Whereas Kaprow used the ritualistic form of an Activity to make us aware of the unconscious rituals of everyday life, Lee Mingwei elicits a similar awareness by bringing these rituals once more into the institutional space of the museum or exhibition. Lee's early work *100 Days with Lily* (1995), conceived as a way of mourning for his late grandmother who had been a great inspiration to him, is a record of a performance over a 100 day period where he carried around a lily in a pot or under his arm while reading, eating, writing, sleeping, or masturbating. If the process of sharing this cycle of life and death, starting with the germination of the lily and extending through its growth, blooming and death constitutes Lee's personal Activity, then *The Dining Project* (1997) and *The Sleeping Project* (2000) might be seen as one-on-one Activities with a stranger. The former project began when Lee invited someone to his studio for a one-on-one meal while he was pursuing graduate studies at Yale University, while the latter

project was based on Lee's experience of having spent the night talking with an elderly gentleman whom he had not met before on a night train while traveling throughout Europe. In terms of their conceptual frameworks, these works are simply conceived. The act of having a meal with someone you are meeting for the first time in the non-quotidian space of the museum, however, and the act of sleeping in the same space, makes one aware of the nature of unconscious everyday rituals. The unconscious rituals that we all perform on a daily basis — food preferences, the order in which one eats certain foods, how one holds the chopsticks, and one's way of speaking in *The Dining Project*, or the timing at which one puts on one's pajamas or takes off one's socks in *The Sleeping Project* — are made self-evident to us in front of a companion who is a stranger to us. For these projects, which can only be carried out on a one-to-one basis, a limited number of participants are chosen by lottery from among all visitors to the exhibition. As such, although the sense of equality and democracy that one expects of "participatory art" is comparatively low, the museum experience of those who have been chosen is a special, unique one. What is responsible for this unique experience, furthermore, is not the logic of visitor numbers within a market economy, but rather a commitment to reassess the quality of one's experience of art.

Projects that involve eating or spending the night inside a museum can also be found in well-known artworks by Rirkrit Tiravanija and Ozawa Tsuyoshi. Works in which meals are consumed include Tiravanija's representative project that served Thai curry to the audience (1992–), and Ozawa's *Vegetable Weapon* series (2001–). On the other hand, projects where participants spent the night include Tiravanija's *Untitled 1999 (Tomorrow Can Shut Up and Go Away)* (1999), where the artist installed a recreation of his own apartment in the gallery and made it available for anyone to use for a 24-hour period, and Ozawa's *Sodan Art Hotel* (2001), in which visitors spend the night in capsule hotels exhibited inside the gallery, subsequently offering the artist advice on how to improve it based on their experience. In 1995, when Lee held an event that would later evolve to become *The Dining Project* while still studying at Yale, a professor who saw a similarity between this event and work of Tiravanija in terms of how they "created relationships

through the medium of food" invited Tiravanija to be a guest lecturer for one semester. Whereas Tiravanija's projects served curry made in a large pot to the general public, Lee's project entails a meal made for the sake of one person. At first glance, Tiravanija's project seems to take the form of a banquet with an extremely open policy, while Lee's project seems rather introspective. Of his own work, however, Tiravanija has this to say. "In my works, I serve curry to a great number of people. But my own role is merely to make the curry backstage, so to speak — which is an extremely introverted approach to take. In comparison, your project is extremely extroverted — it involves opening up your heart and mind to the person you're making the meal for, and arriving at an understanding him or her through dialogue and conversation." In contrast, for Ozawa's *Vegetable Weapon* series, the artist went shopping with the local women, had them hold guns made out of those ingredients, and shot their portraits, before teaming up with the project participants and visitors to cook dishes using those food items and sharing the meal around the same table. Through this sequence of actions, Ozawa's project seeks to accept and transcend cultural and social differences. Although this series was begun in response to the multiple terror attacks in the US in 2001, some 52 works in 33 cities and 17 countries around the world have been produced since the first iteration, *Vegetable Weapon: Saury fish ball hot pot / Tokyo*. The latest version, *Vegetable Weapon: Imoni (Taro potato soup with pork) / Fukushima*, was created in Fukushima in 2012. The unconscious, everyday ritual of shopping for ingredients, cooking, and eating together ended up forcing a completely different type of awareness onto the participants as the unexpected result of the 2011 earthquake and Fukushima Daiichi nuclear disaster.

Meanwhile, Tanaka Koki's *Each and Every* (2003) is a video work that captures the actions of a single chef working in the kitchen of a Japanese *izakaya* pub. More than the context of "food," Tanaka's work trains its gaze on how the continuous sequence of a chef's deft, seasoned actions is unable to yield any specific dish. What we are invited to imagine is a composition that shows us how these endless fragments of complex tasks make up a bigger picture that includes the complicated relationship of the chef with several other cooks in the kitchen, and a string of coordinated tasks. Although Tanaka has in recent years been attempting to visualize this notion of a "complex relationality" woven together by multiple people, the essence of this idea seems to already have been condensed within *Each and Every*.

Thinking Connections of History, Culture, Society through Personal Memories

Works that involve the construction of a one-to-one relationship, like *The Dining Project* and *The Sleeping Project*, are premised on notions of intimacy, trust, and the belief that humans are fundamentally benevolent. Recent years have seen the advent of social media that expands one's networks using "friends" whom one assumes to be trustworthy as intermediaries. The quality of those friendships and connections, however, has been much questioned. Another key to the intimacy embodied by Lee Mingwei's projects is the way in which they employ personal memories and narratives. The acts of sharing daily elements of one's personal stories and responding to them have also become an everyday experience in the age of social media. At a time when it is no longer possible to get a firm grasp of the bigger picture, what these phenomena seem to suggest is the fact that the only path towards understanding the larger narratives of history, culture, and society is through fragments of individual, personal stories.

The personal stories and anecdotes seen in Lee's own family history also bring a host of new perspectives to the political relationship between Japan and Taiwan. According to the terms of the Treaty of Shimonoseki at the close of the Sino-Japanese War, Japan governed Taiwan for 50 years from 1895 until 1945 — a period through which Lee's grandparents and parents lived through. His maternal ancestors were Taiwanese Plains Aborigines, while his great-grandfather was a politician who had served as the mayor of Puli, in Nantou County to the south of Taichung. Both his grandparents had studied in Tokyo during the 1920s and 1930s. His grandfather had studied law at Meiji University, while his grandmother had studied Western medicine at Tokyo Women's Medical School (now Tokyo Women's Medical University). After returning to Taiwan, his grandfather became a school principal, while his grandmother opened a clinic that practiced Western medicine.

The two Chinese characters used to write Lee Mingwei's given name, Mingwei (明維), derive from the Japanese for Meiji Restoration (明治維新), and were apparently largely inspired by the Japanese spirit that his grandparents had learned. The negative aspects from a political or historical perspective are often emphasized when discussing the Japanese colonization of various Asian countries since the modern era. However, in the case of individuals who came to admire and learn about Western culture and make a significant contribution to later generations, one finds that their stories are far from simple. Although photographs from this era can convey a certain sense of desperation and urgency in studying abroad in Japan as a last resort, the prospect of Lee's grandparents staying in touch with their former teachers and students even after the war conveys something of the mutual human connections that transcend political relationships.

As described earlier, Lee reserves a particularly profound respect and adoration for his maternal grandmother. *The Letter Writing Project* (1998) was inspired by the experience of writing a letter to the late grandmother that had passed on in order to express what he had failed to convey to her in person. Visitors are invited to enter three beautifully designed small booths to compose a letter to someone that expresses the gratitude or apology that they were previously unable to convey. Participants can choose to write the letter while standing, sitting, or kneeling — the same three postures that one can adopt for the practice of Zen meditation. The museum staff members will then mail out those letters that are sealed and addressed to someone, but those left open may be read by other visitors. Although these are letters written by strangers, the personal stories and emotions inscribed within possess a strength and intensity that can move the hearts of those who read them. In particular, when this project was carried out at Shiseido Gallery in Tokyo in 2012 after the Great East Japan Earthquake, when Japanese society seemed to be stricken by an ineffable sense of loss, I remember being unprepared for the tears that almost welled up in my eyes. *Fabric of Memory* (2006), on the other hand, is based on Lee's memories of his mother putting a handmade jacket on for him, in response to his refusal to attend his kindergarten's entrance ceremony. The cloth items embedded with personal memories that

were collected from the general public for this exhibition have been placed in beautiful wooden boxes together with their associated episodes, and displayed on a simple platform. Visitors are invited to gaze as these cherished items while reading the personal narratives written on the insides of the box covers, just as if they were admiring a precious tea ceremony bowl.

In fact, all that the artist creates in both *The Letter Writing Project* and *Fabric of Memory* are instructions that allow visitors to participate in the project, and elegantly designed devices. The moment when the personal memories and stories intervene and touch the hearts of other individual visitors is when each artwork really starts to come alive.

In contrast, *Guernica in Sand* (2006), which makes reference to Picasso's *Guernica* (1937), was inspired by the 2003 American air bombings over Iraq. *Guernica*, which was painted by Picasso in response to how many ordinary citizens perished during the Nazi air raids of 1937 during the Spanish Civil War and shown in the Spanish Pavilion for the Paris Expo that same year, had been displayed in The Museum of Modern Art in New York up until it was returned to Spain in 1981. For the fourteen-year-old Lee, who encountered this painting in New York just before it was returned, seeing *Guernica* was the first time he became aware of the political dimension of a work of art. For *Guernica in Sand*, which is drawn in sand, Lee will complete an unfinished section of the piece in the middle of the exhibition period. At the same time, visitors will be allowed to walk one at a time over the piece. Finally, four performers including Lee himself will sweep all the sand, gradually erasing the image. Buddhist sand mandalas from Tibet depict the structure of the universe using multicolored sand, but these sand mandalas that take days to construct are destroyed in a single stroke after they are completed. This repetitive cycle of creation and destruction is an expression of the natural laws of providence. The performance for *Guernica in Sand*, which will be conducted over a whole day in the middle of the exhibition period, prompts in us an awareness of the transience and vanity of this world. At the same time, however, it perhaps serves as a consolation to the individual lives that are sacrificed during omnipresent political conflicts, as well as the hearts of those who have lost their loved ones.

Value of Invisible Threads

The final work in the exhibition is *The Living Room* (2000), a project that Lee originally created in 2000 for the Isabella Stewart Gardner Museum, which opened in Boston in 1903. Mrs. Gardner was a well-known patron of the arts who often gave her support to Okakura Kakuzō (also known as Okakura Tenshin), who was working as a curator at the Museum of Fine Arts in Boston at the time. *The Living Room* was created as a space within the museum where her private collection would be made open to the public, so that the visitors could hear stories and episodes from the museum staff and people in the neighboring communities about their personal collections. This room is now permanently installed in the new annex to the museum that was constructed in 2011, where the act of unraveling these personal stories sheds light on the history, society, and culture that underlie them. At this exhibition, volunteer hosts will regale visitors with personal stories related to the Mori Art Museum, the Roppongi area, and their own collections.

The foregoing discussion has examined the practice of Lee Mingwei from various perspectives related to participatory art. Lee's practice, presented here through the framework of an "exhibition at a contemporary art museum," finds its completion through "participation" at many levels, and in accordance with the instructions attached to each work. The conceptual framework that lies at the core of his practice serves to tie all the leaves, branches, and fruits together by drawing on an accumulation of real-world experiences and actions, and the sharing of memories. Unlike a fixed exhibition that involves confronting a series of material objects, the situations and circumstances in Lee's presentation shift and multiply day by day. In this way, the exhibition becomes a sort of time and space that contains those actions, experiences, dialogues, and resonances, and the only way to appreciate it as a viewer is to actually experience it there, first-hand. Lee's practice is to be experienced through participation, according to instincts and sensations that are stimulated, and through the power of imagination and association; hence, the explanations above should ultimately be regarded merely as a secondary aspect to facilitate an understanding of his practice. So what can

audiences take home with them from the exhibition gallery? The sensations, consciousness and memories evoked by their experiences at the exhibition will hopefully help Lee's viewers to form a new layer of immaterial value — or the value of "invisible threads" — allowing the unconscious everyday rituals of each person to become a source of radiance and light.

This exhibition is also a standing challenge to the definition of what an "exhibition at a contemporary art museum" is, how it should be positioned within various histories and societies, and what role it ought to play. As the field of contemporary art, along with its environments and institutions, continue to grow ever more complex, perhaps "participatory art" broadly defined will become a kind of intangible gift that allows us to continue to question what art is.

1. Cotter, Holland, "Art in Review; Lee Mingwei — 'Project 80'," *The New York Times*, November 21, 2003.

2. Lacy, Suzanne, "Cultural Pilgrimages and Metaphoric Journeys," *Mapping the Terrain — New Genre Public Art*, Suzanne Lacy (ed.), Seattle, WA: Bay Press, 1995, p.19.

3. Bourriaud, Nicolas, *Esthétique relationnelle*, Dijon: Les presses du reel, 1998 (French Edition). Bourriaud, Nicolas, *Relational Aesthetics*, Dijon: Les presses du reel, 2002 (English Edition).

4. Bourriaud, Nicolas, "Pour une esthétique relationelle (première partie)," *Documents sur l'art 7*, Spring 1995, pp.88-99. (Bourriaud, Nicolas, "traffic: The Relational Moment," trans. Molly Stevens, *theanyspacewhatever*, New York: The Solomon R. Guggenheim Museum, 2008, pp.172-173.)

5. As above, p.173.

6. Bourriaud, Nicolas, "An Introduction to Relational Aesthetics," *TRAFFIC*, Bordeaux: CAPC musée d'art contemporain de Bordeaux, 1996.

7. Bourriaud, Nicolas, *op. cit.*, *theanyspacewhatever*, p. 173.

8. Interview with Nicholas Bourriaud, "Relational Aesthetics and Curating Today," text by Matsui Midori, *ARTiT*, No.22, Winter-Spring 2009, p.52.

9. As of 2014, the book has already been translated into various languages around the world, with the Chinese version having been published in 2013. More than 20 years after it was first proposed, a Japanese translation — apparently in preparation for publication — is eagerly being awaited.

10. Bishop, Claire, "Antagonism and Relational Aesthetics," *OCTOBER*, Cambridge, MA: The MIT Press, No. 110, Fall 2004, pp.51-79.

11. Here, Bishop is referring to the following argument by Ernesto Laclau and Chantal Mouffe. "Laclau and Mouffe argue that a fully functioning democratic society is not one in which all antagonisms have disappeared, but one in which new political frontiers are constantly being drawn and brought into debate — in other words, a democratic society is one in which relations of conflict are sustained, not erased. (…) they maintain that without the concept of utopia there is no possibility of a radical imaginary. The task is to balance the tension between imaginary ideal and pragmatic management of a social positivity without lapsing into the totalitarian." (*ibid.*, pp.65-66.)

12. As above, p. 52.

13. Bourriaud, Nicolas, *op. cit.*, *theanyspacewhatever*, p.175.

14. Jacques Rancière, *Le spectateur émancipé*, Paris: La fabrique éditions, 2008. For more on this series of developments, refer to Hoshino Futoshi's detailed analysis in "Relational Aesthetics and After | Reading the Bourriaud-Ranciere Controversy" (in *EOS Art Books Series 001: Contemporary Art Theory*, Tsutsui Hiroki (ed.), Tokyo: EOS Art Books, 2013, pp. 36-70).

15. Spector, Nancy, "theanyspacewhatever: An exhibition in ten parts," *op. cit.*, *theanyspacewhatever*, p.15.

16. *The Art of Participation: 1950 to Now*, London: Thames & Hudson (November 17, 2008), published in association with the San Francisco Museum of Modern Art.

17. Bourriaud, Nicolas, *op. cit.*, *TRAFFIC*.

18. Spector, Nancy, *op. cit.*, *theanyspacewhatever*, p.14.

19. From an email interview conducted by the writer, 2014.

20. As above.

21. Seibu Art Museum (later the Saison Art Museum and the Saison Museum of Modern Art), Hara Museum of Contemporary Art, Sagacho Exhibition Space, ICA Nagoya, Touko Museum of Contemporary Art, etc. The only institution among these that is still in operation today is the Hara Museum.

22. 1989 saw the opening of municipal museums in the cities of Yokohama, Nagoya, and Hiroshima, the last of which was the first public museum of contemporary art in Japan. A fully functional contemporary art gallery opened in Mito in 1990, and the Museum of Contemporary Art, Tokyo opened in 1995.

23. Gaweewong, Gridthiya, "The Point of No Return (for beyond relational aesthetics conference)," The 7th Asian Museum Curators' Conference, JFIC Hall "Sakura," The Japan Foundation, Tokyo, September 29, 2011 (Session 1, Presentation 1)

24. At a solo exhibition held in Bangkok in 2010 entitled "Who's afraid of red, yellow and green," Tiravanija stood in the center of the gallery, serving curry in colors that symbolized the differences in party affiliations while painters depicted the political history of Thailand since 1970 on the walls.

25. Nāgārjuna was a Buddhist monk from India. The exact era through which he lived is not certain, but it is thought that he lived during the 2nd through 3rd centuries.

26. D.T. Suzuki, "Lecture No. 5: Zen from the viewpoint of psychology," *What is Zen?* (revised edition), Kadokawa Shoten, 1999, p.130.

27. Hyde, Lewis, *The Gift: Imagination and the Erotic Life of Property*, New York: Random House, 1983, Introduction

28. Kaprow, Allan, "Pinpointing Happenings," *Essays on the Blurring of Art and Life* (Expanded Edition), Jeff Kelly (ed.), Berkeley, Los Angeles and London: University of California Press, First Edition: 1993, Expanded Edition: 2003, p.87.

29. Kaprow, Allan, "Success and Failure When Art Changes," *op. cit.*, *Mapping the Terrain — New Genre Public Art*, p.158.

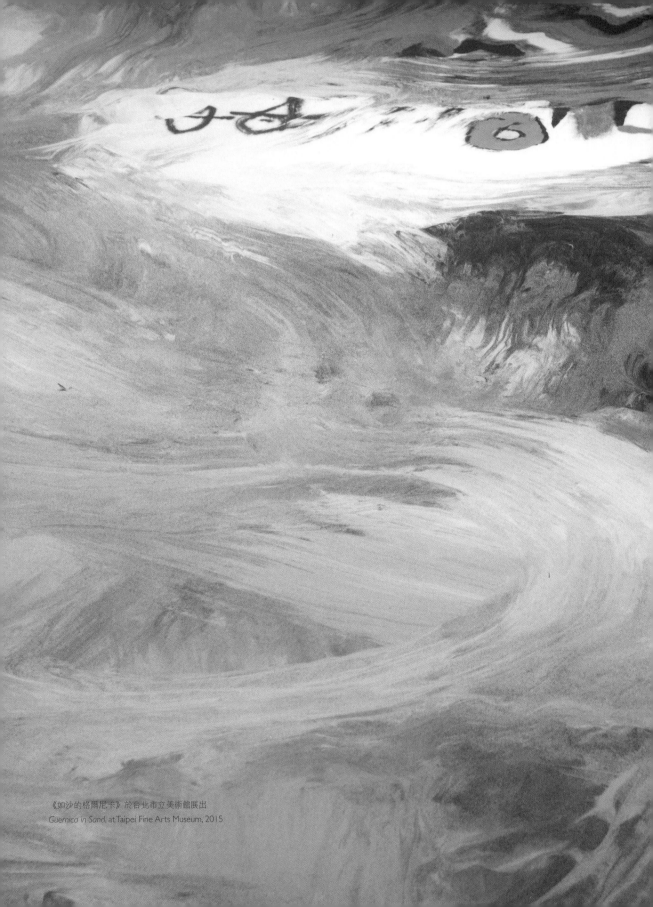

《如沙的格爾尼卡》於台北市立美術館展出
Guernica in Sand, at Taipei Fine Arts Museum, 2015

一種社會研究的藝術

哈維・莫洛區
社會學家 / 紐約大學社會學與都市研究教授

格林・瓦登
藝術修護員 / 紐約大學美術館研究臨床助理教授

「關係」在藝術界引起關注可能是近期的事，殊不知「關係」乃社會學的基石，甚至是社會心理學和許多社會學相關領域的重心所在，社會學家早就對「人類是如何連結的」提出過疑問。的確，人類究竟是怎麼「聯繫」的呢？對於這個老問題，藝術家李明維提出了新方法，開啟新的途徑來思考藝術與藝術的品質，以及我們該如何透過藝術本身去了解人類的連結。

社會學家運用社會學的研究方法，如焦點團體訪談（focus groups）、調查和各種實驗來了解人際關係。就實驗這點來說，社會學家會把人置於「實驗室（laboratories）」中，讓這些人經歷各種活動，藉以「試驗（trials）」人與人之間如何彼此互動，這裡所謂的「試驗」是社會學家技術上的用語，就像實驗者把老鼠放在迷宮或把鴿子放進盒子裡。社會學家可能只會問一些調查問題，比方說，他們喜歡或不喜歡誰？他們對某種人或某組群有什麼看法？——而或許，與李明維創作最有關係的——他們信任誰？他們如何處理這種信任可能帶來的社會焦慮？

無論以何種方式切入，學者受的訓練就是要保持距離，像觀察牆上的蒼蠅那般——盡其所能來分析自己的研究領域，但「站在它的外圍」。所謂「不介入」的科學方法；學者的任務是去找出發生了什麼事，且同時讓自己隱形，不留痕跡，或不對自己的研究對象造成影響。對比之下，藝術家則沒有冷眼旁觀的藉口。無論他們創造的是掛在牆上的繪畫或是庭園中的雕塑，他們毫不掩飾地表現出自己對這個世界的主觀詮釋，因為他們留下了些東西。他們希望自己的種種介入能被看見，他們希望留名，並真的就在作品上題下自己的名字。

藝術家又再度與社會學家的立場形成對比，藝術家試圖透過自己的作品去呈現內在感受與外在景觀的種種事實——所有作品都來自藝術家的觀察、分析與詮釋。再者，這些藝術作品傾向於會有一個固定和最終版本。無論是在美術館

展出或被納入收藏，這件東西——一旦作為藝術作品而存在——它就已經完成，而且會一直保持這樣的狀態。任何可能的變化，都會對它造成問題、麻煩、「失敗」。倘若資源許可，藝術品保存修復專家（art conservators）還會介入維護這件作品，令其恢復原貌——秉承創作者的初衷加以保存（save），使未來世代得以體驗。

凡此種種，李明維的操作方式不同，大大地不同。問題的關鍵不在於作品本身，而在於作品所帶來的質問，以及這些裝置持續產生的影響——即便作品被從美術館取下，收進倉庫，或者作品不再具有任何物質形式，而這是李的作品最常發生的事。李明維對完成品沒興趣。他的作品會衍生出種種關係，由於關係會延續下去，所以他的作品就會持續讓人有所發現。李和參與者，以及所有那些在現實中、在記憶裡、或透過紀錄體驗過這些作品的人，都從這些關係中學習到什麼。所以，就某種意義上而言，這些裝置作品都是教學設備。身為大學教師的我們，唯有佩服二字。如同其他精彩的教學時刻，只要李明維作品的見證人和參與者還在，這些作品就繼續存在，甚至超越了最初相遇，至少可以預期的是：它們可能超出藝術家自己的一生。它們可能是有形的痕跡，但更可能是非物質的，純粹就是延續下去。

李明維的計畫總帶有風險，人生本身就會有的那些風險。我們每次過馬路，就把生命握在自己手中；搞不好我們會被瘋子殺了；或者只是一個飆自行車的人，他沒看到我們，我們任何人的腳都有可能被壓在他的輪下；火車上，鄰座那人的手肘可能佔了太大空間，或者很大方，會請我們吃好吃的東西，或是——誰會真的知道呢？——我們吃東西的時候，他反而抓了我們的東西就吃。店裡的銷售員可能很有禮貌，也可能粗魯，可能討人歡喜或讓人看了就不爽，而我們的家庭成員在家裡也可能會顯出愛意或表示反感。不論這些遭遇看起來多麼瑣碎，它們卻可能會很強烈，因為我們想知道在別人眼中我們如何「呈現」，為之後有更好的交流而制訂方案，或是在我們每天經歷的各種情況中，去仔細想清楚自己回應別人的方式。我們可以想想這些事情或更多此類之事，不論是個別想或組合起來想，它們全部都很重要。

李明維對關係的探詢就在於處理這類遭遇：它們在過去是怎麼發生的？它們在即至的未來可能會發揮什麼作用？他的計畫探詢的議題範圍甚廣，但信賴（trust）是箇中最重要的一環。事實上，身為藝術家的這個位置，讓李可以進行對信賴的實驗。一般人的生命均始於極致依賴，依賴母親，在現代環境中，很典型的會依賴帶我們來到人世的醫療團隊。但隨後則有向外擴展的可能性：我們可以信賴誰和什麼？以及很單純的，何時和怎樣才能信賴？除了母親的懷抱，信賴領域甚至會擴展到陌生人——教室裡的老師同學、牙醫和飛機的駕駛員。可是信賴也可能擴展到瞄你一眼、衝著你轉身走開，或者向你說聲「嗨」的路人。不過信賴不見得一直那麼容易；信賴有可能造成緊張，它需要小心、技巧與思考。我們仰仗陌生人，以及以正面且相互支持的方式而與我們彼此關聯的人所帶來的好意。以他人的需要與想望來滿足自我意識的人，有時會因為他人的福利之故，而在社群中找到共同目標和相互依賴。

問題的範圍擴大了。在一個噪音嗡嗡響和氣候變遷的世界中，每個公民——不僅僅是那些共享人行道，而是共享地球的人們——面對他人的時候，都需要敏銳的感覺，也需要去彌合因尷尬或狹隘的自我追求所造成與他人的疏離。幫別人提重物，或者以宏觀的尺度，限制自己的碳足跡，每個人都得知道，如果我們做了好事，就會引起他人仿效。信賴成為文明存在和物種延續的基礎，而不僅止於人與人之間的問題。因此，信賴值得我們學習——這意味著，只要藝術家願意，也可以透過藝術來學習信賴。

李明維便是如此。

他隨機邀請某些美術館的訪客跟他一起在館內過夜（《睡寢計畫》，2000），無論是他或是他們都不知道會發生什麼事。首先，他們都冒著基本人身安全的風險——美術館連環殺人犯是個暗黑的可能性。有太多令人臆想的未知。會不會有對話？對話會怎麼發生？還是會一片尷尬沉默？無意義的閒聊？有人會很有趣、一派嚴肅、或整夜哭個不停？會打呼？有異味？兩人終將知曉答案。《睡寢計畫》的第一個發

現（finding）是：「好的（yes）」，大家都同意這麼做，同意到李明維的展示空間，帶著所有這些未知過上一夜。李明維將他們納入計畫。而且，至少我們發現：到目前為止，似乎沒人受到傷害。

與李明維在美術館中一起用餐也一樣，他在《晚餐計畫》（1997）中在美術館做菜；受邀進美術館用餐的人沒遇到過麻煩，他們跟他一樣都活了下來。可是這個計畫也是始於未知數。然而，在這種奇怪的狀況下用餐有什麼意義？李明維到底會不會烹飪啊？他會準備什麼菜餚呢？我該狼吞虎嚥？還是淺嚐即止？我怎樣表現出我有多榮幸——大聲讚許？還是沉默以示尊敬？這位藝術家想要從我這裡得到什麼？（在這個地方？這個計畫？這一刻？）而我又該怎麼報答這個一直都如此親切的好人？萬一我的湯灑了，或者更慘的是，萬一我不喜歡吃呢？就李明維那方面，面對這些他必須信任的陌生人，藝術家自己也帶著一堆未知在進行他的計畫，他無法像在機場安檢門或大學招生委員會那般來篩選用餐者。即將來臨的生命中潛藏了哪些細微之事？李明維在學習，透過他的紀錄和美術館的文件資料，我們也在學習。

概念豐富，擅長烹飪，殊不知李明維連針線活也很在行，他還會縫補東西。在《補裳計畫》（2009）中，大家帶衣物或其他需要修補的布製品來讓他縫補。他一件一件地縫，縫補這些衣物的線五顏六色，線軸就裝置在美術館牆上。縫縫補補在社會生活中司空見慣，但在美術館裡就不然。針線活，如果是在工廠出現，那就不是縫補而是生產，而且是以一種完全客觀的方式來幫不認識的人進行這項工作。如果是在家裡，受益者則是自己或家中成員。李明維遇到這些帶東西進到美術館裡的人，他跟他們修補關係，當他做針線活的時候，這些人有的會在旁觀看，並跟他互動。但是，即便他們已經不能算是全然的陌生人，他們也不是李明維生活圈裡的人——他們是一種介於中間的存在（inbetweeness）。他們不是生活周遭熟悉的人，也不像那些在異國幫我們做衣服的人般全然不認識。對他們稍有了解，會增添社會性的緊張情緒（及報答），這些是我們在花錢購買商品或服務時所不見的。

凡此種種都提高了計畫的不確定性。大家帶來一些藝術家無法事先預料的東西，他必須因應所有來到他面前的縫補挑戰——或者沒有挑戰（因為沒有人會幫他評分，藝評家並不會評價他縫製技術的天賦）。當然，帶東西給他的人可能會對他縫補過後的衣物感到失望，誰知道呢？這也是一個未知數，這是他們和李明維要冒的風險。

李明維不只是修補物件而後物歸原主。修補行為隨著計畫進展，轉變成一種展示，五顏六色的元素從越疊越高的修補物擴展到周遭環境——因為李明維與參觀訪客及他們衣物之間的種種連接，一個抽象的網絡從而建立。即使他在修復每個物件時，都會留下——暫時地——一小部分未完成，因為這個未完成，使得原本與世界分離的物件產生了關聯。它不再是一件獨立的襯衫或上衣，現在它與所有其他物件、美術館、計畫（以及李明維本身的技巧與考量）產生了關聯。李明維確實有把每件託付給他照料的物件歸還物主而且都仔細地縫合妥當。但整個過程，他展示給所有觀眾的是人與人之間的聯繫，這些人可能他從來沒見過，而且未來也可能不會再見，現在卻透過他們共同完成的這件作品而彼此關聯。

II

事實證明李明維也染指大師傑作。他在《如沙的格爾尼卡》（2006）中，就是處理巴布羅·畢卡索的《格爾尼卡》（1937）——忠於畢卡索的原始圖像，卻畫在地板上，而非掛在牆上。李不用油彩，而是把五顏六色的沙子鬆散地倒在畫上，模仿畢卡索發自內心的吶喊（cris de coeur）。至於方法，則令人聯想起並且以類似「數字畫」作品來進行。線條帶點漫畫的趣味，而色彩與形狀的區分近似原畫，但不精確。但就像李明維的其他作品一樣，任何不精確都精確地（precisely）近似，那包括，在《如沙的格爾尼卡》這種情況下，沙畫的圖案不會走樣，在展出期間維持穩定。

李明維再度重彈「信賴」老調，在這件隨著時間而呈現出結果的裝置過程中，他表現出對美術館和公眾的信賴。他信賴

那些看著他創作的人（公眾一直都在場），不會太早打擾他，破壞他辛苦孕育的沙畫。而當展覽期間的某個時間點到了——美術館地板剩餘未完成的部分都填滿了、也完成了——李明維就會邀請觀眾走在沙畫上，這明顯是破壞行為。再次，這是一種實驗：觀眾會如何摧毀這幅傑作？帶著猶豫？審慎？愛戀？喜悅？不論怎樣的心情和方法，這件作品又回歸到沙的狀態，經過踩踏後，所有顏色混雜在一起。經過一整天這樣的侵入行為，夕陽西下後，李明維和他的助手拿掃帚掃過沙子，進一步擾亂了畫面。於是，這件作品的最終畫面由此展開，再度開放給遊客觀賞。李明維的《如沙的格爾尼卡》仍然存在，但卻是以這種——相互作用的破壞行為之證據——透過某件現代藝術傑作來表現他對作品永續性的質疑。藝術是一門製作手藝，是種生理的擾亂，以及社會的回響。

李明維在他早期的《孕夫計畫》（2000）中，以成為世上第一個懷孕的男人，又另類地擾亂了傳統生理‧社會的習慣。它的性質是一名年輕男子的計畫，李明維走在紐約街頭，精實的上身卻帶著一個明顯看似孕婦的腹部，並記錄公眾的反應。他穿著緊身 T 恤以展現他的「懷孕」狀態。從他網站介紹中的錄像可以看到他的動作和其他人的反應（如今在 YouTube 上，約 60 萬人次點閱過），有的人看得目不轉睛，有的人（比方說一個紐約中東裔計程車司機）則不以為然。「其他人的反應則相當正面；街上有名女子格外開心，她對這名男子分享她視為女性負擔的懷孕經驗而大表讚揚。她熱烈盛讚李明維此一驚人壯舉，不只因為他個人大膽懷孕這點，也因為他明顯與女性主義者團結——可以說是女性主義者的伙伴。

《石頭誌》（2012）則是一個比較沒那麼高調介入的計畫，但同樣也相當激進。李明維藉由這件作品來擾亂「擁有」的概念。他提出質疑：所謂你擁有某樣東西是什麼意思？就傳統意義上就是持有「所有權」，但誠如所有物質的特點，「擁有」絕對是暫時的。就絕對的角度看，你不會永遠都在，你所擁有的那樣東西，也只是暫時的。而所謂的社會連結則總是與物質擁有相連：炫耀我們擁有它，將它傳給我們的下一

孕夫計畫
2000

代，或是跟我們愛的人分享它。萬一我們得捨棄它，會發生什麼事呢？

李明維強勢主導這個議題，當然，以他一貫溫和卻力道十足的作法，他讓得到這件作品的人必須在他或她有生之年放棄其中一半——不是將它當成禮物送人，而是丟棄（discard）它——李特別指明這是作品的一部分。就表面上看來，這件作品是由兩個物件所組成，兩者都呈小石頭的形狀，其中一個是李在大自然中找到的，另一個則是青銅鑄造的複製品。

他將這一系列共 11 對的物件送給潛在收藏家。藝術不是這兩小塊岩石；而是擁有者與這兩個物件、還有與李明維的關係。擁有者必須作出決定：我要留下哪一個？我何時以及如何丟棄另一個？我是把它埋在地下、留在公車上、還是扔進河裡？我要鄭重其事還是隨便就把它丟棄？要帶著喜悅或是遺憾？我又該怎麼「保存（preservation）」它呢？將這件藝術作品的物理元素保持在一起來「拯救（save）」它，或是摧毀它呢？這是李明維提出的兩難問題。

無論結果如何，《石頭誌》都促使擁有者去思考自己的所有權，不論準備好了與否，不論現在或未來，去深切地思考擁有的短暫性。作為一件藝術作品，這個物件只是體現此種思維的結果。藝術家並沒有完成它；「他的」石頭以不確定的方式與不確定的時序繼續往前發展：擁有者可能在獲得它後的幾分鐘便作出選擇，也可能花上一輩子。唯有那時，我們才會知道發生了什麼事，但最有可能的是結果永遠不為人知。就這個意義上，這件作品是永恆的，超越所知。

在此，信賴扮演的角色再度起著作用：獲得《石頭誌》的人會尊重李明維的意圖而減去這件作品一半的量體嗎？或是擁有「它的全部」，這種世俗需求會壓倒美學願景呢？至少可以說，這麼做簡直就是在摧毀這件作品。我們會這麼想相當合理，這不僅只是關於這件藝術品，而是攸關人類未來的普遍性問題。

李明維式的花園也在移動，而且以重要的方式。在《移動的花園》（2009）中，他將排列得很美，或線性，或纏繞，或結團的折枝花卉組合在一起，邀請美術館觀眾在離去的時候拿取一朵。結果每位觀眾都很興奮，人手一花，好似即興遊行。

不過，李明維在此又再度立下但書：觀眾在回家途中必須將這朵花送給陌生人。伴隨送花這種簡單的社會相遇而來的，會是令人振奮的、尷尬的、或多疑的狀況，事先誰也不知道。當我們離開布魯克林美術館展出《移動的花園》展覽時，上述所有反應，我們都有看到。我們一位年輕的舊識，也許總

是有點害羞的傾向，他小心仔細地選擇送花的對象，他猶豫好久，失去了好幾個機會，因為他選上的陌生人都已走出身邊的範圍。至於我們呢？我們送起花來毫無問題，對方都開心回應。

在進行這個關係實驗時，李明維利用一個物質元素——花——去面對人與人的分隔。送花的這種單純行為，在日常生活中是家常便飯（母親節或是學校畢業），但是「無緣無故」送花，就成了一種較為大膽的行徑。就單一的行為而言，它缺乏預兆，它不像國家領導人簽署條約那般在締造世界史；然而，就它本身來說卻是相當激進的，它違反了人際分隔的日常習慣。李利用一種隨機的善意行為，來打破人與人之間的分隔。

III

李明維透過一個還在構思中、非常新的計畫，強化事前分析，將機構本身作為探詢的主題與介入的場域。李稱這個計畫為《五音步詩行》（2014），就跟他的《移動的花園》以及其他計畫一樣，也屬於「臨床」實驗，只不過《五音步詩行》的目標放在組織的麻煩上。他的實驗對象是機構，實際作品則包括五根由他所製作的黑色花崗岩棒。它們很容易碎，而且會因共同參與行動的人而變得越來越破，這正是它們存在的理由之一。

李明維認為許多（搞不好全部）機構內部都經歷過一些困難，諸如成員的願望、目標或策略相左。尋求外部顧問協助，去調整優先處理順序或「糾正」錯誤作法，只有這樣是不夠的。李的解決方案是讓客戶端（有可能是美術館），做一些藝術上的破壞。購買這件作品的組織成員拿出其中一根棒子，在眾人圍觀下，見證它的瓦解。可以透過丟落、粉碎或擠壓，或許用錘子或其他工具來進行。不論哪種方法，這個行動都不僅僅在於打破棒子，而是打破已經造成麻煩的各股力量的勢頭。在這個案例中，破壞就是打破常規，破壞了舉世尊崇藝術家的一件作品。 它意味著美術館摧毀了自己

收購的藏品。殊不知，正因如此才賦予這件作品力量，甚至因為它的消失，藝術品才算完整。

當然，無論這件作品變成多少碎片，甚至所有棒子都變成一段一段，它依然繼續發展。無論最終狀態如何，其結果都呈現了該機構在這個世界上的一個經驗，以及在破壞之前、期間和之後，他們經歷的所有勞動和情緒——厭惡、喜愛、深思和挫折。李明維以他一貫的方式推斷：之後的關係將跟之前的全然不同，而且隨著藝術開展，不論作品是完整或是變成碎片，關係都會繼續不同。

這件作品——「組織的藝術」，我們會這麼稱呼它（這可能是一個新類型）——又是唯有透過參與才會存在的一件作品。首先，這件作品是在多方同意下而展開：極有可能，收購本件作品的機構當時就存在著麻煩。所以，這件作品至少有某些實質部分注定是暫時的。收購方接受的前提是：他們必須知道物件何時會被改變？改變得多徹底？（破壞一根棒子？還是三根？或者更多？）。但是他們也得接受，棒子處於外形改變的狀態——即使棒子成了他人眼中的「垃圾」

——它依然存在。最後，尤其是這件作品成功（藝術上的成功）的話，他們就會認知到藝術成功會改變他們是誰，還有，在他們共同創造藝術的這個過程中，他們是如何彼此產生關聯的。藝術改變組織。對這一點，李明維大膽假設，一旦時機成熟，當某樣東西必須變成四分五裂，一群人才能在更為祥和的情況下重新連結時，本件作品的收藏者就會聚集起來並破壞它。

李明維的實驗和社會學家針對關係所做的某些實驗，這兩者之間的對比差異很大。社會學家做的關係實驗中最赫赫有名——也最惡名昭彰——的就屬史坦利・米爾格倫（Stanley Milgram）於 1960 年代初，在耶魯大學所進行的「權威服從實驗（obedience studies）」。米爾格倫利用所謂的「學習實驗」詭計，讓他雇來的助手鼓勵一般人去做出會嚴重傷害另一個人的事（給予電擊），那個人會痛苦大叫，懇求對方別再這麼做。雖然大家公認米爾格倫的實驗方式極其出色，但也引起許多爭議，其中最具爭議的就是他讓他的實驗對象遭受痛苦。那個一副受到電擊驚嚇的人，其實一點都沒有受到傷害，因為他只是個被雇來製造效果的演員罷了，一個

五音步詩行
2014

「傀儡」，照這行的術語來説。可是執行電擊的那個人（傷害一路攀升到可能致命的強度），可説是被置於精神上高危險的狀態下。的確，在看完以這個實驗所拍成的影片後（以「米爾格倫（Milgram）」和「服從（obedience）」兩個關鍵字去查，就可以在 YouTube 網站搜尋到好幾部短片[3]），我們可以看到米爾格倫那些被蒙在鼓裡的受試者所承受的壓力有多大。

李明維的作品當然是反其道而行，他的做法很溫和，致力於留給參與者一個比相遇之前更好的狀態。某些科學家當然可以宣稱（而且已經宣稱了），即使像米爾格倫所做的那種有爭議性的實驗，也會因為實驗結果而讓世界變得更美好——我們的確（do）會「沒有正當理由」就去傷害別人——這個發現最終有助於遏制人們肆意危害他人的傾向。李明維並沒有去找這種「冠冕堂皇」的辯解。相遇本身就是良好的，若相遇造成緊張，那也只是在日常生活中的一些小「問題」。整體的呈現優美文雅，這就是李明維美學的一部分，也是其實際成就。李的美學源自藝術家本人的生活作風，而非本於包羅萬象的欺矇伎倆。如我們在美國説的（從非裔美國人的生活中借用來的詞彙）——李的美學「深情款款（soulful）」。它的力量與美來自於他對他人的愛戀與同理心，也來自於跨越時空、與其相連結的那個志趣相同的靈魂。李明維的計畫觸動人心（touching）。

IV

美國知名社會學家霍華德‧貝克爾（Howard Becker）解釋説，我們很難指出藝術家開始創作一件作品的確切時間。[4]到底是某天早上淋浴時，福至心靈的那一刻？還是父母或老師提供想法、受到他們刺激的時候？還是之前在便條紙上隨手塗鴉而成形的那一刻？或是藝術家組合材料或首度把刷子放進油漆罐或朝石頭鑿下第一銼的時候？至於作品的完成，怎樣才算結束呢？所謂的「結束」是否發生在當藝術家對著作品看上最後一眼，滿意且放心地説「我做完了」的那個當下？還是一天或一週後，藝術家加了一個裝飾或是拿掉什

麼？更有可能的是，貝克爾如此假設，得等到卡車開來，把作品運到美術館的那一刻。因為從那一刻起，就不可能再改來改去，因此，就實際面來説，這件作品也就完成了。

李明維的作品迴避開始與結束這種單純的想法，他作品中的曖昧性有助於定義它們自己的性格。很顯然，李的計畫不是僅藉由物質元素開啟，更重要的是，讓人想像人們與這些物質東西之間的關係（「僅僅（mere）」物質的東西，有的人會忍不住這麼説）。我們不知道他心中究竟是怎麼想的，但八成是反覆修改的情節，一些元素隨著想像而或增或減，終於至少暫時性地完成了。李明維是「製作者（producer）」，不是指創作出傑作的偉大藝術家這種定義，而是更偏向於戲劇方面對「製片」的定義——利用道具、背景，以及演員與觀眾的互動來安排各種活動的人。直到它們被呈現出來，它們才會發生；它們沒有底稿，沒有實物模型，沒有原型或設計草圖，也沒有正式登上百老匯前的預演。

然而，將李的作品比為戲劇只有到此為止，他作品中的戲劇成分逐漸弱化，因為李的作品是透過人們即時制定自己的特定（ad hoc）關係而產生。他作品中之所以有戲劇成分，那是因承繼即興戲劇的傳統，以及和 1960 年代紐約「偶發藝術」的流派有關，當然還有當代表演藝術的影響。可是針對嘗試戲劇或藝術的新形式這點上，李明維的計畫並不是「實驗性」的，至少那不是首要目標。它們反而回歸到社會學的主題，是種行為實驗，目標在於發現，當一個人面對某些他只能有限控制的環境條件，而其他人的行為也會影響他們時，這個人會怎麼反應。這些就是信賴實驗——共度一宿的人與人之間、主與客、送花與受花人之間的雙向信賴。

在挑戰跨越人與人的邊界這點上，李明維通常都仰仗面對面相遇，或者至少是人與人之間親密連結的記憶。李大可創作出一些涉及網際網路而產生關係的作品，這是其他藝術家和社會學家已經做過，且正在積極從事的所謂「網絡分析」，但是，那樣就會削弱現實社會中特有的、能直接體驗他人脈動的張力。這種即時的人際互動也有助於賦予現實生活中不可預測的興奮震顫——以及學習——而這些都已被李明維建

構進每個計畫的開展中。

我們通常不會把藝術視為開展。美術館和收藏家都應該擁護不變才對。投資的經濟價值取決於物件能否保持特定形狀和形式，這一點才讓藝術作品貨真價實（bona fide）、值得納入（in）收藏，至少在理想上符合永存不變的價值。所以在李明維的關係實驗脈絡之下，我們該如何去想像作品的永久性呢？沒有傳統的物件，不同於其他許多當代藝術家的作品，使得我們不得不自問：我們該如何看待永久與短暫？這個疑問跟李明維在他自己作品中所提出的議題類型十分雷同，比方說他在《石頭誌》中，已經設想好要把自己作品的一半材料丟棄，或在《五音步詩行》中，特別指定必須破壞的這個條件：何謂作品的「真實性」？又何時失去或得到？當藝術修復師開始這麼問「何謂真實的？我們要怎樣保存一個新定義的真實性？」他們開始讓藝術家以自己的說辭去定義永久性與真實性，以及在不斷改變狀態的藝術作品中，應該被保存的核心本體是什麼。[5]

就李明維作品的情況，該怎麼定義呢？他當然不會在乎他端出來的菜有沒有被保留下來。他睡的那張美術館床墊也不帶神聖關聯；隨便哪張舒適的床墊都可以勝任。一旦他的劇本展開，他必須在場嗎？顯然不是。當被問及他出現在自己的作品中「演出」時，李明維回答說：「我一直認為，這些計畫有自己的生命。我只是把它們帶到這個現實世界、讓它們得以發聲的那個人而已。我所有的計畫，對我和觀眾來說有一點非常重要，那就是認知到不是李明維跟你做這些事，而是一個陌生人，這個做東西給你吃或者跟你一起睡的陌生人剛好是李明維而已。」[6] 的確，在日本森美術館展出的「李明維與他的關係」這個展覽中，李就選擇讓其他人與陌生人共眠。

長期以來，無論在藝術或社會學方面，都有一種傾向，認為永久才有價值，所以假設美或有關社會生活所推定的事實有固定不變的標準。但如今無論在人文學科或社會學方面的認知都有了急遽轉變，開始肯定偶發性（contingency）的存在——了解觀察者的「立足點」（歷史時刻、地理位置、他

們的性別及種族）會影響他們判斷何者是否具有美學價值或是這個世界的合理「事實」。不只是認知到就算大理石和青銅也會惡化，甚至在歷史長河裡完全消失，現在，更正面體認到不管其在物質上有沒有變化，作品的意義無可避免一定會有所轉變。《格爾尼卡》就經歷了這樣的改變，它從最初畢卡索標記出佛朗哥鎮壓的恐怖時刻，變到紐約當代藝術館的牆上，現在又回歸西班牙——更何況還被李明維改造成沙畫複製品。

這場靜止槓上偶發的辯論——這場爭論一直持續到現在——像李明維這種藝術家勢必要捲入。他們原本就不追求固定性，事實上，他們反而更善於發揮（leverage）不穩定性，他們對「開放式作品（open works）」——借用安伯托·艾柯（Umberto Eco）的話——較為在行。[7] 誠如一篇樂章，作曲者了解它將呈現出不同形式，取決於演奏它的人、演奏的地點與時間，所以說李明維的樂章未來如何開展，也會因人、事、時、地而自我展現。它們不是只為了成為這個或那個而被創出來，而是沒有結束，總是在進行中的作品——也作為對這個世界的探詢（inquiries）。因此，李的任何計畫都沒有該做出些什麼或該保留些什麼的「正確性」；因為它始終都是實驗性的，所以它不可能錯。萬一真有關於專業保存之類的需要，那麼就將這件作品以備忘錄（aide-mémoire）形式扼要記錄下來（李明維明確表示不鼓勵他的作品冗長錄像）。

至關重要的是，李的計畫會因所交織捲入的那些人而不斷變化——即使只在很微小的方面，即使一次只有一個人。它進入了一種新體驗和新思維，而且因為它在社會的各個領域都引起迴響，我們可以預見的是它將對改變他人的命運造成連鎖性影響（cascading influence，譯註：指前一事件能激發後一事件的一連串連鎖事件所造成的影響）。所有這種情況的發生不是藝術的結果，它們就在藝術裡面（within the art）。隨著時間過去，作品會透過這種種關係保存住自己。保存下去，如它被創作出來時的「最初原點（first place）」，藝術需要的無非是對日常生活有禪的參透，以寬容柔軟的心，任社會無限地自行開展。

1. 首度（而且半開玩笑式的）宣告，請參見：http://www.malepregnancy. com/mingwei/。

2. 社會學家在「違反規範實驗（或譯為破壞性實驗）」中處理的是：人在遇到莫名其妙的社會狀況時會如何反應？例如結束會話時卻說「你好」，或者面壁搭電梯。這些研究案例的目的在於記錄一般人都會努力重新恢復正常。相關研究結果文件，請參閱：Garfinkel, Harold, *Studies in Ethnomethodology*, Englewood Cliffs, NJ: Prentice Hall, 1967; Cambridge / UK: Polity, 1984, 1991.

3. 範例 請參見：https://www.youtube.com/watch?v=mnBY0FCqJU0。

4. Becker, Howard S., *Art from Start to Finish: Jazz, Painting, Writing, and Other Improvisations,* Chicago: University of Chicago Press, 2006.

5. Corzo, Miguel Angel (ed.), *Mortality Immortality?: The Legacy of 20th-Century Art*, Los Angeles: The Getty Conservation Institute, 1999; Laurenson, Pip, "Authenticity, Change and Loss in the Conservation of Time-Based Media Installations," *Tate Papers*, Issue 6, October 1, 2006 (http://www.tate.org. uk/download/file/fid/7401); Scheidemann, Christian, "Authenticity: how to get there?," in Erma Hermens and Tina Fiske (eds.), *Art, Conservation and Authenticities: Material, Concept, Context,* London: Archetype Publications, 2009, pp.3-12.

6. Interview with Lee Mingwei by Shao Yixue and Shen Yuan, a student project in Glenn Wharton's seminar, "The Museum Life of Contemporary Art," in the Museum Studies Program at New York University, February 21, 2014.

7. Eco, Umberto, *The Open Work,* trans. Anna Cancogni, Cambridge, MA: Harvard University Press, 1989.

An Art of Social Studies

Harvey Molotch

Sociologist/
Professor of Sociology and Metropolitan Studies, New York University

Glenn Wharton

Art Conservator/
Clinical Associate Professor in Museum Studies, New York University

"Relations" may be a recent thing for art, but they are bedrock for social science, indeed the very heart of the fields of social-psychology and a lot of sociology. Social scientists have long asked how humans connect; how, indeed, do they "relate?" To this old problem, the artist Lee Mingwei brings a fresh approach, one that opens new ways to think about both art and its qualities as well as how we can learn about human connectivity through the art itself.

Social scientists run with their own techniques for learning about people's relations: focus groups, surveys, and experiments of all kinds. In the case of the experiments, they may set people up in "laboratories," putting them through various activities, "trials" as they are technically termed, to see how they interact with one another. It is much like experimenters do with mice in a maze or pigeons in a box. Sociologists might just ask people survey questions, like who they like or dislike, what are their opinions of one kind of person or group or another — maybe, especially relevant to Lee Mingwei's work — who they trust and how they handle the social anxieties that trust may entail.

Whatever the specifics of approach, academics are trained to be distant, like observant flies on the wall — doing everything they can to analyze their field of study but "staying out of it." The scientific method says, "don't interfere;" your job is to find out what goes on while making your own being invisible, leaving no trace or impact on those you study. In contrast, artists have no pretense of standing apart. Whether they create paintings on the wall or sculptures in the garden, they unabashedly assert their own subjective interpretation of the world as they leave something behind. They want their interventions to be seen and they want their name to be on them, literally inscribed on the work.

Again in contrast to the stance of the social scientist, artists seek to present truths through their own products, truths about inner-feelings, of the external landscape — all products of artistic observation, analysis, and interpretation. And furthermore, these artworks are intended to have a fixed and final version. Whether in a gallery or collection, the piece —

once it exists as a work of art — is done and durable. Any future change it may undergo is a problem, a trouble, a "failure." If resources permit, art conservators are brought in to nurse it back into proper being — to *save* it for the experience of future generations, true to its creator's initial intent.

On all these fronts, Lee Mingwei operates differently, very differently. The point isn't the stuff at all, it is the inquiry to which it leads and the lingering effects the set-ups continue to have — even as the work is taken down from the museum, retreats into storage, or ceases to have, as is most usual with his work, any material form whatever. Lee isn't interested in finished products. His works generate relationships that, as they continue on, reveal. They teach him, the participants, and all those who experience them in real time, in memory, or in documentation. So in a sense, and in a way that we as university teachers can only admire, they are teaching devices. And as with other great teaching moments, they persist as long as their witnesses and participants live on. Even beyond the initial encounters and at least in prospect, they may go on beyond the artist's own lifetime. Traces, perhaps material, more often immaterial, just go on.

There is always risk in his projects, risks that are those of life itself. Every time we cross the street we take our life in our hands. A madman may kill us, or just a wayward bicyclist who doesn't see us coming could catch one of our feet in his whirling wheel. The person in the train seat next to us may take too much elbow room or, if generous, offer us delicious food or even — who is to really know? — grab a bit of our own food as we eat. At the shop, a sales person may be courteous or rude, uplifting or upsetting, and our family member at home may show affection or resentment. However trivial such encounters may seem they can be intense as we wonder how we "stand" in the other's eyes, make plans for a better exchange later on, or think through our own ways of responding to other people as we move through everyday situations. We can think about such matters and a whole lot more, and they all, singly and in combination, count.

Lee Mingwei's relational inquiries deal with such encounters, as they happen, how they occurred in the past, or the way they might function in some time to come. His projects inquire across a wide range of topics, but *trust* tends to figure in. In effect, he takes artistic license to run trust experiments. For individuals in general, life begins with radical dependence, on one's mother and, typically in modern settings, the medical team that brings us into being. But then the possibilities expand outward: who and what is to be trusted and just when and how. Beyond mother's arms, the zone of trust takes in even strangers — people in our schoolroom, dentists, and airplane pilots. But also passersby who may cast an offending glance, turn-away, or say "hello." It is not always easy; doing trust can be tense and it requires care, skill, and thought. We depend on the kindness of strangers, of people relating to one another in a positive and mutually supportive way. People fill their consciousness with others' needs and wants, sometimes consider those others' well-being to find common cause in community and mutual dependence.

The problem scales up. With a world of drones and climate change, each citizen — not just those who share a sidewalk, but those who share the earth — needs to have a keen sense of the other and to bridge whatever awkwardness or narrow self-seeking that keeps people apart. And they need to know that if they do the right thing by helping another carry a heavy load or, at the macro scale, by limiting their carbon footprint, others will follow suit. Trust becomes the basis of civilized existence and the perpetuation of species, not just the human one. So trust is worth learning about — and that means, through art, too, if artists are up to it.

Lee Mingwei is.

When he invites a random museum patron to spend the night with him in the gallery (as he does with *The Sleeping Project* [2000]) neither he nor they know what will happen. For a start, they risk basic personal safety — the ax murderer in the museum is a dark possibility. There are many unknowns to wonder about. Will there be talk? How will the talk happen? Awkward silences? Meaningless jabber? Will someone be funny, sober, cry all night? Snore? Smell? Both parties will learn. One first *finding* of *The Sleeping Project* is that "yes," people do agree to do it, to come into Lee Mingwei's gallery space, with all of

its unknowns and stay the night. Lee takes them in. And, at least as provisional finding, and so far, nobody seems worse for the wear.

The same with sharing a meal that Lee Mingwei has cooked in the museum in *The Dining Project* (1997); he has no trouble getting takers, and the takers appear to survive just as he does. But this too starts with unknowns. What does it mean to be given a meal in this strange situation? Does the artist actually know how to cook? What dish will be prepared? How much do I take in a gulp or bite? How do I show my pleasure — with noisy appreciation or respectful silence? What does this artist (this place? this item? this moment?) want of me? And just how do I reciprocate to this nice man who has been so gracious? What if I spill the soup or, even worse, don't like it? For his part, the artist works with his own range of unknowns about people he must trust, not screened like those at the airport security gate or by a university admissions committee. What details of life lurk in the offing? Lee learns and, by his records and the museum's documentation, we learn as well.

So conceptually rich and ready to cook, Lee Mingwei is also handy with needle and thread. He sews. In *The Mending Project* (2009) people bring articles of clothing or other fabric goods that need repair. He takes on one such sewing job after another, using threads in all varieties of color pulled from reels attached on the gallery walls. Mending is ordinary in society, but not in an art gallery. Sewing in a factory is not about mending but about production and it is done for unknown people in an utterly impersonal way. If it is done at home, the beneficiary is oneself or a family member. Lee's mending relations are with people he meets as they bring their objects in, some of whom watch and interact with him as he does his work. But otherwise they are not people from his life circle even though they cease being complete strangers — it is an inbetweeness. They are not domestic intimates and they are not, like those who make our clothes in a foreign land, utterly unknowable. Knowing them a little injects a social tension (and reward) absent when we buy a product or pay for a commercial service.

All this ups the ambiguity. People bring in items the artist cannot anticipate beforehand and he must rise to whatever

mending challenge comes his way — or not (nobody is giving him a grade and the art critics are not evaluating the skill of his sewing talent). The people who bring the articles to him might, of course, be disappointed in the quality of his work, who knows? That too is an unknown, a risk they and Lee take.

He doesn't just fix the article and hand it back. After the act of mending, as the project proceeds, it grows as a display, with multi-color elements reaching from the piles of mended goods out into the surrounding environment — an abstract web built from connections he has made with his gallery visitors and their artifacts. Even as he fixes each article, he leaves — for the time being — an element remaining to be done later. The incompleteness erodes the separateness of the article from the rest of the world. It is no longer an independent shirt or blouse, but now attached to all the other artifacts, to the gallery, to the project (as well as to his own skill and considerations). He does return each artifact to the person who placed it under his care — and with the last stitching appropriately in place. But along the way, he gives all visitors a display of linkages among people who likely have never met and likely never will, now united through a work they have collectively brought into being.

II

Lee Mingwei also, it turns out, traffics in masterpiece. With *Guernica in Sand* (2006), he deals with Pablo Plicasso's *Guernica* (1937) — faithful to Picasso's original image but created on the floor, not the wall. Instead of oil paint, he makes it of differently colored sands, loosely poured to mimic the Picasso's *cris de coeur*. As method, it brings to mind and starts to resemble works done through "paint by numbers." The lines are somewhat cartoonish with divisions among colors and shapes being close but imprecise. But as with everything else Lee does, any imprecision is *precisely* approximate and that includes, in this case, its capacity to hold in place, to remain stable during its exhibition period.

The trust refrain sounds again. He trusts the gallery and the public in this process-installation as it unfolds with time. He takes it that those who watch him at work (the public is there

all along) will not, at a premature moment, disturb the forms he arduously brings into being. And when the time is up at a point during the exhibition period — with the remaining unfinished part of the configuration on the gallery floor gets filled in and completed — the artist starts to invite people to walk on it, in an act of apparent destruction. Again, it is experimental: how will they destroy this masterpiece? With hesitation? Deliberation? Affection? Delight? However the mood and method, the work returns to sand, now with each color intermingled with all the others. After the sunset of the day of this invited act of invasion done, Lee and his assistants then further upset the image by sweeping up the sand with their brooms. Hence the final view of the work commences, open for the visitors again. Lee's *Guernica* remains, but as such — an evidence of the interactive acts of destruction — a questioning of permanence by taking on one of the masterworks of modern art. The art is a craft of making, a physical disturbance, and a social response.

In one of his early projects, *Male Pregnancy Project* (2000), Lee Mingwei disturbed a different type of physical-social convention by becoming the world's first pregnant man. By its nature a young man's project, Lee walked around New York with his otherwise lean torso displaying the abdomen of a pregnant person, and documenting public reaction. He wore a clinging T-shirt to show his state of expecting. From the video made of his movements and others' responses to his website presentation (now with about 600,000 YouTube views), we learn that some people stare, some (like a New York taxi driver of Middle-East origin) disapprove.[1] Others react positively; an especially delighted woman on the street celebrates this man for sharing in what she regards as a female burden. She fervently congratulates him on his amazing feat, not just for his personal daring to get pregnant, but also for his evident feminist solidarity — for being a fellow feminist, so to speak.

Stone Journey (2012) is a less raucous intervention, but also radical. Here Lee Mingwei disturbs possession. He raises the question of what it means to possess something that is yours in the conventional sense of ownership but like all material particulars, is utterly transitory. You won't last forever and the stuff — as your possession — is, in an absolute way, temporary

Male Pregnancy Project
2000

as well. And what of the social connectivity always interlinked with material possessions: showing off we have it, passing it on to our children, or sharing it with others we love. What happens when we are just supposed to relinquish?

Lee Mingwei forces the issue, gently of course as with all his forcings, by specifying that as part of having the work, the person who acquires it must discard half of it during his or her lifetime — not gift it, but *discard* it. On the surface, the work consists of two physical objects, both shaped like small rocks, one just as Lee found it in nature, and the other is a replica cast in bronze. He offers them to potential collectors as a

series of eleven pairings. The art is not the two rocks; instead it is the relation the owner has to these two objects and to Lee. A decision must be made: which one of them do I keep? When and how do I discard the other? Do I bury it in the ground, leave it on a bus, toss it in the river? Will it be done with ceremony or casual aplomb, joy or regret? What of its "preservation"? Would keeping the physical elements together "save" the artwork or, the dilemma is posed by Lee, destroy it?

Regardless of outcome, *Stone Journey* pushes its owner to ponder ownership itself and, ready or not, now or later, the profound impermanence of possession. As an artwork, the piece is realized as the outcome of just such thinking. The artist does not ever finish it; "his" rocks go forward in time in indeterminate ways and with indeterminate timings: the choices could be made in minutes after acquisition or evolve over a lifetime. Only then would we learn what happened and most likely outcomes will never be known at all. In that sense, the work is timeless and beyond knowing.

Again, there is the role of trust: Will those who acquire *Stone Journey* respect its artist's intent and decrease its volume by half? Or will the worldly need to possess "it all" overpower the aesthetic vision and, at least arguably, destroy the work in so doing? Quite reasonably, this is a question relevant not just to this artwork but for human futures in general.

Gardens, of the Lee Mingwei sort, also travel and in important ways. In *The Moving Garden* (2009), he assembles cut flowers in beautiful arrays, linear, winding, or in clumps and invites gallery goers to take one of the blooms as they leave. The result is a kind of happening parade of exiting gallery-goers each carrying a stem in their hands.

But there is, once again, a Lee Mingwei hitch: they are to give the flower to a stranger on their way home. The simple social encounter that follows is, in degrees unknown beforehand, exhilarating, awkward, or suspicious. We had occasion to see elements of all these responses when we left *The Moving Garden* exhibition at the Brooklyn Museum. One young acquaintance of ours, perhaps always tending to be shy, put great care into selecting his recipient, hesitating so long that he lost several opportunities as his chosen stranger walked out of range. For our parts, we had no problem making presentations, with a happy response in each case.

In running this experiment in relations, Lee uses a material element — flowers — to confront the human divide. The simple act of presenting a flower, commonplace enough in some life circumstances (mother's day, or school graduation) is a more daring move when taking place "for no reason." As single acts go, it lacks portent; it is not making world history as when national leaders sign a treaty. Instead, radical enough in its own way, it breaches the everyday conventions of separation. It presses against the divide with a random act of kindness.

III

Through a very new project still in design, Lee Mingwei ups the analytic ante, making an organization itself the subject of inquiry and site of intervention. *Pentameter* (2014), as Lee calls it, is also, like his gardens and others of his projects, "clinical," but now aimed at organizational troubles. His target consumers are institutions. The physical work consists of five rods of black granite, crafted by the artist. They are breakable. And getting broken, by people acting together, is part of their reason for being.

Lee supposes that many, maybe all, organizations experience internal difficulties. People have contrary aspirations, goals, or tactics. Something is needed beyond calling in outside consultants to prioritize or "correct" bad practices. Lee's solution is to have the client, perhaps a museum, do some art-breaking. Staff members of the organization that purchases the work are to take one of the rods and, watching together, witness its disintegration. It could be done by dropping, by smashing, or crushing, perhaps with a hammer or some other tool. Whatever the method, the activity does not just break the rods, it breaks the momentum of forces that have yielded the trouble. Breaking is the breach in this case, disrupting an artwork by a respected world artist.[2] It portends a museum destroying an acquisition. This is what gives the work its power, even as it disappears as an intact artifact.

But of course the artwork continues on, no matter how many pieces it becomes, even if all of the rods become small fragments. Whatever the end-state, the result stands in for an organization's experience in the world and all the labors and emotions — dislikes, affections, thoughtfulness, and frustrations — that have come before, during, and after the breakage. The relationships afterward, Lee speculates in his usual way, will be different than those that came before and will go on being different as the art evolves, intact or in bits.

Again this artwork, "organizational art," we'll call it (and here we may have a new genre) exists only through participation. It comes in the first instance as part of a multiparty agreement: in the very acceptance of the thing, those who make the acquisition enroll in the idea that institutions have possible troubles ahead. So at least some of the work's physical aspects are destined to be temporary. The acquirers accept the premise that they will know when the object will be changed and how radically (one rod to break? three? more?). But they also accept that, in its transformed state — even resembling what for others is "trash" — it remains. And finally, of course they realize that, especially if the work is a success, an artistic

success, it will change who they are, how they relate to one another through the art making they have done in common. Art changes organization. For his part, Lee presumes his collector will gather and break when the time is ripe, when something needs to be put asunder so that a group of people can reconnect under a more auspicious circumstance.

What a contrast between Lee's experiments and some of those performed by social scientists making their inquiries into relations. The most famous — and notorious — are those conducted by Stanley Milgram at Yale who, in the early 1960s, set up what have come to be called the "obedience studies." Milgram had his paid assistants encourage, through the ruse of a so-called "learning experiment," ordinary people to deliver what they thought would be severe shocks to another human being, a human who cried out in pain for the proceedings to stop. Among other controversial aspects of Milgram's experiments, recognized as brilliant in their way, was the pain he put his subjects through. The person presented as being shocked was in fact not being harmed at all; he was just an actor hired for the purpose, a "stooge" as it is termed in the trade. But the person doing the shocking (all the way up to a

Pentameter
2014

possible fatal level) was arguably placed at psychological risk. Indeed, in watching the film dutifully made of the experiment (now available on various YouTube sites through the words "Milgram" and "obedience"[3]), one can see the intense strain that Milgram's naïve subjects were undergoing.

Lee's work, of course, goes in the opposite direction, gentle in its instructions and striving to leave its participants in a better state than when the encounter began. Some scientists can proclaim, of course, and have proclaimed, that even experiments like Milgram's yield a better world because the findings — that people *do* readily harm other people for "no good reason" — can eventually help curtail the propensity of people to commit wanton harm against others. Lee does not look for such "larger" justification. The encounter is itself benign and if tense, only in the way that ordinary life has its small "issues." The overall gentility is part of its aesthetics as well as practical accomplishment. It begins with the artist's way of being in the world, not as part of an overarching strategy to deceive. As we might say in the US, and borrowing from the vocabulary of African-American life, it is "soulful." It receives its force and beauty from affection and empathy for others and a kindred spirit that connects across time and space. Lee's projects are *touching*.

IV

It is always difficult, the distinguished American sociologist Howard Becker explains, to specify when any artist starts a work.[4] Is it the moment of a first conjuring during a morning shower? When a parent or teacher offers up an idea or prodding? When an early sketch takes form on a note pad? Or when the artist assembles materials or as a brush first goes into a paint pot or a chisel first marks a stone? And what about the finish, the end? Does that happen when the artist looks a last time and says with satisfaction and confidence, "I'm done"? Or the day or week later when the artist adds a new flourish or takes something else out. Still more likely, presumes Becker, it may be when the truck arrives to carry the work to the gallery. At that moment, there can be no more fiddling and thus, as a practical matter, the work is complete.

Lee Mingwei's works evade any simple idea of start and finish but here the ambiguity helps define their very character. Quite obviously, a Lee Mingwei project starts not only with physical elements but also, far more importantly, envisioning humans' relations to those physical things ("mere" physical things, one is tempted to say). There are, we presume without knowing exactly what happens in his mind, iterative scenarios, elements dropped and added as imagination scores them, provisionally at least, into being. He is a "producer," not in the sense of a great artist making master works, but more in the theatrical sense of "producer" — the person who arranges activities along with props, backdrops, and an interacting cast and audience. They do not happen until they are presented; there can be no cartoons, no mock-ups, no prototypes or maquettes, and no pre-Broadway run-throughs.

Yet the theater analogy takes us only so far. It weakens because Lee's works emerge through people's real-time enactment of their own *ad hoc* relations. If theater is in play, it is following in the tradition of improvised theater and related schools of the New York 60s "happenings" and, finally, performance art of the contemporary scene. But Lee's projects are not "experimental" in the sense of trying out new versions of what theater or art can be, or at least that is not a primary goal. Instead, they are, to return to the social science motif, behavioral experiments. They aim to discover how people act when confronted by distinctive conditions over which they have limited control and where others' behaviors will affect them. These are experiments in trust — the two-way trust between sleepers, between host and guest, collector of a flower and a person to receive it.

In his challenges to cross borders, Lee Mingwei typically relies on face to face encounters, or at least memories of close-in human connectedness. Lee could have created works involving relations via the Internet, something done by other artists as well as by social scientists now engaged actively in what is called "network analysis." But that would weaken the intensity that is unique to real sociality, where people can directly experience the pulsating other. Such real-time human interaction helps also to bestow, as with real life, the frisson of unpredictability — and learning — built in to each project's unfolding.

We usually do not think of art as unfolding. Museums and collectors are supposed to be custodians of the unchanging. The financial value of the investments hinge on the thing's maintaining a specific shape and form. This gives the artworks their *bona fide* as worthy to have *in* the collection and, at least ideally, in perpetuity. So how then can we think about longevity in the context of Lee Mingwei's relational experiments? Without the conventional object, absent from the work of numbers of other contemporary artists as well, we have to ask how we should consider permanence and impermanence. This is a question rather resembling the type of issue Lee raises in some of his own work like when he sets up the discarding of half of a material work, as in *Stone Journey*, or specifies the conditions of breakage in *Pentameter*: what is the "real" of the work and just when is it lost or gained? As conservators are starting to put it, "what is authentic, and how can we preserve a newly defined authenticity?" They are beginning to allow artists to define permanence and authenticity in their own terms, and the core identity of their work that should be conserved as it changes from one instantiation to the next.[5]

How might that be decided in the case of works by Lee Mingwei? Surely he doesn't care if the pots he cooks with are retained. The gallery mattress he sleeps on also has no sacred relevance; pretty much any comfortable mattress will do. Does he even have to be present when his scenarios unfold? Apparently not. When asked about his presence in restaging of his work, Lee replies, "I always think that these projects have their own lives. I am only the person who brought them to this reality and to bring their voices out. With all my projects, it is important for me and for the audiences to know that it is not about Lee Mingwei doing this with you. It is about a stranger and it happens to be Lee Mingwei cooking the meal for you or sleeping with you."[6] Indeed, others are selected to sleep with strangers in the *Lee Mingwei and His Relations* retrospective exhibition at the Mori Art Museum.

There has long been a tendency, both in art and social science to valorize permanence, assuming unchanging standards of beauty or putatively fixed facts about social life. But both in the humanities and social science the shift has been to appreciate contingency — to understand that the "standpoint" of the observer (the historic moment, geographic location, their gender and race) affects what is or is not taken as aesthetically worthwhile or a legitimate "fact" of the world. Beyond acknowledging that even marble and bronze deteriorate, and indeed over the long historical arc, completely disappear, there is now the appreciation that whatever happens materially, meanings themselves inevitably shift. *Guernica* undergoes such change as it moves from Picasso's moment of marking the horror of the Franco repression to the walls of MoMA and now back to Spain — never mind its remaking into sand by Lee Mingwei.

Into this debate about stasis versus contingency — and it is a debate that continues into the present time — artists like Lee Mingwei have no need to become embroiled. They have no aspiration for fixity. Indeed they *leverage* the instability. They are at home with something like, in Umberto Eco's term, "open works."[7] Just as a musical composition was understood by its composer as taking different forms depending on who played it where and when, so the compositions of Lee will manifest themselves depending on the who, what, when, and where of a future unfolding. They are set-up not to be just this or just that, but instead to play out, always as works in progress — and as *inquiries* of the world. So there is no "rightness" for how a Lee project should be made or kept; it cannot go wrong because it is always experimental. If anything like professional conservation could be relevant, it is in documenting the work as an *aide de mémoire* (Lee explicitly discourages long videos of his work).

Lee's projects continue, most crucially, in the changes they make in the people with whom they intertwine — even if only in a small way, one person at a time. A new experience or new thought enters and, as it reverberates across social spheres, can — the prospect holds — have a cascading influence that alters the fate of still others. All this happens not as a result of the art, but *within the art*. As it goes on, the work conserves itself through such relations. To be preserved, as with being created in the "first place," the art needs nothing more than a Zen-like awareness of the everyday, along with the grace to let the socially infinite run its course.

1. For the first (and tongue-in-cheek) announcement, see: http://www.malepregnancy.com/mingwei/

2. In their "breaching experiments," sociologists confront people with socially inexplicable situations, like ending a conversation by saying "hello," or riding the elevator facing the back wall. The purpose in this case is to document people's struggle to regain a sense of normality. For the founding document, see: Garfinkel, Harold, *Studies in Ethnomethodology*, Englewood Cliffs, NJ: Prentice Hall, 1967; Cambridge / UK: Polity, 1984, 1991.

3. For example, see: https://www.youtube.com/watch?v=mnBY0FCqJU0

4. Becker, Howard S., *Art from Start to Finish: Jazz, Painting, Writing, and Other Improvisations*, Chicago: University of Chicago Press, 2006.

5. Corzo, Miguel Angel (ed.), *Mortality Immortality?: The Legacy of 20th-Century Art*, Los Angeles: The Getty Conservation Institute, 1999; Laurenson, Pip, "Authenticity, Change and Loss in the Conservation of Time-Based Media Installations," *Tate Papers*, Issue 6, October 1, 2006 (http://www.tate.org.uk/download/file/fid/7401); Scheidemann, Christian, "Authenticity: how to get there?," in Erma Hermens and Tina Fiske (eds.), *Art, Conservation and Authenticities: Material, Concept, Context*, London: Archetype Publications, 2009, pp.3-12.

6. Interview with Lee Mingwei by Shao Yixue and Shen Yuan, a student project in Glenn Wharton's seminar, "The Museum Life of Contemporary Art," in the Museum Studies Program at New York University, February 21, 2014.

7. Eco, Umberto, *The Open Work*, trans. Anna Cancogni, Cambridge, MA: Harvard University Press, 1989.

《如實曲徑》於台北市立美術館展出
Our Labyrinth, at Taipei Fine Arts Museum, 2015

座落於灰色地帶的「觀眾
參與」──談「李明維與
他的關係」

陳貺怡

國立台灣藝術大學美術系所副教授兼系主任

1998 年在惠特尼美術館以個展「驛站」（Way Stations）初試啼聲，展出《魚雁計畫》（The Letter Writing Project）與《晚餐計畫》（The Dining Project）的台裔藝術家李明維，由於展覽的成功，從此轉戰於歐、美及亞洲的各大美術館，逐漸被認為與「觀眾參與」，以及同樣在 90 年代誕生的「關係藝術」有關。2014-15 年由策展人片岡真實於日本森美術館策畫的展覽，就叫做「李明維與他的關係：參與的藝術」，似乎非常清楚的將李明維放在關係藝術與參與式藝術的脈絡底下。此展於 2015 年巡迴至台北市立美術館，正好在「關係美學」的倡導者布西歐（Nicolas Bourriaud）擔綱策畫的台北雙年展之後，也使得台北藝壇一時之間增加了許多對於相關議題的關注與討論。然而，究竟何謂「參與式藝術」與「關係藝術」，這些原本在西方即引起相當多討論，甚至是爭議的藝術論題？而李明維的創作與它們究竟有什麼關連？對李明維這樣的標籤與定位究竟能不能有助於理解他的創作，還是適得其反？李明維的藝術與其演變，能否在某種程度上回應這些從 90 年代至今，甚囂塵上的爭議與論戰？

灰色地帶？

欲解決上述問題，我們首先要提問的是李明維究竟是如何，而且在什麼樣的背景裡走上藝術這條路？這樣的提問，原因在於 1964 年，他誕生於台灣埔里的一個醫學世家，14 歲抵達美國舊金山，繼初中、高中之後在家人的期待下至華盛頓大學（University of Washington）讀了四年生物，以便為承接家業作預備，但最後卻選擇了加州藝術學院（California College of the Arts）的紡織和建築（Textile & Architecture），並且拿到紡織學位。最後，在工作兩年之後，1995 年到耶魯（Yale University）讀雕塑創作碩士（MFA sculpture），從此踏上藝術創作之途。當被詢及為何棄科學就藝術時，李明維表示科學所需的理性與精確帶給他極大的壓力，然而藝術的世界對他而言卻是相對不同的世界，他表示：

我喜歡在一個沒有禁忌的世界觀裡面，也就是我很喜歡有灰色地帶，我不喜歡絕對的對和絕對的錯，我覺得藝術比較可以給我這樣子的一個生活態度。……反觀我作品裡面，它都有一個非常不明確的東西在那邊，而且這個明確和不明確的區域，其實是它的張力所在，這對我來講很重要。[1]

從這段訪談中可得知李明維的基本藝術觀乃是一種「灰色地帶」，他被藝術內蘊的一種在「明確與不明確」之間拉扯的區域所吸引，並認為那是藝術有別於其他學科之處。

然而，究竟何謂此「灰色地帶」？藝術世界向來也有它黑白分明的一面，我們必須試著釐清他的理念座落在藝術世界的哪一個區塊。所以，是否如沃福林（Heinrich Wölfflin, 1864-1945）在對古典主義與巴洛克進行觀察之後，界定後者的精神走向是一種繪畫性的或印象的概念：由於對整體效果的追求，以及反對結構性的流暢，所引致的形式的不清晰？並且恰恰與古典主義的絕對清晰相反，此一不清晰所指向的比較是感官，比較不是理性？[2] 還是如德勒茲（Gilles Deleuze, 1925-1995）也論巴洛克，認為「巴洛克藝術自我定義為褶子（*pli*）的藝術」。「褶子」與「反褶」（*repli*）參與了「再現」的消解，破壞截斷了形，搞亂了事物的正面與反面，製造了某一種模糊地帶？[3] 又或者，浪漫主義對於「已消逝」或「未完成」的眷戀？不論是康士塔伯（John Constable, 1776-1873），透納（William Turner, 1775-1851）還是佛列德列希（Caspar David Friedrich, 1774-1840），都無法擺脫對「廢墟」題材的執念，似乎廢墟對他們而言，擁有巨大而神秘的吸引力，那種對於灰色的需求，似乎超越了明晰的絕對。正如班雅明（Walter Benjamin, 1892-1940）所言：「寓意之於思想，正如廢墟之於物。」[4] 的確，廢墟作為被摧毀之物而存在，吸引人之處正是在於它的不存在，已消逝的過去供人憑弔，而可能重建的未來則供人幻想，它召喚的並非觀者視覺能掌握的實存，而是憑弔者自身的內在思維，這種「非實體性」（insubstantialité）成為它最大的特徵。廢墟的有趣之處也在於它的「不確定性」（incertitude）：狄德羅（Denis Diderot, 1713-1784）為 1767 年的沙龍展寫下：

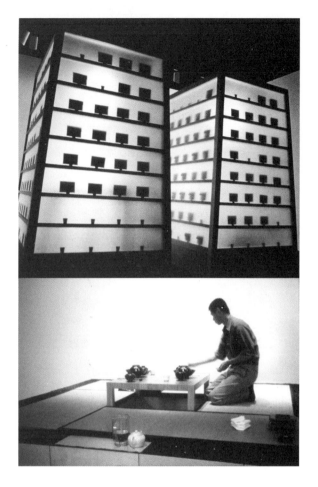

《魚雁計畫》及《晚餐計畫》於紐約惠特尼美術館「驛站」展出，1998

「必須摧毀一座紀念物，才會讓它變得有趣。」[5] 廢墟也並非全然虛無，通常剩下一些「碎塊」（fragments），由此有待拼湊的不確定中，產生出修補與重建的可能性，正是它最大的灰色地帶。

同理，李明維的作品中充滿了對於已逝時間的憑弔與感嘆：《水仙的一百天》緬懷外祖母的過世，並以水仙萌芽、枯萎與死亡的週期來隱喻生命的消逝；《魚雁計畫》是對驟逝的

外祖母來不及說出的話；《如沙的格爾尼卡》隱喻歷史的生成與衰落，甚至消失；《去留之間》則是對不可回返的時間之嘆息；《織物的回憶》是對伴隨著物之記憶的感懷。這些作品均指向所憑弔之物的「非實體性」。

然而，李明維並未停留在對已逝的唏噓與感懷中，他也不斷在作品中討論補縫或重生的可能：水仙開花之後，看似枝葉零落凋萎，但其實球莖只是冬眠，只要妥善保存隔年仍能重生。《女媧計畫》中的女媧，以「補天」著稱。在《補裳計畫》中重要的並非那些有待修補的衣物，而是「損壞」、「聯繫」與「修補」這些非實體的概念，以及修補衣物這個事件所引發的思維。試問，在今日即拋式的消費文明之下還有什麼樣的衣物值得修補？但「物」並不只用來滿足物慾，「物」與「人」是相應的概念，正如柏格森（Henri Bergson）在《物質與記憶中》一書中描述「物」的存在不是純物理性的存在，而是時間性的感性累積。[6]當觀眾帶著有待修補的衣物前來，他帶來的是「碎片」，引發的是已逝過往的經驗與記憶，如何面對「損壞」這件事，以及認真地想「修補」，並且與一位陌生人共同思考修補它的方法，而「損壞」、「聯繫」與「修補」，也可能是人際關係的生動隱喻。當然，在這樣的創作中，如何修補這件事因著帶衣物來的人，帶來的衣物，以及縫補的人的不同，便蘊藏著極大的可能性。

這種「非實體性」與「不確定性」極可能正足以部分說明李明維所謂的「灰色地帶」。有如安伯托‧艾可（Umberto Eco）在 1965 年觀察當代藝術家時，所提及的「開放的藝術作品」（oeuvre ouverte），由於當代藝術家將矛盾（ambiguité）視為一種價值，因此創作時不惜借用「非形」（informel）、失序、偶然，以及結果的不確定性（indétermination），並由此試圖展開一場「成形」（forme）與「開放」（ouverture）的辯證。但艾可也非常清楚的指出此種辯證「能決定一件作品聚焦於矛盾的程度，以及有賴於觀眾主動介入的程度」，並且即便如此，也不失去其作為「作品」（oeuvre）的質素。至於何謂作品？艾可則將它界定為「一個具有結構本質的物，可以引起並調配一連串詮釋的可能及觀點的演變」。[7]

藝術與日常生活

李明維作品的另一大特徵是以日常生活的尋常舉止為基礎：吃飯、睡覺、書寫、閱讀、清掃、縫補、操持、休憩、交談、往來等人類身心基本需求所構成的規律生活週期，日復一日，年復一年，少有變化也不需變化。藝術中對於日常生活的關注與描述其來有自，但卻因為古典文藝理論將作為藝術功能的「模仿」（mimesis）界定為「模仿人類行動中最高貴者」，使歷史題材遠遠凌駕於其他主題而形成「門類階級」，直至 17 世紀的荷蘭畫派才開始重新關注日常生活，並創造了「風俗畫」。歷史畫與風俗畫的對峙，其實就是超卓與平凡的對峙，前者為了逃避日常生活的嚴峻及枯燥，追求超凡入聖的英雄主義；而後者則試著在最基本和平庸的動作中發現美感與意義。Tzvetan Todorov 即認為荷蘭畫家們被日常生活的高貴所感動，他們曉得在享受在事物單純的存在中，讓理想與真實自我詮釋，然後在生活自身當中旬的生活的意義：「不應因為輕視，或為了其他的事物而放棄日常生活，而應該從內在裡去改變它，使它從意義與美感中重新綻放光芒。[8]」印象派繼承了荷蘭畫派的日常生活主題，但卻失落了其內在的光芒，主題逐漸變成形式主義的藉口，最後趨於抽象。

1960 年代的美國藝壇，抽象具象之爭已經徹底落幕，取而代之的是兩大陣營的對峙。一方面是形式主義藝術家與其後繼者低限主義藝術家。另一方面則是企圖在形式主義的重圍下殺出生路的新達達、普普與新寫實主義藝術家。他們或是杜象（Marcel Duchamp, 1887-1968）的信徒，或受到凱吉（John Cage, 1912-1992）啟發。杜象的作品與他的想法在 1960 年代相當受到歡迎，他所謂的「現成物」（ready-made）乃是工業大量製造的日用產品，經過「選擇」之後，成了它的作品，強烈挑戰藝術的定義與界線。一個日常生活中的尋常物件被升級至藝術作品之列，固然標示著杜象給予藝術的一連串質疑，但也宣稱了日常生活的不可忽視，以及藝術並不在日常生活以外。

凱吉則試圖在日常生活的物理環境中尋找藝術的源頭。他對藝術家的內在生活與情感內涵不感興趣，卻轉往外在的世界以及人的感官察覺能力。他認為藝術的功用在「改變觀看的方式，打開我們的眼睛，以至於能看到所有供人觀看的東西」。[9] 為了要擬彷現實的外在環境，凱吉排除造形藝術中所有關於聲響、材質、形式與色彩的階級之分：所有獨立的，或以各種方式連結的，有意無意的材料皆是藝術。凱吉宣稱所有的噪音與寂靜皆是音樂，同理，舞蹈家古寧翰（Merce Cunningham, 1919-2009）也宣稱所有的運動，包括行走、跑步、跌倒皆是舞蹈，目的在喚醒我們的「肌運動移情」（sympathie kinesthésique）。凱吉表示：「如果藝術有什麼樣的功用，那並非為了自我指涉，而是為了指涉使用它的人。而人們並非在與藝術的關係中，卻是在與日常生活的關係中使用它。……藝術最好能培養娛悅與樂趣，而不是痛苦」。[10] 所以，對凱吉而言，藝術必須是「無任何目的的免費的遊戲，……但卻能顯示生活──並非整合混亂，也非使藝術創作演進的企圖，它只是喚醒生活本身，喚醒我們的生活，只要我們的精神與慾望不介入其中，任其自由運作，生活就會變得如此美好」。[11] 論到杜象，凱吉似乎曉得將達達的精神與企圖正向化，現成物對他而言並非反藝術的象徵，反而是消弭藝術與生活邊界的利器。[12]

隨著新一代藝術家的崛起，「藝術與生活」的界線的確更加模糊不清，二者進入一種微妙的辨證關係。羅遜伯格（Robert Rauschenberg, 1925-2008）與瓊斯（Jasper Johns, 1930-）等新達達藝術家直接取用日常生活中的物件「堆積」（Assemblage）成藝術作品，強調「物件自身」（objecthood）。凱吉對羅遜伯格、瓊斯與卡布羅等藝術家最主要的影響是將他們的注意力轉向生活，並且照其所是的加以接受。他們重新發現日常生活中的影像、人工製品與例行的事件；這些平凡無奇的事物成為冥想的對象，甚至是崇拜的物件，日常生活中的聖像！藝術成為生活，生活成為藝術。

此外，哲學家杜威（John Dewey）也扮演著關鍵性的角色：1934 年他出版《藝術即經驗》一書，開宗明義的指出：「建構美學理論所憑藉的藝術作品（works of art）的存在，成了關於它們的理論的障礙」！[13] 原因是藝術作品經常被視為「經驗之外」的建築、繪畫與雕塑。這些被聖化的經典之作，從此進入藝術單獨的殿堂，自我封閉起來，與生活經驗失去聯結。杜威因此將寫作藝術哲學的任務自許為「恢復藝術作品這種被精緻化與強化了的經驗形式，與被普遍認為建構經驗的日常生活中的事件、事務與痛苦等二者之間的連接性（continuity）」。為了恢復被束之高閣的藝術與現實生活之間的關係，消除藝術與非藝術之間的界限，杜威首先試圖鼓吹藝術經驗與日常生活經驗的連接：他認為「為了理解藝術產品的意義，我們必須暫時忘記它們，繞過它們，求助於平凡的力量與經驗的條件，而我們通常不認為它們是美學的。」[14] 所以，我們並不是只有在接觸藝術作品時才能產生所謂的藝術體驗，在日常生活中，美學經驗其實無所不在，任何抓住我們的注意力，引起我們興趣的事物，都有可能引起美感經驗。

由上述理論中，杜威積極的建立他的日常生活美學，並且宣稱：「藝術的材料應該從所有的源頭中汲取營養，藝術的產品應該被所有的人接受。」[15] 杜威的理論對美國前衛藝術家們不無影響。偶發藝術的建立者卡布羅更公開標榜「像藝術的生活」（artlike life）和「像生活的藝術」（lifelike art），將藝術與生活帶入一種更為吊詭的辯證關係。卡布羅於 1956 至 1958 年間在 New School for Social Research 選修凱吉的課程，此一課程對他發展所謂的「偶發藝術」（Happening）有決定性的影響。被定義為以隨機方式「突發的純粹事件」的「偶發」，事實上是一種為時短暫的完全藝術，卡布羅用它來對抗繪畫的專業與其恆久性。一方面，凱吉引導他進入創作中的偶然與即興的概念，另一方面，杜威的《藝術即經驗》啟發他恣意的開發日常生活的活動、經驗與藝術的關係。他終於放棄繪畫，轉往物件／堆積、環境，終至偶發。身兼理論家的卡布羅也嘗試建立偶發藝術的理論基礎，而此一理論，基本上是建立在藝術與生活的關係之上。他在 1958 年發表的文章〈關於完全藝術的創造〉中，相當簡要的追溯了完全藝術的歷史，但似乎不認為完全藝術已獲致成功：中世紀時，各類藝術存在著某種神學上的和諧，

也許相融，卻並不完全統一。華格納和象徵主義者也不過是仿照早期教會的例子，而仍延續這種方式的包浩斯只不過是將形式和取材現代化。既然卡布羅斷定完全藝術的嘗試到目前為止是失敗的，便致力於建立新的觀念與方法：

> 各類經過長時間發展，並緊密聯合在一起的藝術形式，並非輕而易舉的便能完全融合：單就他的凝聚性和表現的領域而言，它們是自成一格的。但若我們不管「藝術」，而以自然為藍本或出發點，也許可以先湊集日常生活中各種感官現象的片段——諸如一片葉子的綠色、小鳥的鳴唱、腳下的小石子、蝴蝶的翩翩飛舞等，而產生另一種藝術。[16]

所以卡布羅欲建立的「新完全藝術」相當特殊，熟知藝術史且研究蒙德里安的他，必定了解 20 世紀初期，各類藝術在長期分科的狀況下欲重新結合的困難，既然完全藝術的典範在於藝術與生活結合的遠古時代，不如根本撇開「藝術」的問題，直接從人人皆能擁有的「生活」經驗中出發，卡布羅的「偶發藝術」於焉誕生。1959 年，他在紐約的魯本畫廊發表第一個偶發藝術作品《分成六個部分的 18 個偶發》。在分隔成 18 個隔間的畫廊中，安排了若干藝術家同時進行一些諸如以油漆刷作畫、演奏樂器、朗誦，或甚至進行一些排列積木、拍球、播放唱片、榨柳橙汁之類日常生活中平凡無奇的動作。

在杜象、凱吉和杜威等人的影響之下，60 年代前衛藝術家擬定的策略是以生活混融、滲透並進而顛覆、挑戰和挪移藝術的邊界。杜象和凱吉還教會了年輕藝術家任何藝術或非藝術的活動或文件也可以是藝術：莫里斯（Robert Morris, 1931-）的《檔案櫃》（1962）真的是一個檔案櫃，裡面從 A 到 Z 排列著整個藝術創作過程的相關描述。卡布羅、歐登伯格（Claes Oldenburg, 1929-）、狄恩（Jim Dine, 1935-）等人的偶發藝術，福魯克薩斯（Fluxus）的事件（event）與活動（activity）皆在此脈絡之下，正如 Oldenburg 也認為偶發是一種行動或物件的戲劇（人物也被視為是一種物件）。[17] 此外，尚需加入 60 年代末興起的「表演藝術」（Performance Art），以及紐曼（Bruce Nauman, 1941-）與阿空奇（Vito Acconci, 1940-）的「身體藝術」（Body Art）。

90 年代在美國接受藝術養成教育的李明維，認為影響他最大的是加州藝術學院求學期間的老師馬克‧湯普森（Mark Thompson）和蘇珊‧雷西（Suzanne Lacy），二者都負責教授批判理論的課程，二人對哲學和美學的討論使李明維獲益良多。馬克‧湯普森是養蜂者，他的作品關注蜜蜂的生態，並以茲與人類生態做對照。蘇珊‧雷西則探討社會議題，關心女性、老年等弱勢的社群，也因為雷西是卡布羅的學生，她建議李明維閱讀卡布羅的書，甚至曾引介李明維去耶魯時找機會與卡布羅見面。李明維未使用傳統的繪畫或雕塑創作，並且在作品中賦予日常生活特殊的關注，應該毫無疑問地延續自此一脈絡。

觀眾參與的灰色地帶

在這種日常生活美學的脈絡之下，觀眾，也逐漸由單純的旁觀者變成真正的「參與者」。前已提及艾可非常敏銳地在 60 年代即積極的討論觀眾角色的轉變，透過談論現代音樂、不定形藝術（L'artinformel）、電視和文學，特別是喬埃斯（James Joyce, 1941-）的作品如何不斷加強「不確定」和「偶然」的比重，並且透過「資訊」（information）理論，指出當代藝術作品如何因為其「傳播」（communication）的意圖而開放，而此種「開放的藝術作品」，若無觀眾主動積極的介入，便無法成立。當然，從無藝術作品無法產生情感的交流，也從無藝術作品不需要觀眾，弗洛依德就非常清楚地提出「超納西斯主義」（transnarcissisme）的原則，指明藝術家只有在獲得觀眾理解與讚賞時才能散發魅力。但 60 年代的轉變在於藝術家比諸其他時代，所提供的是具有更多種詮釋可能，也就是具有更多消費可能性的產品。但是，艾可也強調：

開放不意味著溝通的「不確定」，形式「無止盡的」可能性，以及詮釋的全然自由。讀者擁有的只不過是一連串開展在他面前的可能性，但都已被仔細的設計和制約過，以至於他的詮釋性的反應不至於脫離作者的控制。[18]

因此，即便偶發藝術家或福魯克薩斯藝術家的創作，由於召喚了真實生活而不再處於「再現式」（representational）的狀態，連帶的使觀眾從被動的觀看者，變成主動的參與者，但他們仍扮演導演和藝術家的身份，不過是在設定好的情境和條件中，引領觀眾參與其作品的獨特形式。在此情況下，如果觀眾參與被 Boris Groys 視為是一種藝術家的自我犧牲，並且始於 1850 年代「完全藝術」被提出之際，目的在於反轉藝術家與觀眾的角色，讓作者權的出讓成為逃脫觀眾批評的方法，（因為在二者角色互換的情形之下，所有的批評都將成為自我批評）[19]，那麼，我們仍應仔細的檢視藝術家對於其作者權的犧牲與出讓究竟能到達什麼程度？而他與觀眾之間的協作、抗衡，甚至是角力又究竟能到達什麼程度？

以卡布羅為例，他自認為對於「觀眾參與」的看法與其他偶發或福魯克薩斯藝術家不同；他期待的不只是觀眾對其作品形式的參與，而是喚醒觀眾的意識，以至於後者能在真實生活中體驗到藝術。卡布羅引葛夫曼（Erving Goffman）的《日常生活中的自我表現》，強調日常例行工作中接近表演的本質，倡議將某些特定的動作（搖頭、吃飯、握手、道別）視為現成物，施以特別的注意力，並且重複使用，將「生活和藝術之間傳統的區別和分析、秩序都放在一邊」，直到自我意識滲透每一個動作，改變世界為止。試引卡布羅：

> 有意識的實際生活，對我而言是最有說服力的。當你有意識的去生活，無論如何，生命將變得十分奇特——專心會改變事情的面貌——因此偶發藝術並非像我所假設的那樣與現實生活接近。但讓我學習到與生活相關的事務，以及生命。

由此衍生了一項新的藝術／生活的浮世繪，它同時反映了日常生活中的藝術成分，和藝術創作中的生活質地。[20]

若果真是如此，卡布羅的偶發就具有一種模糊的身份，是一種不折不扣的藝術，但又必須能引發觀眾意識實際生活的能力，換言之，透過藝術改變他們的實際生活，因此，作品的結果產生在觀眾的實際生活中。但是在卡布羅最早的偶發中，除了作者之外，事實上有兩種不同的觀眾，一是表演者，另一是參觀的群眾。能夠實際產生這種體驗進而被改變的，其實只有表演者，而非仍停留在被動狀態的觀眾。或者觀眾也能因觀看表演者的表演，或與表演者互動而產生改變，但二者的途徑與歷程應該是截然不同的。所以，就此定義，卡布羅所謂的觀眾相當接近「表演者」，具有或不具有藝術背景，藉著「參與」日常生活中例行公事的「表演」，進行一種現象學式的「藝術／非藝術」的體驗。由於視美術館為「無法和生活結合的地方」，卡布羅後來的偶發逐漸偏好在非傳統的展演空間中進行，如倉庫、停車場、雜貨店等，並大量使用日常生活中的物件為道具。此舉充分的顯示他企圖消除表演者與觀眾之間的距離，使二者在生活中合而為一。為此，卡布羅界定偶發的本質是生活而非藝術，因此試圖摒除一切「藝術的內涵、觀眾、單一時間／地點的桎梏，舞台的區隔、角色、腳本、表演技巧、排練、反覆的表演，甚至一般可讀的草稿。」然而，卡布羅事實上無法真正的去除所有的規則，他所有的作品都有關於表演的明確指示，作者顯然仍需扮演主導與控制的角色。

1990 年代之後，對於觀眾參與的討論甚囂塵上，藝術家的創作形式日趨多元，藝術家與觀眾協作、分享，建立各種社會接待的機制、集體參與在各種政治的、社會的或環保的行動中，觀眾從被動地觀看與精神的參與，轉為主動的參與，並從而與產生直接的關係、身體的交換、立即的互動與真實的接觸，逐漸蔚為所謂的「參與式藝術」（Participatory Art）。策展人布西歐（Nicolas Bourriaud）於 90 年代策劃了一系列的展覽，並在 1998 年將所發表的評論彙編成所謂的《關係美學》。他在此書中開宗明義地指出當代社會制約了人與人之間的接觸，使原本自然且頻繁的接觸，囿限於特定的時間與空間的消費上，社會關係也因此成為標準化的人工製品。他引用居依‧德波（Guy Debord）的「景觀社會」概念，後者指出二戰後西方社會的人際關係不再被「直

接的體驗」，而是被其「景觀」式的再現所疏離。布西歐因此質疑當藝術史的發展傳統上植基於世界的「再現」時，藝術是否還能有助於人與世界的關係？如果德波認為藝術的世界是一個充滿範例的資料庫，只等待我們在日常生活中加以實踐，布西歐卻宣稱今日的藝術並非範例，它已經是一個直接體驗社會的場所，一個使我們的行為得以避免被制式化的空間。[21] 因此，藝術需被布西歐加以重新定義：「藝術是一種透過符號、形式、姿態或物件在世界上製造關係的活動」；而在此藝術新定義之下，藝術家也需要被重新定義為「一位符號的操作者，他模型化生產的結構，以便於提供其雙重的符旨。一位企業家／政治家／實踐者。所有藝術家最普遍的共同點是他們指出某個東西。指出這個動作即足以定義藝術家，不論是關於再現或關於指示。」此外，他認為藝術作品的功能從古至今的演變，以及其再現形式的變化，證明了藝術經驗已日漸趨城市化，當代藝術不再是藝術作品在空間上的收藏與轉手，而是一種歷時的經驗，開啟了討論的無限可能。由此，他提出一種「關係藝術」（l'artrelationnel）的可能性，是一種「以互為主體性（intersubjectivité）作為基質的藝術形式，其中心議題乃是聚集在一起（l'être-ensemble），介於觀者與畫作之間的相遇（rencontre），意義之集體製造。」[23] 這種藝術的新定義試圖將作者與觀眾置於對等的位置，在某種程度上再度挑戰了作者與觀眾的傳統角色，並且以「互為主體性」凸顯了90年代的觀眾參與60年代在基準點上的不同。不過布希歐的關係美學卻被 Claire Bishop 批評只適用於博物館和畫廊的論述和計畫，因為他所支持的藝術家「不夠關心人際關係和社會脈絡，比較關心觀看者，他們更全面性的嵌入展示、時間性、虛構、設計和『腳本』的體系裡」。[24] 反之，Claire Bishop 關心的是90年代藝術家的「社會轉向」（social turn），雖然其目的始終是企圖顛覆藝術品、藝術家和觀眾的傳統關係：

藝術家與其被認為是互不相關物件的個別生產者，不如說是情境的協作者和生產者；藝術作品作為有限的、可攜的、可商品化的產物，被重新認知為持續或長期的計劃，沒有明確的開始與結束；以前觀眾被認為是個「注

視者」或「觀看者」，現在則重新被定位成共同生產者或參與者。[25]

簡而言之，參與式藝術公開而且大規模的邀請觀眾介入其中，所提供的作品不是物件，而是部分或全部有待建構的情境；在創作的實踐中，作者不再是一位強勢主導者，而是透過溝通與協商，由觀眾將作品集體完成，其創作的機械原理強調的是開放性、過程性、傳遞性（transitivité）、互為主體性、集體性，甚至是集體修行（Cénobitisme），Paul Ardenne 甚至創造了一個新詞「他者主義」（autrisme）來對照「自閉」（autisme）這種封閉孤獨的創作方式，[26] 二者似乎截然不同，彼此對立。當然，可以想像這種對他者開放的創作方式從60年代以來不一而足：除了福魯克薩斯成員的「事件」（event）、卡布羅與普普藝術家的「偶發」之外，自稱為「提議者」（propositor）的 Lygia Clark 從1964年以來，利用類雕塑的抽象「小物」（Bichos）去強迫觀眾面對自己與他人的關係；到70年代 Gordon Martta-Clark 在蘇活區街上架設的公路人休憩的《開放小屋》（Open House），到80年代出現在紐約街頭，由「有用藝術」（useful art）藝術家 Krzysztof Wodiczko 與街友同策畫的《街友車計畫》（Homeless Vehicle Project）；或是 GRAV 的成員在巴黎街頭規劃為路人設計的機動藝術遊戲，不論其性質、形式與規模，他者主義式的藝術試圖引起個體對他人的關注、群聚與社會團結，召喚公眾，實踐是藝術民主化的理想，因此被稱為「新類型公共藝術」（New Genre Public Art），[27] 服務的對象是社會全體，特別是弱勢團體，而目的則在於透過藝術的力量鞏固社會、改變社會。從這個角度來看，參與式藝術的原則似乎仍然是凱吉主張的藝術無所不在，藝術能征服一切，藝術就是生活，而生活就是藝術。

至此，我們似乎能明白參與式藝術的根源為何必須回溯至蘇聯構成主義、包浩斯等20世紀前衛主義，或是19世紀中葉的完全藝術，或是更早至17世紀，甚至中世紀，甚至連積極持反歷史立場，意圖將關係藝術視為90年代新藝術的布西歐，都不得不承認藝術作品的可傳遞性「就像世界一樣的老」。所以，不論其形式如何推陳出新，手法如何令人眼

花撩亂，本質上是對於藝術之社會功能的信仰，並且以之對抗形式主義為藝術而藝術的自私與封閉，而90年代的參與式藝術只不過是上述信仰的借屍還魂。而且，當這些藝術家意欲捲土重來，宣稱自己已經從作者、主導者轉變成協作者或情境生產者時，仍然可能遭遇他們的先驅們所曾遭遇到的種種困境。

首先，不論被要求協作的觀眾出於自願或不自願，順服或反抗，被取悅或被激怒，作者都必須變身為19世紀聖西蒙主義所主張的「策畫者」（Organisateur）：建造現代社會的關鍵人物，公眾的夥伴及負責人，即知即行，無怨無悔的全心投入社會推動與改革，但他並非無政府主義者，而是居中協調者。這位居中協調者必須熟諳社交禮節（protocole），才不至於冒犯鄰人與群眾，最顯著的例子是參與者肖像權的問題，他是否同意自己的影像出現在你的作品中？甚至更進一步的，他是否願意成為你作品的一部分，而不至於感覺到被侵犯或被利用？而且更弔詭的是，雖然藝術家把作者權分給了他，大部分的時候他卻仍停留在匿名的狀態。至於奔走協商、規畫管理的能力，由於不在傳統藝術家養成的範圍之內，就算他很幸運地擁有，也必須意識到可能為此犧牲了在私人工作室中安靜創作的權力，在走上街頭之外，還需要像個經理人一樣迷失在大大小小的瑣事當中，甚至在人道或政治的激烈抗爭中慘烈的觸法。當然，參與式藝術可以在博物館的保護下進行，也可以在網路虛擬世界中進行，何況從90年代至今，的確在世界各地都有許多參與式藝術在官方機制的策畫或邀請下進行。不過，可以想像這種馴化了的參與式藝術顯然會因為違背了參與式藝術的本質而招致批評，試想由政府主導的政治宣傳式的社區營造，或只有在博物館開放的時間才能參與的藝術，或只有在虛擬的世界中才能參與的藝術，如何製造相聚、群聚、合作與團結？因此何參與之有？又如何與生活結合？只能說是「偽」（pseudo）參與式藝術吧？而且，已經在60年代已經走出博物館四面牆的藝術家，又怎能在90年代回歸其中呢？而這也正是布西歐的策展最為人詬病與批評之處。參與式藝術的五花八門，以及其與現實生活關係的模糊不清，正說明了它作為藝術實踐本身可能存在的灰色地帶。

此外，由於關係式藝術自詡為改革社會的動力，並且對立於為藝術而藝術的態度，便因此犧牲了藝術的自主性（autonomie），甚至不得不認為美感（esthétique）對於關係式藝術有害。關於藝術自主性的爭論，是現代主義懸而未決的老問題：藝術究竟是只關乎自己，還是必須與社會有所聯繫？藝術究竟應該致力於追求美感效果（藝術作品固有的感官知覺模式），還是展現它滲入現實，顛覆現實的能力？不過，藝術真的有顛覆現實的能力嗎？如果有，我們也必須釐清這種能力從何而來。Jacques Rancière認為藝術的「政治」能力恰好是來自於美感，因為正如康德所言，審美判斷會中斷理性和知性的統御，這正是政治之所在，因為感性經驗可以質疑既有世界的秩序，並從而探究改變和重新分配此世界的可能性。這種看法似乎某種程度上調和了二者的衝突，避免了藝術過度貼近生活而犧牲了藝術。[28] 而對於觀眾的角色，洪席耶更認為不應該落入從柏拉圖到景觀社會的前設，認為「觀看的人不懂得如何觀看」，因此要求觀眾擺盪在兩極之間：介於布萊希特（Bertolt Brecht, 1898-）的敘事戲劇與阿爾托（Antonin Artaud, 1896-）的殘酷劇場之間：「前者要求觀眾保持距離，後者要求觀眾消弭一切的距離。前者要求觀眾訓練並且精進自己觀看的能力，後者要求觀眾乾脆放棄觀看者的位置。」[29] Rancière反對這樣的前設，認為我們不應一廂情願的認為觀眾不知如何觀看，身為觀眾，即意味著行動的受限與階級的劃分，因此他勢必有能力對顛覆他自己的社會地位做出貢獻，因此，解放觀眾意味著肯定他觀看的能力，以及觀看之後的回應能力。[30] 這樣的看法也許正可以用來針砭參與式藝術的過度，特別是當「美感的灰色地帶被排除了」，重回感性以及適度的解放觀眾，最起碼能免除參與式藝術於討厭的倫理態度與道德勸說。[31]

李明維式關係

在90年代如此紛擾的脈絡與氛圍下創作的李明維，如果真的選擇了參與式藝術並且持續至今，也就意味著他選擇正面迎戰上述難題，並且透過他的創作提出解決之道。回歸李明維的作品，他雖然師承自卡布羅與雷西，但卻明確的表示並

未加入卡布羅的陣營：

> 當我看到卡布羅做那樣的東西的時候，我其實很明確的
> 知道那不是我要的，對我來説缺了什麼，缺少的這一部
> 分，後來我才知道是我會有很粗糙的一個遊戲規則，那
> 這個遊戲規則，第一，你要不要參與對我來説都可以。[32]

由此可見與其他參與式藝術家極其不同之處，李明維並未要求觀眾化被動為主動，對他而言，觀眾可以自行決定參與的方式與尺度，從被動的觀看，到主動積極的介入，以及介入的幅度，完全由觀眾自行選擇、拿捏。此外，李明維對於作品的形式格外考究，他的展場，即便去除掉觀眾，仍然可以躋身於高質素的繪畫、裝置或雕塑作品之列。更甚者，他坦承非常「害羞」，能不出現就不出現在自己的作品中，他也幾乎不上街頭，不碰觸尖鋭的時事議題，不改造任何的社區，甚至不願意在美術館之外的地方進行創作，因為他把美術館當成「保護者」。這種安靜、隱沒、低調的創作方式，是否意味著李明維根本不是參與式藝術家？而觀眾的參與對李明維而言根本可有可無呢？卻又不是。李明維清楚的強調他創作中觀眾的重要性，觀眾的參與不但為作品帶來張力，觀眾甚至是作品的「內容」，而作品的物理形式只不過是容器：「（觀眾）的生活和生命去灌注作品的內容，如果沒有這些觀眾的話，就只會是美美的花器」。[33] 換句話説，李明維將觀眾納入作品之中成為活生生的材料，而由於這種「材料」的多變與無法掌握，標示了作品的非物質性、不確定性，簡而言之，如前所述之開放性。

正如他的作品《移動的花園》，色彩繽紛的鮮花蜿蜒在黑色花崗石檯的峽狀切口中，散發著高度的視覺吸引力，但卻只是「美美的花器」。觀眾被建議免費拿取一朵，然後離開美術館之後將花朵贈與一位陌生人。當然觀眾可以完全不理會藝術家的提議，選擇僅做一位旁觀者，或選擇拿取花朵卻

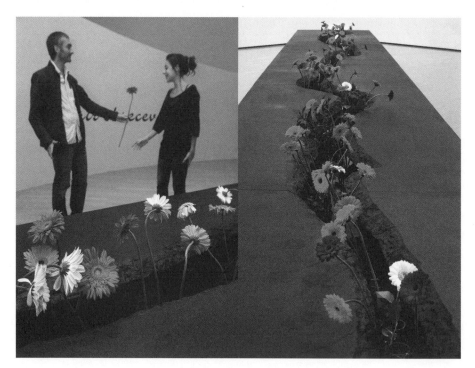

《移動的花園》於法國里昂雙年展
「每一天的視點」展出，2009

不送人；因為藝術家並未追蹤或統計花朵的去向。對李明維而言，科學性的統計與分析，對於事物的清楚定位均為他所厭惡，作品應產生於個人的感性經驗與或然率之中。至於參與式藝術強調的社會面向，或者說藝術的社會顛覆功能，是否不適用於李明維的作品？李明維的創作是否缺乏政治性？也許我們不應忘記這件作品是為了回應 Lewis Hyde 的著作《禮物，現代世界中的創造力與藝術家》。[34] 在今日完全被金錢統御的文化以及氾濫成災的商品中，作者極力維護並宣揚創造力的價值及重要性，因為藝術家由上帝免費賦予的「天賦」（gift）是世人能得到的，唯一能掙脫貨幣與價格交換的「禮物」（gift）。的確，Marcel Mauss 在 1924 年即識破在人類經濟社會中，「贈與和共享」與「佔有和掠奪」在本質上並無差異，禮物的贈與標示著贈與人與受贈人雙方的社會地位，而回禮的習俗說明了所謂的贈與，其實只是一種等價交換。[35] 積極參與李明維這件作品的觀眾究竟能得到什麼？根據一位參與者親口告訴筆者，她走了許多條街仍然無法找到願意接受花朵的人，可見這個社會已經教會了我們「天下無白吃的午餐」，在無等價交換的條件下，受贈者無可避免的因為懷疑贈與者的動機而拒絕接受禮物。但作為被解放的觀眾，不管他選擇了哪一種參與方式，都可以得到藝術家的創造力作為禮物。

而身為藝術家，李明維從 Hyde 學到的卻是藝術創作的奧秘：藝術家從一個更高的存在得到禮物，但他也必須將禮物回饋給社會，否則就無法再得到禮物，禮物的流通正是藝術家創作能量的來源，藝術家也因此必須擺盪在空與滿、倒出與盛載的週期中。這種創作的神秘法則，說是禪的美學也好，說是中國繪畫的虛實留白也好，雖然李明維從不強調他的東方背景，也從未皈依任何的宗教，但我們幾乎可以斷言，李明維作品的政治性的位點（locus），可能正是座落在不確定性與非物質性所構成的，感性的灰色地帶。

1. 節錄自筆者與李明維於 2015 年 6 月 8 日在台北市立美術館所進行的訪談，紀錄整理者：謝杯萱小姐。
2. Wölfflin, Heinrich, *Principes fondamentaux de l'histoire de l'art : Le problème de l'évolution du style dans l'art moderne*, Paris: Gérard Monfort, 1992.
3. Deleuze, Gilles, *Le pli, Leibniz et le Baroque*, Paris: Minuit, 1988.
4. Benjamin, Walter, *Origine du drame baroque allemande*, Paris: Champs-Flammarion, 2000, p. 191.
5. Diderot, Denis, *Ruines et paysages, Salon III* (1767), Paris: Hermann, 1995, p. 348.
6. Bergson, Henri, *Matière et Mémoire*, Paris: Flamarrion, 2012.
7. Eco, Umberto, *L'oeuvre ouverte*, Paris: Edition du Seuil, 1979, p.10.
8. Todorov, Tzvetan, *Eloge du quotidien, Essai sur la peinture holandaise du XVIIe siècle*, Paris: Edition du Seuil, 1997, p. 146.
9. Sandler, Irving, *Le triomphe de l'art américain, l'école de New York*, Paris: Carée, 1991, p. 140.
10. 同上註，p.141。
11. Cage, John, *Silence: Lectures and Writings*, Cambridge, Massachusetts: M.I.T. Press,1967, p. 12.
12. Sandler, Irving, *op. cit.*, p. 146.
13. Dewey, John, *Art as Experience*, New York: Perigee, 2005, p. 1.
14. 同上註，p. 2。
15. 同上註，p. 214。
16. Allan Kaprow 著，Jeff Kelley 編，徐梓寧譯，《藝術與生活的模糊分際，卡布羅論文集》，台北，遠流，1996，頁 40。
17. Oldenburg, Claes, *Store days*, New York: Something Else Press, 1967, p.80.
18. Eco, Umberto, *op. cit.*, p.19.
19. Groys, Boris, "A Genealogy of Participatory Art," ed. Rudolf Frieling, *The Art of Paricipation-1950 to Now*, San Francisco: SFMOMA, 2007.
20. Allan Kaprow 著，Jeff Kelley 編，徐梓寧譯，同註 16，頁 274。
21. Bourriaud, Nicolas, *Esthetique relationnelle*, Paris: Les presses du réel, 2001, pp. 15-16.
22. 同上註，p. 111。
23. 同上註，p. 15。
24. Bishop, Claire, "Relational Aesthetics", in *OCTOBER*, 110, Fall 2004, pp. 51-79.
25. Bishop, Claire, *Artificial Hells: Participatory art and the Politics of Spectatorship*, London, New York: VERSO, 2012, p. 2.
26. Adenne, Paul, *Un art Contextuel*, Paris: Champs Flammarion, 2004, p.182.
27. 此詞源出於李明維的老師 Suzanne Lacy 於 1995 年編纂的合輯 *Mapping the Terrain : New Genre Public Art*, Seattle, WA: Bay Press, 1995. 此合輯收錄多位藝術家的創作及 11 篇論述，聚焦於社區回應或觀眾主導式的藝術實踐，及其不同之社會政治及藝術史脈絡。
28. Rancière, Jacques, *Le partage du sensible*, Paris: La fabrique éditions, 2000.
29. Rancière, Jacques, *Le spectateur émancipé*, Paris: La fabrique éditions, 2008, p.11.
30. 同上註。
31. Bishop, Claire, *Artificial Hells: Participatory art and the Politics of Spectatorship, op. cit.*, pp. 37-41.
32. 李明維曾在與筆者的訪談中表示：「」以上節錄自 2015 年 6 月 8 日在台北市立美術館進行的訪談，紀錄整理者：謝杯萱小姐。
33. 同上註。
34. Hyde, Lewis, *The Gift, Creativity and th Artist in the Modern World*, New York: Vintage, 2007.
35. Mauss, Marcel, *Essai sur le don*, Paris: Presses universitaires de france, 2012.

The Gray Area of Viewer Participation— On "Lee Mingwei and His Relations"

Kuang-yi Chen

Associate Professor, National Taiwan University of Arts Fine Arts Department and Graduate Program in Fine Arts

The Taiwanese-born American artist Lee Mingwei first stepped onto the public stage in 1998 with his solo exhibition "Way Stations." Unveiled at the Whitney Museum of American Art and featuring such works as *The Letter Writing Project* and *The Dining Project*, the exhibition met with acclaim, and soon thereafter major art museums in Europe, North America and Asia had opened their doors to Lee's art. Gradually, he became associated with "viewer participation," as well as another rising movement of the 1990s, "relational art." The exhibition "Lee Mingwei and His Relations" of 2014-15, curated by Mami Kataoka of the Mori Art Museum in Japan, clearly placed Lee within the context of relational art and participatory art. This exhibition toured to Taipei Fine Arts Museum in 2015, shortly after the Taipei Biennial, which had been curated by the well-known champion of relational art, Nicolas Bourriaud. In a short period of time, the Taipei art world experienced an upswell of attention and discussion on the subject. But what are "participatory art" and "relational art," these concepts that originally stirred so much conversation, even controversy, in the West? And exactly how is Lee's art related to them? Are these labels ultimately a help, or a hindrance, in understanding his work? Can Lee Mingwei's art and its evolution respond to some extent to the clamorous controversies and debates that have raged from the 1990s to the present day?

Gray Area?

If we wish to answer these questions, we must first ask how, and by virtue of what experiences, Lee followed the path of art. The answer begins in 1964. Born into a doctor's family in Puli, Taiwan, he moved with his family to San Francisco at the age of 14. After finishing his secondary education, he studied biology for four years at the University of Washington in Seattle, in preparation for pursuing the family profession, as per parental expectations. However, he ultimately chose to transfer to the California College of Arts and Crafts, where he earned a BFA in textiles. Finally, he earned an MFA in sculpture from Yale University in 1995, and began to work in the field of art. When asked why he had abandoned science for art, Lee answered that the rationality and precision required to do science made him feel tremendous pressure, but the world of art was a

completely different universe:

> I like to have a worldview without taboos. I really like to
> have a gray area. I don't like absolute right and absolute
> wrong. I think art is more able to give me this kind of an
> attitude toward life... Looking back on my works, they all
> have something very uncertain in them, and this zone
> between certitude and incertitude is actually the seat of
> tension. This is very important to me. [1]

These comments reveal that Lee fundamentally views art as
a "gray area." He was attracted to a realm arising from the
variance between specificity and ambiguity that he sees as
intrinsic to art, and that separates it from other intellectual
pursuits.

But what exactly is this "gray area"? In the past, art has often
been delineated in black and white. We must attempt to clearly
understand where this idea of ambiguity falls in the terrain of
the art world. Does it harken back to Heinrich Wölfflin (1864-
1945), who, when considering the relationship of classical
and Baroque art, defined the latter as pursuing a "painterly"
or impressionistic style, whose pursuit of overall effect and
opposition to structural fluidity resulted in a lack of clarity in
form? The ambiguity of the Baroque was, in Wölfflin's view, the
diametrical opposite of the clarity of classicism, appealing to the
senses, rather than reason. [2] Or could this "gray area" reflect
the concepts of Gilles Deleuze (1925-1995), who defined the
Baroque as the art of the "fold" (pli)? Folds and refolds (repli)
served to dissipate representation, fracturing form, conflating
the obverse and reverse sides of things, and generating a sense
of equivocality. [3] Or is it similar to the infatuation with the
"vanished" and the "unfinished" that reigned supreme among
Romantic painters? John Constable (1776-1873), William Turner
(1775-1851) and Caspar David Friedrich (1774-1840) were
all inescapably obsessed with ruins. For them, ruins possessed
an enormous and mysterious attraction, and seemed to fulfill
a certain need for grayness transcending the absoluteness of
clarity. As Walter Benjamin (1892-1940) observed: "Allegory is
in the realm of thought what ruins are in the realm of things." [4]
Certainly, what attracts people to ruins, the still-extant part
of things that have been destroyed, is their non-existence.

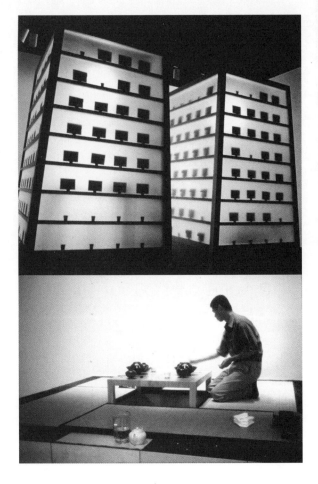

The Letter Writing Project and *The Dining Project*, as installed at "Way Stations,"
Whitney Museum of American Art, New York, 1998

They give us food for thought about the vanished past, and
fuel our imaginations about the future that could be rebuilt.
They arouse not the material presence grasped visually by the
beholder, but the inner thoughts of the nostalgic ponderer.
Insubstantiality is their most prominent feature. What makes
ruins fascinating is their incertitude: Denis Diderot (1713-1784)
wrote of the Salon of 1767: "One must destroy a monument
to make it interesting." [5] Ruins are not completely annihilated;
some fragments are usually left. Within this incertitude of

disassembled pieces lies the possibility of mending and reconstruction – its greatest gray area.

By the same token, Lee Mingwei's art is full of homage and wistfulness for times past: *100 Days with Lily* commemorates his grandmother's passing, employing a lily's germination, withering and dying as a metaphor for the transitory nature of life. In *The Letter Writing Project*, he communicates the things he never had the chance to say to his departed grandmother. *Guernica in Sand* alludes to the rise and fall, and even disappearance, that takes place throughout history. *Between Going and Staying* is a lament for irrecoverably lost time. *Fabric of Memory* expresses sentiment for the memories of personal objects. All these works pay homage to their subjects by referencing their insubstantiality.

Yet Lee does not stop at grief and reminiscence. In his works he also constantly discusses the possibility of mending and rebirth. After a lily blooms, it appears to wither and fall, but in fact the bulb is merely dormant. If preserved well until the next year, it will be reborn. *Nu Wa Project* considers the mythical goddess Nuwa who patched up the sky. The central point of *The Mending Project* is not the garments that need repair, but the insubstantial concept of damage, connection and mending, as well as the thoughts spurred by the act of mending. We wish to know, in today's disposable consumer culture, what kind of clothing is worth patching up? But objects do more than satisfy material desire. Objecthood and humanity are reciprocal concepts. As Henri Bergson (1859-1941) contended in *Matter and Memory*, materiality is not purely physical existence, but a temporal accumulation of the senses.[6] When a visitor appears with a garment to be mended, they bring fragments, inciting experiences and memories of the lost past. By dealing with damage and seriously contemplating its repair, by joining together with a stranger in considering how to mend a garment, one can employ damage, connection and mending as vital metaphors for human relationships. Of course, this form of creative act harbors enormous potential for variation, involving different people with damaged garments, different garments, and different menders.

Such insubstantiality and indeterminacy may go far in explaining Lee's "gray area." In 1965 Umberto Eco proposed that contemporary art was typified by "open work" (*opera aperta*). Because contemporary artists viewed ambiguity as a value, they had initiated a dialectic between form and openness, through "the informal," nonsequentialism, coincidence and indeterminacy. Nevertheless, Eco clearly asserted, this dialectic was able to determine the level of ambiguity in a work and its dependence on the involvement of the viewer, without robbing the work of its essence. Eco defined a work as an object possessing structure, which could instigate and allocate the possibility of a multiplicity of interpretations and evolving perspectives.[7]

Art and Everyday Life

Another major characteristic of Lee Mingwei's work is its grounding in everyday life: the regular cycle of life composed of eating, sleeping, writing, reading, tidying up, sewing, running errands, resting, chatting, interacting – basic human physical and psychological needs that change little and need little change, day after day, year after year. Indeed, art has a tradition of concern for and depiction of daily life, but because the classical humanities defined the artistic function of "mimesis" as the "imitation of the noblest form of human action," they prized historical subject matter far more than other themes, forming a "hierarchy of genres." Not until the 17th century did the painters of the Dutch School begin to place renewed attention on daily life, in their "genre paintings." The dichotomy between historical paintings and genre paintings was actually the dichotomy between the transcendent and the mundane. The former pursued the sublime and the heroic in order to escape the severity and monotony of quotidian existence, while the latter attempted to discover beauty and meaning within the humblest of activities. The Dutch painters, according to Tzvetan Todorov, were moved by the nobility of daily life. By appreciating the simplicity of existence, they consciously allowed ideals and truth to interpret themselves, finding the meaning of life in the midst of life itself: "One should not forsake everyday life out of contempt or for the sake of other things, but should change it from the inside, making it radiate

new light through its meaning and beauty."[8] The Impressionists inherited the theme of daily life from the Dutch School, but lost this expression of light, and the subject gradually became a pretext for formalism, ultimately tending toward abstraction.

By the 1960s the debate between abstract and concrete had firmly taken root in the American art world, and had grown into two opposing camps. On the one side were the formalists and their successors, the minimalists. On the other side were the artists of Neo-Dada, pop art, and new realism who were attempting to break through the siege lines of formalism and blaze a new trail. They followed in the footsteps of Marcel Duchamp (1887-1968) or took inspiration from John Cage (1912-1992). The works and thought of Duchamp were quite popular in the 1960s. His so-called "readymades" were commonplace mass-produced goods, which became artworks through the process of "selection." This was a robust challenge to the definition and boundaries of art. That an unexceptional everyday product could be elevated to the status of artwork signified skepticism as to the meaning of art, but it also signaled that daily life could not be ignored, and that art did not exist apart from everyday life.

Cage attempted to seek out the source of art within the physical environment of daily life. He was uninterested in the inner life and emotions of the artist, but instead turned to the outside world and the powers of observation of the human senses. He felt the purpose of art was to change the way we see and to open our eyes, so that we could see the things that were there to see.[9] To simulate the real external environment, Cage ruled out all categorization according to sound, material, form or color in the formative arts: every medium, independent or connected by any means, meaningful or meaningless, was art. Cage declared that both noise and silence were music. In a similar vein, Merce Cunningham (1919-2009) declared that all movement, including walking, running and falling over, was dance. Its objective was to awaken our "kinesthetic sympathy." If art has any purpose, Cage insisted, it is not to reference itself, but to reference those who use it. And people use it not within their relationship to art, but within their relationship to daily life... Art should nurture joy and fun, not pain.[10] Art must be:

...a purposeful purposelessness or a purposeless play. This play, however, is an affirmation of life – not an attempt to bring order out of chaos nor to suggest improvements in creation, but simply a way of waking up the very life we're living, which is so excellent once one gets one's mind and one's desires out of its way and lets it act of its own accord.[11]

Making mention of Duchamp, Cage seemed aware of the spirit of Dada and intent upon moving it forward in a positive direction. For him, readymades were not a symbol of anti-art, but a tool to blur the lines between art and life.[12]

With the rise of a new generation of artists, the line separating art and life blurred even more. Art and life entered into a subtle dialectical relationship. Such Dada artists as Robert Rauschenberg (1925-2008) and Jasper Johns (1930-) directly appropriated articles of daily life, forming artworks via "assemblage" and emphasizing "objecthood." Cage's greatest influence on such artists as Rauschenberg, Johns, and Allan Kaprow was to make them more attentive to daily life, and more accepting of it as it is. They rediscovered the images, manmade goods and routine events of daily life. These unacceptable things became their objects of contemplation, even veneration – the sacred images of the everyday. Art became life, and life became art.

Another key player in this process was the philosopher John Dewey. He started off his 1934 treatise *Art as Experience* with a bold opening salvo: "The existence of the works of art upon which formation of an esthetic theory depends has become an obstruction to theory about them."[13] This is because "the work of art is often identified with the building, book, painting, or statue in its existence apart from human experience." Once placed within the sanctum of art and declared classics, artworks become isolated from association with human experience. Thus, Dewey contended, a primary task of the art philosopher should be "to restore continuity between the refined and intensified forms of experience that are the works of art and the everyday events, doings, and sufferings that are universally recognized to constitute experience." To restore the relationship between exalted art and real life, to erase the

line between art and non-art, Dewey stressed the connection between artistic experience and the experiences of daily life: "In order to understand the meaning of artistic products, we have to forget them for a time, to turn aside from them and have recourse to the ordinary forces and conditions of experience that we do not usually regard as esthetic."[14] Consequently, we do not have so-called artistic experiences solely when coming into contact with works of art. The aesthetic experience is in fact ever-present in daily life. Anything that grabs our attention or attracts our interest may induce the sensation of beauty.

On this theoretical foundation, Dewey built his aesthetic of everyday life, declaring that art should draw nourishment from all sources, and everyone should be the recipients of artistic products.[15] Dewey's ideas were not without impact upon the avant-garde artists of the United States. Allan Kaprow, the father of art "Happenings," openly trumpeted "artlike life" and "lifelike art," framing the art/life dichotomy within an even more intensely paradoxical dialectic. Kaprow studied under John Cage at the New School for Social Research from 1956 to 1958, and this class had a decisive influence on his development of the Happening. Defined as a "sudden pure event" arising in a random manner, a Happening was in fact a brief moment of complete art. Kaprow used them to combat the professionalism and permanence of painting. On the one hand, Cage introduced him to the concept of coincidental, spontaneous creation, while on the other hand, Dewey's *Art as Experience* inspired him to freely pursue the entwining of everyday activities, experience and art. He ultimately abandoned painting and turned to objects/assemblage, environmental art and finally Happenings. Both artist and theorist, Kaprow attempted to build a theoretical foundation for Happenings, and this theory was basically built on the relationship between art and life. In his 1958 essay "Notes on the Creation of a Total Art," he offered a concise history of "total art." But he seemed to believe that no attempt at total art had yet to completely succeed: In the middle ages the various fields of art co-existed in a kind of theological harmony, perhaps melded, but not unified. Wagner and his symbolism only imitated the example of the early church, and Bauhaus extended his methods while merely attempting the modernization of form and subject matter. Kaprow's dream of achieving total art remains unfulfilled to this day, yet he did make strides at developing a new perspective and a new method:

> Art forms developed over a long period and articulated to a high degree are not amenable to mixture: they are self-sufficient so far as their cohesiveness and range of expression are concerned. But if we bypass "art" and take nature itself as a model or point of departure, we may be able to devise a different kind of art by first putting together a molecule out of the sensory stuff of ordinary life: the green of a leaf, the sound of a bird, the rough pebbles under one's feet, the fluttering past of a butterfly.[16]

The "new total art" that Kaprow advocated was quite special. Very familiar with art history and indeed having done research on Mondrian, he certainly was aware of art's long process of balkanization into countless movements that began in the early 20th century, and the difficulty of achieving any new integration. If the archetype of total art lay in ancient times when life and art were one, why not completely break away from the question of "art" and directly embark from life experiences, which everyone possesses? Thus, Kaprow's Happenings were born. In 1959 he held *18 Happenings in 6 Parts* at the Reuben Gallery in New York. In a gallery partitioned into three sections, he arranged for several artists to paint a picture, play an instrument, recite a poem or engage in a number of ordinary activities commonly encountered in day-to-day life, like stacking wood, dribbling a ball, playing a record, or squeezing an orange.

Under the influence of Duchamp, Cage and Dewey, the avant-garde artists of the 1960s devised a strategy in which life would intermingle with and permeate art, and ultimately subvert, challenge and move art's boundaries. Duchamp and Cage even taught young artists that any activity or document, artistic or not, could be art: *Card File* (1962) by Robert Morris (1931-) really was just a card file, holding cards, indexed alphabetically, that documented the process of creating the work. The Happenings of Claes Oldenburg (1929-), Jim Dine (1935-) and others, and the "events" and "activities" of Fluxus, all fall within this movement. In Oldenburg's view, a Happening is a drama of actions and objects (he saw people as a kind of object).[17] To these we may add the performance art of Bruce Nauman (1941-) and the body art of Vito Acconci (1940-).

Lee Mingwei, who received his artistic education in America of the 1990s, has cited as his greatest influences his teachers at the California College of the Arts, Mark Thompson and Suzanne Lacy. Both taught courses in critical theory, and Lee learned much from their discussions of philosophy and aesthetics. Mark Thompson is a beekeeper, and his work focuses on the ecology of bees, and by extension human ecology. Suzanne Lacy explores social issues such as feminism, aging and disadvantaged groups, and because Lacy was a student of Kaprow, she recommended that Lee read Kaprow's books, and she even arranged for Lee to meet Kaprow on a visit to Yale. Lee's eschewing of conventional painting and sculpture and his artistic focus on daily life unquestionably arise from this lineage.

Viewer Participation and the Gray Area

Within this context of everyday aesthetics, viewers gradually evolved from bystanders to participants. We have already noted Umberto Eco's trenchant discussion of the changing roles of viewer in the 1960s. Addressing the frequent accentuation of ambiguity and chance in modern music, *L'art informel*, television and literature, particularly that of James Joyce (1882-1941), and making reference to information theory, Edo contended that the openness of contemporary art is intended as a means of communication, and an open work of art cannot be complete without the active involvement of an observer. Of course, all artwork must create a flow of feeling, and all artwork requires a beholder. Sigmund Freud clearly noted the principle of transnarcissism, indicating that artists can only radiate magnetism if they gain the understanding and appreciation of the viewer. But in the 1960s, more than in other eras, art provided greater possibility for interpretation – that is, products with greater possibility for consumption. However, Eco stressed:

> "[O]penness" is far removed from meaning "indefiniteness" of communication, "infinite" possibilities of form, and complete freedom of reception. What in fact is made available is a range of rigidly preestablished and ordained interpretative solutions, and these never allow the reader to move outside the strict control of the author.

Thus, even though the artists of the Happenings and Fluxus appealed to real life, renounced allegiance to a "representational" state, and led viewers in a transition from passive spectators to active participants, they still played a directorial role as artists. They initiated a unique form of audience participation under predesignated circumstances and conditions. In such a situation, participatory art became an enactment of self-abdication, as Boris Groys argues. Ever since the 1950s, with the rise of the quest for "total art," the motive lay in switching the roles of the artist and the viewer. Transferring authorial power from artist to audience became a means of escaping the criticism of the viewer (because when the two parties exchanged roles, all criticism became self-criticism).[19] If such be the case, should we carefully inspect precisely how much the artist has abdicated and transferred their authorial power? And to what extent are the artist and the viewer cooperating, contending, or even wrestling for power?

Kaprow, for example, considered his own view of "audience participation" to differ from those of other artists of the Happening or Fluxus movements, in that he hoped not only to get viewers to participate in the form of the artworks, but also to awaken the viewer's consciousness, so that they could experience art in real life. Citing Erving Goffman's *The Presentation of Self in Everyday Life*, Kaprow insisted that routine work is intrinsically similar to performance, and he viewed certain specific motions (shaking one's head, eating, shaking hands, waving farewell) as readymades, giving them special attention and employing them repeatedly. He rejected the traditional divisions between life and art, and the traditional modes of analysis and ordering, until self-consciousness permeated every action, and ultimately altered the world. Kaprow wrote:

> Doing life, consciously, was a compelling notion to me. When you do life consciously, however, life becomes pretty strange – paying attention changes the thing attended to – so the Happenings were not nearly as lifelike as I had supposed they might be. But I learned something about life and "life."

A new art/life genre therefore came about, reflecting equally the artificial aspects of everyday life and the lifelike qualities of created art. [20]

If such was truly the case, Kaprow's Happenings possessed an ambiguous status. They were full-fledged art, but art that needed to stimulate the viewer's awareness of real life. In other words, he was attempting to change their real lives through art. Therefore, the effects of the artwork occurred in the real lives of the viewers. But in Kaprow's earliest Happenings, there were two kinds of viewers (in addition to the artist himself): a group that performed and a group that observed. Only the performers were able to genuinely have this experience and be changed, to escape the state of the passive spectator. Perhaps the observers could be changed by viewing the performances of the performers or interacting with the performers, but the paths and experiences of the two groups still must have been entirely different. Thus, by this definition, Kaprow's so-called audience was quite similar to performers, with or without a background in art. By "participating" in the "performance" of everyday life routines, they engaged in a phenomenological "art/non-art" experience. Viewing art galleries as places unsuited for integration with real life, Kaprow gradually moved his Happenings to unconventional performance spaces, such as a warehouse, a parking lot or a grocery store, and making extensive use of everyday articles as props. This fully demonstrated an attempt to eradicate the gap separating performers and spectators, making the two roles one and the same in life. Kaprow defined the essence of a Happening as life, not art, and to this end attempted to eliminate "art contexts, audiences, single time/place envelopes, staging areas, roles, plots, acting skills, rehearsals, repeated performances, and even the usual readable scripts." Yet he was, in reality, unable to dispense with all rules. All his works provided specific instructions to the performers. The artist still had to play the role of conductor.

Since the 1990s a great brouhaha has arisen over audience participation. Artists are creating in an increasingly diverse variety of forms, and cooperation and sharing between artists and viewers has resulted in an array of community outreach mechanisms, collective participation programs, and political, social or environmental movements. Audience members have been transformed from passive beholders to active participants, engendering direct relationships, physical exchanges, immediate interaction and real contact. This form of creativity has gradually come to be known as "participatory art." The curator Nicolas Bourriaud organized a series of exhibitions throughout the 1990s, compiling his statements into the 1998 treatise *Relational Aesthetics*. In it he explicitly states that contemporary society restricts interpersonal contact, so that human interaction, originally natural and frequent, has become reduced to consumption, circumscribed in time and space, and social relations have become standardized, artificial products. He cites the concept of Guy Debord in "Society of the Spectacle" that human relations in post-World War II Western society are no longer "directly experienced" but have been alienated by "spectacular" forms of representation. Given that the development of contemporary art history has been traditionally grounded in the "representation" of the world, Bourriaud questions whether art can help facilitate humankind's relationship with the world. If Debord considered the art world to be no more than a "reservoir of examples" awaiting tangible achievement in daily life, Bourriaud asserts that "artistic praxis appears these days to be a rich loam for social experiments, like a space partly protected from the uniformity of behavioural patterns." [21] Thus, Bourriaud redefines art:

Today's artist appears as an operator of signs, modeling production structures so as to provide significant doubles. An entrepreneur/politician/director. The most common denominator shared by all artists is that they *show* something. The act of showing suffices to define the artist, be it a representation or a designation. [22]

The evolution of artworks from ancient times to the present, both in function and form, demonstrates "a growing urbanisation of the artistic experiment," Bourriaud contends. A contemporary artwork is not "a space to be walked through," but rather "a period of time to be lived through," ushering in unlimited potential for discussion. Hence, the "relational art" he espouses: "an art form where substrate is formed by inter-subjectivity, and which takes being-together as a central theme, the 'encounter' between beholder and picture, and the collective elaboration of meaning." [23]

Such a definition of art attempts to place the artist and the beholder in positions of parity, and to an extent presents a renewed challenge to the traditional roles of artist and audience. This intersubjectivity underscores the different focal points separating audience participation of the 1990s from that of the 1960s. Yet Claire Bishop criticizes Bourriaud's relational aesthetics as being confined to the discourse and organization of the museum or gallery, because the artists he supports are not concerned enough about interpersonal relations and social context, but are more concerned with the viewer and remain thoroughly embedded within the system of exhibition, temporality, fabrication, design and "scenario."[24] Bishop, by contrast, emphasizes the "social turn" that artists have taken since the 1990s, centered on the objective of overturning the traditional relationship among the art object, the artist and the beholder:

> [T]he artist is conceived less as an individual producer of discrete objects than as a collaborator and producer of *situations*; the work of art as a finite, portable, commodifiable product is reconceived as an ongoing or long-term project with an unclear beginning and end; while the audience, previously conceived as a 'viewer' or 'beholder', is now repositioned as a co-producer or *participant*.[25]

Simply put, participatory art is an open and sweeping invitation to the public to become part of the art. The work is not an object; rather, the work, in part or in full, awaits completion. In their creative practice, the artist is no longer a dominant leader. Instead, through communication and negotiation, the artwork is completed with the help of the viewer. Its mechanistic principle is one of openness, process, transitivity, intersubjectivity, collectivism, or even communal monasticism (*cénobitisme*). Paul Ardenne invented the term *autrisme* ("otherism") as a foil to *autisme* (autism), the tendency to create art in isolation, representing the two as diametrically opposite approaches.[26] Of course, we can also imagine this form of creativity open to the other as an uninterrupted lineage from the 1960s: starting with not only the "events" of Fluxus and the Happenings of Kaprow and the pop artists, but also the Brazilian artist Lygia Clark, a self-described "propositor" who in 1964 began producing *Bichos*, sculpture-like objects that forced the viewer

to address their relationships with others. The lineage continued through the 1970s when Gordon Martta-Clark created *Open House*, an installation on the streets of Soho open to the public as a resting place, and into the 1980s when Krzysztof Wodiczko employed his concept of "useful art" to organize the *Homeless Vehicle Project* in collaboration with homeless people. The members of GRAV organized a kinetic art game for passersby on the streets of Paris. In its nature, form and scale, "autristic" art attempts to incite individuals to notice others, and to encourage group or social cohesion, calling on the public to practice the ideal of artistic democracy. For this reason, it has been referred to as "New Genre Public Art."[27] Its objective is to serve society as a whole, particularly disadvantaged groups. The principle of participatory art still seems to be the omnipresence of art that John Cage originally championed: Art can conquer all. Art is life, and life is art.

This seems to lead us to an understanding that the roots of participatory art must be traced back to Soviet constructivism, Bauhaus and other avant-garde movements of the 20th century, to the mid-19th century quest for total art, or even earlier, to the 17th century or the middle ages. Even Nicolas Bourriaud, whose extremely anti-historicist stance attempts to present relational art as a new art form of the 1990s, must admit that the transitivity of art is as old as the world itself. However novel its forms or eye-popping its techniques, it is in essence a faith in the social function of art, and a resistance to the selfishness and isolation of formalism and art-for-art's-sake. The participatory art of the 1990s is merely the resurrection of this faith. And when these artists seek to renew the struggle, declaring themselves no longer authors and leaders but collaborators and initiators of scenarios, they are still likely to encounter the same difficulties faced by their forebears.

First, regardless of whether the audience that is called upon to collaborate does so voluntarily or involuntarily, whether they obey or resist, whether they are pleased or irritated, all artists must become what the 19th-century Saint-Simonianists termed an *organisateur* (organizer): a key figure in the creation of modern society, the partner of the masses and the person in charge. An *organisateur* is a person of action, fully devoted to social reform without complaint. They are not an anarchist,

but a central coordinator. This central coordinator must be familiar with the protocols of social engagement, so as to avoid offending neighbors and community groups. The most prominent example is the problem of participants' portrait rights. Do they agree to have their image appear in your work? Or to take it a step further, do they agree to become part of your work, without feeling abused or exploited? Somewhat inconsistently, the artist delegates some of the authorial powers to the participants, yet usually relegates the audience to a state of anonymity. The skills of public interaction, negotiation, planning and management lie outside the purview of traditional artistic expertise. If an artist is lucky enough to possess them, they must still be aware that they may still have to sacrifice the privilege of quietly making art in a private studio. They must not only take to the street, but also lose themselves in a host of details, large and small, even harrowing encounters in the midst of intense humanitarian or political strife. Of course, one can engage in participatory art within the protective confines of the art museum, or in the virtual domain of the internet. Indeed, from the 1990s to the present, official institutions have either organized or hosted numerous participatory art events all around the world. Yet, as one might imagine, this tamed breed of participatory art has drawn criticism for betraying the essence of the art form. How can community development led by the government and tainted with political propaganda, or art one can only participate in when the museum is open, or art only available for participation in a virtual environment, truly generate mutual encounters, bonding, cooperation and solidarity? What kind of participation is possible? And how can it be integrated with life? Should it not be called pseudo-participatory art? And how could artists that moved outside the four walls of the art museum way back in the 1960s return to them in the 1990s? This is the problem for which Bourriaud has received the most stringent criticism. The wide variety of participatory art forms and their ambiguous connection to real life point to the gray area that may exist in artistic practice itself.

Furthermore, because relational art claims to be motivated to reform society and opposed to the attitude of "art for art's sake," it sacrifices the autonomy of art, and must even view the pursuit of aestheticism as harmful to art. The debate over autonomy in relational art is an old problem of modernism that has long lain unresolved: does art ultimately only concern itself with itself, or must it have some connection to society? Should art ultimately strive for aesthetic effect (the intrinsic sensory perception model of art) or should it enact its potential to permeate and overturn reality? But does art really have the ability to overturn reality? If it does, then we must clearly understand from where this ability arises. Jacques Rancière contends that in fact art's political powers derive from its aesthetic nature. As Kant argued, aesthetic judgment disrupts the reign of reason and understanding. And this is the foundation of politics, because sensorial experience can question the existing world order and explore the possibilities of changing and redistributing the world. To an extent, this perspective ameliorates conflict between the two extremes, preventing art from cleaving too closely to reality and thus sacrificing its artistry.[28] As for the role of the viewer, Rancière rejects the presumptions that have held sway from Plato all the way to Debord's "Society of the Spectacle", which dismiss the theater as a "place where ignoramuses are invited to see people suffer" and perpetually oscillate between two extremes – Bertolt Brecht's (1898-1956) epic theater and Antonin Artaud's (1896-1948) theater of cruelty: "For one, the spectator must be allowed some distance; for the other, he must forego any distance. For one, he must refine his gaze, while for the other, he must abdicate the very position of the viewer."[29] Instead, Rancière argues, we should not lightly assume that the viewer does not know how to view. The very existence of an audience implies a restriction and a class division. The viewer must have the ability to upend their own position in society to make a contribution. Thus, the emancipation of the spectator is the affirmation of their ability to behold and their ability to respond after beholding.[30]

Such a perspective may serve to temper the excesses of participatory art, particularly when "the grey area of *aisthesis* is excluded." A return to perception and an appropriate emancipation of the spectator may at least ameliorate participatory art's moralistic attitude and homiletic tendencies.[31]

Relations à la Lee Mingwei

If Lee Mingwei really did choose to make participatory art in the tumultuous 1990s and has persisted in it to this day, this implies that he has chosen to battle the aforementioned problems head-on, and to propose a path toward a solution through his artworks. While he inherited the legacy of Kaprow and Lacy, he has specifically stated that he did not join the Kaprow camp:

> When I saw the things that Kaprow had made, I actually knew quite clearly that that wasn't what I wanted. For me, something was missing. It was lacking a certain part. Later, I understood that I would use a very crude set of game rules. The first rule was, whether or not you want to participate, either way is fine with me. [32]

This reveals the aspect in which Lee Mingwei is extremely different from other participatory artists: he does not ask viewers to convert from passive to active. For him, the spectator is free to decide for themself the way and the extent that they will participate, from passively observing to actively interjecting themself. And the degree of participation is entirely determined by the viewer. Moreover, Lee is exceptionally punctilious about the form of his works. His exhibition spaces stand in their own right as paintings, installations of sculptures of the highest quality, even if all viewers are removed. He even admits to being very shy. He does not appear in his own works if he can avoid it. He almost never joins in protest movements, addresses controversial current affairs, or attempts to change any community. He is even reluctant to make art anywhere outside the art museum, which he views as his "protector." Does this quiet, reclusive, low-key creative method suggest that Lee Mingwei simply is not a participatory artist? And that audience participation is non-essential to him? Such is not the case either. Indeed, he unmistakably asserts the importance of the viewer in his works. Viewer participation is the source of his works' tension. In fact, viewers are the "contents" of each work,

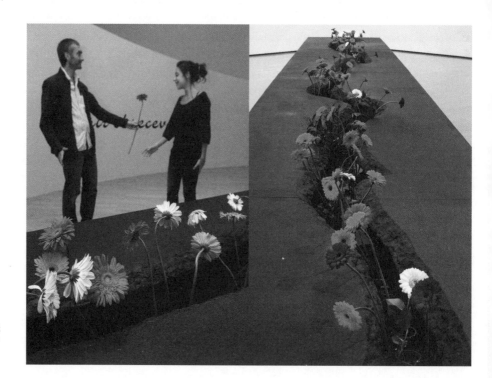

The Moving Garden, as installed at "The Spectacle of the Everyday," Lyon Biennial, France, 2009

and the physical form of the work is merely the container: "Their life and life force is poured into the work. Without the viewers, it would be nothing but a pretty vase." [33] In other words, Lee Mingwei incorporates the viewer into his works as a living medium, and because this "material" is full of changes and impossible to grasp, it demonstrates his work's insubstantiality, indeterminacy and, in a nutshell, its openness.

For example, in his work *The Moving Garden*, vividly colorful fresh flowers meander down a narrow groove in a black platform, exuding a highly attractive visual aura, but it is only a "pretty container." Visitors are invited to take a flower, gratis, and then give it to a stranger after leaving the museum. Of course, visitors can completely disregard the artist's suggestion and choose to only act as a bystander, or to take a flower but not give it to someone else. The artist does not keep track or keep count of the flowers' whereabouts. Lee Mingwei detests scientific statistics, analysis, and specific definitions of things. An artwork should take place in the realm of individual perceptual experience and random probability. And is the social dimension that participatory art emphasizes, or, one might say, art's socially subversive function, inapplicable in Lee's works? Does the art of Lee Mingwei lack a political dimension? We should not forget that this work was made in response to Lewis Hyde's book *The Gift: Creativity and the Artist in the Modern World*. [34] In it the author champions the value and importance of creativity in today's culture, which is dominated by money and overrun with merchandise, because the "gift" of the artist is the only "gift" available to humankind that can transcend the exchange of currency and commodities. Certainly, in 1924 Marcel Mauss recognized that in human economy and society "gifting and reciprocity" are fundamentally no different from "possession and exploitation." A gift denotes the relative social positions of the giver and recipient, and reciprocation is in fact an exchange of equivalent value. [35] What exactly does a viewer gain when they actively participate in Lee Mingwei's artworks? As one participant personally stated to the writer, she walked down many streets but could never find anyone willing to accept her flower. Clearly, this society has taught us, "There's no free lunch." Lacking the condition of equal exchange, the recipient inevitably refuses the gift, because they question the motives of the giver. But regardless of the method of participation they choose, every emancipated spectator can have the gift of the artist's creativity.

And what Lee Mingwei learned from Lewis Hyde was the secret to artistic creativity: an artist receives a gift from a higher presence, but they must also give a gift back to society; otherwise, they will be unable to receive another gift. The flow of gifts is the source of an artist's creative energy. And for this reason an artist must abide within the cycle that runs between emptiness and fullness, pouring out and filling up. This mysterious law of creativity may be a Zen aesthetic, or perhaps the balance between emptiness and substance in Chinese painting. Although Lee Mingwei has never vaunted his Eastern heritage or converted to any religion, we can say with near certainty that the locus of his politicality lies in the composition of indeterminacy and insubstantiality, and the gray area of perception.

1. Cited from the author's interview with the artist on June 8, 2015 at Taipei Fine Arts Museum, recorded and transcripted by Ms. Hsieh He-hsuan.

2. Wölfflin, Heinrich, *Principles of Art History: The Problem of the Development of Style in Later Art,* Mineola: Dover, 1950.

3. Deleuze, Gilles, *The Fold : Leibniz and the Baroque*, tr. Tom Conley: University of Minnesota, 1992.

4. Benjamin, Walter, *The Origin of German Tragic Drama*, tr. John Osborne, London: Verso, 1998, p. 165.

5. Diderot, Denis, *Ruines et paysages, Salon III* (1767), Paris: Hermann, 1995, p. 348.

6. Bergson, Henri, *Matter and Memory,* tr. Nancy Margaret Paul and W. Scott Palmer, London: George Allen and Unwin, 1911.

7 Eco, Umberto, *The Open Work*, tr. Anna Cancogni: Harvard University Press, 1989.

8. Todorov, Tzvetan, *Eloge du quotidien, Essai sur la peinture holandaise du XVIIe siècle*, Paris: Édition du Seuil, 1997, p. 146.

9. Sandler, Irving, *The Triumph of American Painting: A History of Abstract Expressionism*, New York: Praeger, 1970.

10. *Ibid.*

11. Cage, John, *Silence: Lectures and Writings*, Cambridge, Massachusetts: M.I.T. Press, 1967, p. 12.

12. Sandler, Irving, *op. cit.*, p. 146.

13. Dewey, John, *Art as Experience*, New York: Perigee, 2005, p.1.

14. *Ibid.*, p. 2.

15. *Ibid.*, p. 214.

16. Kaprow, Allan, *Essays on the Blurring of Art and Life*, ed. Jeff Kelley, USA: University of California Press, 2003, p. 10.

17. Oldenburg, *Claes, Store Days*, New York: Something Else Press, 1967, p.80.

18. Eco Umberto, *op. cit,* p.19.

19. Groys, Boris, "A Genealogy of Participatory Art," ed. Rudolf Frieling, *The Art of Participation-1950 to Now*, San Francisco: SFMOMA, 2007.

20. Kaprow, Allan, *op. cit.*, p. 195.

21. Bourriaud, Nicolas, *Relational Aesthetics*, tr. Pleasance, Woods, Copeland, Paris: Les presses du réel, 2002, pp. 8-9.

22. *Ibid.*, p. 108.

23. *Ibid.*, p. 15.

24. Bishop, Claire, "Relational Aesthetics", in *OCTOBER*, 110, Fall 2004, pp. 51-79.

25. Bishop, Claire, *Artificial Hells: Participatory art and the Politics of Spectatorship*, London, New York: Verso, 2012, p. 2.

26. Adenne, Paul, *Un art contextuel*, Paris: Champs Flammarion, 2004, p. 182.

27. This phrase orginated from Lee Mingwei's teacher, Suzanne Lacy, who edited the essay collection *Mapping the Terrain: New Genre Public Art*, Seattle, WA: Bay Press, 1995. The book compiled the works of numerous artists, as well as 11 treatiseson socially responsive or viewer-directed art practice, as well as art history in a variety of social and political contexts.

28. Rancière, Jacques, *Le partage du sensible*, Paris: La fabrique éditions, 2000.

29. Rancière, Jacques, *The Emancipated Spectator*, tr. Gregory Elliot, London, New York: Verso, 2009, pp. 3-5.

30. *Ibid.*

31. Bishop, Claire, *Artificial Hells: Participatory art and the Politics of Spectatorship, op. cit.*, pp. 37-41.

32. From the author's June 8, 2015 interview with the artist.

33. *Ibid.*

34. Hyde, Lewis, *The Gift: Creativity and the Artist in the Modern World*, New York: Vintage, 2007.

35. Mauss, Marcel, *Essai sur le don*, Paris: Presses universitaires de France, 2012.

對「關係」、「連結」
和「之間」的思考

如人際關係或因果關係等,「關係」,是令人想起人們與事物彼此互動或聯繫的一個詞彙。而「連結」與「之間」,則是讓我們意識到事物這種互動狀態與範圍的契機。不是將人與物視為獨立的個體,而是要去意識他們錯綜複雜相互關連的「之間」領域。藉此,我們或許可以找到理解李明維作品的線索。

古代的人們自天地異變及季節移轉等超出人類可控制的現象中,創造出許多神話。由此可知,古往今來,人們就一直對天地之間抱持關心。中國古代開天闢地的神話中所謳歌的女媧,即是傳說中補天的女神。李明維在《女媧計畫》中,將女媧形象製作成一只風箏,作品的所有者必須讓風箏飛上天後剪斷線,就像女媧被放回天上。《去留之間》也是透過冥想體驗的方式,讓我們馳想天地關係的空間。

放眼悠久的歷史,在綿延不絕的時間長流中,可以看到我們自身的存在。《石頭誌》源自李明維在紐西蘭的波羅拉里河,拾得冰河時期地殼變動形成的石頭。在《傳移摹寫》中,他分別請台灣藝術家,以及在亞洲以外地區活動的藝術家,臨摹中國清初代表性畫家石濤的山水畫。這些藝術家各自重新詮釋石濤的畫作,形成多彩多姿的作品群,也讓我們看到東方與西方不同的藝術觀點。

《補裳計畫》則是把觀眾帶來的衣物,交由藝術家或接待的主人縫補。縫補期間的對話,編織出種種「關係」與「連結」,化為動態的裝置藝術,在空間中呈現出來。

Thinking Relations, Connections and In-between Space

"Relations" is a word that calls to mind "human relationships," "causal relationships" and other mutual connections and relationships among multiple people and things. And words like "connections" and "in-between" are an opportunity to focus our awareness on the condition and extent of such relations among things. Not considering people and things as individual, independent entities, but focusing our awareness on the "in-between" space where they are intricately interconnected. By doing this, perhaps we can find a clue to understanding the Lee Mingwei's artwork.

In ancient times, people created countless myths concerning phenomena that were beyond human control, such as natural disasters and the changing of the seasons. From this we know that down through the ages, humans have been interested in that which lies between heaven and earth. In ancient Chinese creation myth, Nuwa is the goddess who mended the sky when it was in danger of collapse. Inspired by this, Lee Mingwei

made a kite adorned with an image of Nuwa for *Nu Wa Project*. The owner who bought it is supposed to cut the string while it is flying high in the sky, thereby releasing Nuwa into the heavens. In a similar vein, *Between Going and Staying* is a space designed to make us think about the relationship between heaven and earth by way of a meditative experience.

If we look at history immemorial, it is clear that we ourselves exist amidst the continuous passage of time. *Stone Journey* began with a visit by Lee to the Pororari River Valley in New Zealand where he found a number of stones shaped by tectonism during the last glacial age. For *Through Masters' Eyes,* Lee asked two sets of artists, one in Taiwan and one outside Asia, to create "copies" of Chinese-style landscape paintings by the famous early Qing dynasty painter Shitao. Each of the artists involved came up with his/her own original reinterpretation, giving rise to a variegated group of artworks that provide a fascinating glimpse of the different approaches to art in the East and West.

And *The Mending Project* is a project in which the artist or a host mends articles of clothing brought to this gallery by visitors. From the conversation that takes place while the articles are being mended, various "relationships" and "connections" are established, turning the gallery space into a dynamic installation.

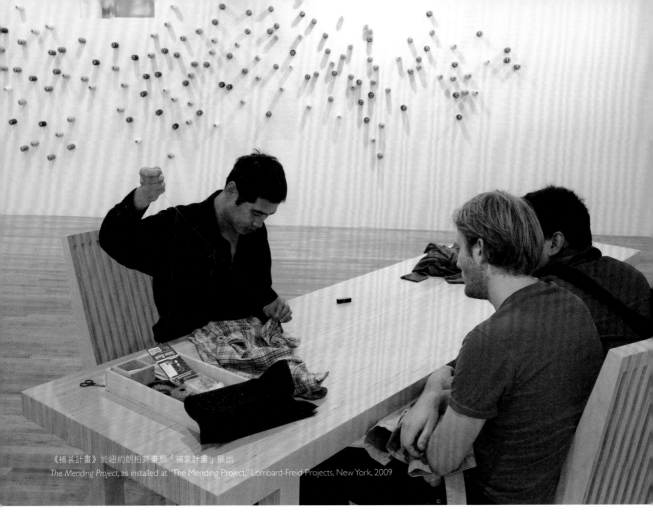

《補裳計畫》於紐約朗柏菲畫廊「補裳計畫」展出
The Mending Project, as installed at "The Mending Project," Lombard-Freid Projects, New York, 2009

補裳計畫

2009 / 2015

複合媒材互動裝置
桌、椅、線、織物

《補裳計畫》運用線、色、縫等極簡的元素，形成一個互動性空間裝置。從微妙的內在關係出發，探索自我對於環境與陌生人間彼此分享的經驗。展廳中陳置了長桌及兩張椅子，與布滿牆面彩色繽紛的線軸形成千絲萬縷的連結。補裳人將在展覽開放時間，為委託補裳的參與者進行縫補並交流。參與者可以自行選取色線，等長桌上陸續堆滿已縫畢、但未剪斷線頭而仍與線軸相連著的衣物時，線軸所牽引出的細絲，將在空間中交織成虛實交映的心靈網絡。

由於交託物件對個人的重要性，修補行為也承載了情感價值，譬如最喜歡的襯衫或是老舊卻少用的桌布。與裁縫師不同的是，李明維不選擇與破損處布料相近的顏色，反倒是挑選色彩鮮明、與周遭布料大相逕庭的色線。他並不試圖掩蓋破損的事實，而是去銘記與歡慶縫補行為，彷彿藉此宣示「一件好事曾在這裡發生，一項禮物曾被給予，這件衣物甚至比原來更美好。」

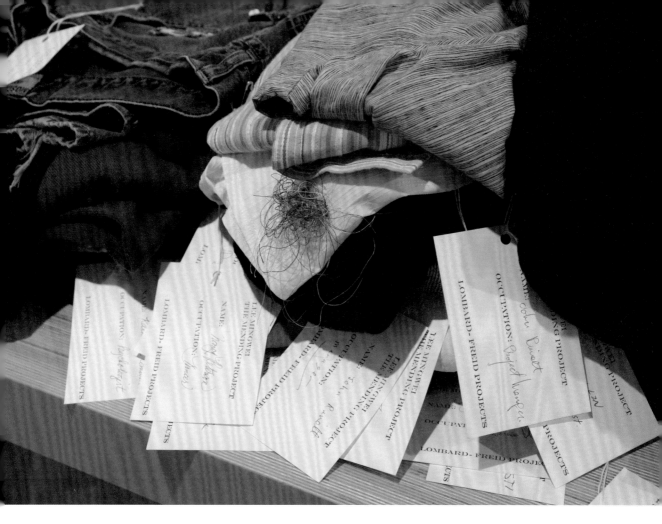

The Mending Project

2009 / 2015
Mixed media interactive installation
Table, chairs, threads, fabric items

The Mending Project is an interactive conceptual installation using very simple elements — thread, color, sewing — as points of departure for gaining insights into the relationships among self, other and immediate surroundings. It also constitutes an act of sharing between the host and a stranger. Visitors initially see a long table, two chairs and a wall of colorful cone-shaped spools of thread. During museum hours, a host is seated at the table, to which visitors can bring various damaged textile articles, choose the color of thread they wish, and watch as the host mends the article. The mended article, with thread ends still attached, is then placed on the table along with previously mended items.

These acts of mending take on emotional value as well, depending on how personal the damaged item is, e.g., a favorite shirt vs. an old but little-used tablecloth. This emotional mending is marked by the use of thread which is not the color of the fabric around it, and often colorfully at odds with that fabric, as though to commemorate the repair. Unlike a tailor, who will try to hide the fact that the fabric was once damaged, the mending in this work is done with the idea of celebrating the repair, as if to say, "Something good was done here, a gift was given, this fabric is even better than before."

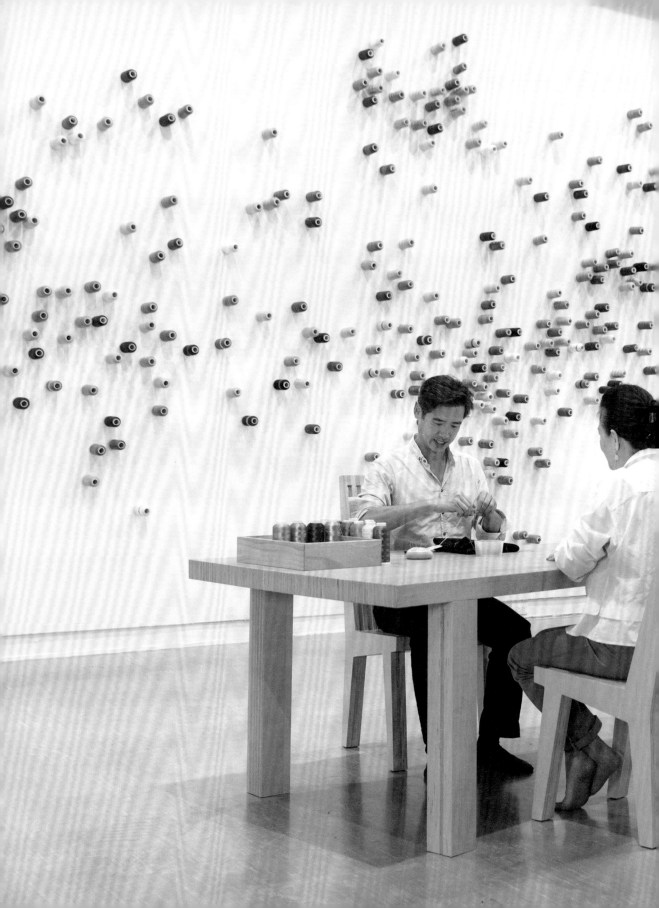

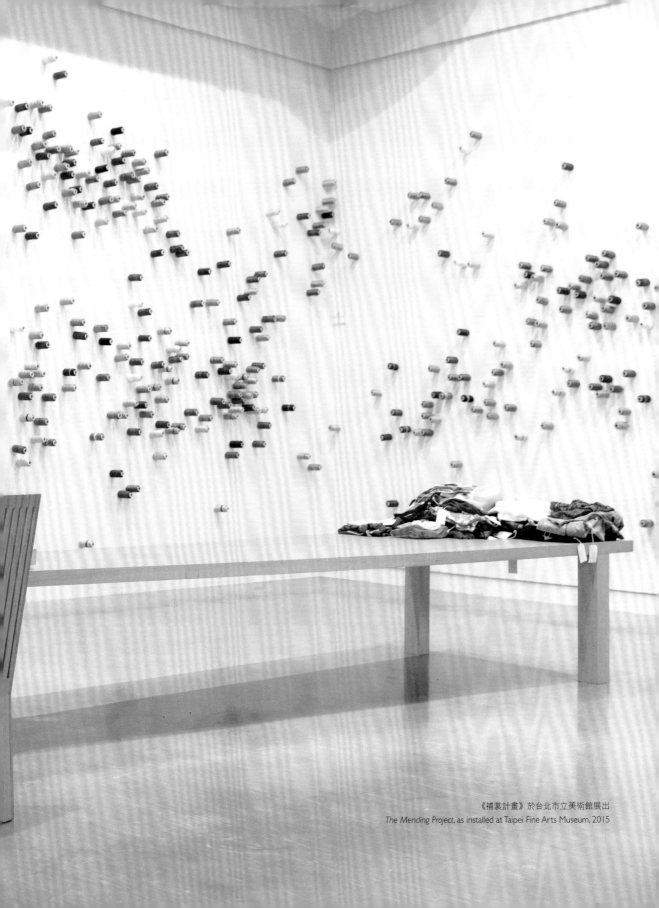

《補裰計畫》於台北市立美術館展出
The Mending Project, as installed at Taipei Fine Arts Museum, 2015

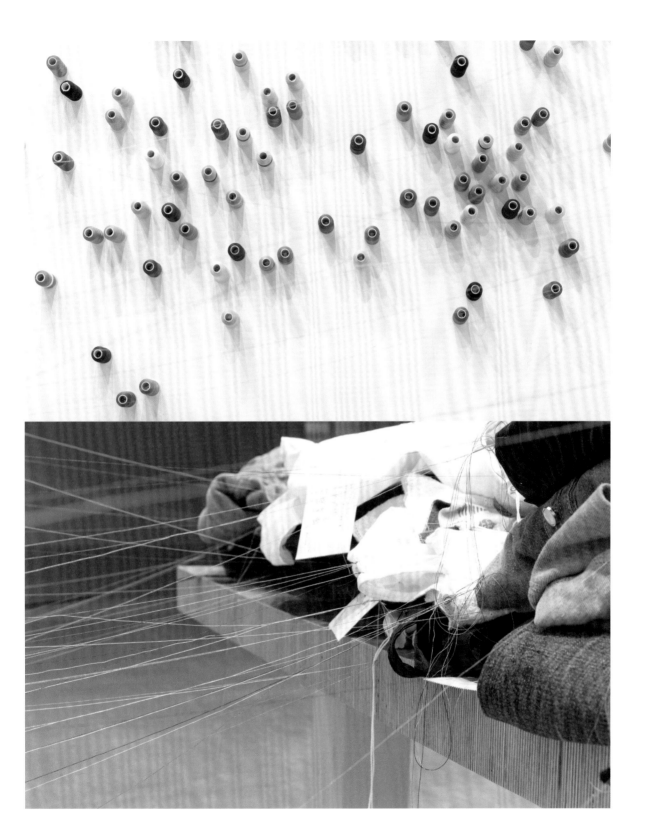

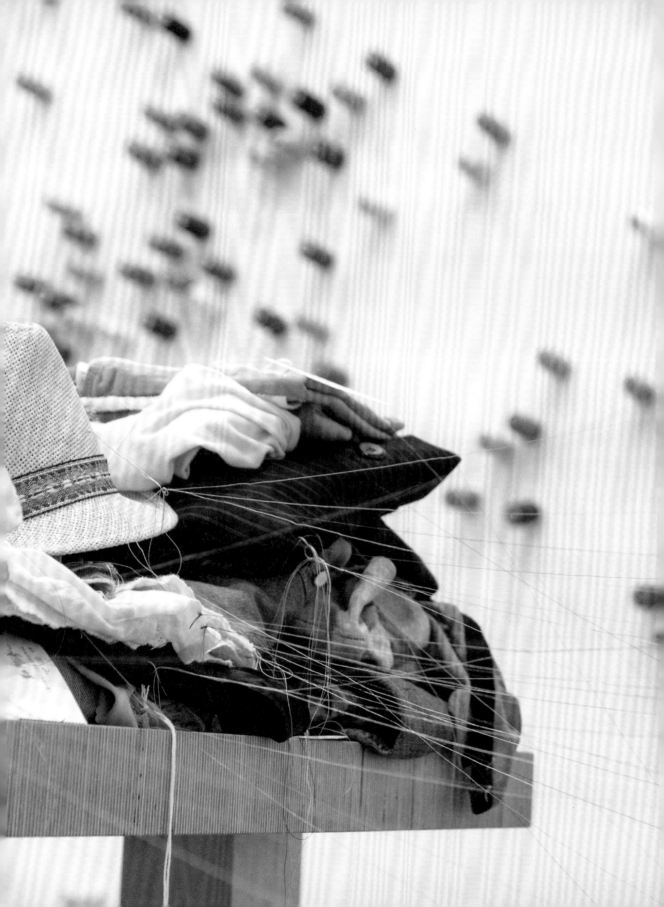

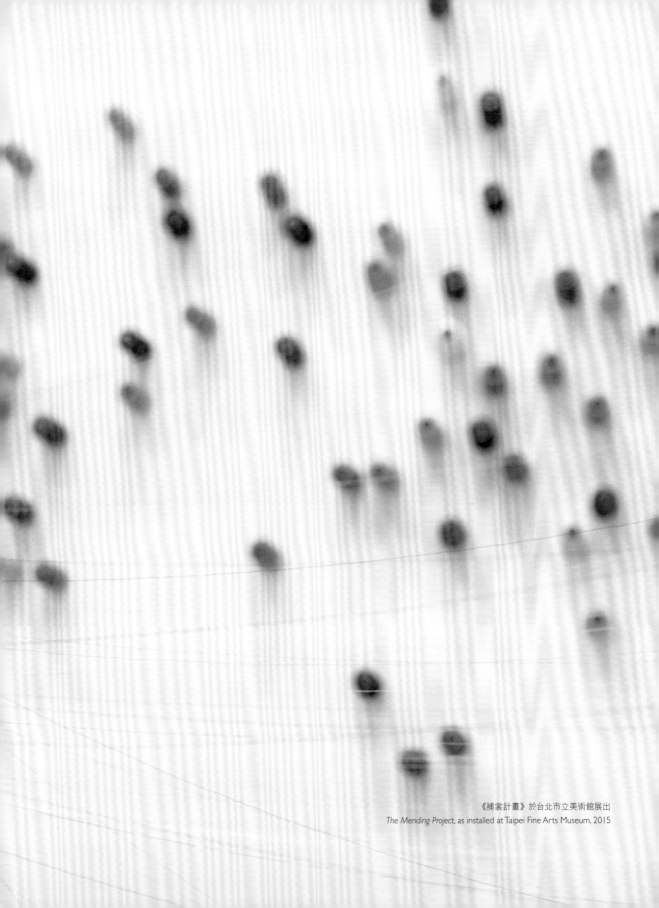

《補裰計畫》於台北市立美術館展出
The Mending Project, as installed at Taipei Fine Arts Museum, 2015

女媧計畫

2005

竹、絲、綿線、壓克力顏料

350 x 112 cm

在猶太文化的安息日結束儀式中，人們會傳送香料盒，讓接下來回歸日常工作時得以享受馨香並緬懷安息日。在 2005 年舊金山當代猶太博物館委任製作的計畫中，李明維以中國創世神話中女媧的形象做成風箏，重新詮釋香料盒的概念。人首蛇身的女媧是傳說中的上古女帝，與人首魚身的伏羲為兄妹。盤古開天後，女媧以自己的形象摶土造人，制嫁娶之禮，延續人類生命。相傳支撐天地的「不周山」因火神祝融與水神共工不合，而被共工無心擊塌，造成天地傾斜災患不斷。女媧採煉五色石以修補天的裂縫，最終甚至獻出自身以補天際彩石之不足，終於使山河大地恢復平靜。猶如儀式般，藝術家在風箏上寫下人們經歷酸甜苦辣的人生百味，然後讓風箏隨風輕揚，漸向天際遠隱，如同遠古女媧補天般撫慰人心，並留下人天之間遙遠聯繫的訊息。

Nu Wa Project

2005
Bamboo, silk, cotton thread, acrylic
350 × 112 cm

During the annual Jewish Havdalah ceremony, performed at the end of Shabbat, a "Spice Box" is passed around so that its fragrance may be enjoyed and recalled later during the secular work week. Commissioned by the Contemporary Jewish Museum, Lee Mingwei interpreted the spice box as a kite in the form of the mythical Chinese goddess Nuwa who, according to legend, patched up the sky after Gonggong, the god of water, ripped a huge hole in it during a battle with Zhurong, the god of fire. Nuwa collected a pile of five-colored stones and used them to repair the sky. After using up all the stones, a small hole still remained. The only thing she could do, in order to save her human children, is to patch up this hole by throwing herself against it. Ancient Chinese tradition holds that we experience life as having four flavors: *suan* (sour), *tian* (sweet), *ku* (bitter) and *la* (spicy). Here, the real project is not the kite itself, but rather the ritual of writing down one's associations with *suan, tian, ku* and *la* on the kite, then sending it aloft so that Nuwa can receive the sensations and feelings of humanity.

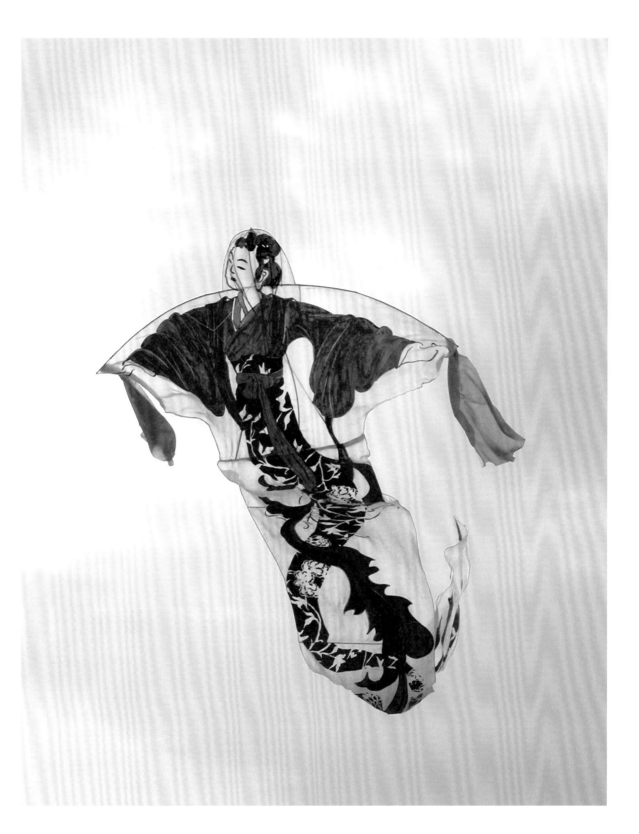

去留之間

2007 / 2015

複合媒材裝置
沙、燈、聲音

「一切可見，一切無形，一切近在眼前，一切遙不可及。」——
奧塔維歐‧帕斯〈去留之間〉

《去留之間》直接引用墨西哥詩人奧塔維歐‧帕斯（Octavio Paz）的同名詩篇。在黝黯的展廳中，黑色細沙從垂懸的幽光中緩緩流瀉，如沙漏般靜靜注滿整個空間，伴隨著來自遠處蒙古馬頭琴的幽微之音。它是藝術家在天地穹蒼與歷史洪流中，面對自身以及宇宙洪荒以來亙古時間中的「我」，一種對生命的凝思與清明的照見；不論是李明維作品中經常出現的「去」、「留」，或自古至今人類在形體和心靈上不斷的「去」、「留」，去留之間，既是新的開展，也是延續自過往的當下註解，恆存著人類迎向未來時須時刻以對的生命課題。

Between Going and Staying

2007 / 2015

Mixed media installation
Sand, lamp, sound

"All is visible and all elusive, all is near and can't be touched." —
Octavio Paz

Between Going and Staying was inspired by lines from Octavio Paz's poem of the same name. In a dimly lit gallery, fine black sand falls continuously through a broken light bulb suspended from the ceiling, quietly filling the entire room, along with a voice-like sound track played on a Mongolian stringed instrument called a *matouqin*. The project deals with the ephemeral experience of an artist who finds himself existing between Heaven and Earth, caught in the currents of history, facing himself and the "self" that is part of eternal time in the cosmic torrent, asking visitors to reflect on the nature of the moment. Whether the immediate experience is of "going" or "staying," mankind continues to "go" and "stay" both physically and emotionally.

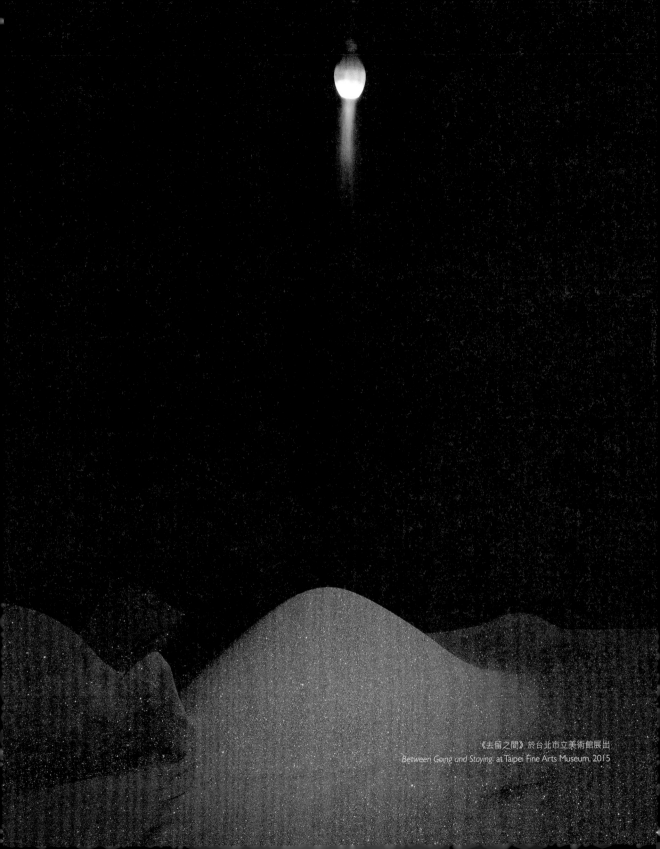

《去留之間》於台北市立美術館展出
Between Going and Staying, at Taipei Fine Arts Museum, 2015

石頭誌

2010

複合媒材裝置
冰河石、銅、木台座
11 組，各 10.5 × 50 × 15.5 cm

《石頭誌》靈感來自於紐西蘭的旅行。李明維在紐西蘭的萬年冰河區，找到 11 件形似中國山水的石頭，每件約莫是可以用手握住的大小。他用鑄銅的方式複製了另外 11 件。兩件形狀相同的作品，被放在一個約 50 公分長的原木台座上，原件的石頭下方，刻著「65mil BCE（西元前 6 千 5 百萬年）」，另一邊新做的銅製品，刻著「2009 CE（西元 2009 年）」。本件創作強調對擁有權的再思考，一場「物質擁有」與「精神擁有」間的拉鋸戰，考驗收藏家物質擁有一件作品的慾望與看到喜歡的物件回歸大自然的決心。同時亦挑戰藏家對藝術品價值的認知，哪一個石頭比較珍貴？是天然的冰河原石，還是藝術家做的翻銅複製？李要求藏家收藏這件作品之後，須決定何時、何處、如何將其中的一件捨棄；此時，這件作品才真正成為一件藝術品，而這個思考／價值判斷的過程是整件創作的核心思維。

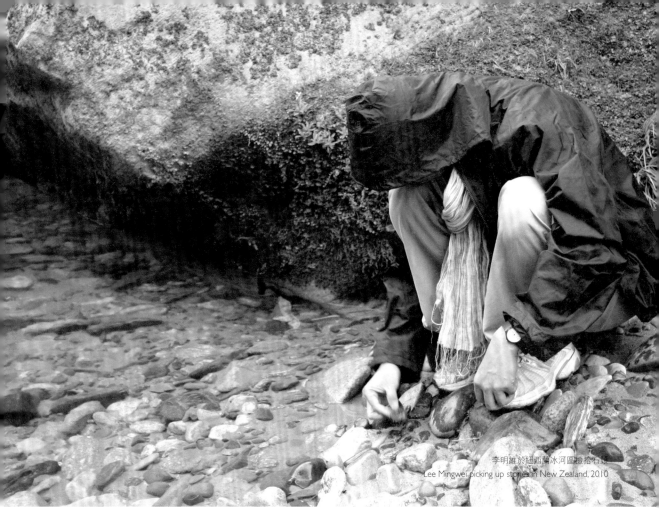

Stone Journey

2010
Mixed media installation
Glacial stone, bronze, wood
11 sets, 10.5 x 50 x 15.5 cm each

Stone Journey was inspired by a journey to New Zealand. Whilst walking along a river formed by glacial movements millions of years ago, Lee Mingwei picked up 11 stones similar in shape to those found in Chinese landscape paintings. Each stone was about the right size to hold in one's hand. Later, he had them replicated in bronze. He then placed each pair of stones on a wood platform 50 cm long, on which he engraved the words "65,000,000 BCE" under the original stone and "2009 CE" under the bronze replica. This project centers on two ideas.

First is the notion of ownership. What does it mean to own something, either natural or manmade? Second is the concept of value. Which stone is more precious, the natural stone or the fabricated one? Lee asks those who become the owners of these stone pairs to decide when, where and how to discard one of them, a decision involving considerations of ownership, control, value and loss. It is this thinking/valuing process that Lee believes to be the heart of the project, not the stone pairs themselves.

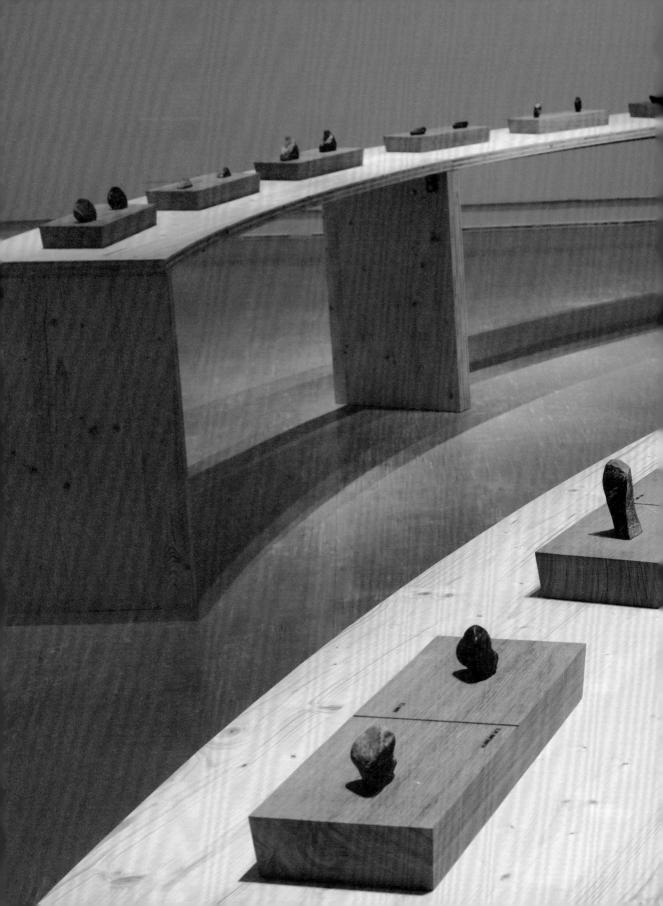

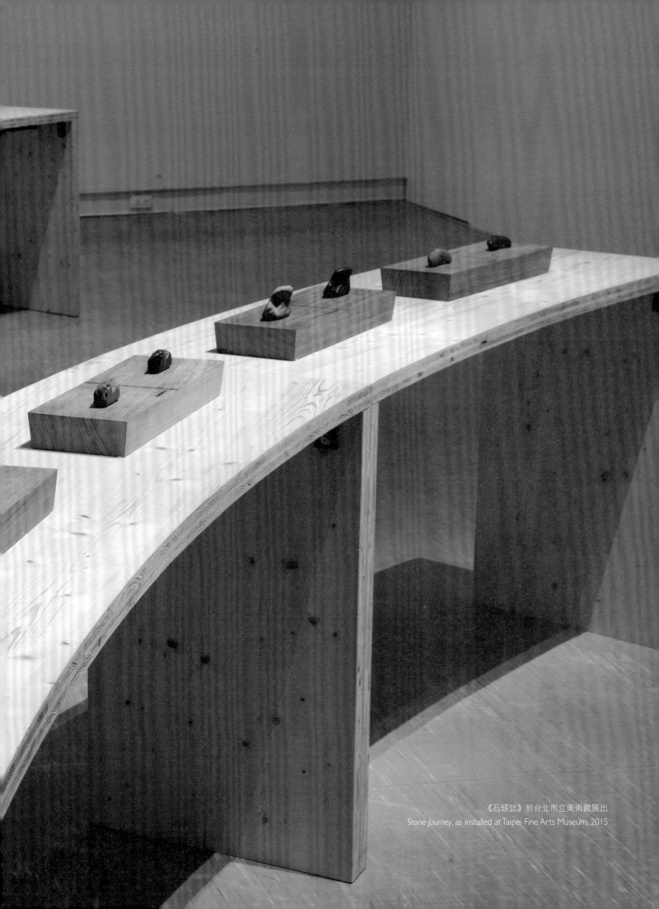

《石頭誌》於台北市立美術館展出
Stone Journey, as installed at Taipei Fine Arts Museum, 2015

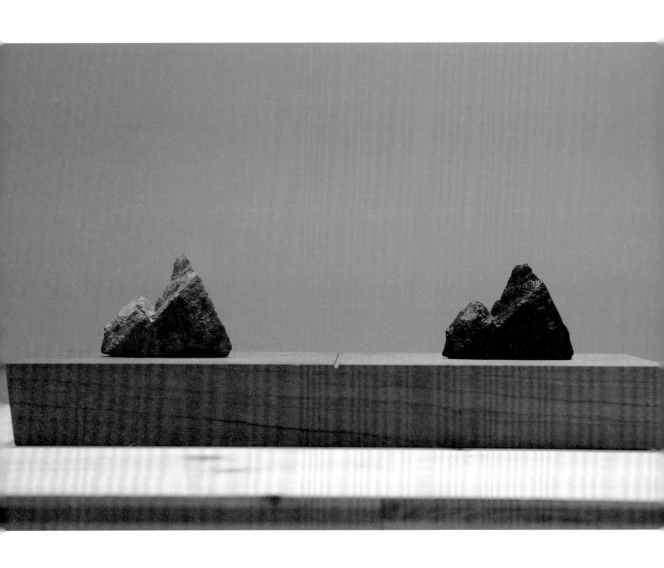

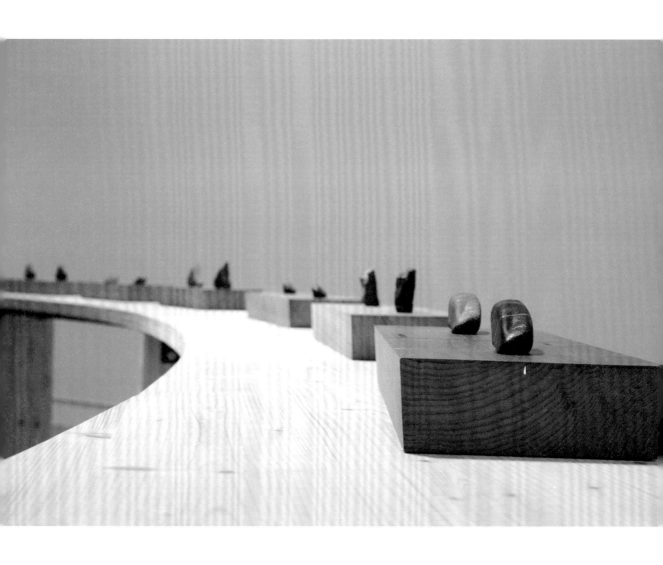

傳移摹寫

2004

複合媒材互動裝置
11 位藝術家臨摹所作
各 34 × 26.7 cm

以美國洛杉磯郡立美術館（Los Angeles County Museum of Art）所藏的石濤冊頁經典《鳴六先生山水冊》中的一幅畫作〈憶寫黃山三十六峰〉為範本，邀請東西方不同文化背景的藝術工作者，以不同媒材的創作方式，一一傳移臨摹。創作者同時與石濤原作的複製品及前次臨摹者的創作，進行一場關於臨摹的內在經驗互動與對話，傳達出東西繪畫系統中「傳移摹寫」或「大師摹仿」的不同創作思維，並加入創作者本身獨特的創作媒材與當代表現方法。同一件作品的臨摹因不同的文化底蘊與藝術傳統，呈現了「傳神」或「寫意」的內在精神變化。這批透過臨摹而達到再創作目的的 11 件作品，除了仿石濤原作裝裱展出外，並以複製品裝幀成傳統冊頁，邀請參觀者親手翻閱品賞這些作品。

Through Masters' Eyes

2004

Mixed media interactive installation
Creative reproductions by 11 artists, 34 × 26.7 cm each

In *Through Masters' Eyes*, Lee Mingwei approached artists in Taiwan and other countries outside of Asia, and commissioned them to create reproductions, in their own style, of a piece by the early Qing dynasty painter Shitao. Each artist passed his or her reproduction, along with the image of the original piece by Shitao, onto the next artist, who then referred to both the images before making a new reproduction. The various attempts to comply with the artist's request fell into two broad categories. The Taiwanese artists who took an Asian approach to the task honed their own powers of expression through the act of earnestly mimicking the work of the master. Those artists from outside Asia, on the other hand, whose practices are rooted in modern Western thinking, preserved the original spirit and intent of Shitao's work while transforming it into their own artistic idiom. Looking closely at each of these works, we find that each of them is both a "copy" and an "original" at the same time. These 11 works, which are all both imitations and reimaginings, have been exhibited in frames replicating the one holding Shitao's original, and bound together in a traditional album, so that visitors may flip through the works by hand to view them.

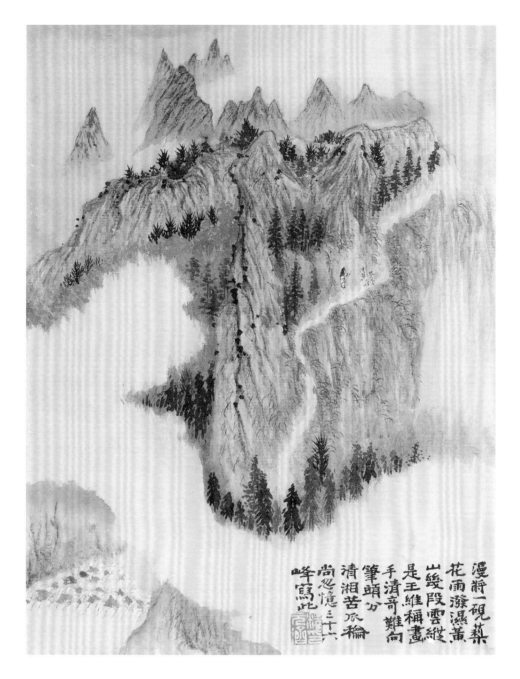

漫將一硯藝

花雨潑濕黃

山綴段雲縱

是王維稱畫

手清奇難向

筆頭分

清湘苦瓜

尚憶三十六

峰寫此

文本根據
石濤 (1642-1707)
山水
1694・清代
八頁冊頁之一；紙本設色
27.9 × 22.2 cm
原作由洛杉磯郡立美術館收藏

Based on
Shitao
Landscape
Qing dynasty, 1694
One leaf of an eight-leaf album; ink and color on paper
27.9 × 22.2 cm
Collection of Los Angeles County Museum of Art

現居台灣的藝術家
Artists Based in Taiwan

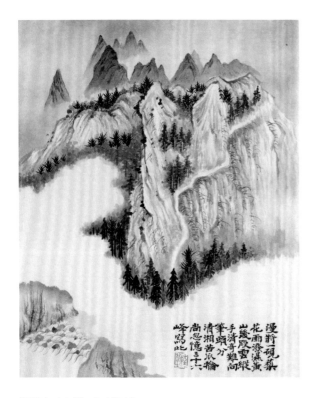

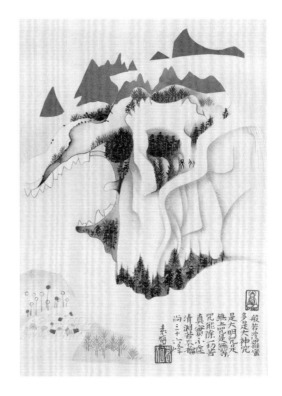

陸蓉之（台灣，b. 1951）

無題（仿石濤）
2004
紙本水墨設色
34 × 26.7 公分

Victoria Yung-Chih Lu (Taiwan, b. 1951)

Untitled (after Shitao)
2004
Ink and color on paper
34 × 26.7 cm

陸蓉之生於台灣，於美國加州接受藝術教育。是一位兼為策展人、藝評家及教授於一身的創作者。悠遊於東西方的影響促使她輕易地展開兼容並蓄的當代藝術對話。畫作中的書法係由著名中國美術史學者傅申教授所寫。

Victoria Yung-Chih Lu was born in Taiwan and educated in California. A curator, art critic, and professor at Shih Chien University in Taipei, she has been influential in facilitating dialogues about contemporary art between Taiwan and the West. Fu Shen, a professor of Chinese art history, performed the calligraphy in this work.

袁旃（台灣，b. 1941）

無題（仿石濤）
2004
紙本水墨設色、拼貼
34 × 26.7 公分

Yuan Jai (Taiwan, b. 1941)

Untitled (after Shitao)
2004
Ink and color on paper, collage
34 × 26.7 cm

袁旃主修傳統中國書畫並在比利時取得文物修復之博士學位。曾任職於國立故宮博物院文物修復處。近年創作以入乎傳統之色彩、筆意，出乎抽象變形的造型，融會出獨特的新意。

Yuan Jai studied traditional Chinese painting in Taipei before receiving a doctoral degree in conservation in Belgium. She was a research fellow in the Department of Conservation, National Palace Museum, Taipei. Her recent works are a distinctive approach blending traditional colors and brush techniques with abstract variations of form.

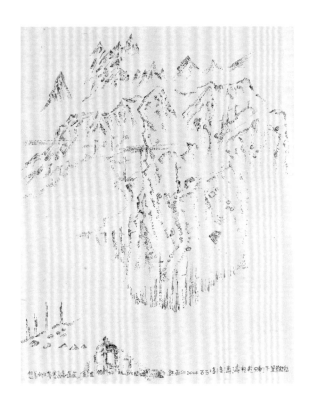

許雨仁（台灣，b. 1951）

無題（仿石濤）
2004
紙本水墨
34 × 26.7 公分

Hsu Yujen (Taiwan, b. 1951)

Untitled (after Shitao)
2004
Ink on paper
34 × 26.7 cm

許雨仁出生於台南佳里漁村，鹽山所形成的粗礪且貧瘠的地景深刻影響了許雨仁的創作肌理，其水墨畫作中如詩如俳句般的文字重疊，亦融入了作者對被破壞的生態大地的詠嘆與愧惜。

Hsu Yujen was born in Jiali, a small Taiwanese fishing village in Tainan. Once a major center for salt mining, the rough landscape of his now impoverished hometown informs the texture of Hsu's works. His ink paintings contain overlapping text suggestive of poetry or haiku, incorporating the artist's incantations and laments for the damaged earth.

洪順興（台灣，b. 1967）

無題（仿石濤）
2004
紙本水墨設色、拼貼
34 × 26.7 公分

Hung Shun-Hsing (Taiwan, b. 1967)

Untitled (after Shitao)
2004
Ink and color on paper, collage
34 × 26.7 cm

洪順興為專業文物修復及裝裱師，現任職於國立故宮博物院書畫處。

Hung Shun-Hsing is a classical Chinese brush painter and a specialist in traditional album mounting. He currently works in the Department of Painting and Calligraphy, National Palace Museum, Taipei.

林銓居（台灣，b. 1963）

無題（仿石濤）
2004
動畫；木炭、墨水、紙
10 分 12 秒（動畫）；34 × 26.7 公分

Lin Chuan-Chu (Taiwan, b. 1963)
Untitled (after Shitao)
2004
Animation; charcoal and ink drawing on paper
10 min. 12 sec. (animation); 34 × 26.7 cm

林銓居為一當代水墨畫家及作家。曾旅居芝加哥兩年，其間修習多媒體與動
畫藝術。誠如他的自述：「介於西方藝術形式與東方藝術心靈之間的衝擊」
深化豐富了他的藝術創造。

Lin Chuan-Chu is a contemporary Taiwanese ink painter and writer. While living
in Chicago for two years, Lin studied multimedia and animation art, experiencing
what he describes as a "concussion between contemporary Western art forms
and the soul of the Oriental artist," profoundly changing his works.

現居非亞洲地區的藝術家
Artists based outside Asia

張洪（美國，b. 1954）

無題（仿石濤）
2004
紙本水墨
34 × 26.7 公分

Arnold Chang (USA, b. 1954)
Untitled (after Shitao)
2004
Ink on paper
34 × 26.7 cm

張洪為一華裔美籍藝術家、著名書畫學者及經紀人，從習傳統中國山水畫逾二十年。

Arnold Chang (Chang Hong) is an American-born Chinese artist, scholar, and art dealer who has studied traditional Chinese landscape painting for over twenty years.

余契爾·泰倫（美國，b. 1974）

黃山勝景（仿石濤）
2004
油彩、壓克力、紙
34 × 26.7 公分

Sergio Teran (USA, b. 1974)
Discovering Mt. Huang (after Shitao)
2004
Oil and acrylic on paper
34 × 26.7 cm

余契爾·泰倫原居洛杉磯，為墨西哥裔美籍第一代移民之油畫家，現居紐約。其繪畫根植於當代拉丁美洲的文學意象，並受到十七世紀北歐繪畫的影響。

Sergio Teran, originally from Los Angeles, is a first-generation Mexican-American painter. Now living in New York, he paints imagery rooted in contemporary Latin-American culture that reveals the influence of seventeenth-century Northern European painting.

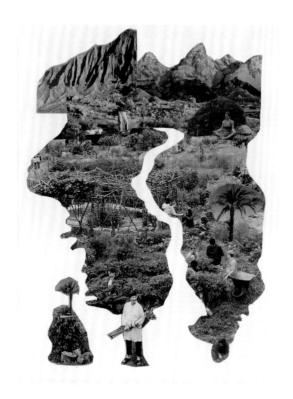

克里斯群・亞歷山札
（羅馬尼亞出身，活躍於美國，b. 1968）

無題（仿石濤）
2004
拼貼、紙
34 × 26.7 公分

Cristian Alexa (Romania, b. 1968, active in USA)
Untitled (after Shitao)
2004
Collage on paper
34 × 26.7 cm

克里斯群・亞歷山札為羅馬尼亞裔，主修美術，現移民紐約。電影、錄影及攝影等大眾媒材中提煉出他自己繪畫中簡潔有力的敘事性、未定的狀態與轉變中的關係。

Cristian Alexa studied fine arts in his native Bucharest, Romania, before moving to New York. Culled from popular culture — movies, videos, and photographs — his drawings read as condensed stories of events, unresolved situations, or relationships in flux.

傑生・瓦隆（美國，b. 1976）

四十個不同瞬間下的石濤（仿石濤）
2004
數位輸出、紙
34 × 26.7 公分

Jason Varone (USA, b. 1976)
Shitao at Forty Different Moments in Time (after Shitao)
2004
Digital print on paper
34 × 26.7 cm

傑生・瓦隆為一原住在紐約市布魯克林區的錄影與複合媒體藝術家。他創作了錄影式的「繪畫」，顛覆了人造意象與當地景觀的關係。

Jason Varone is a native of Brooklyn, New York. A video and mixed media artist, he creates "video drawings" that explore the relationship between man-made images and the urban landscape.

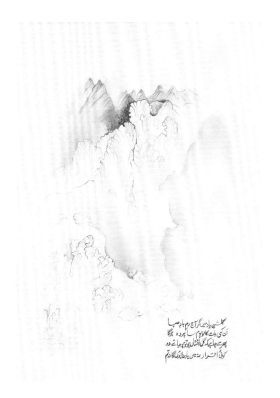

謝素梅（盧森堡，b. 1973）

無題（仿石濤）
2004
木刻凸版，A/P 版
34 × 26.7 公分

Su-Mei Tse (Luxembourg, b. 1973)

Untitled (after Shitao)
2004
Woodblock relief print, A/P
34 × 26.7 cm

謝素梅為一位盧森堡籍中英混血之錄影藝術家及大提琴家，崛起於 2003 年威尼斯雙年展，為歷年最年輕之金獅獎獲獎者。她以卓越的音樂素養創造出清新的錄像裝置，呈現了對生命疏離而自制的質問。

Su-Mei Tse is a video artist and classical cellist. Raised in Luxembourg by her Chinese father and English mother, Tse uses her musical talents to create sublime video installations that address questions of alienation and autonomy.

莎夏雅・希堪德（巴基斯坦，b. 1969）

無題（仿石濤）
2004
紙本水墨
34 × 26.7 公分

Shahzia Sikander (Pakistan, b. 1969)

Untitled (after Shitao)
2004
Ink on paper
34 × 26.7 cm

莎夏雅・希堪德為巴基斯坦裔繪畫名家，傳習於印度與波斯的傳統工筆畫。她統合了濃烈的傳統風格，使所創造的西方具象藝術表現呈現超越時空的意境。

Shahzia Sikander is originally from Lahore, Pakistan, a former division of Punjab, India. Trained in Indian and Persian miniature paintings, she combines this highly stylized Eastern tradition with the subjective expression found in Western art to create works that transcend place and time.

《傳移摹寫》於台北市立美術館展出
Through Masters' Eyes, as installed at Taipei Fine Arts Museum, 2015

行、住、坐、臥──
日常經驗的再認識

李明維的作品中，有許多會讓我們重新去思考「行走」、「飲食」、「睡眠」這些日常行為。李在年少時始接觸的禪宗思想，重視的是「此時・此地」，但他並未拘泥於艱深的教義與理論，他質疑的是，對於每天的日常生活與實際體驗，我們意識到多少？

《水仙的一百天》，正是代表李這種態度的作品之一，他一邊懷念過世的外祖母，一邊記錄下自己逐一意識到行走、飲食、睡眠這些日常生活的行為。《晚餐計畫》與《睡寢計畫》，則是透過公開抽選的參與者，與藝術家或美術館工作人員在閉館後的美術館一同用餐或共度一寢。這些建構一對一關係的作品計畫，讓日常行為變成私密而特別的體驗。造訪展間的觀眾，從那裡留下的睡寢痕跡及影像記錄，可以想像他們是如何度過、如何對話。

《移動的花園》中，觀眾拿起展間內展示的鮮花，選擇與來時不同的路線返回途中，把花送給陌生人。這件作品靈感源自強烈吸引李的「禮物」（gift）思想概念。19 世紀末至 20 世紀大為活躍的文化人類學家馬瑟・牟斯（Marcel Mauss），把關注焦點放在古代文化或世界各地先住民文化中的贈與及交換儀式，而非以競爭或利益為優先的市場經濟，對後世造成極大的影響。進而，現代美國評論家路易斯・海德（Lewis Hyde）也表示，藝術家擁有天賦才華（gift），贈與人們打動心靈的體驗。在本作中，李贈送的鮮花禮物，由每位觀眾再度轉送給未知的陌生人，美麗贈禮的連鎖得以在城市中延伸擴大。

此外，表演作品《聲之綻》中，當觀眾在展間內觀賞作品時，突然有穿著特製服裝的歌者演唱舒伯特的藝術歌曲，贈送給某一位觀眾。這也是在偶然的邂逅中，藝術家送給觀眾的無形禮物。

Walking, Eating and Sleeping — Rethinking Everyday Action

Many of Lee Mingwei's artworks make us re-think about everyday activities such as "walking," "eating" and "sleeping." Zen philosophy, which Lee encountered in his childhood, emphasizes being in the "here and now," rather than being bound by difficult doctrines and theories, it involves questioning how aware we are of the minor actions and actual experiences that make up our daily lives.

100 Days with Lily is a work that clearly demonstrates this approach of Lee's in that it records his daily life over 100 days during which he focused on each individual act of walking, eating and sleeping while thinking of his departed grandmother. In *The Dining Project* and *The Sleeping Project*, participants chosen by lottery are invited to either dine with or spend the night with the artist or one of the museum's staff members in the museum after it has closed. In these projects, which build one-to-one relationships, everyday actions become intimate and special experiences. As well, by looking at the remnants

and records of these stays left behind in the museum, visitors can imagine how those involved spent their time and what they talked about.

In *The Moving Garden*, visitors are invited to pick one of the fresh gerbera displayed in the gallery, make a detour from their intended route when leaving the museum, and give the flower to a stranger along the way. This work was born out of the philosophy of "gifts," to which Lee was strongly attracted. The anthropologist Marcel Mauss, who was active from the end of the 19th century to the middle of the 20th century, was interested in rituals of gift-giving and exchange in ancient civilizations and indigenous cultures around the world that set them apart from market economies that prioritize competition and profit, and had a major influence on later generations. Furthermore, the contemporary American critic Lewis Hyde describes artists as individuals blessed with a gift from heaven who in turn give gifts in the form of experiences that move people. In *The Moving Garden*, by giving the gift of a flower they received from Lee to a stranger, each visitor contributes to extending across the city a beautiful chain of gifts.

In the performative piece *Sonic Blossom*, an opera singer in a costume suddenly approaches a visitor while they are viewing the exhibition and offers to sing them Franz Schubert's Lieder. This act is also an intangible gift from the artist to the visitor in the context of a chance encounter.

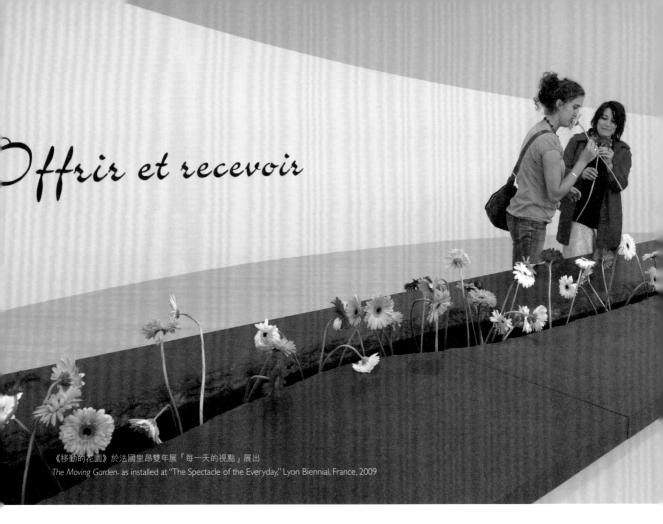

Offrir et recevoir

《移動的花園》於法國里昂雙年展「每一天的視點」展出
The Moving Garden, as installed at "The Spectacle of the Everyday," Lyon Biennial, France, 2009

移動的花園

2009 / 2015

複合媒材互動裝置
花崗石、水、鮮花
1200 x 134 x 60 cm

《移動的花園》靈感源自美國文化評論家路易斯·海德（Lewis Hyde）之著作《禮物：詩的想像和物欲生活》（*The Gift: Imagination and the Erotic Life of Property*）。書中提到禮物交換有別於市場經濟的獨特性以及其對施者與受者所引發的互惠效應，讓李明維感到特別有趣。有一次，他在春天的法國里昂隆河河堤旁，無意間看見數以百計的花朵順流而下，引發此一創作。展廳中陳設了長達 12 公尺的黑色花崗石檯，

沿檯面峽谷狀切口布滿鮮花。參與者可免費取一朵花，但必須循「互動規則」：離開美術館後繞道而行，並在前往下一目的地途中，將花送給一位有緣的陌生人。李並不追蹤或記錄花朵在離開美術館之後發生什麼事，而是將一切交由命運。在展覽期間，城市的某處，有些陌生人因這個「施與受」的機緣而相遇，對藝術家來說就是最好的回饋。

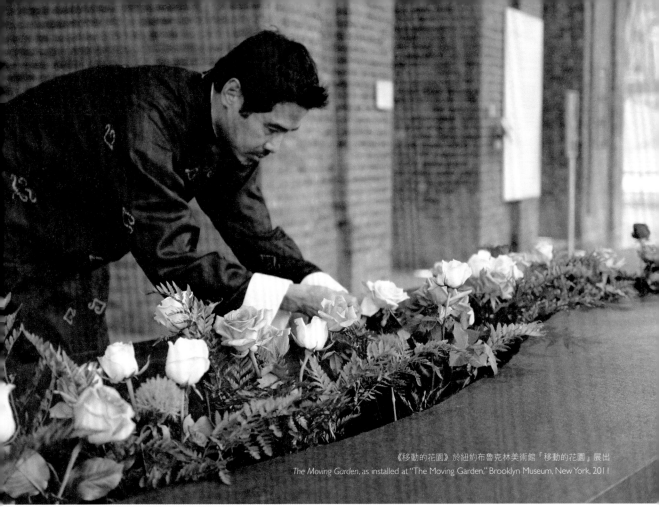

《移動的花園》於紐約布魯克林美術館「移動的花園」展出
The Moving Garden, as installed at "The Moving Garden," Brooklyn Museum, New York, 2011

The Moving Garden

2009 / 2015
Mixed media interactive installation
Granite, water, fresh flowers
1200 × 134 × 60 cm

While reading Lewis Hyde's *The Gift: Imagination and the Erotic Life of Property*, Lee Mingwei was fascinated by the author's examination of the effects of both our total immersion in a market economy and the myth of the free market on our views about gifts and our abilities to give and receive them. In this project Lee created a welcoming space in the gallery containing beautiful, fresh flowers. Museum guests are invited to take one of these flowers with them when they leave the museum, if they will agree to do two things: first, to make a detour from their intended route when leaving the museum

for their next destination; second, along this detour, to give the flower to a stranger whom they feel would benefit from this unexpected act of generosity. The artist chooses not to document what happens once the flowers leave the museum. As in life, we rarely learn how far our kindnesses (or unkindnesses) extend. In this project he chooses to make it easier for others to be kind, and leave the rest to fate. In return, the artist receives the gift of the knowledge that somewhere in the city, during the exhibition, some strangers have connected through acts of unexpected giving and receiving.

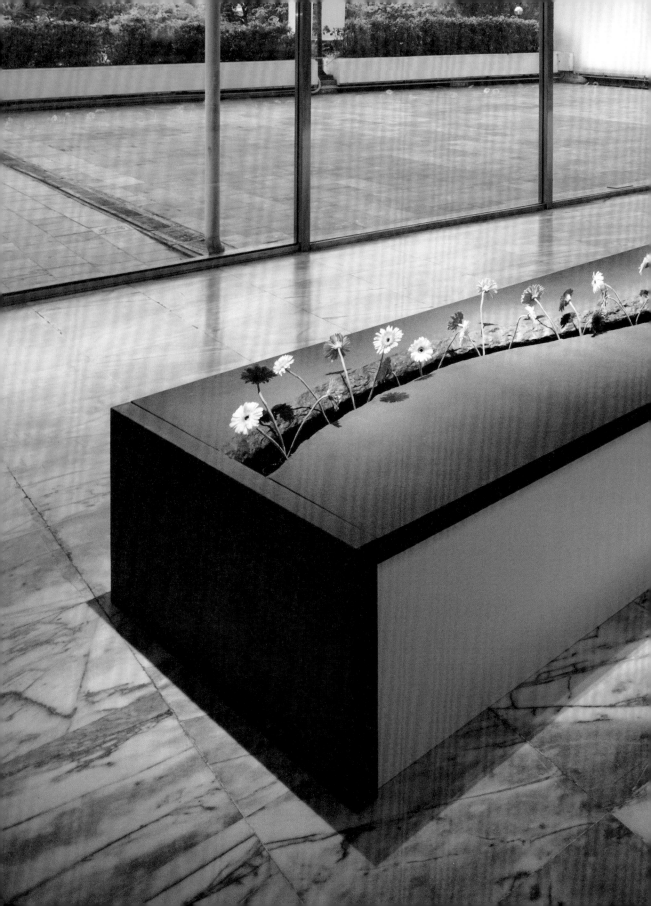

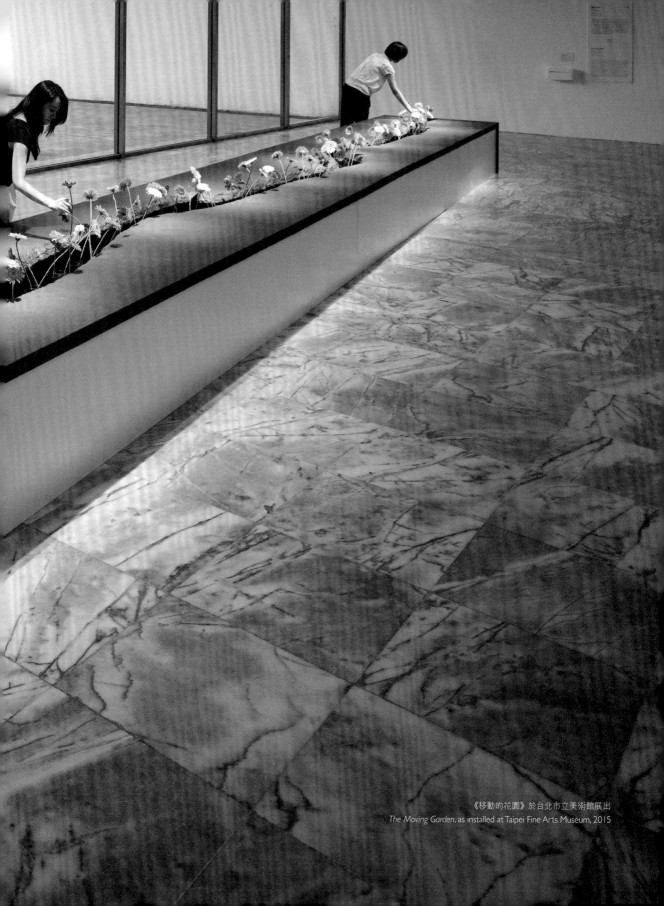

《移動的花園》於台北市立美術館展出
The Moving Garden, as installed at Taipei Fine Arts Museum, 2015

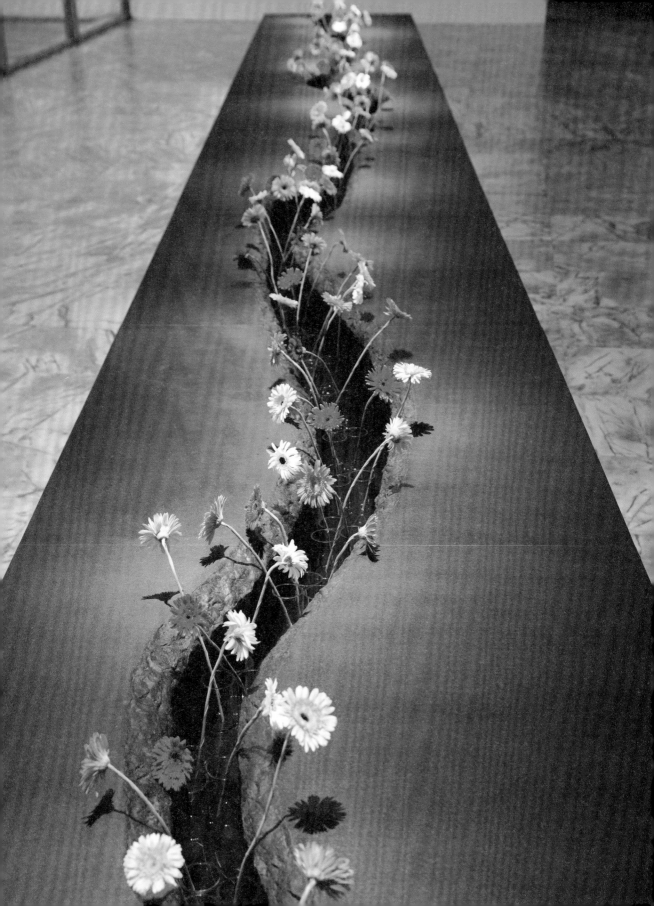

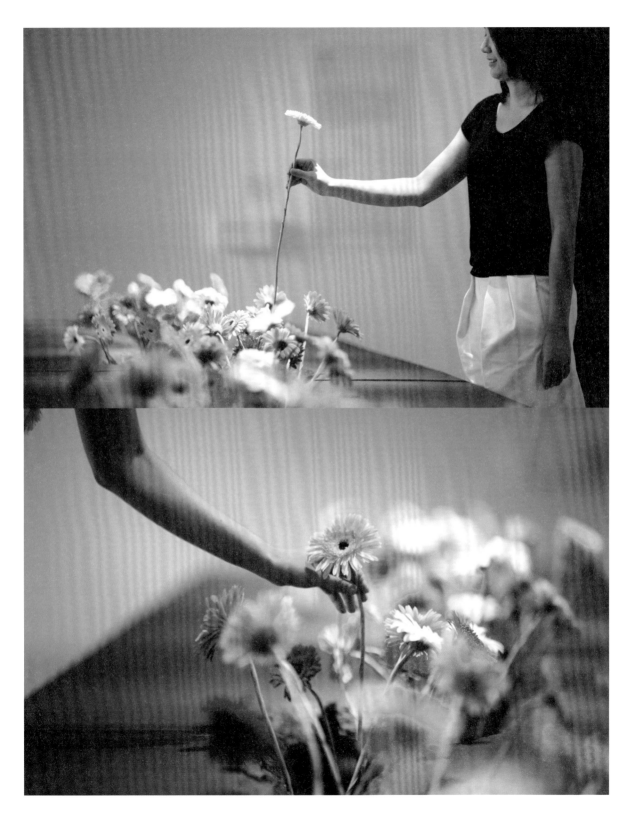

晚餐計畫

1997 / 2015

複合媒材互動裝置
木作平台、榻榻米、黑豆、米、錄像
335 × 335 × 85 cm

《晚餐計畫》源自李明維剛進入耶魯攻讀碩士時的一項行為藝術，當時他深感校園生活中人際關係的疏離，於是透過海報邀請陌生人共進晚餐，從中體驗分享、尊重與傾聽。這段經歷在1998 年受惠特尼美術館之邀，轉化成藝術家與陌生人在美術館中一對一用餐，以食物作為陌生的人際關係之催化劑和媒介，探索人我之間開放與私密的模糊界域。透過抽籤，獲選的參與者可以在展廳中享用「主人」悉心為他準備的晚餐，並藉由席間自在地交談，從陌生到逐漸熟稔。錄影機記錄下晚餐的對話及互動過程，影像紀錄連同餐桌陳設展出，讓參觀者一起體驗這段奇妙的歷程。觀者無法辨識出餐敘者，也無從得知實際對話內容，而是體認到溝通的觀念本身，以及每一個對話的獨一無二性。

The Dining Project

1997 / 2015

Mixed media interactive installation
Wooden platform, tatami mats, beans, rice, video
335 × 335 × 85 cm

Inspiration for *The Dining Project* arose during Lee Mingwei's first year at Yale University, where he completed his MFA. Feeling isolated, he posted hundreds of posters all over the campus, inviting anyone interested in "sharing food and introspective conversation" to contact him. When Lee was invited to hold an exhibition at the Whitney Museum of American Art in 1998, this process evolved into a series of one-on-one culinary encounters with strangers in the museum. At certain prearranged nights during the exhibition period, a member of the public, selected by lottery, is invited to the museum, where the host shares a private dinner, using food as a catalyst and medium for trust and intimacy. The first evening's exchange is recorded on video/audio, and later the recording is played in the gallery, slightly altered and barely audible. While visitors cannot fully comprehend the content of the conversation, this visual/aural memory allows them to sense the inimitable atmosphere of each private interaction.

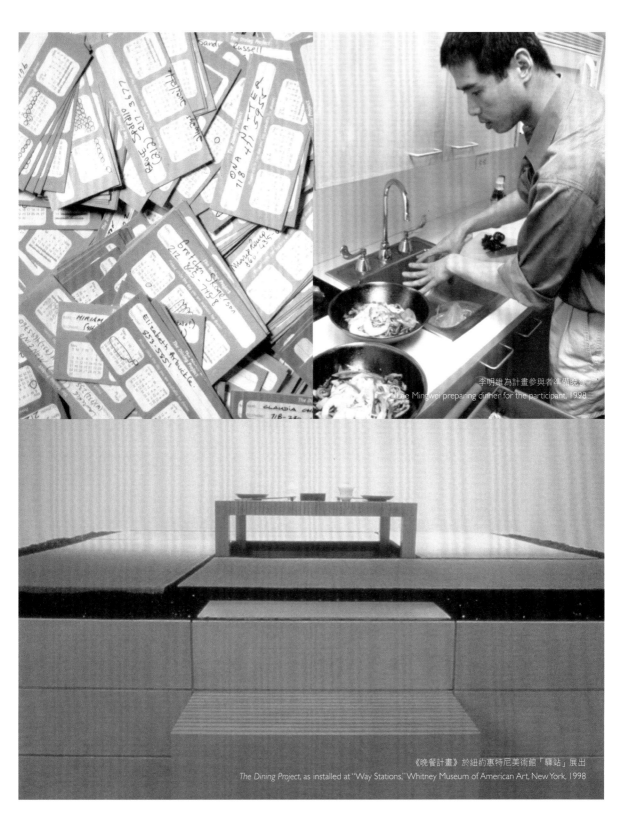

李明維為計畫參與者準備晚餐
Lee Mingwei preparing dinner for the participant, 1998

《晚餐計畫》於紐約惠特尼美術館「驛站」展出
The Dining Project, as installed at "Way Stations," Whitney Museum of American Art, New York, 1998

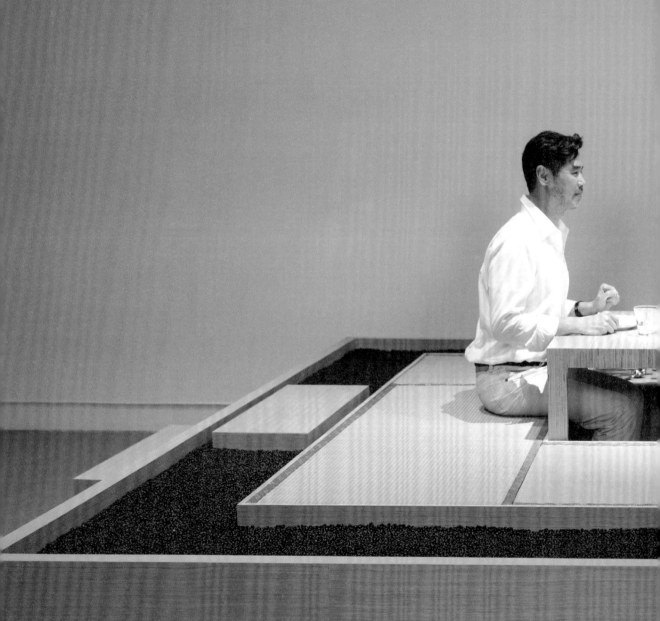

《晚餐計畫》於台北市立美術館
The Dining Project, at Taipei Fine Arts Museum, 2015

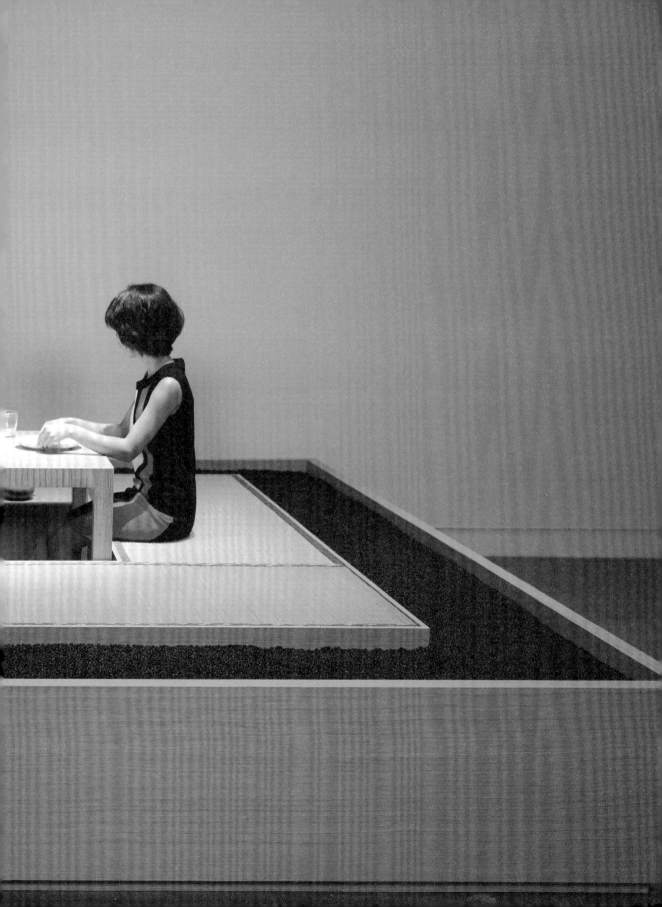

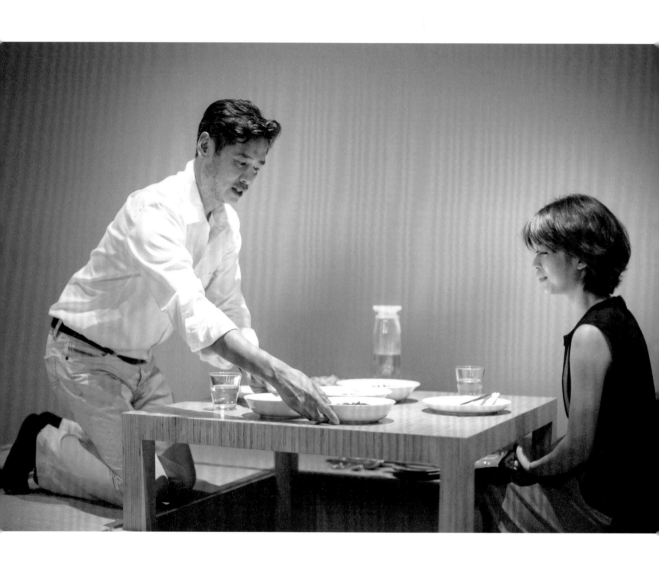

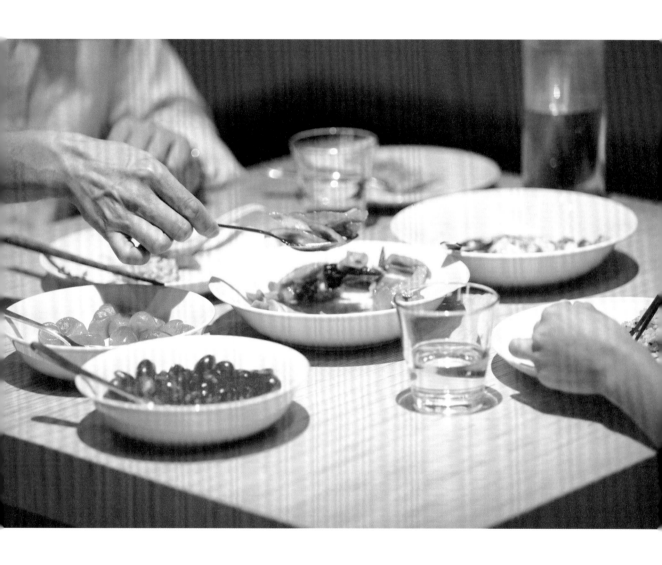

《晚餐計畫》於台北市立美術館
The Dining Project at Taipei Fine Arts Museum, 2015

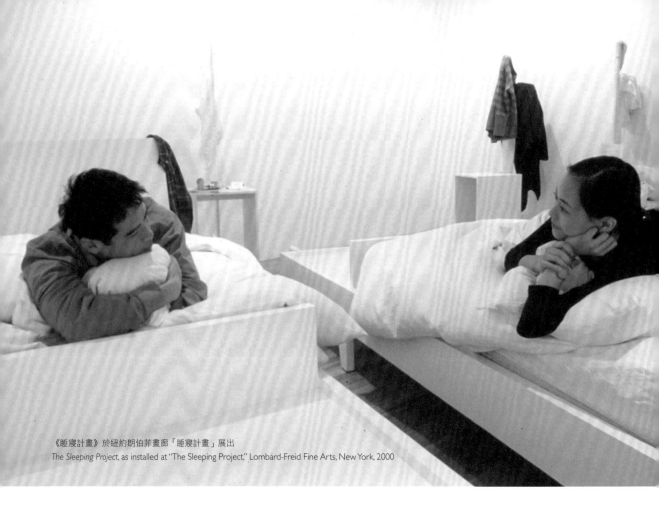

《睡寢計畫》於紐約朗伯菲畫廊「睡寢計畫」展出
The Sleeping Project, as installed at "The Sleeping Project," Lombard-Freid Fine Arts, New York, 2000

睡寢計畫

2000 / 2015

複合媒材互動裝置
木床、床頭櫃

《睡寢計畫》根源於高中時期從巴黎搭火車至布拉格，與一位波蘭年長者共乘臥鋪車廂的經驗。他倖存於納粹集中營，將返鄉接受賠償。應李明維的請求，他分享了這段經歷，並告訴他有關家人及其他人在集中營裡的狀況，他是家中唯一的倖存者。說完，他道聲晚安即睡了。李卻無法入眠，意識到若干年前，也有旅者在這樣的夜晚，可能同一道車軌上，無法倖活到早晨。多年後，藝術家才足以製作這項計畫來回應那天晚上所經歷的感觸。

在《睡寢計畫》中，李重新檢視「睡覺」和「與誰共眠」這兩者之間的差異。一位陌生人被邀請在藝術場域中與「主人」共度一宿，分享自己進入無意識狀態的幾個小時，藉此探索一天中最脆弱、最私密時刻的各種現象與心境，以及兩個素昧平生的人如何開誠佈公、深度交流，並在各自生命中留下彼此的印記？獲選的參與者被要求攜帶自己床邊的私人物品，如鬧鐘或照片等，翌日，這些物件會留置在床頭櫃上，提供觀眾蛛絲馬跡去臆測兩人之間的對話與互動狀態，以及面對陌生人時的親密與信賴關係。

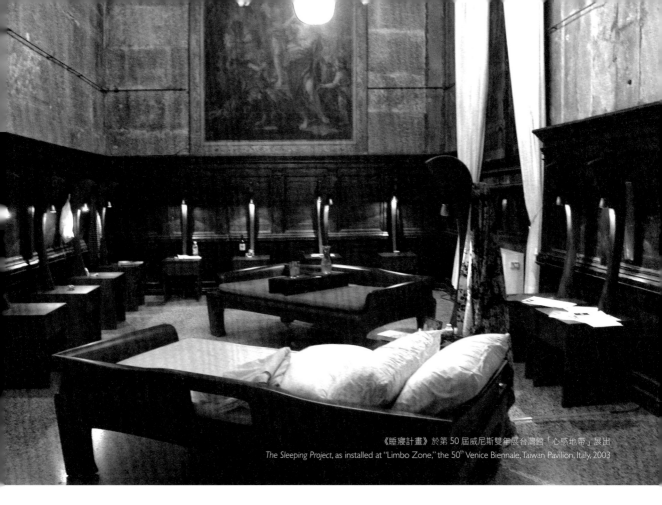

《睡寢計畫》於第 50 屆威尼斯雙年展台灣館「心感地帶」展出
The Sleeping Project, as installed at "Limbo Zone," the 50th Venice Biennale, Taiwan Pavilion, Italy, 2003

The Sleeping Project

2000 / 2015
Mixed media interactive installation
Wooden beds, night stands

When he was a high school student, Lee Mingwei once traveled on an overnight train from Paris to Prague, sharing his sleeper compartment with an elderly Polish gentleman who was going back to receive his compensation after surviving the horrors of a Nazi concentration camp. At Lee's request, he shared his memories of the camp and stories others had told him. He was the only survivor in his family. After their conversation, he bade the young Lee goodnight and went soundly to sleep. But Lee remained awake, realizing that, years ago, there were people traveling on these kinds of nights, possibly on the same track, who would not live until morning. Only many years later was the artist able to create a project in response to the emotions he experienced that night.

In *The Sleeping Project*, Lee Mingwei examines the differences between "sleeping" and "sleeping with." How do two strangers shape a night together into an open, profound, mutually influential encounter that they know will not be sexual? A participant chosen by lottery is asked to bring objects from the space in which they usually sleep — a clock, a photo — and spend the night with the host. The next morning, the participant leaves these objects on the nightstand. During the remainder of the exhibition, these personal objects provide gallery visitors with clues about the interactions between the host and the anonymous overnight guests, interactions that suggest the range of ways in which individuals experience intimacy and trust when confronted with an unknown other.

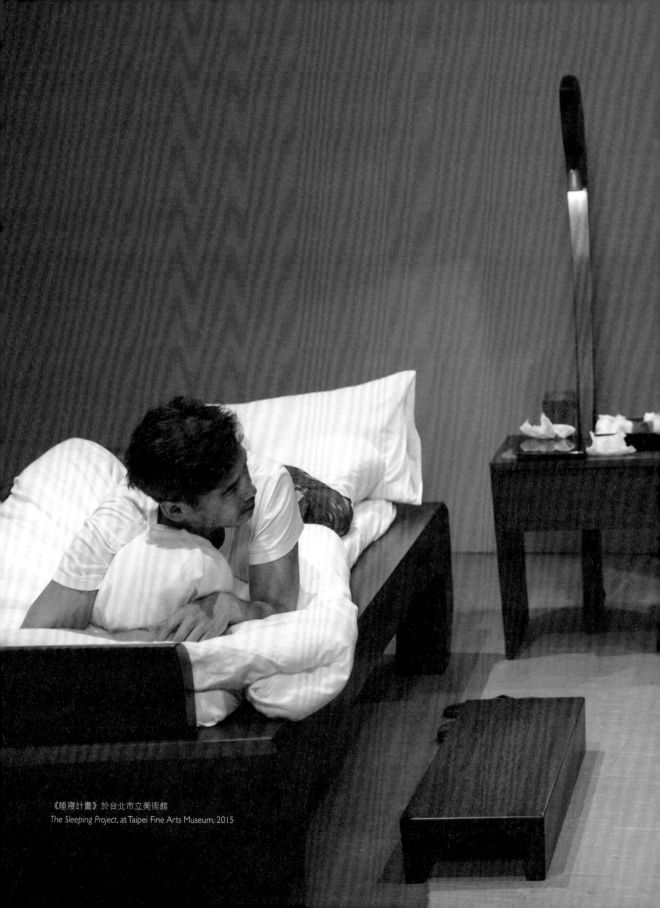

《睡覺計畫》於台北市立美術館
The Sleeping Project, at Taipei Fine Arts Museum, 2015

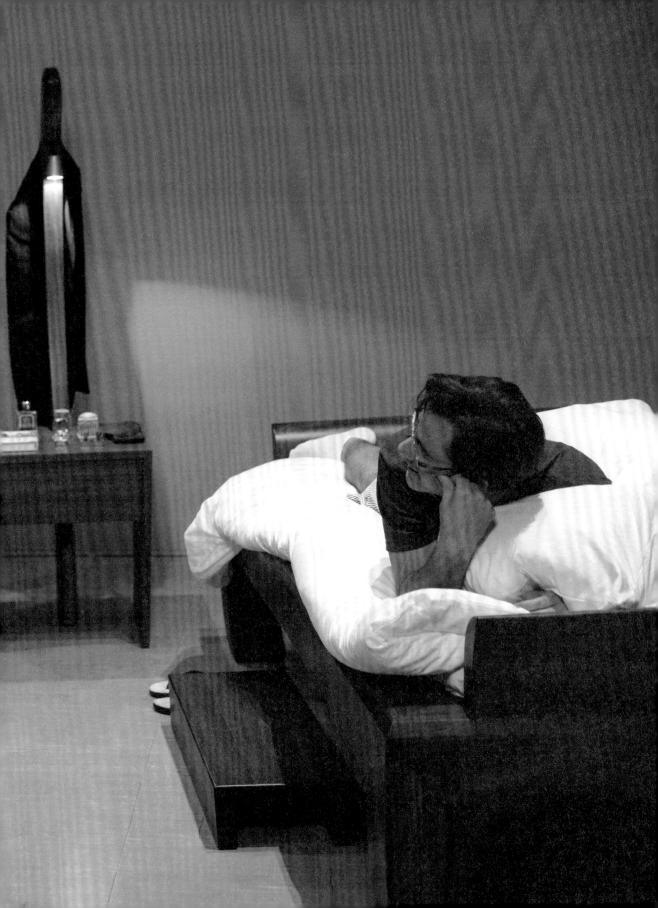

水仙的一百天

1995

影像輸出
五件，各 166.5 × 115 cm

《水仙的一百天》是為緬懷過世的外祖母而作。李明維選擇不分晝夜 24 小時與一盆水仙一起生活，為期百日，來悼念外祖母。從種下水仙的球莖，歷經發芽、開花、凋萎、到最後死亡的過程，他親身經驗了一個生命的週期，也藉此對生死一氣以及生命過渡的本質有更深層的體悟。在這一百天中，他每天隨機地記錄當下的日常活動及水仙形體的變化。最後，將這些活動紀錄疊印在水仙五個生命階段的攝影輸出上。第 79 天時，水仙已經凋零，但李不願讓它離開，因為它已經成為自己身體的一部分；21 天後，李接受了它的死亡，他把水仙的球莖清乾淨，埋進土裡，知道季節到了，它會再生。

100 Days with Lily

1995

Silver dye bleach prints
5 pieces, 166.5 × 115 cm each

Lee Mingwei created *100 Days with Lily* soon after the death of his maternal grandmother. The artist chose to live with a lily 24/7 for 100 days, as a form of ritual grieving. From the day he planted the lily bulb, through its germination, sprouting, blossoming, fading and death, the artist experienced at close-hand a full cycle of its life and, by extension, his grandmother's and his own. Lee randomly chose a moment in each day to document what he was doing, always with the lily present. In the final presentation, he overlaid text onto five of the photographs to create images showing both various stages of the lily's life and his activities at various moments. The lily died on day 79, at which point Lee postponed interment, instead carrying the now dormant lily bulb in his hands for the remaining 21 days. After he had lived with the lily for a full 100 days, he finally laid it to rest, and accepted the changing of seasons.

Day 1 10:23 Planting Lily
Day 2 06:34 Sleeping with Lily
Day 3 12:05 Eating with Lily
Day 4 09:14 Walking with Lily
Day 5 07:12 Meditating with Lily
Day 6 14:34 R____ with Lily
Day 7 23:13 ____ with Lily
Day 8 15:21 Ri____ with Lily
Day 9 12:34 Co____ with Lily
Day 10 16:56 Gardening with Lily
Day 11 08:54 Walking with Lily
Day 12 17:42 Talking with Lily
Day 13 13:54 Reading with Lily
Day 14 20:31 Showering with Lily
Day 15 13:42 Eating with Lily
Day 16 21:23 Shitting with Lily
Day 17 04:__ Sleeping with Lily
Day 18 22:13 Reading with Lily
Day 19 09:56 Meditating with Lily
Day 20 05:21 Writing with Lily

Day 21 11:04 Shopping with Lily
Day 22 10:38 Germination of Lily
Day 23 17:49 Talking with Lily
Day 24 16:29 Thinking with Lily
Day 25 18:50 Masturbating with Lily
Day 26 21:28 Laughing with Lily
Day 27 18:40 Typi with Lily
Day 28 13:21 E with Lily
Day 29 09:40 M ating with Lily
Day 14:48 C g with Lily
Day 21:56 W g with Lily
Day 19:43 Shopping with Lily
Day 33 09:23 Eating with Lily
Day 34 17:26 Cooking with Lily
Day 35 19:39 Masturbating with Lily
Day 36 12:34 Eating with Lily
Day 37 09:19 Riding with Lily
Day 38 10:20 Talking with Lily
Day 39 12:43 Cooking with Lily
Day 40 13:41 Eating with Lily

Day 41　20:49 Reading with Lily
Day 42　14:58 Writing with Lily
Day 43　09:32 Shooting with Lily
Day 44　11:0? Gardening with Lily
Day 45　10:48 Singing with Lily
Day 46　21:54 Reading with Lily
Day 47　13:06 Sewing with Lily
Day 48　12:46 Cooking with Lily
Day 49　19:08 Riding with Lily
Day 50　15:43 Napping with Lily
Day 51　21:49 Reading with Lily
Day 52　13:26 Eating with Lily
Day 53　19:51 Laughing with Lily
Day 54　16:?? Writing with Lily
Day 55　18:48 Meditating with Lily
Day 56　04:12 Sleeping with Lily
Day 57　19:21 Walking with Lily
Day 58　09:52 Blooming of Lily
Day 59　07:45 Meditating with Lily
Day 60　11:26 Shopping with Lily

Day 61 18:32 Studying with Lily
Day 62 14:52 Eating with Lily
Day 63 08:29 Shitting with Lily
Day 64 15:40 Riding with Lily
Day 65 20:10 Eating with Lily
Day 66 12:43 Driving with Lily
Day 67 23:12 Reading with Lily
Day 68 04:45 Sleeping with Lily
Day 69 10:38 Singing with Lily
Day 70 08:41 Meditating with Lily
Day 71 15:28 Talking with Lily
Day 72 12:40 Cooking with Lily
Day 73 10:08 Studying with Lily
Day 74 21:51 Writing with Lily
Day 75 09:07 Walking with Lily
Day 76 08:45 Sewing with Lily
Day 77 19:02 Reading with Lily
Day 78 19:06 Gardening with Lily
Day 79 11:43 Death of Lily
Day 80 15:21 Gardening with Lily

Day 81 10:40 Walking with Lily
Day 82 19:18 Masturbating with Lily
Day 83 15:40 Meditating with Lily
Day 84 19:50 Gardening with Lily
Day 85 12:06 Cooking with Lily
Day 86 19:34 Shopping with Lily
Day 87 21:49 Writing with Lily
Day 88 16:06 Shitting with Lily
Day 89 10:01 Walking with Lily
Day 90 21:51 Reading with Lily
Day 91 05:45 Shower with Lily
Day 92 12:07 Cooking with Lily
Day 93 14:32 Napping with Lily
Day 94 23:06 Sleeping with Lily
Day 95 20:54 Writing with Lily
Day 96 13:13 Eating with Lily
Day 97 19:40 Gardening with Lily
Day 98 08:03 Meditating with Lily
Day 99 09:43 Walking with Lily
Day 100 16:32 Exhumation of Lily

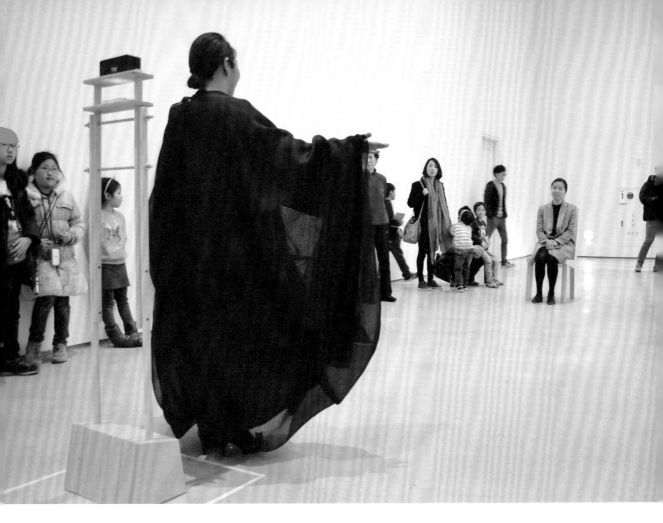

聲之綻

2013 / 2015

參與式表演裝置
椅子、台座、服裝、藝術歌曲

《聲之綻》源自李明維照顧母親手術後休養期間，聆聽舒伯特樂曲所得到的莫大安慰。這些曲子對他們而言是個意外的禮物，不僅安慰了他們，顯然也有助於他母親的康復。面對生病、虛弱的母親，讓李瞬間體認到死亡的真實；生老病死不再是抽象的概念，而是如此迫近的存在。有一天我們都將離開這個世界，我們的生命就如舒伯特的樂曲一般短暫，但也因為如此而美麗。藝術家將這個經驗轉化為《聲之綻》，他選了五首舒伯特的藝術歌曲，展覽期間，演唱者遊走於美術館迴廊間，選擇合適的觀眾，詢問是否願意接受一首歌作為禮物。若經同意，演唱者將為該名觀眾演唱其中一首舒伯特的歌曲。這件作品發生的時間與地點取決於演唱者和參與者的偶遇，如曇花一現般隨機綻放與捲藏。

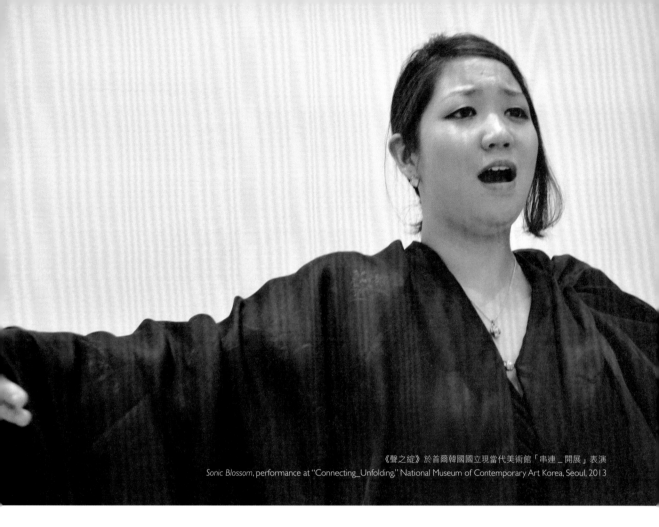

《聲之綻》於首爾韓國國立現當代美術館「串連＿開展」表演
Sonic Blossom, performance at "Connecting_Unfolding," National Museum of Contemporary Art Korea, Seoul, 2013

Sonic Blossom

2013 / 2015
Ongoing participatory performance installation with chair, music stand, costume, and spontaneous song

Sonic Blossom came into existence while Lee Mingwei was caring for his mother as she recuperated from surgery. The two found great comfort in listening to Franz Schubert's Lieder. These songs came as an unexpected gift, soothing and clearly helping his mother to heal. At another level, when the artist saw his mother weak and ill, he suddenly sensed that her (and his own) mortality was very real; aging, disease and death seemed no longer abstract, but immediate and present. Like Schubert's Lieder, our own lives are brief, but all the more beautiful because of this. In this project, the songs serve as a transformative gift to the visitors who encounter these moving

Lieder. Each singer learns five Lieder and meanders through the gallery, finding a visitor that they think might enjoy receiving this sonic gift, approaching them with the question: "May I give you a gift of song?" This is when the song is sung. This happens sporadically both in time and location — the folding and unfolding of a "Sonic Blossom."

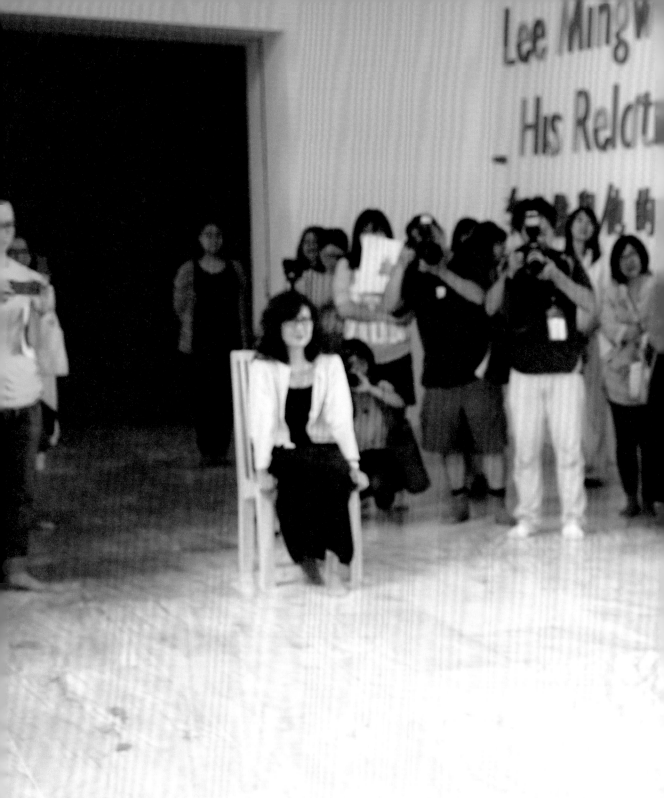

《聲之綻》於台北市立美術館　演唱者：梁又中
Sonic Blossom, performance at Taipei Fine Arts Museum, 2015　Performer: Liang You-Jhong

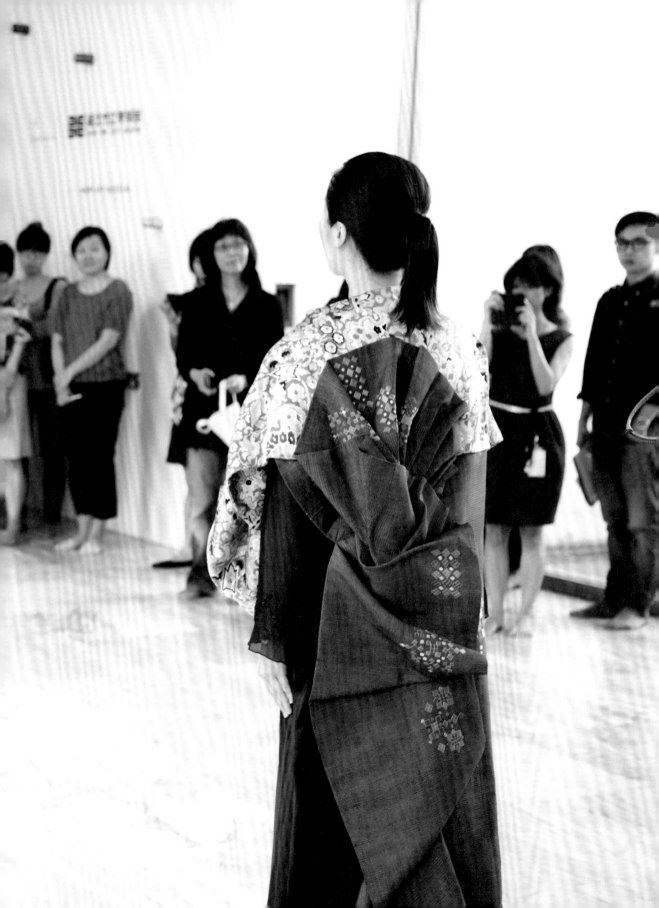

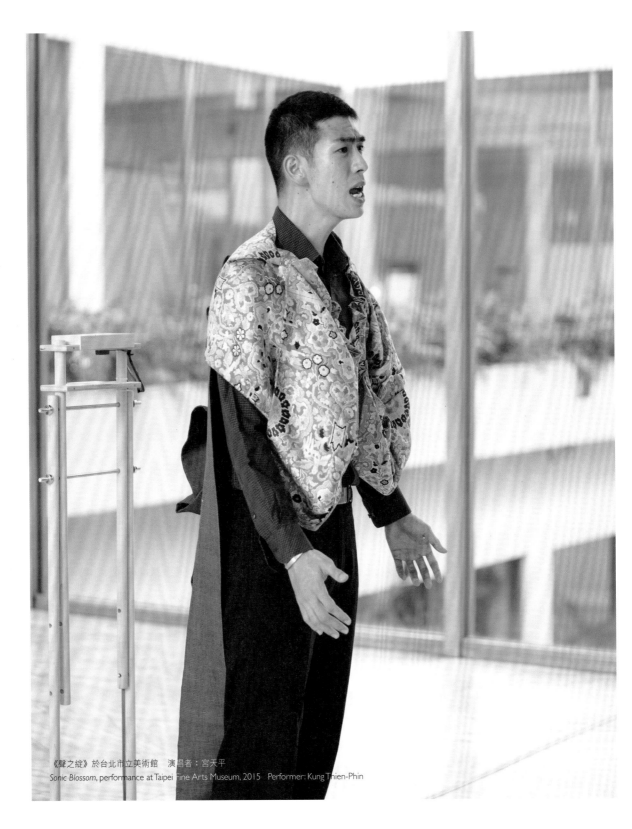

《聲之綻》於台北市立美術館　演唱者：宮天平
Sonic Blossom, performance at Taipei Fine Arts Museum, 2015　Performer: Kung Thien-Phin

如實曲徑

2015

參與式表演裝置
米、穀粒、種子、服裝、舞蹈

一次緬甸的旅行，讓李明維萌生《如實曲徑》的創作靈感。當地民眾在進入寺廟、神社、佛塔之前，須先將鞋子脫下，為了讓參訪者感受此清淨神聖的空間，志工們不斷勤加掃拂。藝術家邀請觀眾脫掉鞋子，親自用雙腳感受履地步行的感覺。當觀眾在欣賞各個作品時，將有一名舞者循著自己內心的曲徑游走於展廳中，掃拂散落的米、穀粒、種子等。他或許會在途中遇到阻礙，但仍將持續以靜默且覺知的方式進行。《如實曲徑》是演出的舞者帶給觀眾的禮物，提供他們在探索這個藝術場域時，一個身心靈純淨的空間。

Our Labyrinth

2015

Ongoing performance installation with rice, grains, seeds, costume and dance

A visit to Myanmar was the seed for *Our Labyrinth*, inspired both by the gesture of removing one's shoes before entering any temple, pagoda or mosque, and by the pristine space created for visitors by volunteers who constantly swept the sacred grounds. For this project, the artist will first ask exhibition visitors to remove their shoes, thereby enhancing the sensations produced by walking. Second, as visitors walk among the projects, a dancer will sweep a mixture of rice, other grains and seeds through the space, along a labyrinthine path of their choosing. This dancer may encounter obstacles along the way, but will navigate these silently and mindfully. This project is a gift from the performers to the visitors, the providing of a "pure" space, both physically and spiritually, as they explore the sacred space created by the projects.

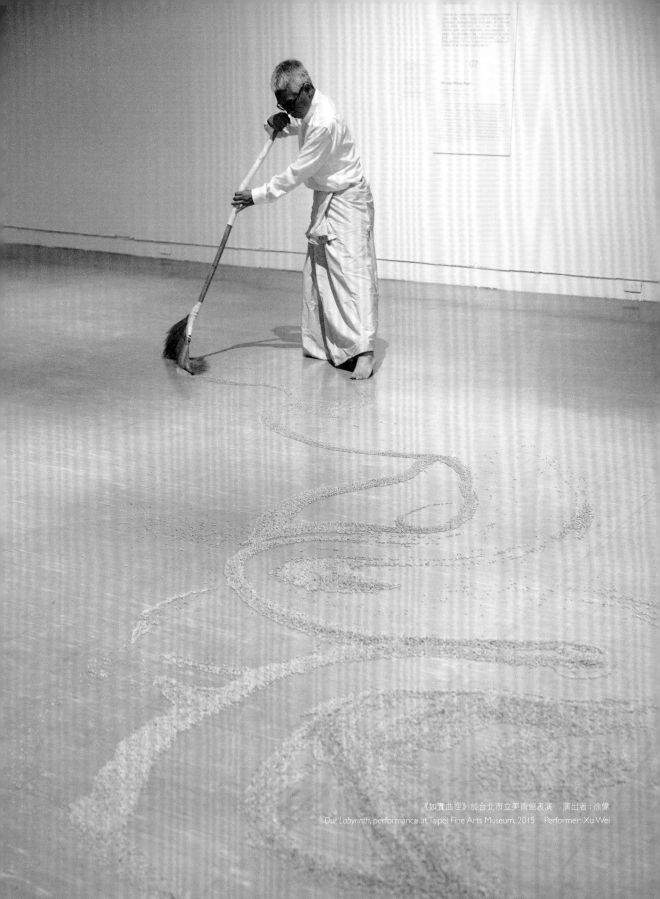

《如實曲徑》於台北市立美術館表演　演出者：徐偉
Our Labyrinth, performance at Taipei Fine Arts Museum, 2015　Performer: Xu Wei

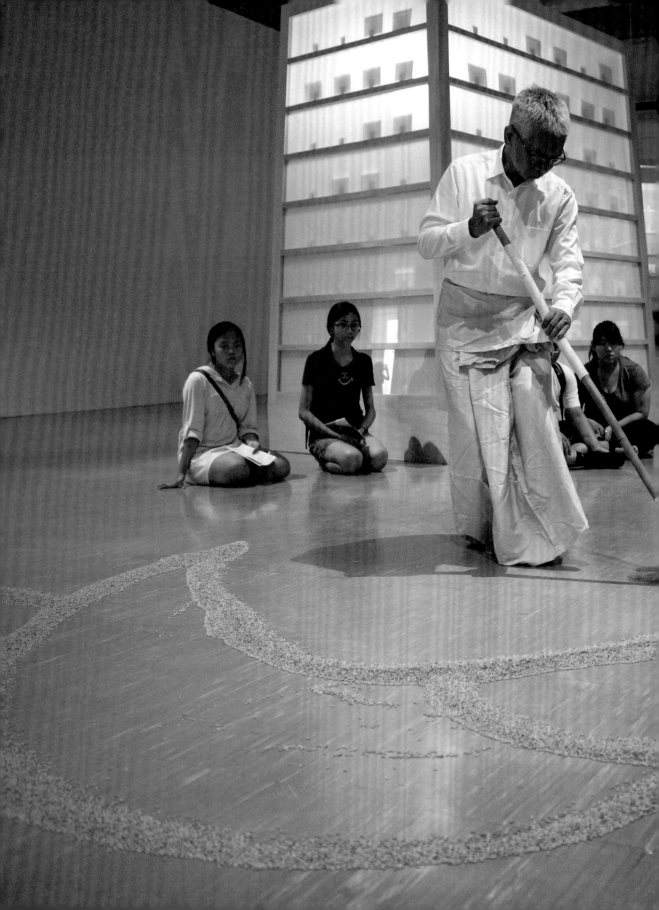

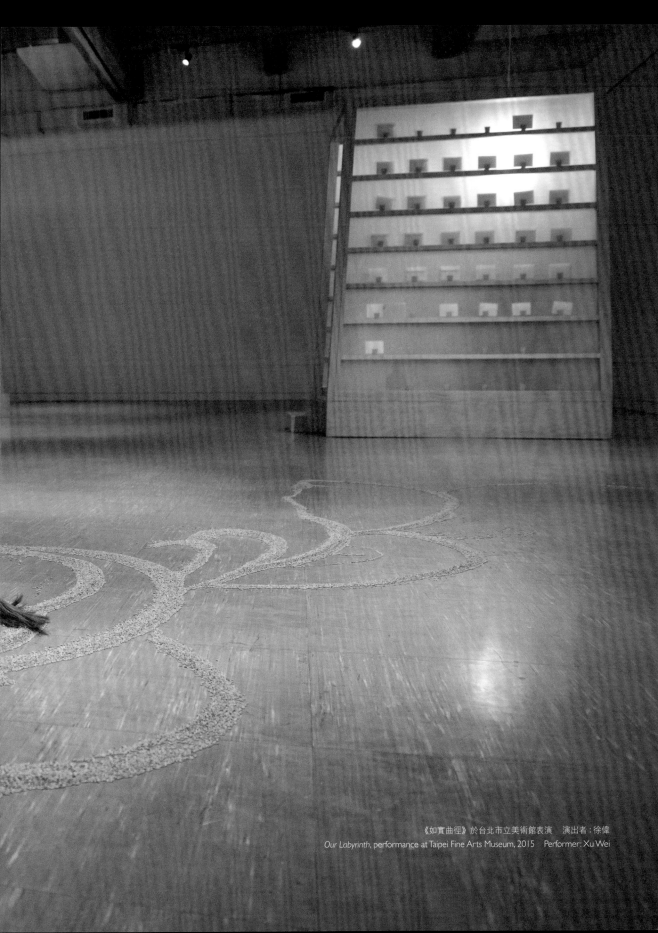

《如實曲徑》於台北市立美術館表演　演出者：徐偉
Our Labyrinth, performance at Taipei Fine Arts Museum, 2015　Performer: Xu Wei

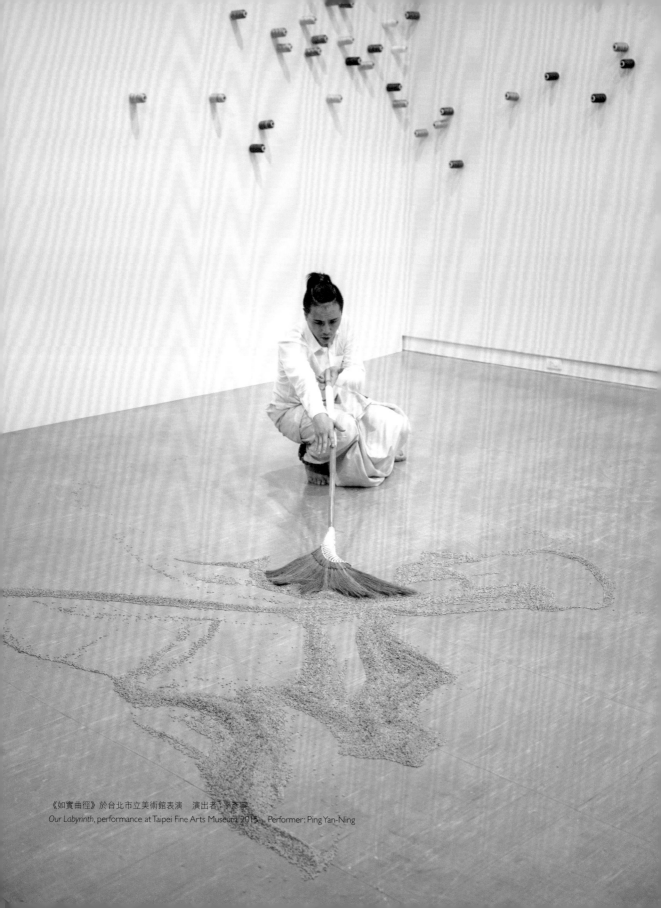

《如實曲徑》於台北市立美術館表演　演出者：平彥寧
Our Labyrinth, performance at Taipei Fine Arts Museum, 2015　Performer: Ping Yan-Ning

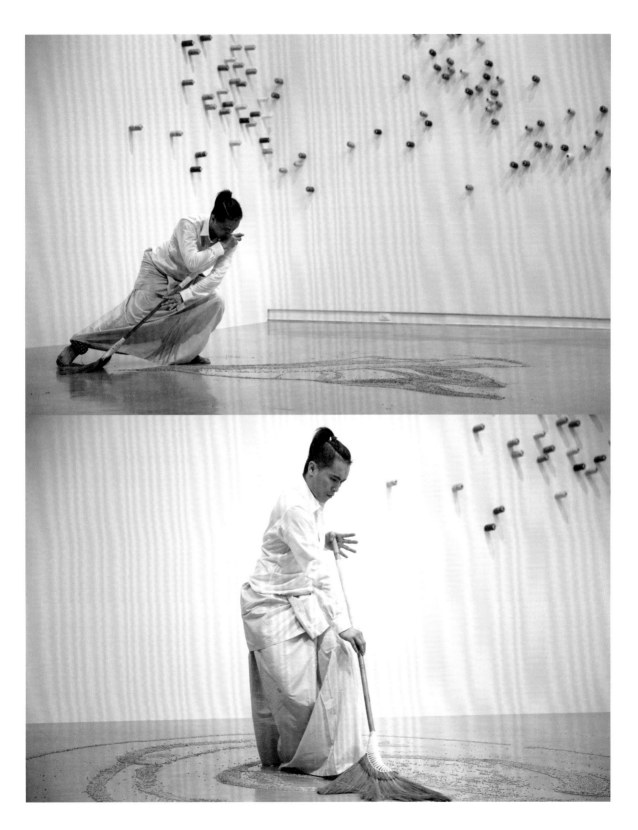

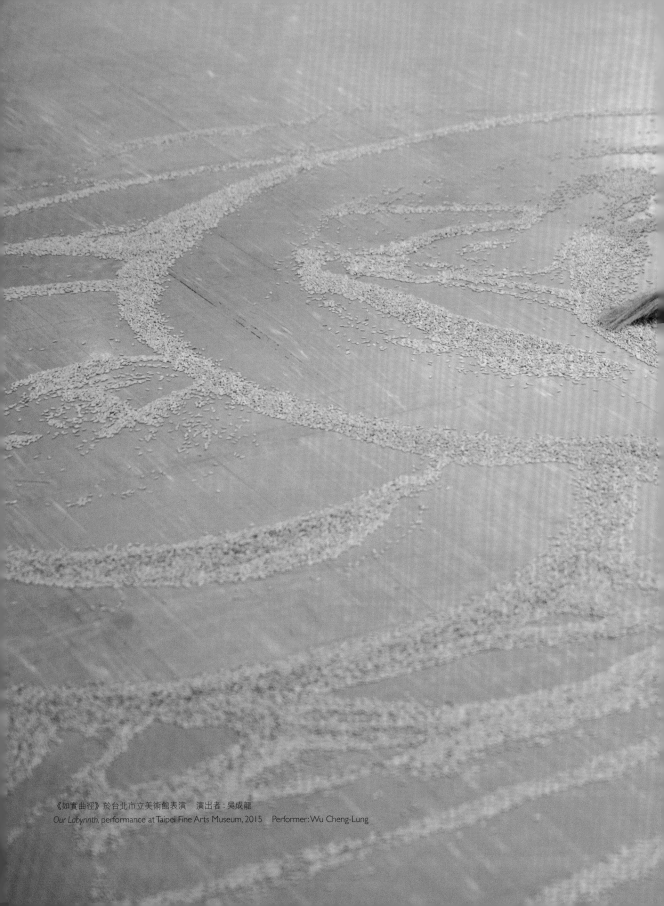

《如實曲徑》於台北市立美術館表演　演出者：吳成龍
Our Labyrinth, performance at Taipei Fine Arts Museum, 2015　Performer: Wu Cheng-Lung

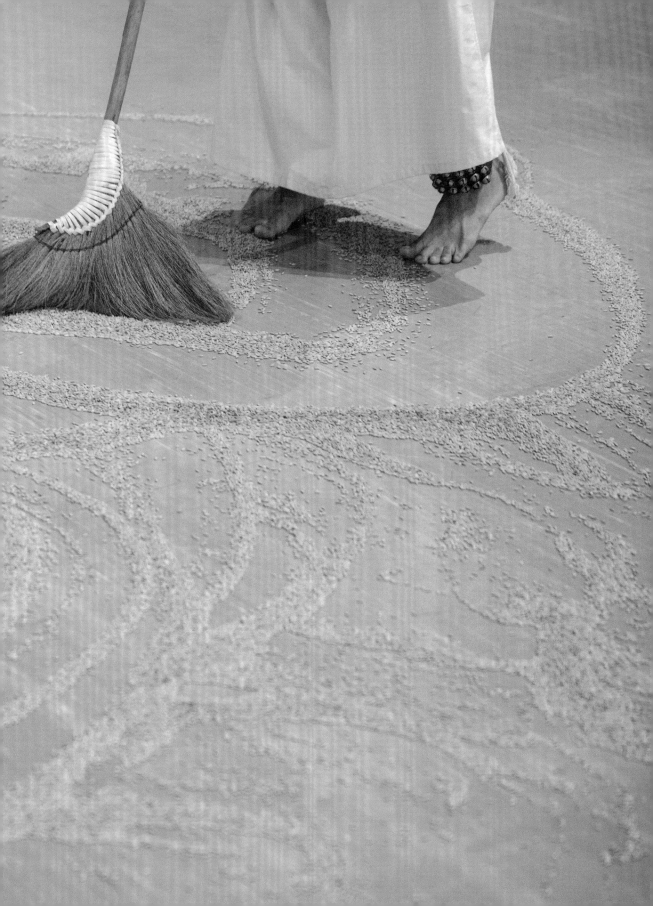

SECTIÓN III

從個人的記憶為起點，
思索與歷史、文化、
社會的連結

李明維的名字，來自日本的明治維新。台灣自 1895 年至 1945 年受到日本統治，李的祖父母與雙親那一輩都經歷了那個時代。1920-1930 年代，李的外祖父在東京的明治大學專攻法學，外祖母在東京女子醫學專業學校（現今東京女子醫科大學）學習西洋醫學。從李明維的家族照片，可以看到他的外祖父母與留學期間的恩師、同學之間，即便在統治終了後依然保持來往。比起社會與政治這種龐大的關係性，從個人的關係架構來思考，又會展現出不同的面貌。

李明維在精神上深受其外祖母的影響。《魚雁計畫》源自於李將他想對已故外祖母表達的感激，親筆寫在信上的體驗。《織物的回憶》則是根據他上幼稚園的第一天，靠著母親親手做的外套得到勇氣的回憶而創作的作品。這些作品計畫，都是以他自己的個人體驗為本，參與者的回憶及經歷與之重疊，令計畫可無止境地擴大。

另一方面，他的裝置及表演作品《如沙的格爾尼卡》，援用了畢卡索以西班牙內戰時無數市民死傷的格爾尼卡這個城市的慘劇為主題，於 1937 年描繪的《格爾尼卡》。21 世紀的今天，世界各地依然紛爭不斷，我們或許可以從李的《如沙的格爾尼卡》看到這人世間的諸行無常，歡喜悲傷，乃至人們的生與死，都在不斷變化的歷史洪流中。

《客廳計畫》則是當初為美國波士頓嘉德納美術館所作。在20 世紀初曾支援岡倉天心等人的嘉德納夫人，是著名的藝術收藏家也是藝術家的贊助者，1903 年創立這間美術館公開展出自己的收藏品。李在美術館內佈置了一間客廳，請館員或當地民眾把他們自己珍貴的收藏品拿來，一一陳述背後的故事與插曲，創造出與觀眾對話的機會。這次，美術館的客廳也不時會有人扮演主人，迎接所有觀眾。

Thinking Connections of History, Culture, Society through Personal Memories

The two Chinese characters that form Lee Mingwei's given name, Mingwei (明維), derive from the four characters used in Japanese for the Meiji Restoration (明治維新). Taiwan was ruled by Japan from 1895 to 1945, and Lee's grandparents and parents generation lived through this era. From the 1920s into the 1930s, Lee's grandfather studied law at Meiji University in Tokyo, while his grandmother studied Western medicine at Tokyo Women's Medical School (now Tokyo Women's Medical University). From looking at Lee's family photos, it is clear that even after Japan's rule of Taiwan ended, exchanges between Lee's grandparents and their former teachers and classmates continued. By considering them from the framework of personal relationships, larger relationships such as society and politics take on a different complexion.

It could be said that Lee was influenced spiritually by this grandmother more than anyone else. *The Letter Writing Project* began with Lee's own experience of writing in a letter the feelings of gratitude he wished he had expressed to her before

she passed away. *Fabric of Memory* was inspired by Lee's memory of being heartened on his first day at kindergarten by the jacket his mother made for him. Both of these works are based on Lee's own personal memories, and by combining these with the memories and stories of participants, the projects expand indefinitely.

At the same time, the installation and performance piece *Guernica in Sand* uses as its point of departure Picasso's 1937 painting *Guernica*, which deals with the tragedy of the bombing of the town of Guernica during the Spanish Civil War, resulting in the deaths of scores of civilians. Today in the 21st century, as conflicts continue around the world, perhaps one can detect in *Guernica in Sand* the message that all things on this earth are impermanent, that joy and sadness and even human life and death are part of the vast flow of history.

The Living Room was originally commissioned by the Isabella Stewart Gardner Museum in Boston. Mrs. Gardner, who in the early 20th century enjoyed a close relationship with Okakura Kakuzō (also known as Okakura Tenshin) among others, was a famous art collector and patron who in 1903 established an art museum to display to the public her own collection. By creating a living room inside Gardner Museum, Lee enabled visitors to hear from the museum staff and people in the neighboring communities their personal collections, stories and episodes of their objects. For this touring retrospective, in *The Living Room* at the museum, a host will occasionally be present to welcome visitors.

織物的回憶

2006 / 2015

複合媒材互動裝置
木作平台、木盒、24 件織物

那是上幼稚園的第一天，照片中不安的李明維，因為穿上母親親手縫製的衣服，才有了上學的勇氣。《織物的回憶》源自 2006 年利物浦雙年展的邀請，利物浦曾是個活躍的紡織工業城，這個特殊的歷史背景，讓藝術家聯想起兒時家庭手織物的溫暖記憶，而開啟了此一涵融城市歷史與個人私密回憶的創作計畫。透過公開徵件，邀請參與者提供一件與個人成長歷程或家庭經驗有關的手工織物，並寫下埋藏在這件織物背後的動人故事；隨後，藝術家從中挑選展出。織物伴隨屬於它的小故事，珍藏在特製的木盒裡，隨著開啟木盒，參觀者宛如遁入時光隧道，靜靜遊歷一個個珍貴的記憶寶盒。

李明維與其母親
Young Lee Mingwei with his mother, 1969

Fabric of Memory

2006 / 2015

Mixed media interactive installation
Wooden platform, wooden boxes, 24 fabric items

The inspiration for *Fabric of Memory* arose from a childhood photograph of Lee Mingwei, dressed entirely in clothing his mother had made for him, holding his mother's hand. The photo was taken on his very first day of kindergarten, and the idea of being away from his parents made him very unhappy. Lee finally agreed to go to school after his mother told him to think of the jacket he was wearing as her embracing him throughout the day. *Fabric of Memory* began in 2006 when Lee took part in the Liverpool Biennial. Liverpool once had a vibrant textile industry. This special historical background stirred in the artist heartwarming memories of handwoven textiles and launched this art project that melds city history with private recollections. The artist has invited submissions from local residents, a piece clothing or cloth related to their growing-up experiences or their family life. He also asked them to write down a touching story that lay behind this item. Lee then chose several of the items for exhibition, arranging them with their accompanying tales, in specially crafted wooden boxes. When a visitor opens one of the boxes, they seem to travel back in time, quietly delving into a treasure chest of cherished memories.

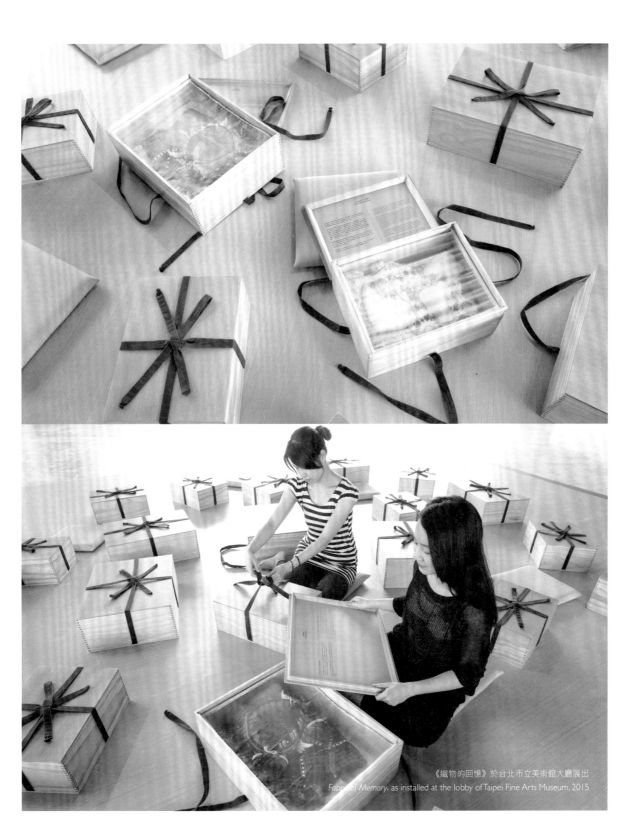

《織物的回憶》於台北市立美術館大廳展出
Fabric of Memory, as installed at the lobby of Taipei Fine Arts Museum, 2015

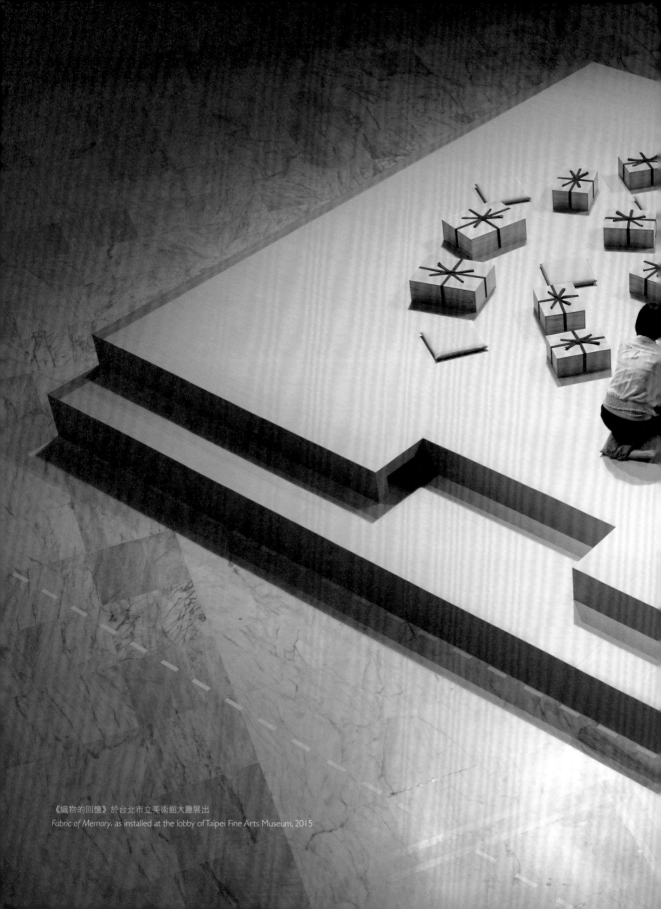

《織物的回憶》於台北市立美術館大廳展出
Fabric of Memory, as installed at the lobby of Taipei Fine Arts Museum, 2015

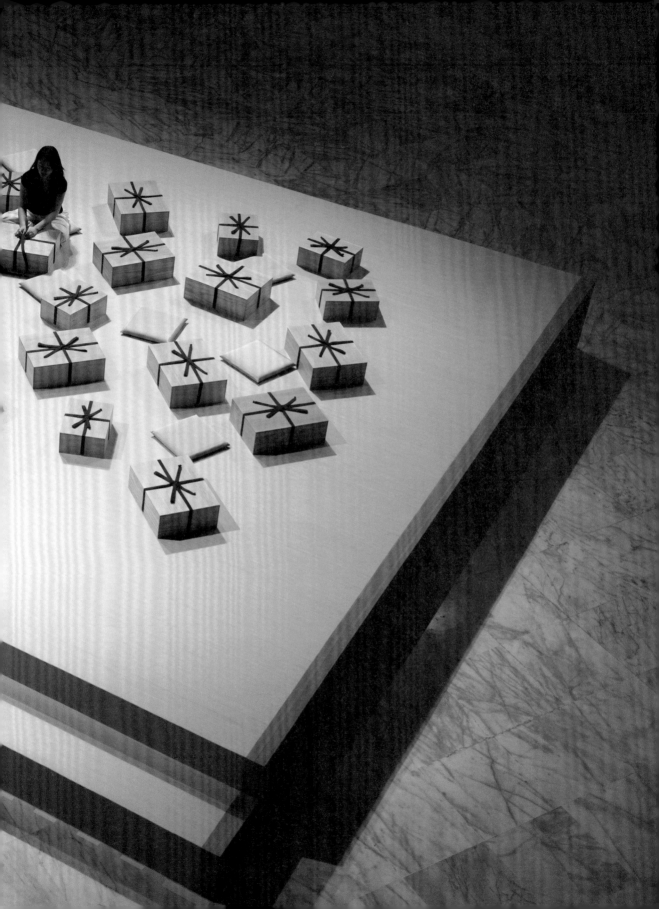

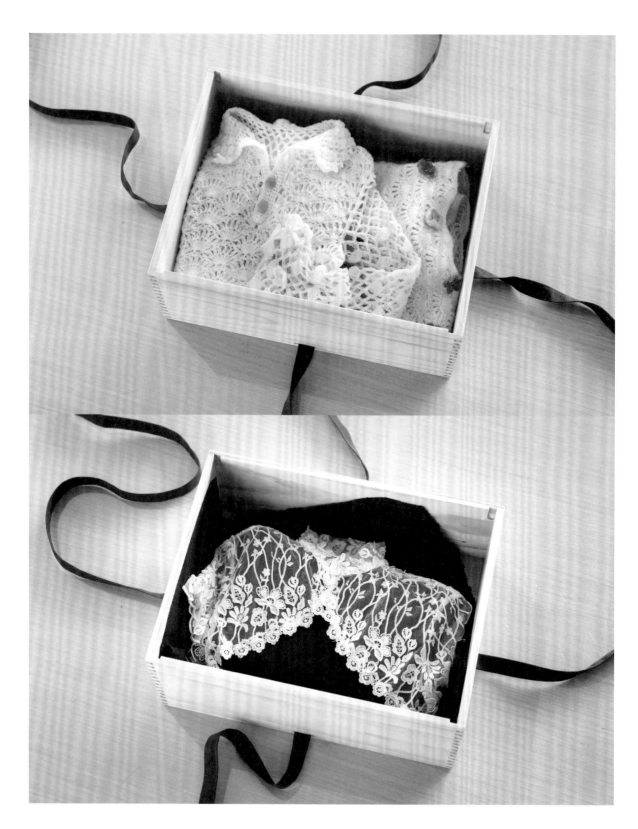

毛線小洋裝

時光回到我七歲那年，小叔叔即將要結婚，為著這場喜宴，我的堂姊妹們都興高采烈地採購了美麗的新衣裳。而家裡的經濟並不寬裕，無法負擔這額外的支出。母親白天忙工作忙家事，夜裡犧牲了睡眠，花了一個月的時間，一針一針織出這件毛線小洋裝。早熟的我，對此，心情是複雜的，雖然這是一件獨一無二的衣裳，我卻覺得為什麼我不能和別人一樣，它太與眾不同了。最終，喜宴的合照，唯獨我彆扭的不肯入鏡。

如今，它靜靜地躺在女兒的衣櫃深處，雖然女兒再也穿不下。印象中女兒曾經有穿著它拍照，坐在電腦前看了一夜的相片卻遍尋不著。因著女兒小時候的照片勾起許多回憶，忍不住喚她來看，女兒從目錄中隨意點選，沒想到開啟的第三張，就是她開心的穿著這件外婆編織的小洋裝，而時間正落在她七歲的那年。

37 年後，母親當年編織進衣服裡的愛與滿心的期待，依舊透著光輝在我內心閃耀著。

夜靜如水，一趟美好、溫暖的回憶之旅。

願

那一年，我要在蘇格蘭出嫁了。

夫婿的家鄉是個臨尼斯湖的小鎮，比起繁華的台北市，資源匱乏許多。於是我為自己的婚禮訂立了一個大原則：「一切從簡」。舉凡喜帖、會場擺設的裝飾物、伴手禮、新娘捧花、頭飾等等，需要印的、貼的、編的、織的、排版的、上色的，全都自己動手來。

依照當地的習慣，新娘婚紗是要用買的──顯然「租賃婚紗」是個很不浪漫的想法。於是我和未婚夫挑了個吉日，驅車跋涉到愛丁堡找尋我的夢幻婚紗。

說是「夢幻」，但實際上，手裡還是不免要錙銖必較地扣緊預算，加上深植於我的「回收再利用」精神發酵，我們探險似的開著中古小車，穿梭在美麗古城愛丁堡的小巷裡尋找二手婚紗店。

不到一天的時間，我就買到了最佳二手婚紗。只是到目前為止，這般高效率、零失誤的婚禮籌備攻堅行動，卻讓我的心裡感到一絲缺憾，一種強烈難抑的孤獨感。

不久之後，我收到媽媽越洋寄來一件搭配婚紗的薄紗披肩。儘管還沒有親眼看到婚紗，只靠我簡單的描述和基本的尺寸，媽媽為我親手縫製的薄紗披肩是如此完美，彷彿她就站在我的面前，帶著她的老花眼鏡，一針一線地縫入她對我們的祝福。

此時我心裡的那股缺憾，瞬間就被填滿了。

Little Dress of Yarn

When I was seven years old, my youngest uncle was getting married. My cousins all bought beautiful new clothes for the wedding banquet. But my family was poor and we could not afford the extra expenditure. Busy with housework during daytime, mother sacrificed her sleep and spent one month knitting this woolen dress. I had mixed feelings about it. The dress was one of a kind, but it looked too different. In the end, I was the only one who refused to pose for the group photos at the banquet.

Now, it quietly lies deep inside my daughter's wardrobe. Even though she could longer wear it now, I recalled she had taken photos dressed in it. But I could not find the photos after searching the whole night. I asked her to come and see her childhood photos, and she clicked at random in the list. The third photo she opened was the one in which she was wearing this little dress knitted by her grandma when she was seven.

Thirty-seven years later, the love and expectations that mother knitted into the dress still glow in my heart.

It was a wonderful and warm trip down memory lane in the quiet night.

Blessing

That year, I was about to get married in Scotland.

My husband's hometown is a little village near Loch Ness, with much fewer resources than bustling Taipei. So for my wedding, I set one principle: "Keep everything simple." Everything, the invitations, decorations and gifts, the bouquet and headwear, I made myself by hand – printing, pasting, weaving, arranging, dyeing.

According to local custom, the bridal dress must be bought – obviously, renting a wedding dress is not a romantic idea. So my fiancé and I chose an auspicious day and drove to Edinburgh, to pick out the wedding dress of my dreams.

I use the word "dreams," but in fact, we had a tight budget. Plus, we deeply believed in recycling and reusing things. So we adventurously drove our second-hand car around the lanes of this historical city, looking for a second-hand wedding dress shop.

Within a day, I had bought the most wonderful used wedding dress. The only thing is, at that point, this highly efficient, perfectly executed mission still left my heart a little empty, with a sense of loneliness that was hard to suppress.

Not long after, my mother sent me a gift from Taiwan – a lace wedding shawl, to go with my wedding dress. Relying only on my description of the dress, my mother had made a perfect shawl by hand, as if she had been standing in front of me, blessing us with each thread.

At that moment, the void in me was instantly filled.

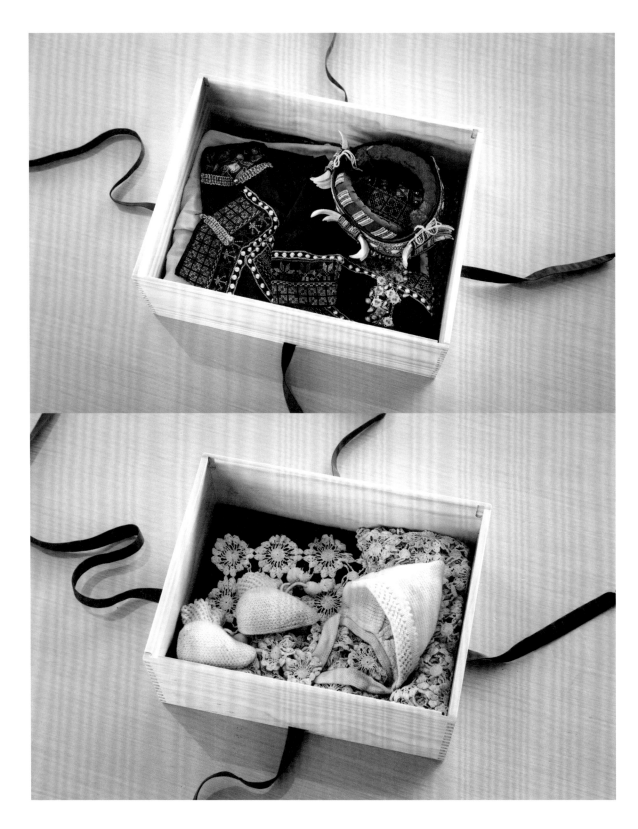

結婚禮服

這是媽媽親手為我與先生所縫製的結婚禮服。

20 年來的婚姻之路，歷經流產三次、先生外遇，憂鬱的生活讓我在懷妹妹的時候曾經想帶著三個孩子離開這個家。女兒出生不到一個月，先生住院開刀，原本我想棄先生而去，但看著先生沒有人照顧，一個人孤零零的在醫院求生存；不管自己還在坐月子仍然辛苦到醫院照顧他。這一次我以真誠的心換到了先生回頭照顧家庭與我。

自從妹妹出生後，我身體變得軟弱無法再到田裡工作，於是我拿起針線向媽媽學習傳統服裝十字繡的繡法，並試圖了解媽媽是如何製作傳統衣服的，因為我有三個兒子與一個女兒，我需要花時間為他們製作傳統服裝，這是我們原住民的傳統文化。

Wedding Suits

These are the wedding suits my mother made by hand for my husband and me.

Over the course of 20 years of marriage, I went through three miscarriages, and my husband was unfaithful to me. I felt depressed, and once, when I was pregnant with my daughter, I thought of taking my three boys and leaving home. Less than a month after my daughter was born, my husband had to have surgery. I had been contemplating leaving him, but when I saw him all alone in the hospital, struggling to survive with no one to take care of him, I stayed with him, looking after him, even though I was still supposed to be resting from childbirth. My faithfulness changed my husband's heart, and he started taking good care of our family and me.

After my daughter was born, I became weak and could no longer work in the fields. So I took up my needles and studied traditional cross-stitch embroidery from my mother. I tried to understand how my mother made traditional clothing, because I have three sons and a daughter. I have to spend time making traditional clothing for them. This is the traditional culture we indigenous people have.

未完成的手工蕾絲

幾年前搬家時，發現父親的衣櫥像是民國 61 年的時空膠囊，保存著幼年時，母親曾穿戴過的舊旗袍、手提包、毛領外套，結婚時戴的手套、相片、賓客簽名本，弟弟即將出生時母親親手做的娃娃鞋，和這條已經編織到一半的手工蕾絲。

對母親的印象很模糊，最常聽到親戚們形容母親的說法，她是個體貼不多話、手巧心細、溫柔善良的人。母親離開後，父親鰥居四十多年，其衣物在父親的衣櫥裏維持得整整齊齊，彷彿母親隨時就要回來了一樣。父親是強烈反對處理掉這些衣物的，只是礙於現實，不得不挑選最值得紀念的帶走。父親選擇了幾件保持得相當新穎的外套，說：這妳們可以穿啊，妳們看，還很新啊，當年妳媽可都是捨不得穿的！這是妳媽親手編織的蕾絲啊，她就愛做這些啊，她一直說織好了可以給剛出生的弟弟當床單啊，只是，都快織好了，還差一點點，怎麼人不在了。

我輕輕碰觸這條母親手織的蕾絲，彷彿母親就在身邊一樣，記憶中早已淡忘的母親的身影，在午後溫暖的陽光裏，浮現出一針一線織給家人們的愛。說來也是巧合，我長大後，在沒有人教導我的情況下居然自己學會編織，好像是天生就會了一般。或許，是母親在我看不見的地方指導我吧。

曾經想過，要不要將母親未完成的部分，自己來勾織最後的完成品，後來，感覺自己技巧不如母親，而且這是屬於父親的記憶，應該留給母親繼續來完成吧。

The Unfinished Lace

A few years ago when we were moving, I opened up my father's wardrobe and discovered what seemed like a time capsule from 1972. In it were the things my mother wore when I was a child – an old qipao, a handbag, a coat with a fur collar – and mementos from their wedding – a pair of gloves, photos, a guest registry book. I found baby shoes my mother made by hand when she was expecting my brother, and also this half-completed lace.

I only have vague impressions of my mother. My relatives say she was loving and taciturn, good with her hands, warm and kindly. After she departed, my father lived as a widower for over four decades. He kept her clothes tidy in his wardrobe, as if my mother might come back at any moment. Father was strongly opposed to getting rid of these clothes. But he really had no choice. He had to pick out just a few to bring along as keepsakes. He chose a few coats that were quite well preserved, saying, "You could wear these. Look, they're still good as new. Back then, your mother thought it was a pity to wear them! This is the lace your mother embroidered by hand. She loved to do those kinds of things. She was going to use it as a blanket for your brother when he was born. She was almost finished, just a little to go, and then she was no longer with us."

I gently touched this lace my mother had made. It was as if she was right next to me. The image of my mother had long ago faded from my memory. In the warm afternoon light, the strands of the love she felt for her family floated into view. It may be a coincidence, but after I grew up, I suddenly took up embroidery, without anyone teaching me, as if I came by the ability naturally. Maybe it was my mother teaching me from a place I couldn't see.

I've often wondered if I should finish that last part my mother had left undone. Ultimately, I decided my technique just wasn't a match for her's. And what's more, this was a memory that belonged to my father. We should leave it for my mother to complete.

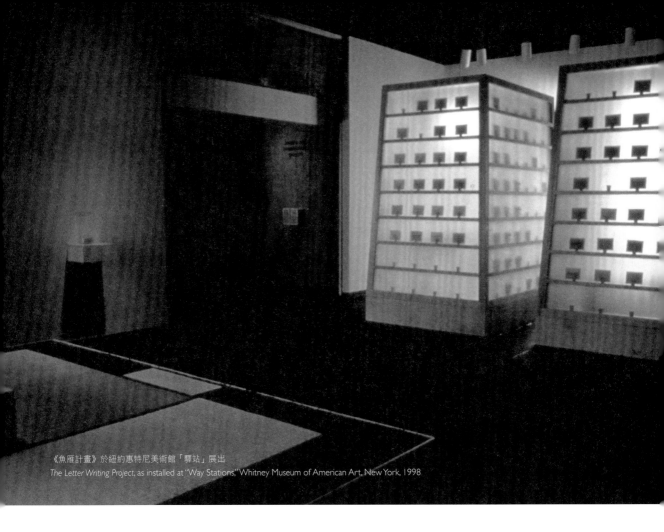

《魚雁計畫》於紐約惠特尼美術館「驛站」展出
The Letter Writing Project, as installed at "Way Stations," Whitney Museum of American Art, New York, 1998

魚雁計畫

1998 / 2015

複合媒材互動裝置
木作驛亭、信紙、信封
三座，各 290 × 170 × 231 cm

《魚雁計畫》源起於李明維對驟然而逝的外祖母無盡的追憶與懷念，在外祖母過世後的一年半時間，他不時寫下自己想對外祖母說、卻來不及說的話語與心情，就彷彿她還在世。藝術家邀請觀眾自由進入展場中三座驛亭，寫下一封掛念著要寫但未完成的信函，以表達「感謝」、「原諒」或悔悟之情；寫完後，可決定是否封緘、或是寫下地址交由美術館代為郵寄，並將信件留置於展示架上，成為展覽的一部分，讓其他參觀者可以閱讀，從而產生情感的連結與分享。透過這個計畫，一方面希望為那些心中同樣有著某些遺憾卻無從傳達的人們，提供一個能夠稍許彌補的可能性；另一方面，在寧謐溫煦的木作小亭中，伴隨深摯訴說而來的凝思與沉澱，讓「魚雁」誕生具有儀式性的療癒力量。

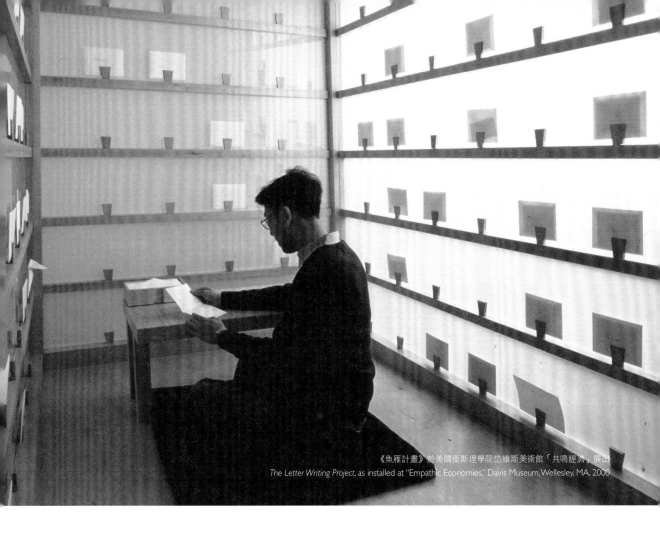

《魚雁計畫》於美國衛斯理學院岱維斯美術館「共鳴經濟」展出
The Letter Writing Project, as installed at "Empathic Economies," Davis Museum, Wellesley, MA, 2000

The Letter Writing Project

1998 / 2015

Mixed media interactive installation
Wooden booth, writing papers, envelopes
3 pieces, 290 x 170 x 231 cm each

When his maternal grandmother passed way, Lee Mingwei felt he still had many things to say to her, but it was too late. For the next year and a half, he wrote many letters to her, as if she were still alive, in order to share his thoughts and feelings with her. In *The Letter Writing Project*, the artist invites visitors to write the letters they have always meant to write, but have never taken the time to. Visitors can enter one of the three booths and write a letter to a deceased or otherwise absent loved one, offering previously unexpressed gratitude, forgiveness or apology. They can then seal and address their

letters (for posting by the museum) or leave them unsealed in one of the slots on the wall of the booth, where later visitors can read them. After reading the letters of others, many visitors may come to realize that they too carry unexpressed feelings that they would feel relieved to write down and perhaps share. In this way, a chain of feeling is created, reminding us of the larger world of emotions in which we all participate. In the end, it is the spirit of the writer that is comforted, whether the letter is ever read.

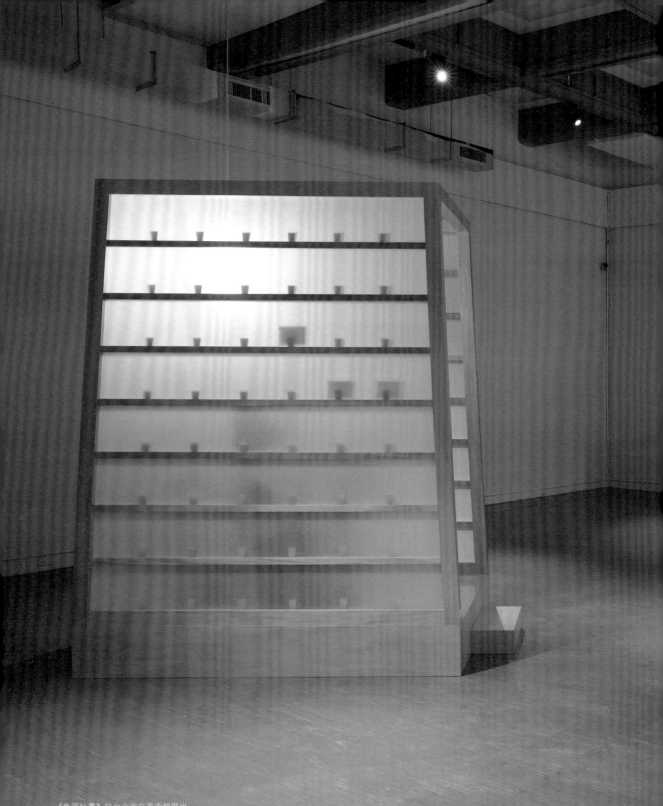

《魚雁計畫》於台北市立美術館展出
The Letter Writing Project, as installed at Taipei Fine Arts Museum, 2015

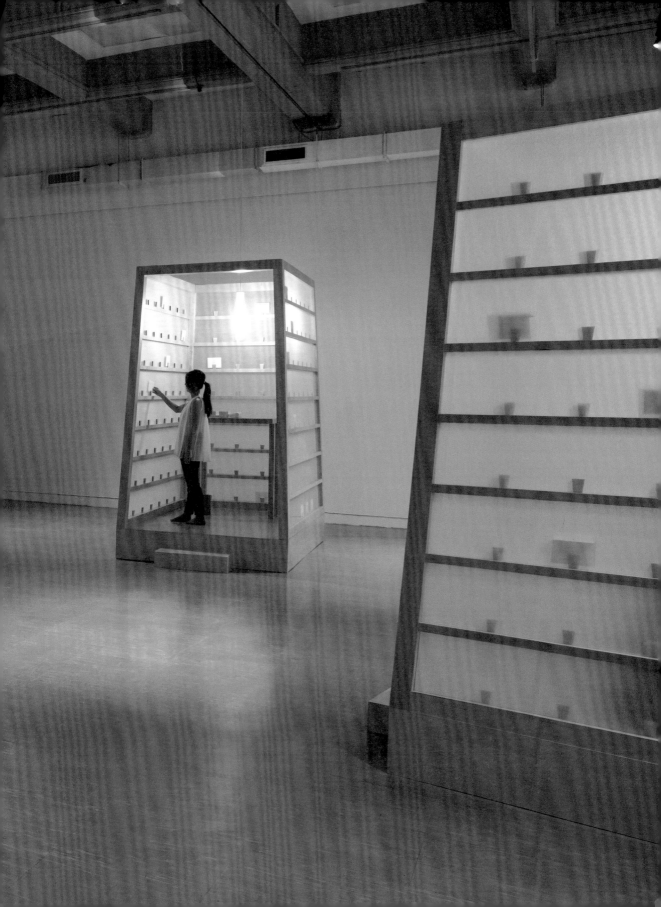

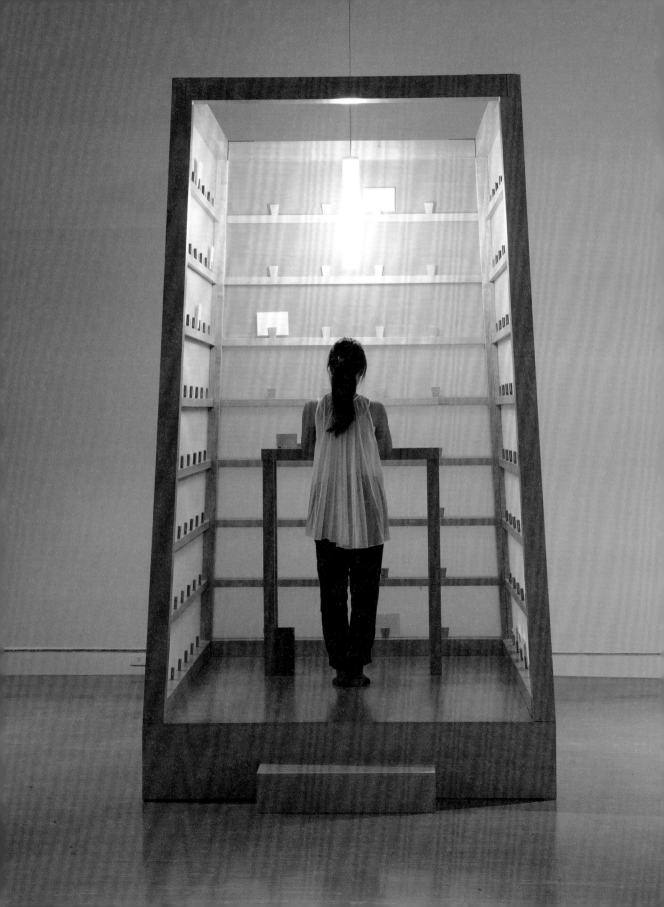

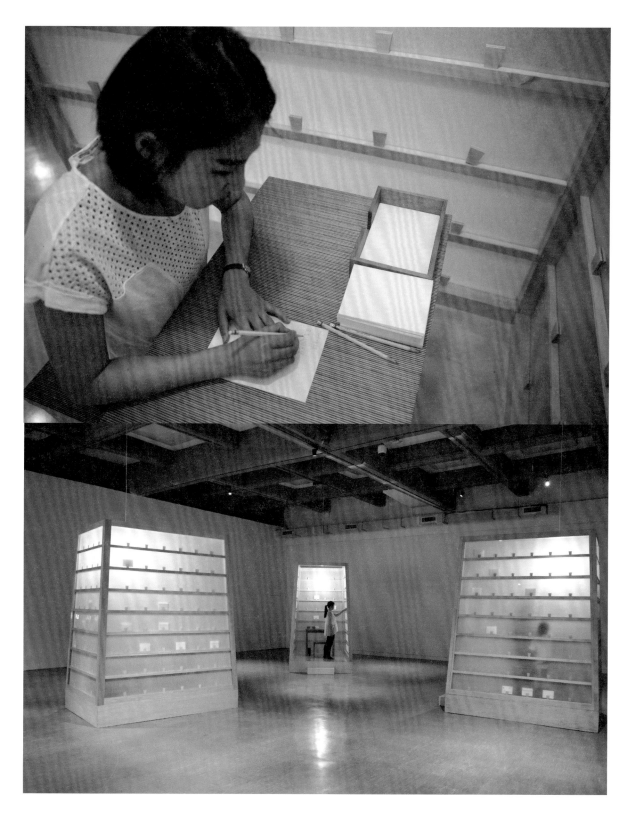

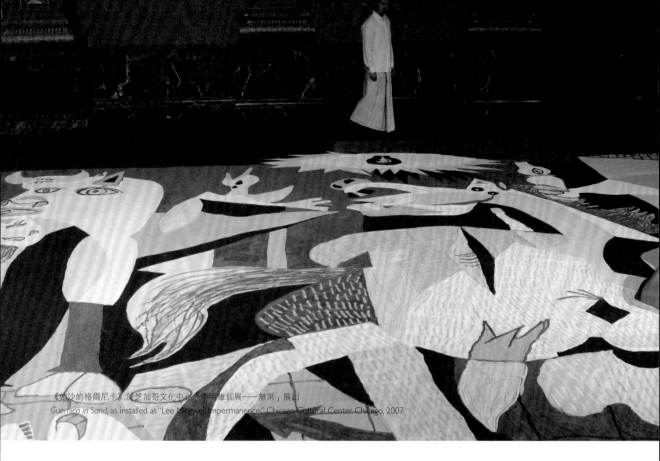

《如沙的格爾尼卡》於芝加哥文化中心「李明維個展──無常」展出
Guernica in Sand, as installed at "Lee Mingwei: Impermanence," Chicago Cultural Center, Chicago, 2007

如沙的格爾尼卡

2006 / 2015

複合媒材互動裝置
沙、木作小島、燈光
1300 × 643 公分

在《如沙的格爾尼卡》中，李明維以沙壇城的形式重新詮釋畢卡索的名作《格爾尼卡》，希望以另一種角度來審視1937 年西班牙內戰期間，發生在格爾尼卡城的殘暴屠殺。面對這些傷害與犧牲，與其停留在既有的批判裡，毋寧以世間無常的概念視之，如同沙是因岩石經風和水的風化作用而分解生成，復經壓力和溫度的作用重新凝固為岩石，李藉由沙來象徵不斷毀滅與創造的持續現象，希望人們在經歷慘痛的歷史後，能看到破壞背後轉化的力量。

開展前，《格爾尼卡》主體的沙畫已完成大半。李明維會擇展期中的某一日，從日出到日落，繼續完成剩下的部分。沙畫上將建造一個木作平台，在這一天，參觀者不只可以登上平台由高處俯視，還能赤足步入沙畫，與藝術家一起經歷沙畫創造、變化及逐漸消失毀壞的過程。日落時分，參與者被邀請一同將沙匯集到展廳中央，並保留這樣的狀態直到展期結束。

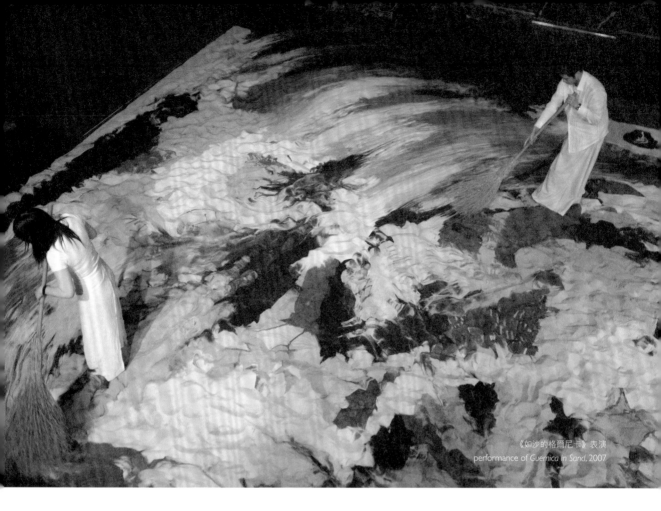

Guernica in Sand

2006 / 2015

Mixed media interactive installation
Sand, wooden island, lighting
1300 × 643 cm

In *Guernica in Sand*, Lee Mingwei used Picasso's *Guernica* as the departure point for a different view of the damage done when human beings are victimized. Instead of simply being critical of what happened in the Basque town of Guernica in 1937, the artist wanted to use the concept of impermanence as a lens for focusing on such violent events in terms of the ongoing phenomena of destruction and creation. Lee used sand to symbolize these processes, since its "lifespan" includes being "born" from the erosion of rock by the action of water or wind, and being reformed into rock by the action of pressure or heat. His goal is to draw attention to the creative power of transformation, rather than to the pain caused by clinging to things as they are.

In this project the artist creates the majority of a sand-painting version of *Guernica* before the exhibition opens. Then, he creates the remainder of the piece within one day, midway through the exhibition. This performance commences at sunrise and concludes at sunset. Throughout this day, one person at a time is allowed to walk (ideally barefoot) on the sand-painting, effacing it at the same time the artist creates it. Visitors are allowed to view this process of simultaneous creation and destruction from the vantage point of a small island constructed above the sand-painting. At sunset on that day, participants are invited to sweep the sand toward the middle of the installation, and the project is then left in this condition until the exhibition closes.

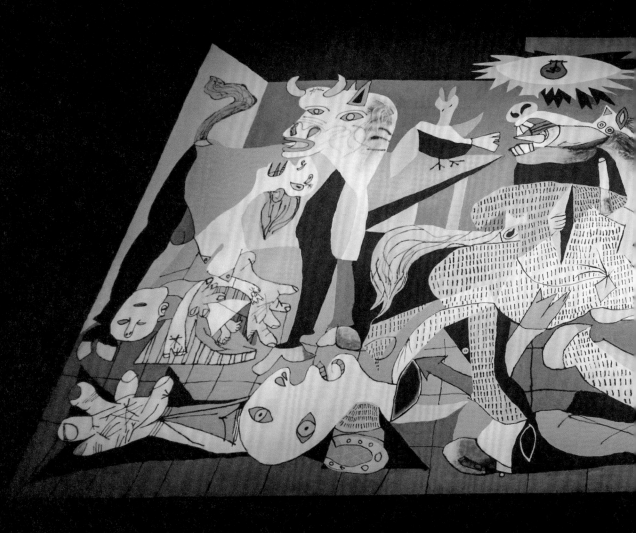

《如沙的格爾尼卡》於台北市立美術館展出
Guernica in Sand, as installed at Taipei Fine Arts Museum, 2015

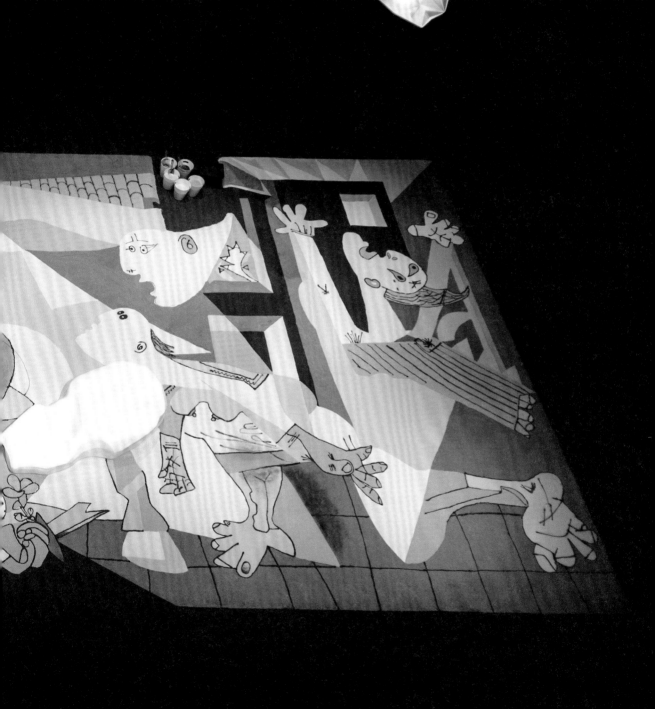

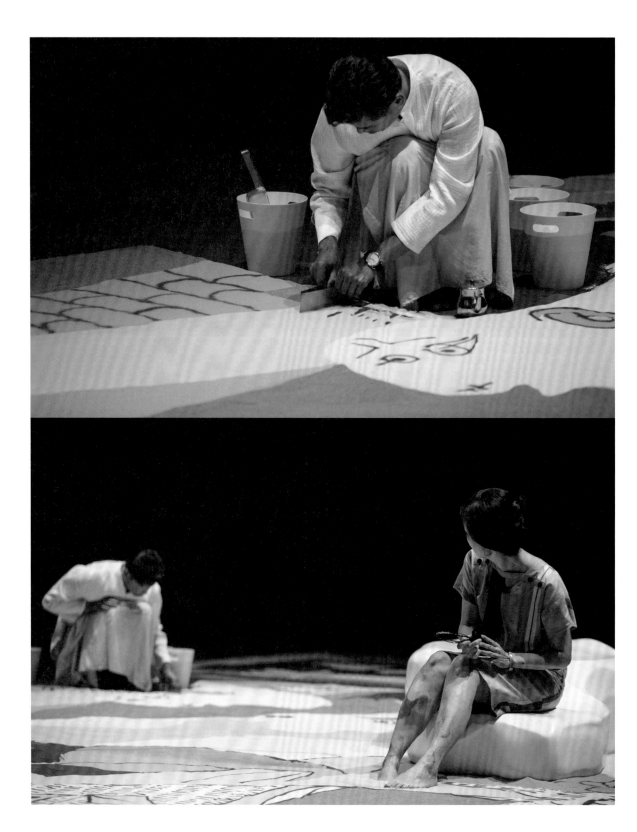

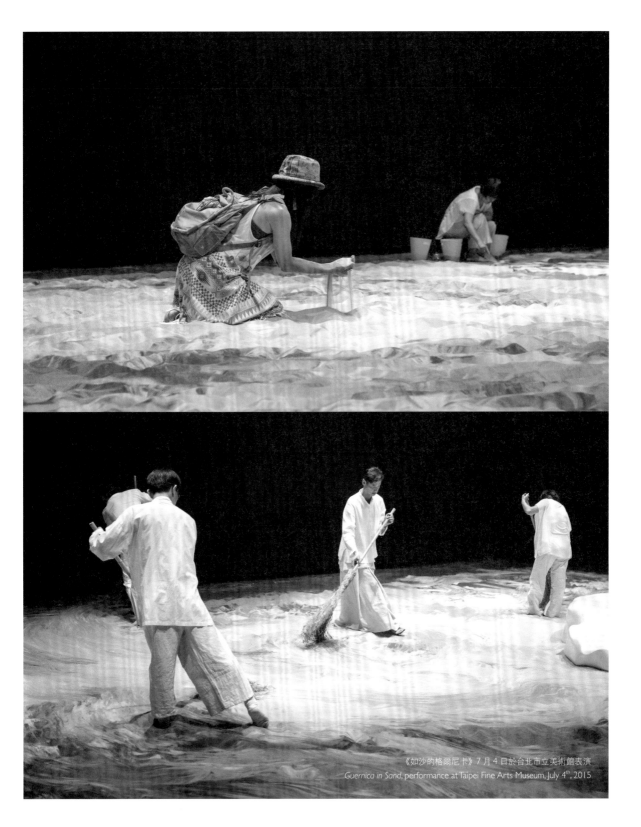

《如沙的格爾尼卡》7月4日於台北市立美術館表演
Guernica in Sand, performance at Taipei Fine Arts Museum, July 4th, 2015

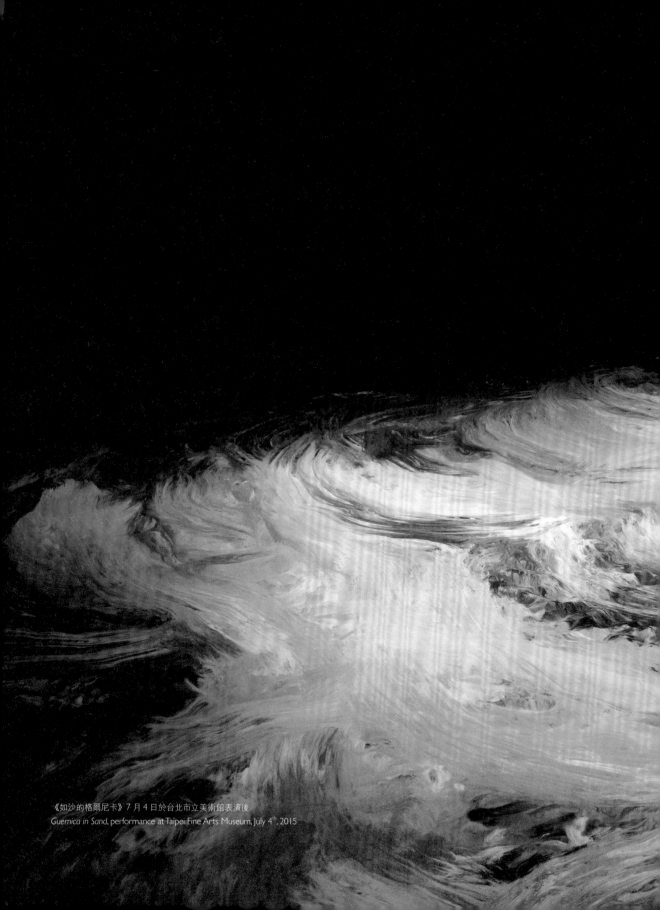

《如沙的格爾尼卡》7 月 4 日於台北市立美術館表演後
Guernica in Sand, performance at Taipei Fine Arts Museum, July 4th, 2015

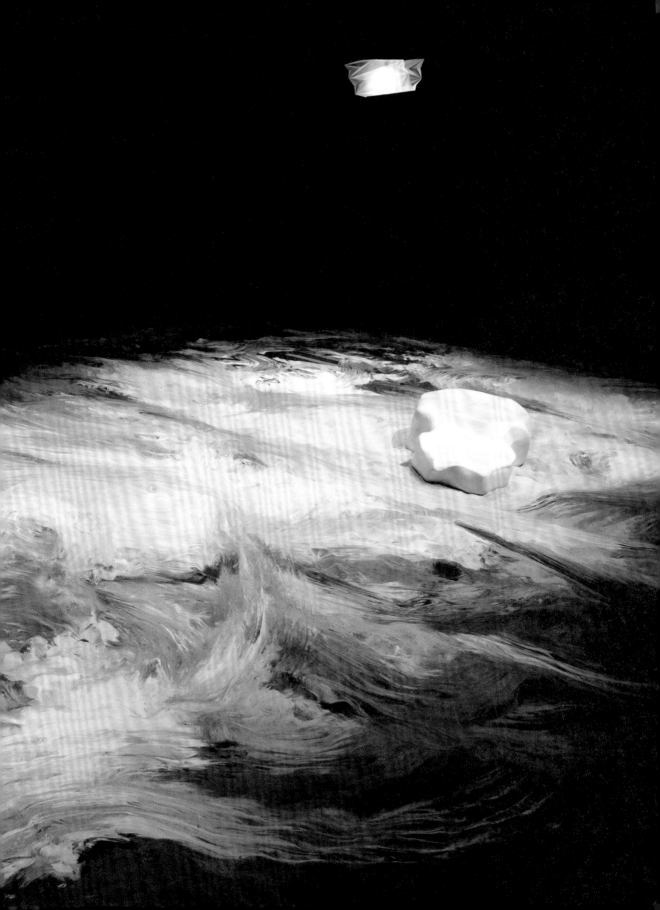

客廳計畫

2000 / 2015

複合媒材互動裝置

嘉德納夫人（Isabella Stewart Gardner, 1840–1924）是世界知名的收藏家，《客廳計畫》係 2000 年受波士頓嘉德納美術館委任製作的計畫。藝術家將歷史悠久的嘉德納美術館轉化成現代客廳空間，並邀請美術館館員、董事會成員等相關人士擔任客廳主人，將他們珍貴的收藏展示於空間中，與前來的觀眾展開對話，分享個人的藏品及美學觀。透過這個方式，使嘉德納夫人生前與眾人分享收藏的精神重獲新生，亦使傳統美術館有了新的體驗。2007 年，館方邀請李明維與

建築師 Renzo Piano 共同規劃新館，在 2012 年新館開設之際重現此計畫，並讓它成為常態的空間設置與永久典藏。《客廳計畫》在各地展出時，亦沿用相同的「展中展」形式，邀請美術館館員、志工或藝術家友人擔任「主人」，述說在地人物及其珍藏品的故事，藉以思考「我們為什麼收藏？」、「藏品如何反映收藏者的人格特質？」、「收藏者與其藏品的關係為何？」等問題。

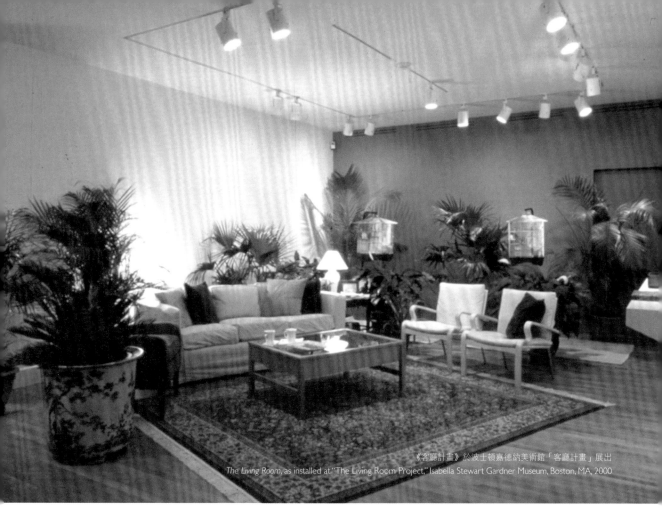

《客廳計畫》於波士頓嘉德納美術館「客廳計畫」展出
The Living Room, as installed at "The Living Room Project," Isabella Stewart Gardner Museum, Boston, MA, 2000

The Living Room

2000 / 2015
Mixed media interactive installation

Isabella Stewart Gardner (1840–1924) was a well-known art collector. In *The Living Room*, originally commissioned by the Isabella Stewart Gardner Museum, Lee Mingwei transformed the museum's gallery into a modern "living room," allowing volunteers from the museum's staff and management, and others having long-term relationships with the museum, to act as hosts in that room. These individual hosts were invited to bring in their own collections of objects having personal or aesthetic significance to them, and engage visitors in dialogues about these. In this way, *The Living Room* revived the experience of personal sharing that had disappeared when Mrs. Gardner died. In 2007 Lee was invited to collaborate with Renzo Piano in designing a new wing of the museum. Opened in 2012, the wing incorporated *The Living Room* as a permanent space, and a part of the museum's permanent collection. Whenever *The Living Room* is exhibited in a different locale, the artist employs the same "exhibition within an exhibition" format, inviting a museum staff member, a volunteer or a friend to serve as the living room's "host." As these local people share stories of their own personal treasures, they lead us to consider such questions as, "Why do we collect?", "What does our collection say about us?", and "How do we relate to our collection?"

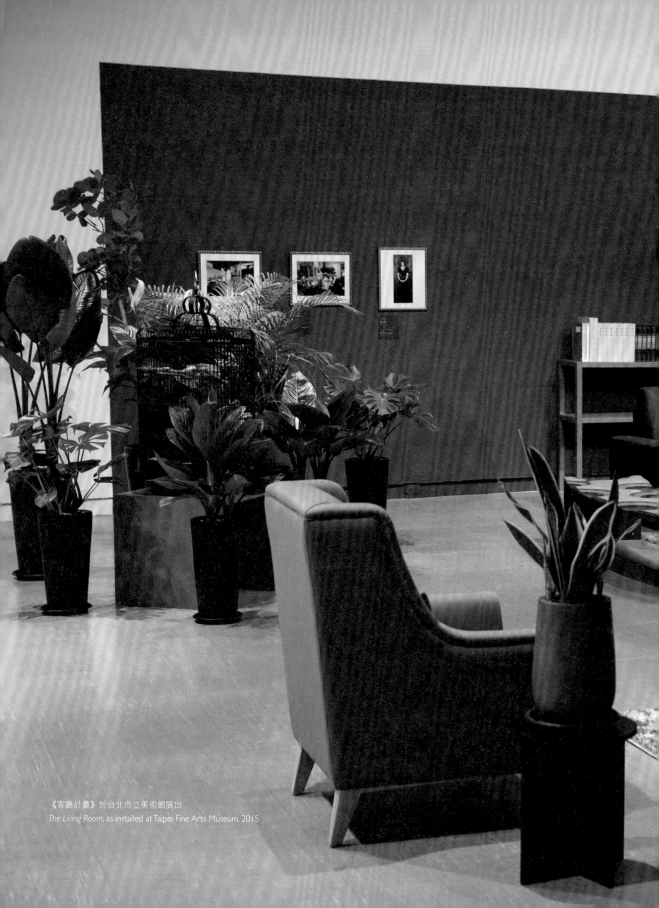

《客廳計畫》於台北市立美術館展出
The Living Room, as installed at Taipei Fine Arts Museum, 2015

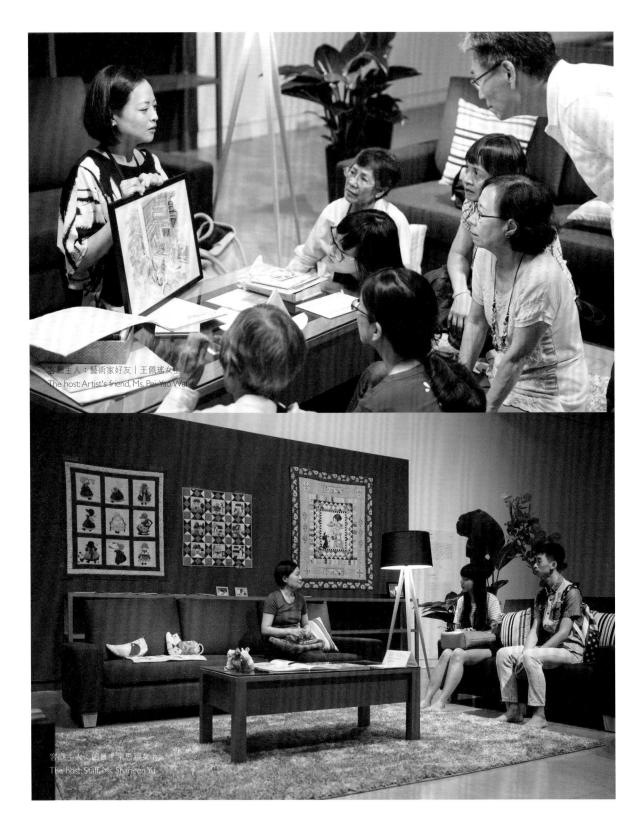

容廳主人：藝術家好友｜王佩瑤女士
The host: Artist's friend, Ms. Pei Yao Wang

容廳主人：館員｜余思穎女士
The host: Staff, Ms. Sharleen Yu

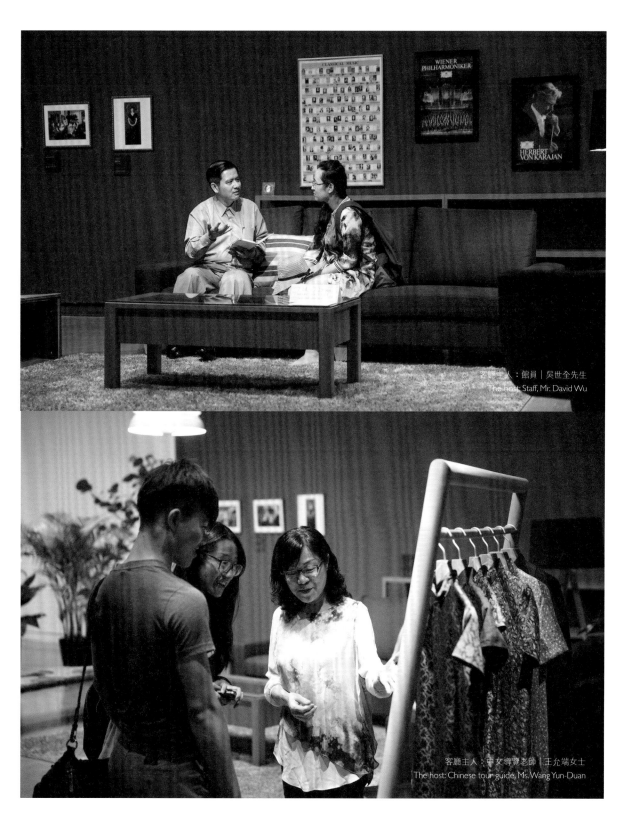

客廳主人：館員｜吳世全先生
The host: Staff, Mr. David Wu

客廳主人：中文導覽老師｜王允端女士
The host: Chinese tour guide, Ms. Wang Yun-Duan

家族相本與個人記憶
Family Album and Personal Memories

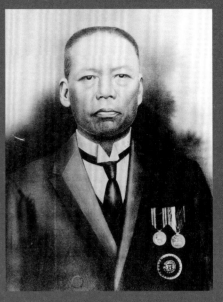

李明維的外曾祖父 (1881-1951)

Lee Mingwei's maternal Great Grandfather (1881-1951)

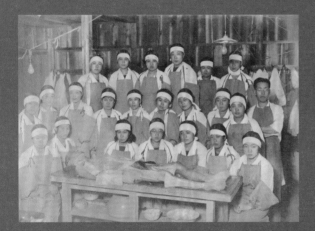

外祖母於東京女子醫學專業學校實習 [中排左三]

Grandmother at her medical practice at Tokyo Women's
Medical School [third from the left in the middle row]

外祖母於東京女子醫學專業學校實習 [後排左八]

Grandmother at her medical practice at Tokyo Women's
Medical School [eighth from the left in the back row]

外祖母與同學們於東京女子醫學專業學校，中為學校創辦人
吉岡博士 [前排右三]

Grandmother with her classmates at Tokyo Women's Medical
School with the founder of the school Dr. Yoshioka in the
middle [third from the right in the front row]

外祖母參加彰化高女畢業同學會，1962 年 [前排右二]

Grandmother at her high school reunion in 1962 [second from
the right in the front row]

1960 年外祖母的恩師吉岡博士造訪台中時，與東京女子
醫學專業學校時期的校友合影 [前排右三]

Grandmother with her former schoolmates at the occasion
of Dr. Yoshioka visiting Taichung in 1960 [third from the
right in the front row]

外祖母王有與外祖父林有川
Grandmother Wang You and Grandfather Lin You Chuan

外祖母 [前排左]、外祖父 [中排左四] 與友人
Grandmother [front left] and Grandfather [fourth from the left in the
middle row] with their friends

明治大學「明台會」畢業生紀念照，1933 年 [外
祖父為第二排中央]
Grandfather commemorating the graduation of
Taiwanese students from Meiji University in 1933
[middle of the second row]

家族於外祖母所開立之「林醫院」前合影，台中，
1960 年代後期 [李明維為前排右二]
Family photograph in front of the Lin Clinic which
Lee Mingwei's grandmother had run in Taichung, late
1960s [Lee Mingwei being second from the right in
the front row]

外祖母 [右] 與李明維的阿姨
Grandmother [right] and Lee Mingwei's aunt

李明維的母親幼年時身穿日本和服
Lee Mingwei's mother in her childhood wearing Japanese kimono

外祖父母與日本友人於自宅前合影，埔里，1930
年代後期

Grandparents in front of their home in Puli, in the
late 1930s, with their Japanese friends

外祖父母於埔里家中 [外祖母後方的椅子及茶
几為李明維作品《水之蓮座》的一部分]

Grandparents at their home in Puli [The chair
and the side table at grandmother's back are
a part of Lee Mingwei's work *Constellation of
Water*]

李明維於多明尼加共和國留學時與雙親合影，1970 年代
Lee Mingwei and his parents while studying in Dominican
Republic in 1970s

家族合照，台北 [李明維為左一]
Family photo in Taipei [Mingwei on the left]

李明維的父母於歐洲旅行，1970 年代
Lee Mingwei's parents traveling in Europe, 1970s

李明維與父母、姊弟，台北
Lee Mingwei with parents, sisters and brother in Taipei

思考「關係」
的作品

白隱 （日本，b. 1685-1768）

鈴木大拙 （日本，b. 1870-1966）

伊夫・克萊因 （法國，b. 1928-1962）

約翰・凱吉 （美國，b. 1912-1992）

亞倫・卡布羅 （美國，b. 1927-2006）

里克力・提拉瓦尼 （阿根廷，b. 1961- ）

吳瑪悧 （台灣，b. 1957- ）

林明弘 （台灣，b. 1964- ）

楊俊 （奧地利，b. 1975- ）

吳建瑩 （台灣，b. 1983- ）

如果世間萬物皆非獨立存在，而是以各種彼此相互關聯的形式所組成的呢？這些「關係」和「連結」不一定是可見的，當我們擴大自身的意識，超越有形，將不可見的領域涵容至我們的世界，那我們就可以看到全新的連結。

縱觀歷史，許多藝術家、宗教家和思想家都曾深切地思考「關係」這個無形的領域。同樣地，李明維藝術創作的本質是奠基於參與其計畫的人們所建構出來的「關係」中，也在其作品所引發對「連結」的反思中，以及人與人之間「贈與」和「信任」等概念的關聯。因此，我們的意識從可見的事物轉向不可見的領域，從結果轉向過程，從物件轉向由物件引發的故事與回憶。

為了對李明維創作的精神性有更深一層的理解，本展設有「省思『關係』的作品」區，展出了十位藝術家、宗教家和思想家的作品及語錄，包含從 18 世紀的日本禪宗大師白隱慧鶴直至當代藝術家等。這些人未必與李明維有直接的關係或影響，而是透過他們對「關係」和「連結」的省思，與李明維互相參照。他們當中有的著眼於自我與他人、天與地的認知，有的關注與佛教世界觀相應的「空」、「無」概念，亦有闡述從踐行日常活動中覺知的禪宗思想。我們也介紹了將非物質、靜寂、無限、日常等東方思想引入創作中的藝術家，以及 1990 年代以來以建構關係和社會參與等新途徑作為創作手段的當代藝術家。

Works for Relationality

What if all the things in the world are not independent of one another, but are interrelated in myriad ways? These relationships and connections are not necessarily visible, but if we extend our awareness beyond the visible and incorporate the realm of the invisible into our world, completely new connections come into view.

Throughout history, many artists, religious leaders and thinkers have attained deeper insight by focusing their awareness on this realm of relationships, on this invisible dimension. The essence of Lee Mingwei's art practice, too, lies in the relationships born out of people's participation in the frameworks of his projects, and in pondering the connections revealed in the workings of nature, the continuity of human relations, and such concepts as gifting and trust. This leads to a shift in our awareness from the visible to the invisible, from the results to the process, and from material things to the stories and memories they evoke.

To facilitate a deeper understanding of Lee's practice, we present "Works for Relationality" – art and quotations by ten artists, religious leaders and thinkers, ranging from the 18th-century Zen master Hakuin to artists active today. These figures have not necessarily had a direct influence on or direct contact with Lee Mingwei, yet, by contemplating relationships and connections, they have focused their awareness on the self and others, heaven and earth, or the concepts of "nothingness" and "emptiness" that resonate with the Buddhist worldview, or they have articulated the Zen philosophy of undertaking everyday activities mindfully. We also introduce artists who have touched on Eastern ideas of immateriality, silence, the infinite and the everyday, as well as those who since the 1990s have pursued a new approach to contemporary art by focusing on relations and social engagement.

內經圖

View of the inner dimensions
(*Nei-jing-tu*)

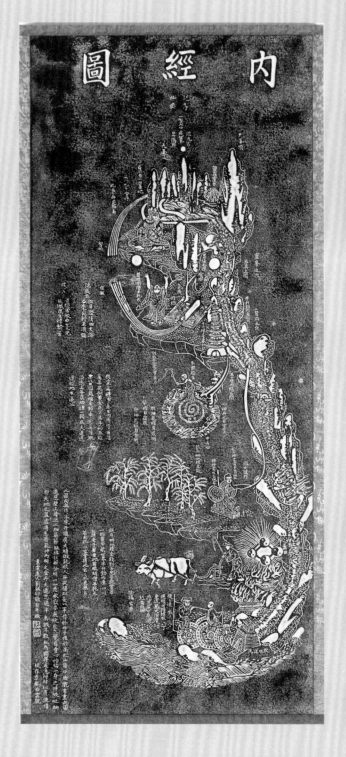

清代
拓本複製
120 × 51 公分

Qing dynasty, China
A replica of a Qing dynasty rubbing
120 × 51 cm

這是一幅根據道教思想的觀點所顯示人體的圖示。把人體內部視為小宇宙，透過冥想法，讓小宇宙和包圍五臟六腑及「氣」的大宇宙相生相合，便能長生不死。

此圖看似坐禪修行者的側面，最上方有仙山聳立，象徵超越生死的精神世界；其下依序為頭部、胸部和腹部三層，各自描繪了「氣」的來源「丹田」。令氣行「丹田」、形神合一之法，即是所謂的內丹術（內觀法）。

據說馬塞爾‧杜象（Marcel Duchamp）的作品《甚至，新娘也被她的男人剝得精光（The Bride Stripped Bare by Her Bachelors, Even）》（1915 – 1923）之靈感來源，就是參考藏於北京道教祖庭白雲觀的本作。此圖將自己的內在世界比作宇宙，用圖像呈現內外調和以修氣養神的概念。

This is a diagram representing the human body as depicted according to Taoist philosophy. The inside of the human body was thought to be a microcosm, and it was believed that immortality could be achieved through a meditation process to harmonize it with the macrocosm that encompasses the organs and "qi," or vital energy.

In this illustration of a side view of a Zazen practitioner, the Mountain of Immortals towers in the upper part, representing a spirit world that transcends life and death. Below in three layers, are drawn the head, chest, and abdomen, each representing the foundation of "qi." 內丹術 (Neidan), or "inner viewing/observation," is the meditation process of circulating the "qi" through these areas, so that spirit and life are fused.

Marcel Duchamp is said to have created his work *The Bride Stripped Bare by Her Bachelors, Even* (1915–1923) referring to the original of this work at the repository of the White Cloud Taoist Temple in Beijing. Imagining the mystery of his inner world as the universe, he created an image of the concept of how harmony of the inner and outer self can be achieved by putting the spirit in order.

白隱

Hakuin

1685 年駿河國（今日本靜岡縣）生。1768 年逝。

白隱慧鶴是日本江戶時代中期的禪僧，出生於駿河國（今靜岡縣），15 歲時自願出家，遊方日本各地潛心修行，31 歲返回故里沼津，成為松蔭寺住持，終其一生遠離權力中樞，致力傳授各階層的人禪法，上至貴族、下至目不識丁的平民百姓。

他被稱為臨濟宗的中興之祖，重振了江戶時代一度沒落的臨濟禪，將其改革為順應時代的新宗派，長達 84 年的漫長人生，皆奉獻於教化民眾。白隱禪創造了公案（參禪課題）並將其系統化，流傳至今。禪宗向來強調「不立文字」，不能以語言傳達，只能靠體驗感受，但白隱卻留下許多禪畫和墨蹟，這些書畫上廣泛引用了前人語錄、故事、和歌及當時的流行歌，有時寓意難解至極。他的作品乍看之下幽默風趣，呈現近乎現代風格，然而其中卻蘊含深奧的訊息。

Born in 1685, Suruga Province (present Shizuoka Prefecture). Died in 1768.

Hakuin Ekaku was a Japanese Zen priest of the 18th century. He left home at the age of fifteen to become a monk. After a long pilgrimage, he returned to his hometown at the age of thirty-one and became priest of the small temple Shōin-ji. There he spent his life, away from the centers of power, teaching Zen to people of all classes from great feudal lords to illiterate commoners.

Revered as the reformer of Japanese Rinzai Zen, he revived the school, then in a period of decline, by devising new methods more in line with the times and spreading the teachings among the populace as a whole. The systematized approach to koan training that he developed, known as Hakuin Zen, remains the most important form of Rinzai Zen practice this day. Zen, which describes itself as "not relying on words and letters," emphasizes direct spiritual experience that cannot be expressed in conceptual language. In order to help convey its message Hakuin employed various creative means, notably Zen paintings and calligraphies. His astounding production of artwork drew on a wide range of sources for inspiration, from the traditional Zen classics to current events to popular songs, occasionally resulting in works that are nowadays very difficult to interpret. Though often filled with humor and wit and rendered in a style that seems almost modern, his paintings nevertheless convey profound messages of timeless importance.

動中工夫

日本江戶時代中期，18世紀

原作為紙本水墨、掛軸；私人收藏

禪宗將透過修行達到精進稱為「工夫」。此作品想表達的禪語是，相較於安靜坐禪的「靜中功夫」，掃地、洗衣、煮飯、耕田和托鉢等一切日常勞動的「動中工夫」，更有「百千億倍」的價值。這句話不只針對修行僧，也鼓勵在家信徒於日常生活中凝神專注，體現禪心。

動中工夫勝靜中百千億倍

Meditation in activity

18th century

Original work: hanging scroll, ink on paper; Private Collection

Meditation in activity is one of the examples of the active and creative engagement in the process of Zen practice known as *kufū* 工夫.

Zen regards "meditation in activity" — *kufū* while engaged in cleaning, cooking, physical labor, and all the other activities of everyday life — as "a hundred thousand million times superior to meditation in stillness." With these words Zen hopes to inspire not only ordained monks in training but also lay believers striving to manifest the Zen mind in their daily lives.

Meditation in activity is a hundred thousand million times superior to meditation in stillness

鈴木大拙

D.T. Suzuki

1870 年日本金澤生。1966 年逝。

鈴木大拙是 19 世紀末到 20 世紀的佛教學者和思想家。圓覺寺管長（首席方丈）釋宗演於 1893 年出席在芝加哥舉辦的萬國宗教會議後，美國開始關注禪學，而當時將其演講稿翻譯成英文的正是鈴木大拙。

後來在宗演的推薦下，鈴木大拙於 1897 年 27 歲時赴美，從事英文佛學相關書籍的出版事務。旅居美國 12 年後返日，任教於學習院大學和大谷大學，同時陸續發行英文雜誌《The Eastern Buddhist》，出版《禪與日本文化》、《禪意生活》等英文著作及眾多日文著作。在出版了 30 本英文著作後，鈴木於 80 歲前夕再度赴美，之後九年在歐美各地演講，正式以「ZEN」的名稱，將禪介紹到全世界。

鈴木 1952 年開始在哥倫比亞大學授課，美國知名作曲家約翰・凱吉（John Cage）等名人皆曾前來聽講，對於藝術、音樂、文學等各領域的藝術家帶來莫大影響。

Born in 1870, Kanazawa, Japan. Died in 1966.

D.T. Suzuki was a Buddhist scholar and philosopher of the late 19th to 20th century. In 1893 when Shaku Sōen, chief abbot of Engakuji Temple, attended the World Parliament of Religions held in Chicago, creating the opportunity for the rise of interest in Zen in America, it was D.T. Suzuki who translated the manuscript of his speech into English.

In 1897, at the age of twenty-seven and at the recommendation of Sōen, he went to America, becoming involved in the publication of Buddhist-related texts there. After spending twelve years, he returned to Japan where he taught at Gakushuin University and Otani University, while publishing the English journal *The Eastern Buddhist* and authoring such works as *Zen Buddhism and Its Influence on Japanese Culture, Living by Zen,* as well as continuing to publish the works in Japanese. Having published over 30 books in English, he returned to America again just before the age of eighty and spent nine years speaking at different locations, creating the impetus that lead to "zen" being known as ZEN.

Artists such as John Cage attended the lectures he gave at Columbia University where he began teaching in 1952, influencing artists in such wide-ranging fields as art, music, and literature.

重重無盡

明治—昭和時代，20 世紀

原作為紙本水墨；掛軸；日本神奈川東慶寺收藏

Endless interrelationship

20th century

Original work: hanging scroll, ink on paper; Collection of Tokeiji, Kanagawa, Japan

「重重無盡」意指所有事物皆相互摻雜反映，無止無境地彼此關聯。此乃大乘佛教經典之一《華嚴經》的教誨，強調人與人之間的關係和一切事物的生成，都存在著無數的關聯性，其關聯性在時空上無限擴展。

The term "*chong-chong wu-jin*" (Endless interrelationship) expresses the mutual interrelatedness of all that exists, an interrelatedness that continues endlessly and inexhaustibly. The concept has its source in the Mahayana Buddhism text known as the *Flower Ornament Sutra* 華嚴經, which stresses the myriad shared interconnections, extending infinitely through space and time, that constitute all human relationships and underlie the arising of all things.

「般若受到無明（Ignorance）和業（Karma）的密雲遮蔽，沉睡於我們心中，禪的目的就是要喚醒般若。無明和業起因於對理智的無條件屈服，禪則是要反抗這種狀態。理智作用表現為邏輯和語言，因此當禪被要求表達自己時，它蔑視邏輯而保持無言的狀態。」

（鈴木大拙《禪與日本文化》，京都：東方佛教徒協會，1938 年、p.5）

"Zen undertakes to awaken Prajñā found generally slumbering in us under the thick clouds of Ignorance and Karma. Ignorance and Karma come from our unconditioned surrender to the intellect; Zen revolts against this state of affairs. And as intellection expresses itself in logic and words, Zen disdains logic and remains speechless when it is asked to express itself."

(D. T. Suzuki, *Zen Buddhism and Its Influence on Japanese Culture*, Kyoto: Eastern Buddhist Society, 1938, p.5.)

伊夫・克萊因

Yves Klein

1928 年法國尼斯生。1962 年逝。

伊夫・克萊因 19 歲開始接觸「歐洲薔薇十字會」，受到神秘思想和鍊金術的影響，1952 年到 1954 年間還曾為學習柔道旅居日本，作為一個藝術家，他不斷探求自己所關心的事物。他在 1950 年代後半起專注於創作概念性作品和行為藝術，作品多以「空氣」——構成宇宙四個第一物質（prima materia）之一——作為主要題材，藉由感知不可視的領域及非物質性，讓觀者思考從中衍生的價值。1960 年，克萊因和藝術評論家皮埃爾・雷斯塔尼（Pierre Restany），以及阿曼（Arman）、丁格利（Jean Tinguely）等多位藝術家，共同提倡「新寫實主義」（Nouveau Réalisme），主張用全新的感知途徑重新捕捉現實。克萊因生長的年代經歷二戰後新能源和工業生產技術快速發展、蘇聯太空人加加林於人類史上首次成功上太空等，近代的物質進步快速且備受矚目，但同時也是對此物質發展提出質疑的時代。

Born in 1928, Nice, France. Died in 1962.

Yves Klein had always pursued a variety of uniquely personal interests — starting in his teenage years, he became influenced by mysticism and alchemy through *Rosenkreuzer* (the philosophical secret society called Rosicrucianism), later also spending time in Japan as a student of judo from 1952 to 1954. Many conceptual works and performances that he produced over an intensive period starting in the late 1950s used air — one of the four *prima materia* that make up the universe — as their main source material. These works allowed viewers to become sensible to the presence of invisible realms and immateriality, prompting them to think about the values that emerged from these phenomena. In 1960, together with the art critic Pierre Restany and artists Arman and Jean Tinguely amongst others, they proposed a theory of "New Realism (Nouveau Réalisme)," which sought new approaches to perceiving reality. The post–World War II era that Klein lived through saw the development of new energy sources and technologies used in industrial production, as well as the space mission that made Yuri Gagarin the first ever human to successfully enter outer space. Although modern material progress started to gain momentum and capture the imagination and attention of the world, this was also a period of growing doubt and suspicion regarding the pros and cons of this alleged progress.

《周日》1960 年 11 月 27 日——
僅發行一天的報紙

1960
報紙
55.6 × 37.9 公分
私人收藏

1960 年 11 月 27 日，克萊因模仿巴黎
報紙《法蘭西晚報》的周日版，設計出
只發行一天的報紙《周日》。報紙標題
為「飛向空中的男人！空間畫家躍入虛
空！」並刊載了克萊因從建築物窗口躍
向空中的蒙太奇照片。報紙內容由克萊
因親自撰寫，有「虛空劇場」、「捕捉
虛空」、「雕像」和「直接痕跡」等報導，
介紹了他一路探索「非物質構想」所抱
持的各種想法。

*Dimanche 27 novembre 1960 —
le journal d'un seul jour*
1960
Newspaper
55.6 × 37.9 cm
Private Collection

On November 27, 1960, Klein published a one-day-only issue
of *Dimanche*, which tried to mimic the design of the Sunday
edition of the Parisian newspaper *France Soir*. The headline
read, "UN HOMME DANS L'ESPACE !: Le peintre de l'espace
se jette dans le vide ! (A MAN IN SPACE!: The Painter of
Space Leaps Into the Void!)," and a photo of Klein jumping out
the window of a building into midair was published alongside

it. The entire newspaper was made up of articles that Klein
himself had written, with various thoughts and musings related
to the immaterial philosophies that he had been pursuing,
such as "Théâtre du vide (Theatre of the Void)," "Capture du
vide (Capture of the Void)," "La statue (The Statue)," and "La
marque de l'immédiat (The Mark of the Immediate)."

Iris Clert vous convie à honorer, de toute votre présence affective, l'avènement lucide et positif d'un certain règne du sensible. Cette manifestation de synthèse perceptive sanctionne chez Yves Klein la quête picturale d'une émotion extatique et immédiatement communicable. (vernissage, 3, rue des beaux-arts, le lundi 28 avril de 21 h. à 24 heures). Pierre Restany

邀請參加伊夫·克萊因「將原料狀態的感性特化成為穩定的圖像感性（虛空）」
展覽開幕典禮
巴黎艾瑞絲·克勒特藝廊，1958 年 4 月 28 日
1958
印刷品
私人收藏

Invitation to the opening of Yves Klein's exhibition, The Specialization of Sensibility in the Raw Material State of Stabilized Pictorial Sensibility [The Void], Galerie Iris Clert, Paris, April 28, 1958
1958
Printed paper
Private collection

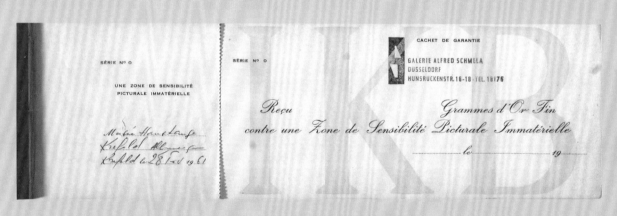

銷售「非物質圖像感性區」收據簿，序號：0
1959
印刷品
私人收藏

Receipt book for the sale of the Zone of Immaterial Pictorial Sensibility, Series No. 0
1959
Printed paper
Private collection

「柔道幫助我理解到，繪畫空間其實是精神鍛鍊的產物。
實際上，所謂柔道，就是在精神空間中發現人體。」

"Judo has helped me to understand that pictorial space is, above all, the product
of spiritual exercises. Judo is, in fact, the discovery of the human body in a
spiritual space."

(Yves Klein, "On Judo," *Overcoming the Problematic of Art: The Writings of Yves Klein*, ed. and trans. Klaus Ottmann, Putnam, CT:
Spring Publications, 2007, p.2.)

「自空無深處抽取出繪畫的非物質區域，我當時已經擁有這個區域，但它
還帶著強烈的物質性。我難以接受為了獲取金錢而販售這些非物質區域，
於是我要求最高的物質性報酬──金條，來換取至高的非物質性。
或許大家很難相信，但事實上這種繪畫的非物質狀態，我已經售出數次。
我在非物質性和虛空中的冒險，無疑有許多可闡述的內容，但終究我還埋
首於眼下書寫性繪畫的創作中，它將被長時間擱置吧！」

"The mining of the pictorial immaterial zones, extracted from the depth of the
void, which I possessed by that time, was of a very material nature. Finding it
unacceptable to sell these immaterial zones for money, I demanded in exchange
for the highest quality of the immaterial the highest quality of material payment
— a bar of pure gold.
Incredible as it may seem, I have actually sold a number of these pictorial
immaterial states. So much could be said about my adventure in the immaterial
and the void that the result would be an overly extended pause while still
immersed in the present erection of my written painting."

(Yves Klein, "Chelsea Hotel Manifesto," *Overcoming the Problematic of Art: The Writings of Yves Klein*, ed. and trans. Klaus
Ottmann, Putnam, CT: Spring Publications, 2007, p.198.)

VENTE - CESSION DE LA ZÓNE
N°I de la SÉRIE N° 4.
160. Grammes d'or FIN. (999,9)
contre "SENSIBILITÉ PICTURALE IMMATÉRIELLE

LA ZÔNE n°I série n°4 est
authentifié par Monsieur FRANÇOIS
MATHEY, Directeur du MUSÉE DES
ARTS DÉCORATIFS.

LA ZÔNE N°I série N° 4 de
SENSIBILITÉ PICTURALE
IMMATÉRIELLE
APPARTIENT A. M. BLANKFORT

PARIS le 10 - 2 - 62

et de plus vient de
s'intégrer a lui, CAR
...l'or, a été rendu à la
NATURE ...

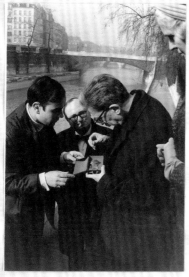

l'acheteur: MICHAEL BLANKFORT
écrivain. Hollywood. USA.

將《非物質繪畫感性區》讓渡給麥可・布蘭克福
的收據，雙倍橋、巴黎、1962 年 2 月 10 日
照片、紙、手寫訊息〔複製品〕
私人收藏

克萊因 1959 年在比利時的安特衛普舉辦了「運動中的視覺
展」，「展出」了《非物質繪畫感性區》。這件「作品」，
事實上只是他讀出科學哲學家加斯東・巴舍拉（Gaston
Bachelard）說過的幾句話，就要價「純金一公斤」。克萊因
不依賴物理性的「物質」，而強烈意識到視覺感官看不見的
感性；之後在 1962 年 1 月到 2 月間，為了讓《非物質繪畫
感性區》的價值明確化，他將純金和收據納入儀式性的行為
藝術中（前者象徵「物質價值」，後者象徵「伴隨物質價值
的經濟活動」）。

"DE LA MATIÈRE POUR DE
L'IMMATÉRIEL."
"DE L'OR POUR LE VIDE."

TÉMOINS: Mr BLANKFORT, Mme
BORDEAUX-LEPECQ, Présid du "SALON
COMPARAISONS". Mr VIRGINIA KONDRATIEF
de la DWAN GALLERY, LOS ANGELES
Mr Jean-LARCADE - Mr Jean de Goldschmidt
Mr PIERRE DESCARGUES.

*Pressbook documenting the transfer of the Zone of
Immaterial Pictorial Sensibility to Michael Blankfort,
Pont au Double, Paris, February 10, 1962*
Photographs on paper with additional handwritten notes [Reproduction]
Private Collection

For the *Vision in Motion* exhibition held in Antwerp,
Belgium in 1959, Klein "showed" what he called "immaterial
pictorial sensibility," which in fact consisted of him reading
aloud certain passages by the philosopher of science Gaston
Bachelard. Affixed to this "artwork" was a price of "1
kilogram of pure gold." Klein, who sought to cultivate a
strong sensibility attuned to invisible presences that did not
rely on physical objects, subsequently spent a period of time
from January through February 1962 holding a series of
ritualistic performances that incorporated within them pure
gold (a symbol of material value) and receipts (symbols of the
economic activity that accompanied material value), in order
to demonstrate the value of "immaterial pictorial sensitivity
zones."

《單調－寂靜交響曲》樂譜
1949–1961
樂譜
41.8 × 29.5 公分
私人收藏

Score of the *Monotone-Silence Symphony*

1949–1961
Printed score
41.8 × 29.5 cm
Private Collection

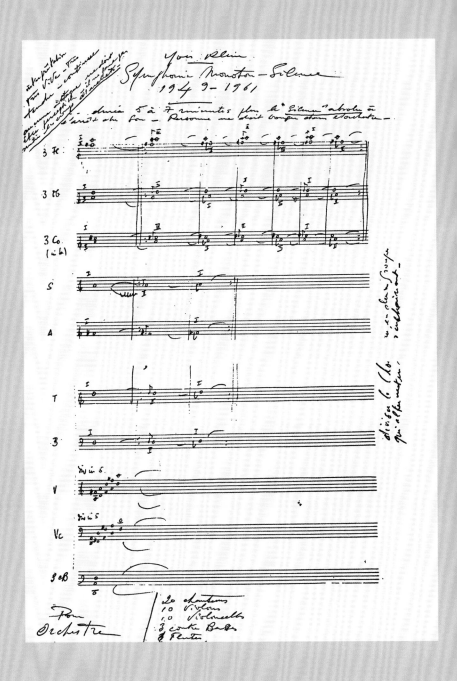

擔任指揮的伊夫‧克萊因，於德國蓋爾森基辛歌劇院

1959
黑白照片
16 × 22.5 公分
私人收藏

以「持續、綿延不絕，沒有起始和結束的唯一『聲音』」為概念而創作出的這首交響樂，前半段是 D 大調和弦構成的單一聲音演奏，後半段則是完全的寂靜。克萊因在 1947 年構思出這件作品，1949年實際作曲。

Yves Klein as orchestra conductor, Gelsenkirchen Opera House, Germany

1959
Black and white photograph
16 × 22.5 cm
Private Collection

This symphony was conceived as nothing more than "one unique continuous 'sound,' drawn out and deprived of its beginning and of its end." The first half features a single sound from a D major chord, while the second half consists of complete silence. Klein got the idea for this artwork around 1947, and actually composed it in 1949.

「這首交響樂持續四十分鐘，正是這樣的長度精準展現征服時間的渴望。（略）這首交響樂不受時間現象學束縛，成為某樣超乎過去、現在與未來的東西，因為總的來說，這首交響樂既不知出生或死亡，同時卻又存在於有聲的物理現實中。」

"The symphony originally lasted forty minutes. It was precisely that long to demonstrate the desire to conquer time. (...) This symphony was freed from the phenomenology of time, becoming something outside of the past, present, and future, since in all it knew neither birth nor death, meanwhile existing in sonorous physical reality."

(*Overcoming the Problematics of Art: The Writings of Yves Klein*, ed. and trans. Klaus Ottmann, Putnam, CT: Spring Publications, 2007, p. 91)

「我的人生，應當像我在 **1949** 年所作的交響樂一般，由始至終是一個連續的聲音，同時是組合和整體，既沒有起始，也沒有結束。
宛如一種持續，顯現、突然具有生命，暫時存在，或許是藉由感覺、或許是在物質性的身體中體驗。」

"My life should be like my symphony of '49, a continuous sound from its beginning to the end, at once united and universal, having neither beginning nor end.
A duration, which appears and suddenly comes to life, for a time, which is experienced perhaps in feeling, perhaps in the physical body."

(Yves Klein, from a note titled "Tableaux: et sculptures de 1961," trans. Klaus Ottmann.)

約翰・凱吉

John Cage

1912 年美國洛杉磯生。1992 年逝。

凱吉是 20 世紀最重要的作曲家之一，他最知名的是在音樂中引進了偶然性和不確定性，其背後受到東洋思想的莫大影響。凱吉曾透過斯里蘭卡的哲學家雅南達・庫馬拉斯瓦米（Ananda Coomaraswamy）接觸到亞洲的藝術思想和中國古代的《易經》，並透過鈴木大拙認識了禪。1950 年代，凱吉在紐約經常去聽大拙講課，1962 年和 1964 年訪日時，還曾到鎌倉的松岡文庫拜訪大拙，由此可窺知一直到大拙晚年，兩人都還有交流。

透過禪，凱吉接觸到「無心」和「融通無礙」的概念，逐漸讓自己趨近於無的狀態，並拓展了他的創作思維，開始將音樂的決斷交付給偶然性或不確定性。此外，就如同禪在「無」中依舊會意識到某些存在，凱吉作品中的「寂靜（silence）」也並非完全無音，而是會讓聽者意識到包含日常生活雜音在內的各種聲音。藉由這個方式，凱吉的音樂淡化了生活和藝術的界線。

Born in 1912, Los Angeles, USA. Died in 1992.

As one of the composers who made the greatest impact on 20th century music, John Cage is known as a figure who introduced the notion of chance and indeterminacy into music. At the root of his legacy, however, is the influence of Eastern thought, such as the philosophy of Indian art that Cage came into contact with through the Ceylonese philosopher Ananda Coomaraswamy, the ancient Chinese treatise, *I Ching* (The Book of Changes), as well as the Zen philosophy that Cage was introduced to by D. T. Suzuki — all of which made a considerable impact on him. Cage was a frequent auditor of Suzuki's lectures in New York in the 50s, and maintained a dialogue with him until his late years, visiting Suzuki at Matsugaoka Bunko in Kamakura during his trips to Japan in 1962 and 1964, for instance.

Through Zen, Cage came into contact with such notions as "no-mindedness" and "unimpededness and interpenetration." As he brought his self closer and closer to a state of nothingness, Cage developed an approach to his work in which musical decisions were delegated to chance, contingency and uncertainty. Just as Zen remained attuned to some sort of presence even within a state of nothingness, the "silence" in Cage's compositions was not entirely bereft of sound — it was a condition that made the listener aware of the presence of all manner of sounds, including the miscellaneous hum of everyday life. In this way, the boundaries between art and the everyday life would become effaced in Cage's music.

I

TACET

II

TACET

III

TACET

NOTE: The title of this work is the total length in minutes and
seconds of its performance. At Woodstock, N.Y., August 29, 1952,
the title was 4' 33" and the three parts were 33", 2' 40", and 1'
20". It was performed by David Tudor, pianist, who indicated the
beginnings of parts by closing, the endings by opening, the key-
board lid. However, the work may be performed by an instrument-
alist or combination of instrumentalists and last any length of
time.

FOR IRWIN KREMEN JOHN CAGE

4 分 33 秒

1952
樂譜
日本山梨縣清里現代美術館收藏

這是凱吉最廣為人知的樂曲之一，由三個樂章組成，第一版的樂譜上只寫了「休止（TACET）」。當聽眾等待演奏開始的同時，會聽見身旁的嘰喳雜音，因此「無聲」或「寂靜」並不存在，反而讓人察覺到包含雜音在內的各種聲音。此作品於 1952 年 8 月 29 日在美國紐約州的伍德斯托克（Woodstock），由鋼琴家大衛‧圖德（David Tudor）首次演奏。創作的背景來自凱吉在 1951 年看過羅伯特‧羅森伯格（Robert Rauschenberg）的作品《白繪畫（White Paintings）》（畫布整個塗上白色），也曾在哈佛大學的無響室聽見自己神經系統和血液循環的聲音，這個體驗讓他認知到完全的寂靜並不存在。

4'33"

1952
Printed score
Collection of Kiyosato Museum of Contemporary Art, Yamanashi, Japan

4'33" is one of Cage's most well known compositions. Made up of three movements, the first printed score contains entirely of tacets. As they wait for the performance to begin, the audience is made to listen to the background noise and hum of their surroundings. As a result, the audience is made to realize that soundlessness and silence do not exist; instead, their attention is drawn to the presence of all manner of sounds, including this background clatter. This piece was first performed at Woodstock, NY, USA on August 29, 1952 by David Tudor. It was apparently inspired by Cage having seen Robert Rauschenberg's *White Paintings* (canvases painted entirely in white) in 1951, and the experience of listening to the sound of his own nervous system and blood circulating inside an anechoic chamber at Harvard University, which made him realize that a state of absolute silence does not exist.

0 分 00 秒（4 分 33 秒第二號）

1962
樂譜
日本山梨縣清里現代美術館收藏

1962 年，凱吉受草月藝術中心之邀首度訪日，帶來了「約翰·凱吉衝擊」。10 月 24 日首次演奏的《0 分 00 秒（4 分 33 秒第二號）》中，樂譜上寫著：「把音量調到最大（不產生回音的程度），然後執行訓練過的動作。」這場首演由凱吉親自進行，他在喉嚨、眼鏡、煙灰缸等處安裝麥克風，將自己抽菸或喝水時發出的聲音，在場內擴增到最大。這件作品的名稱暗示著從有開頭和結尾的樂曲中解放，利用有別於《4 分 33 秒》的方法，讓人意識到日常行為中的聲音。

0'00" (4'33" No.2)

1962
Printed score
Collection of Kiyosato Museum of Contemporary Art, Yamanashi, Japan

In 1962, Cage visited Japan for the first time at the invitation of the Sogetsu Art Center, inciting what became known as the "John Cage Shock." 0'00" (4'33" No.2) was performed on October 24, and on the score was an instruction saying, "In a situation provided with maximum amplification (no feedback), perform a disciplined action." This first performance was executed by Cage himself. Contact microphones were attached to his throat, eyeglasses and ashtray, so that the sounds resulting whenever he smoked or took a drink of water were amplified at high volume throughout the venue. The title of this work alludes to the act of being released from the constraints of a score that has a beginning and end, prompting an awareness of the sounds that accompany everyday actions using a method that differs from the one Cage employed in 4'33".

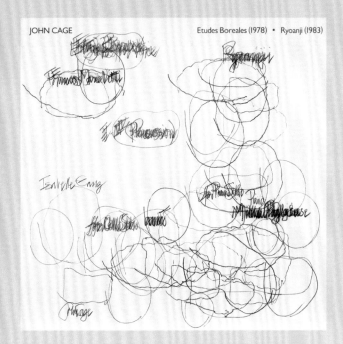

JOHN CAGE Etudes Boreales (1978) • Ryoanji (1983)

龍安寺

1983-1985

LP 唱片

日本山梨縣清里現代美術館收藏

這件作品由京都名剎龍安寺的石庭啟發創作靈感，凱吉
1962 年訪日時，曾到該地一遊。1983 年 1 月，他在加
州的 Crown Point Press 版畫工作室，參照龍安寺開始
創作銅版畫，同年 6 月畫了一系列素描，9 月作曲音樂
作品《龍安寺》。版畫和素描反映了龍安寺石庭的方形
與庭中石頭的數量，同樣地，樂譜也將石頭的外形輪廓
轉化成音樂，凱吉曾多次將此作品比喻為「音之庭」。

Ryoanji

1983–1985

LP record

Collection of Kiyosato Museum of Contemporary Art, Yamanashi, Japan

This work was inspired by the rock garden at Ryoanji, one of Kyoto's most famous Zen temples, which Cage visited during his trip to Japan in 1962. In January 1983, Cage began producing copper etchings that made reference to Ryoanji at the Crown Point Press printing workshop in California. In June that same year, he also made a series of drawings, before composing the musical work *Ryoanji* in September. Similar to how the prints and drawings reflect the form of Ryoanji's rock garden and the number of stones contained within it, Cage frequently likened this piece, which transposed the contours of the rocks into aural form, to a "garden of sounds."

易之樂
1951
LP 唱片
日本山梨縣清里現代美術館收藏

據傳，中國的《易經》是古代神話中的伏羲帝所撰寫的
占卜書。凱吉在《預製鋼琴與室內樂的協奏曲》（1950～
1951 年）的第三樂章嘗試用《易經》表格作曲後，《易
之樂》的作品則全依照《易經》表格，這也成了凱吉第
一件將偶然性引進整首曲子的作品。《易之樂》是四個
分譜構成的鋼琴獨奏曲，具體做法為事先將曲子的節拍
及聲音的種類、強弱寫在表格上，然後丟硬幣決定採用
哪種元素，再將它寫到五線譜上，完成作曲。

Music of Changes
1951
LP record
Collection of Kiyosato Museum of Contemporary Art, Yamanashi, Japan

The Chinese treatise *I Ching* (The Book of Changes) is a book on divination, believed to have
been written by the mythical ancient emperor Fu Xi. After Cage attempted to write the third
movement of his *Concerto for Prepared Piano and Chamber Orchestra* (1950–1951), which was based
on charts from the *I Ching*, he composed the entirety of the piece *Music of Changes* based on charts
taken from the *I Ching*. This was the first work by Cage where the idea of chance operation was
incorporated into the entirety of the piece. *Music of Changes* is a piano solo made up of four parts.
More specifically, the tempo of the piece, the types of sounds, the dynamics and so on were written
in advance by Cage on a chart. A coin toss was used to determine which elements to use, and the
chosen ones were written onto a musical score in order to compose the piece.

「我認為當我們開始意識到日常生活的時候，會發現日常生活遠比節慶形式有趣。意識到這點的『時候』，意味著我們的意圖歸零。然後，突然你發現，世界如此神奇。」

"The attitude I take is that everyday life is more interesting than forms of celebration, when we become aware of it. That *when* is when our intentions go down to zero. Then suddenly you notice that the world is magical."

(Michael Kirby and Richard Shechner, "An Interview with John Cage," *Tulane Drama Review, Vol. 10*, No.2, Winter 1965. Repr. in Kostelanetz 1988, p.208.)

「沒有空無的空間或空無的時間。總有一些事物該看或該聽。其實，就算我們想製造寂靜，我們也做不到。……聲音會一直響起，直到我死亡。而且在我死後，聲音仍會持續存在。我沒有必要擔心音樂的未來。」

"There is no such thing as empty space or empty time. There is always something to see, something to hear. In fact, try as we may to make silence, we cannot ... Until I die there will be sounds. And they will continue following my death. One need not fear about the future of music."

(John Cage, "Experimental Music," *Silence*, London: Calder and Boyars, 1968, p.8.)

$R^2 3$（Where R＝Ryoanji）

1983
銅版畫
川村龍俊收藏

應加州 Crown Point Press 版畫工作室的邀請，凱吉在 1983
年 1 月開始創作《Where R＝Ryoanji》系列。龍安寺的石庭
有 15 顆石頭，凱吉從自己帶來的 16 顆石頭中逐一挑選，並
根據《易經》決定它擺放在銅版格子上的位置。15 顆石頭的
輪廓各描繪了 15 次，共畫出 225 顆石頭。為了達到如真實
石庭般的效果，描繪時還注意到不要超出銅版邊緣。此外，
實際在印刷版畫時，也根據不同的按壓強度，賦予每件作品
不同編號（例如，$R^2 3$ 的壓力小於 $R^2 1$）。

$R^2 3$ (Where R＝Ryoanji)

1983
Drypoint
Collection of Kawamura Tatsutoshi

At the invitation of the Crown Point Press printing workshop
in California, Cage began working on the series *Where
R=Ryoanji* in January 1983. The rock garden in Ryoanji
contains 15 rocks. In contrast, Cage brought with him a bag
containing 16 rocks, choosing one at a time and determining
its position on the grid of the copper plate using the *I Ching*
(The Book of Changes). By tracing the outlines of each of the
15 rocks 15 times, Cage drew a total of 225 rocks. In order
to achieve an effect similar to the structure of an actual rock
garden, Cage took care that the outlines of the rocks did not
cross the edge of the copper plate. In addition, depending on
the strength of the press when the print was actually made,
a different number would be affixed to the title ($R^2 3$ would
have had less pressure applied than $R^2 1$, for instance).

R³（Where R＝Ryoanji）

1983
銅版畫
川村龍俊收藏

在「Where R ＝ Ryoanji」系列，R 象徵作品中使用的 15
顆石頭（rocks）。因此在 R³ 中，15 顆石頭的輪廓各描繪了
15 次，這個動作又重複 15 次，合計描繪出 3375 顆石頭。
描繪的石頭未超出銅版邊緣的作品取名為（R³），超出銅版
邊緣的則取名為 R³。

R³ (Where R=Ryoanji)

1983
Drypoint
Collection of Kawamura Tatsutoshi

In the *Where R=Ryoanji series*, the "R" refers to the 15 rocks
used in the work. Accordingly, R³ refers to a work in which
the act of tracing the outline of 15 rocks 15 times each is
repeated 15 times, yielding a total of 3,375 rocks being drawn.
(R³) was the title given to a work in which the outline of the
rocks did not cross the edge of the copper plate, while R³ was
used to demarcate one in which the edge of the plate was
crossed.

Ryoku, No. 1

1985

銅版畫

川村龍俊收藏

作品名稱是結合「Ryoanji（龍安寺）」和「haiku（俳句）」
的複合詞。配合龍安寺石庭的石頭數，作品描繪了 15 顆石
頭的輪廓：石頭的布局安排在紙面下半部，以讓人聯想到石
庭景觀。此彩色銅版畫系列《Ryoku》共有 13 件，模仿俳
句 5、7、5 的 17 音結構，使用了 17 種天然顏料。

Ryoku, No. 1

1985

Drypoint

Collection of Kawamura Tatsutoshi

The title of this work is a portmanteau word that combines
"Ryoanji" and "haiku." In accordance with the number of
rocks in the rock garden at Ryoanji, the work depicts the
outlines of 15 rocks. The arrangement of these, in a nod to the
landscape within this rock garden, is confined to the bottom
half of the surface of the paper. Made up of 13 color drypoints,
the *Ryoku* series employs 17 different types of natural
pigments, as if to imitate the structure of a haiku, which
consists of 5, 7, and 5 syllables.

亞倫・卡布羅

Allan Kaprow

1927 年美國大西洋城生。2006 年逝。

亞倫・卡布羅以「偶發藝術（Happening）」的提倡者而廣為人知，他讓參觀者經歷一連串的空間體驗，或是根據指示進行各種行動，比如 1959 年他在紐約盧本畫廊舉行的《六個部分的十八個偶發》。除了哲學家約翰・杜威（John Dewey）的著作《藝術即經驗》（1934 年）外，1951 年和約翰・凱吉（John Cage）的邂逅，以及當時在美國廣受矚目的禪等，都讓卡布羅獲得許多啟發。

而另一方面，「偶發藝術」快速被接納，還在超出本人意圖下被廣泛解釋，卡布羅在這之中不斷問自己「藝術是什麼」，同時逐漸和美術館、劇場等藝術場域，甚至跟觀眾保持距離。1970 年以後，他開始探索「活動」（Activity）的概念——「偶發藝術」的一種類型，注意每天重複的小動作。注重杜威所說的實際生活體驗，以及意識到被禪所點醒的各種日常行為，使卡布羅的藝術創作逐漸轉變，從讓觀者觀看轉向發覺自己和他人的一對一關係。接著，他將這些內容製作成《活動手冊》及錄影指示，發展成任何人都能重複體驗的事物。

Born in 1927, Atlantic City, USA. Died in 2006.

Allan Kaprow is known as the originator of "Happenings," whereby visitors undergo a series of spatial experiences, or carry out various actions based on instructions, such as his *18 Happenings in 6 Parts*, which was presented at New York's Reuben Gallery in 1959. Kaprow was profoundly influenced by philosopher John Dewey's book *Art as Experience* (1934), his encounter with John Cage in 1951, as well as the practice of Zen, which was extremely popular in America at the time.

Meanwhile, Happenings grew to be rapidly accepted by the art community, becoming widely interpreted in ways that surpassed Kaprow's original intentions. While Kaprow continued to explore the question of what constituted art, he began to distance himself from museums, theaters and other spaces meant for art, and even his own audiences. After the 1970s, Kaprow began to explore the notion of the "Activity" — a form of Happening that drew one's attention to the little everyday actions repeated on a daily basis. The emphasis on actual lived experience espoused by Dewey and one's consciousness of various everyday gestures awakened by the practice of Zen gradually changed — Kaprow's practice moved away from the act of showing art to an audience, and towards something that was to be discovered in the one-to-one relationship of the self to the other. By leaving behind these self-made "Activity Booklets" and video instructions, Kaprow developed these works into something that could be repeatedly experienced by anyone.

舒適地帶

1975
活動手冊
馬德里凡德烈藝廊出版
亞倫・卡布羅資產及豪瑟暨維爾斯藝廊借展

這個活動測試我們周圍空氣的邊界，以及我們和
他人之間的距離感。兩人一組，然後遠離的一人
逐漸朝自己靠近，或是試圖去感受門後看不見的
人等，藉以讓人去意識物理的或心理的距離感。

Comfort Zones

1975
Activity booklet
Published by Galería Vandrés, S.A., Madrid
Courtesy of Allan Kaprow Estate and Hauser & Wirth

An Activity that tests the boundaries of the air
that surrounds us, and the sense of distance we
have in relation to others. This work makes us
conscious of our physical and psychological sense of
distance when a partner standing far away gradually
approaches us, or when we try to become conscious
of the presence of an invisible partner standing
behind a door.

如何創作偶發藝術

1964

LP 唱片

日本山梨縣清里現代美術館收藏

亞倫・卡布羅資產及豪瑟暨維爾斯藝廊借展

由卡布羅親自錄音，解釋「創作偶發藝術的 11
種規則」，可説是關於偶發藝術的一種綜合性指
示。1966 年和 1968 年，分別以 LP 唱片及艾莉
森・諾爾斯（Alison Knowles）製作的絹印封套
限量版 LP 唱片發行，2008 年以 CD 重新發售。
解説中寫道：「1957 年，亞倫・卡布羅決定嘗
試一種可能性，將行動繪畫（Action Painting）
的『行動』當作是創造的一種儀式行為，而非單
純偶發和狂亂動作所創作出的激烈繪畫。」

How to Make a Happening

1964

LP record

Collection of Kiyosato Museum of Contemporary Art, Yamanashi, Japan

Courtesy of Allan Kaprow Estate and Hauser & Wirth

This is a sound recording made by Kaprow himself, explaining the
11 rules on how to make a Happening — a sort of comprehensive
set of instructions related to Happenings. It was released in 1966 as
an LP, and in 1968 as a limited edition LP with a silkscreen album
sleeve by Alison Knowles. A CD reproduction was issued in 2008.
The liner notes explain that "In 1957 Allan Kaprow decided to try
out the possibility that the 'action' of Action Painting was a ritual
act of creation, not just an incidental frenzy of movement that
produced wild canvases."

假日：偶發藝術日曆

1970
日曆
日本山梨縣清里現代美術館收藏
亞倫・卡布羅資產及豪瑟暨維爾斯藝廊借展

此日曆收集了 1960 年代後半進行的九項偶發藝術的記錄照片和指示。卡布羅作了以下說明：「這本日曆刊載的是過去的事件。上頭的時間為各偶發藝術進行的日期。對參加者來說當天是休息日（Days Off），他們在遊玩。」

Days Off: A Calendar of Happenings

1970
Calendar
Collection of Kiyosato Museum of Contemporary Art, Yamanashi, Japan
Courtesy of Allan Kaprow Estate and Hauser & Wirth

This is a calendar made up of documentary photos and instructions related to 9 Happenings carried out in the late 1960s. Kaprow explained the calendar thus: "This is a calendar of past events. The days on it are the days of the Happenings. They were days off. People played."

January 30th, 1981

Dear

Please forgive this photocopied letter; it's the most efficient way to contact a number of my friends with the same message.

I'm coming to England and the Continent in the Spring for a personal project that interests me. I'd like you to be involved if you can.

The idea is to visit certain of my friends living in England, Germany, Holland, France and Italy, and make for each of them a unique Activity. The visits would be short - 3 or 4 days - and the pieces would be very simple, emerging from the situation itself. After each event we'd tell our stories of what occurred, which I'd like to collect for a small book at the end of my travels.

Basically I want to try an alternative to the art market and, instead, make art for those I enjoy being with.

So I'd like to make a piece for you. All I'd ask from you is your hospitality for the period of my visit. I'll be travelling with my friend Coryl Crane (some of you know her), who is a stained-glass artist, and who will be studying the cathedrals and making contacts in her field during our tour.

Our itinerary is England (Essex and London), April 8-21; Berlin April 21-28; Hamburg April 28-May 2; Amsterdam May 2-7; Cologne May 7-12; Paris May 12-17; Pouillac (Dordogne) May 17-22; Florence May 22-27; Munich May 27-June 2; Berlin June 2-6. (The outside dates in each place would be arrival and departure days of course).

If you're interested and will be at home during the appropriate dates, please telegraph me with one word "OKAY" and I'll be in touch with you soon afterward. If it's not possible telegraph the word "REGRETS". Naturally, I hope you find the idea attractive and will be at home. But do let me know soon!

Fond regards,

Allan Kaprow

Allan Kaprow
1225 Linda Rosa Avenue
Eagle Rock
Los Angeles, CA 90041

歐洲旅行前寄給友人的信

1981
信件
尺寸不明
亞倫‧卡布羅資產及豪瑟暨維爾斯藝廊借展
The Getty Research Institute, Los Angeles (980063)

這封信是一個紀錄，顯示人與關係親密的人之間如何展開一項「活動」。卡布羅寫信向朋友提議一起進行一項活動，作為一種沒有觀眾的私人藝術作品，來換取遊歐時在他們家過夜。這封信寄給了沃爾夫‧福斯特爾（德國）、理察‧哈密爾頓（英國）、羅伯‧費里歐（法國）、皮埃爾‧雷斯塔尼（法國）等人。

Letter for the friends before the European tour
1981
Typed letter
Dimensions unknown
Courtesy of Allan Kaprow Estate and Hauser & Wirth
The Getty Research Institute, Los Angeles (980063)

This is a record that shows how an Activity is something that is carried out between people with an intimate relationship to each other. In exchange for letting Kaprow stay at the homes of friends when he went travelling in Europe, this letter proposes that they carry out an activity together, as a kind of private artwork with no audience. The letter was addressed to figures such as Wolf Vostell (Germany), Richard Hamilton (England), Robert Filliou (France), and Pierre Restany (France).

going: when it's time
staying: at the point of a turn
going: when the wind passes your face
staying: at the descent
going: when the cloud passes the tree
staying: when you have an itch
going: when you hear a word
staying: at the ascent
going: past the edge
staying: when your feet hurt
staying: anyway
going: anyway

a piece for Marianne, Marcelline and Robert Filliou, carried out by them, Coryl Crane and myself, May 21, 1981, at Pouillac-Le Moustier, France.
— Allan Kaprow

去／留
1981
歐洲旅行中的活動指示書
尺寸不明
亞倫‧卡布羅資產及豪瑟暨維爾斯藝廊借展
The Getty Research Institute, Los Angeles (980063)

這份指示的內容是 1981 年卡布羅在歐洲旅行時，於法國多爾多涅省為激浪派（Fluxus）藝術家羅伯‧費里歐（Robert Filliou）一家人所進行的活動。

Going / Staying
1981
Score for activity for European tour
Dimensions unknown
Courtesy of Allan Kaprow Estate and Hauser & Wirth
The Getty Research Institute, Los Angeles (980063)

Instructions for an Activity performed for the family of Fluxus artist Robert Filliou in the Dordogne region of France during Kaprow's travels through Europe in 1981.

七種共鳴
1976
活動手冊
維也納二十世紀美術館出版
亞倫・卡布羅資產及豪瑟暨維爾斯藝廊借展

7 Kinds of Sympathy
1976
Activity booklet
Published by Museum des 20er Jahrhunderts, Vienna
Courtesy of Allan Kaprow Estate and Hauser & Wirth

「偶發」
1967
目錄
25.6 × 22 公分
日本山梨縣清里現代美術館收藏
帕莎蒂納美術館出版
亞倫‧卡布羅資產及豪瑟暨維爾斯藝廊借展

"Happening"
1967
Catalogue
25.6 × 22 cm
Collection of Kiyosato Museum of Contemporary Art, Yamanashi, Japan
Published by Pasadena Art Museum
Courtesy of Allan Kaprow Estate and Hauser & Wirth

兩種鐵律
1974 年
活動手冊
日本山梨縣清里現代美術館收藏
瑪爾塔諾出版
亞倫‧卡布羅資產及豪瑟暨維爾斯藝廊借展

2 Measures
1974
Activity booklet
Collection of Kiyosato Museum of Contemporary Art, Yamanashi, Japan
Published by Martano Editore
Courtesy of Allan Kaprow Estate and Hauser & Wirth

SWEET WALL
TESTIMONIALS

ALLAN KAPROW

甜牆
1976
活動手冊
日本山梨縣清里現代美術館收藏
亞倫・卡布羅資產及豪瑟暨維爾斯藝廊借展

Sweet Wall
1976
Activity booklet
Collection of Kiyosato Museum of Contemporary Art, Yamanashi, Japan
Courtesy of Allan Kaprow Estate and Hauser & Wirth

ROUTINE

ALLAN KAPROW

常規
1975
活動手冊
日本山梨縣清里現代美術館收藏
亞倫・卡布羅出版
亞倫・卡布羅資產及豪瑟暨維爾斯藝廊借展

Routine
1975
Activity booklet
Collection of Kiyosato Museum of Contemporary Art,
Yamanashi, Japan
Published by Allan Kaprow
Courtesy of Allan Kaprow Estate and Hauser & Wirth

迴響—遲鈍
1975
活動手冊
日本山梨縣清里現代美術館收藏
達爾克出版
亞倫‧卡布羅資產及豪瑟暨維爾斯藝廊借展

Echo-Logy
1975
Activity booklet
Collection of Kiyosato Museum of Contemporary Art, Yamanashi, Japan
Published by D'Arc Press
Courtesy of Allan Kaprow Estate and Hauser & Wirth

滿意
1976
活動手冊
日本山梨縣清里現代美術館收藏
紐約 M.L. 達爾克藝廊出版
亞倫‧卡布羅資產及豪瑟暨維爾斯藝廊借展

Satisfaction
1976
Activity booklet
Collection of Kiyosato Museum of Contemporary Art, Yamanashi, Japan
Published by M.L. D'Arc Gallery, New York
Courtesy of Allan Kaprow Estate and Hauser & Wirth

〔「偶發藝術」一詞被用的範圍太過廣泛，為此卡布羅試圖去詳細定義六種類型。〕

「偶發藝術的第六種，也是最後一個類型為『活動』（Activity）。這個類型直接關連到日常世界，無視劇場和觀眾，是一種行動而非冥想，它在精神上更接近於身體運動、典禮、慶典、登山、戰爭遊戲和政治示威。它也和每天無意識的日常儀式有類似的性格，像是在超市購物、在尖峰時刻乘坐地下鐵、每天早上刷牙等。『活動型』偶發藝術選擇了多種狀況加以組合，讓大眾不單是鑑賞或思考其內涵，還能親身參與。」

[Kaprow attempting to define the six types of Happening in more detail after he discovered how the word "Happening" was being used in such a broad context.]

"The sixth and last kind of Happening is the *Activity* type. It is directly involved in the everyday world, ignores theaters and audiences, is more active than meditative, and is close in spirit to physical sports, ceremonies, fairs, mountain climbing, war games, and political demonstrations. It also partakes of the unconscious daily rituals of the supermarket, subway ride at rush hour, and toothbrushing every morning. The Activity Happening selects and combines situations to be participated in, rather than watched or just thought about."

(Allan Kaprow, "Pinpointing Happenings," *Essays on the Blurring of Art and Life* (Expanded Edition), Jeff Kelly (ed.), Berkeley, Los Angeles and London: University of California Press, First Edition: 1993, Expanded Edition: 2003, p.87.)

「我所述説、進行、意識、思考的事情皆為藝術——不論我是否有此意圖——因為意識到今日發生之事的任何人，大概總有一天也會將述説、進行、意識、思考它的行為當作是藝術吧！這麼一來，稱呼自己為藝術家就變得很諷刺，因為決定一個人是否為藝術家，不是源自於特別的技術才能，而是取決於當眼前出現一件無法斷定是藝術還是人生的選項時，那個人所採取的哲學立場。『藝術家』會刻意陷入分類的困境，卻又表現得彷彿分類完全不存在。如果聲音的集聚和有見解的『噪音』音樂會之間沒有明確的差異，那麼藝術家和回收廠商之間也不會有明顯的差別。」

"Anything I say, do, notice, or think is art — whether or not I intend it — because everyone else aware of what is occurring today will probably say, do, notice, and think of it as art at some time or another. This makes identifying oneself as an artist ironic, an attestation not to talent for a specialized skill, but to a philosophical stance before elusive alternatives of not-quite-art and not-quite-life. *Artist* refers to a person willfully enmeshed in the dilemma of categories who performs as if none of them existed. If there is no clear difference between an Assemblage with sound and a "noise" concert with sights, then there is no clear difference between an artist and a junkyard dealer."

(Allan Kaprow, "Manifesto," *Essays on the Blurring of Art and Life* (Expanded Edition), Jeff Kelly (ed.), Berkeley, Los Angeles and London: University of California Press, First Edition: 1993, Expanded Edition: 2003, pp.81-82.)

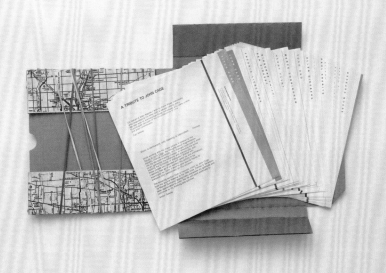

約翰・凱吉備用盒

1987

膠版印刷紙、橡皮筋、幻燈片

21.6 × 21.6 × 3.2 公分

日本山梨縣清里現代美術館收藏

Prepared Box for John Cage

1987

Offset lithograph on paper, rubber bands, slide

21.6 × 21.6 × 3.2 cm

Collection of Kiyosato Museum of Contemporary Art, Yamanashi, Japan

里克力・提拉瓦尼

Rirkrit Tiravanija

1961 年阿根廷布宜諾斯艾利斯生；在紐約、柏林、泰國清邁等地居住和工作。

1990 年代法國藝術評論家尼可拉・布西歐（Nicolas Bourriaud）提倡的「關係藝術（relational art）」，反映了同時期新一代藝術家所做的實踐，也將當代藝術的思考方式從個人表達和個人空間，轉向社會脈絡及人與人之間的相互關係。其中，里克力・提拉瓦尼透過向畫廊和美術館的參觀者提供泰式咖哩與泰式炒麵等作品，成為關係藝術及象徵藝術全球化的藝術家，持續受到國際矚目。他出生於阿根廷，曾居住在泰國、衣索比亞、加拿大和美國等地，敏銳感受到風土氣候與生活習慣所孕育出的各種文化，是如何創造出不同的「日常生活」。從這類經驗誕生的藝術，以「飲食」、「居住空間」和「旅行」等主題作為起點，探索土地的歷史、文化、政治環境，以及觀眾之間相互的關聯性。提拉瓦尼的創作模糊了日常與藝術、主動與被動、內向與外向等相對概念的界線，提供我們一個機會去思考自身的存在。

Born in 1961, Buenos Aires, Argentina.
Lives and works in New York, Berlin, and Chiang Mai, Thailand.

Using a language that reflected the practices of a new generation of artists that emerged around the same time, the "relational art" proposed by French art critic Nicolas Bourriaud in the 1990s shifted the dominant thinking about contemporary art away from notions of individual expression and personal space, pushing it towards social contexts and the interdependent relationships between people. Rirkrit Tiravanija shot to international fame as an exemplar of this relational art against the backdrop of a globalizing art scene through works that involved serving Thai curry and pad thai to visitors in galleries, museums, and other art spaces. Born in Argentina and raised in multiple countries including Thailand, Ethiopia, Canada, and the US, Tiravanija was keenly aware of how the various cultures around the world that emerge as a result of vernacular climate and local customs in fact give rise to different versions of the "everyday." The art born out of these experiences draws on themes of food, living spaces, and travel as a starting point, exploring the history, culture, and political landscape of a particular place in addition to the reciprocal relationships among viewers. Tiravanija's art also presents us with an opportunity to think about our own existence while muddling the boundaries between opposing concepts, such as art and the everyday, active and passive, and introversion and extroversion.

無題 2007（free / still）

2007

16mm 影片、無聲、黑白

60 分 36 秒

東京 SIDE 2 藝廊及紐約蓋文・布朗藝廊借展

提拉瓦尼第一個以「飲食」為主題的作品是 1989 年創作的
《無題 1989》，為裝置藝術，將食材、烹飪器具、飲料包
裝等「日常生活」會出現的物品，直接陳置在展示台上。
這次展出的錄像作品《無題 2007（free / still）》，是記錄
他 2007 年重新演出在畫廊內供應泰式咖哩的《無題 1992
（free）》及《無題 1995（still）》。

Untitled 2007 (free/still)

2007

16mm film, silent, black and white

60 min. 36 sec.

Courtesy of GALLERY SIDE 2, Tokyo and Gavin Brown's Enterprise, New
York

Tiravanija first worked with the theme of food in his 1989
work *Untitled 1989*, an installation on a pedestal that consisted
of the "everyday" presented as is, including ingredients,
cooking utensils, and drink packages. The work on display at
this exhibition, *Untitled 2007 (free/still)*, is a video piece where
Tiravanija reenacts two of his performances in 2007: *Untitled
1992 (free)* and *Untitled 1995 (still)*, where he serves Thai curry
inside a gallery.

吳瑪悧

Wu Mali

1957 年台灣台北生；在高雄、台北居住和工作。

經歷了台灣走向民主化之社會變革的年代，吳瑪悧對戒嚴前後的政治運動極其關注，她在過去 30 年間，透過藝術實踐不斷對藝術的社會角色提出批判性的質疑。其手法不止於在美術館的制度或者當代藝術的框架中，而且從個人身處的社會環境，擴及到政治體制和國家，透過直接與多元社群接觸、貼近其情感，試圖喚起人們對日常生活中各種問題的認知。1990 年代以後，她更針對性別議題及伴隨都市開發的環境問題，執行了多項中長期計畫，透過對話和討論，嘗試讓參與者自覺到個人的體驗，進而提高認知。從這些活動可以了解到，特定個人和地區所處的環境或歷史已經無法自外於全球化浪潮波及的世界，唯有更深入參與自身所屬的社群，才能真正思考現今世界。

淡江大學畢業後，赴德國杜塞道夫國立藝術學院留學，1985年回國。目前擔任國立高雄師範大學跨領域藝術研究所副教授兼所長。

Born in 1957 in Taipei, Taiwan. Lives and works in Kaohsiung and Taipei.

Having lived through the era of democratic transformation in Taiwanese society, Wu Mali has paid great attention to the political movements leading up to and following the end of martial law. Over the past 30 years, she has used her artistic practice to critically question the role of art in society. Her methods are not restricted to the art museum system or the contemporary art framework, but involve extending from individual social environments to touch upon the political system and the nation, and using direct contact, intimacy and empathy with diverse communities to try to awaken people's perceptions of various issues in everyday life. Since the 1990s she has also addressed gender issues and the environmental problems that arise from urban development, implementing a series of mid- and long-term projects that employ dialogue and discussion in order to raise participants' awareness through personal experience. These activities have led to the realization that the environments and history of specific individuals and localities cannot remain divorced from the trends of globalization and the world at large, and only by becoming deeply involved in the communities to which participants belong can one truly consider the world of today.

Wu Mali is a graduate of Tamkang University. After completing her studies at the National Art Academy, Dusseldorf, Germany, she returned to Taiwan in 1985. She currently serves as associate professor and chair of the Graduate Institute of Interdisciplinary Art, National Kaohsiung Normal University.

從妳的皮膚甦醒 2000-2004——皇后的新衣

2004

影片，12分28秒

與台北市婦女新知協會合作

Awake in Your Skin, 2000-2004—The Empress's New Clothes

2004

Video, 12 min. 28 sec.

Collaboration with Taipei Awakening Association

樹梅坑溪環境藝術行動

2011-2012

影片，11分33秒

與竹圍工作室合作

Art as Environment—A Cultural Action at Plum Tree Creek

2011-2012

Video, 11 min. 33 sec.

Collaboration with Bamboo Curtain Studio

《樹梅坑溪環境藝術行動》展板

The panel of *Art as Environment—A Cultural Action at Plum Tree Creek*

樹梅坑溪溯溪行動在 2010 年展開

Tracing the Plum Tree Creek, 2010

北回歸線環境藝術行動
2006-2007
與嘉義縣政府合作

Art as Environment—A Cultural
Action at the Tropic of Cancer
2006-2007
In cooperation with Chiayi
County Government

《從妳的皮膚甦醒 2000-2004
——皇后的新衣》於台北城隍廟
前展示

Awake in Your Skin, 2000-2004—
The Empress's New Clothes, City
God Temple, Taipei, 2004

林明弘

Michael Lin

1964 年日本東京生；在台北、上海居住和工作。

Born in 1964 in Tokyo, Japan. Lives and works in Taipei and Shanghai.

1990 年代，多元文化及全球化逐漸影響到當代藝術，而經濟快速成長的亞洲地區，其當代藝術的發展也匯集了世界注目的眼光。同一時期，藝術的視野從繪畫、雕刻等物質性創作，擴展到探討人際關係的「關係美學」，以及由觀眾參與創作過程或展示空間的「參與式藝術」，也日益受到重視。林明弘在這樣的脈絡之下，試圖梳理特定場域的空間及歷史意義，創造出讓人們自由聚集的動態裝置藝術，在國際間獲得極高的評價。他以卓越的設計品味，不時將台灣或日本的傳統織品圖案轉化到現代空間，觀眾可以在其中重新思考坐、憩、眠、食等日常生活的行為。這些織品圖案也被運用於壁紙、靠墊，甚至滑板道上，成為林明弘代表性的系列作品，它們突破繪畫、雕刻、設計等既定領域，拓展了藝術的表現手法及觀眾體驗。

In the 1990s pluralistic culture and globalization gradually came to influence contemporary art, and world attention began to focus on the development of contemporary art in Asia, which was experiencing rapid economic growth. During the same period, the vision of art expanded beyond material creations such as painting and sculpture, as "relational aesthetics," which explores interpersonal connections, and "participatory art," which encourages visitors to take part in the art process or the exhibition space, increasingly gained prominence. In this context, Michael Lin began attempting to order the spatial and historical meaning of specific locations, creating dynamic art installations that encouraged people to come together naturally. These works have gained considerably high regard in the international art world. With his exceptional taste in design, he often transforms Taiwanese or Japanese traditional fabric patterns into modern spaces, in which visitors can reconsider the activities of everyday life, such as sitting, resting, sleeping or eating. These fabric patterns have been used as wallpaper, cushions, and even skateboard ramps, becoming Lin's hallmark series of works. They break beyond pre-established domains such as painting, sculpture and design, exploring new terrain in artistic expression and viewer experience.

文件
2015
9 分鐘

Documentation
2015
9 min.

《共生共存 37 日》於台北帝門
藝術教育基金會展出
Complementary, as installed at
Dimension Endowment of Art,
Taipei, Taiwan, 1998

《進口》於巴黎畢松當代藝術中心展出

Imported, as installed at Le Ferme Du Buisson Contemporary Art Center, Paris, France, 1998

《又甜又涼》於台北伊通公園展出

Cool and Sweet, as installed at IT Park, Taipei, Taiwan, 2008

《無題》於日本福岡亞洲美術館展出
Untitled, as installed at Fukuoka Asian Art Museum, Fukuoka, Japan, 2009

《空位》於北京當代唐人藝術中心展出
Place Libre, as installed at Tang Contemporary Art Center, Beijing, China, 2013

楊俊

Jun Yang

1975 年生於中國，在奧地利成長；在維也納、台北、橫濱居住和工作。

楊俊自 1990 年代末期開始在國際藝術舞台上嶄露頭角，他以個人往來於歐亞間的多元文化體驗作為起點，採用自傳形式，不斷提問「何謂公共空間」、「何謂藝術的社會功能」。他的觀點既歸屬於多元文化圈，同時具有身為「異鄉人」之外來者的敏銳觀察力，不時對社會制度、文化習慣以及人類心理進行批判分析。然而，他的計畫不以單純的批判為終點，而是試圖找出可能的線索，介入任何社會都存在的矛盾和荒謬，從中提出靈活的新系統，以追求社會的平衡與和諧。因此在他的作品中看不到藝術家的身影，他隱藏於暫時的狀況和制度背景之後。

本展所介紹的計畫，係從楊俊跨錄像、出版、裝置藝術等豐富的作品中，特別挑選出針對一般大眾所創作的公共空間案例。雖然都是臨時性裝置，但或許可視為對美好社會的烏托邦式提案。

Born in 1975 in China, raised in Austria. Lives and works in Vienna, Taipei and Yokohama.

Jun Yang has been prominent in the international art world since the late 1990s. Embarking from his own diverse cultural experiences interacting with both Europe and Asia, he adopts an autobiographical form, constantly asking, "What is public space?" and "What is the function of art in society?" His perspective belongs to that of a diversified cultural circle, yet he also possesses an outsider's trenchant powers of observation, frequently engaging in critical analysis of the social order, cultural customs and human psychology. Nevertheless, the end purpose of his projects is not simply criticism, but an attempt to find possible clues, to interpose the contradiction and absurdities that exist in society, and from these suggest a flexible new system, in order to pursue equilibrium and harmony in society. Consequently, we do not see the figure of the artist in his works. Rather, he hides in a background of temporary conditions and configurations.

The projects introduced in this exhibition have been selected from among a rich array of works in such disciplines as video, publishing and installation, particularly focusing on cases carried out in public spaces for the general public. Although they were all temporary installations, they may also be seen as utopian proposals for a better society.

提案計畫與真實
2015
錄像，9 分 48 秒

Proposals and Reality
2015
Video, 9 min. 48 sec.

《GFZK 花園》於德國萊比錫當代藝術館展出
GFZK Garden, as installed at Museum of Contemporary Art Leipzig, Germany, 2006

《一個當代藝術中心，台北》於 2008 台北雙年展展出
A Contemporary Art Centre, Taipei (A Proposal), as installed at Taipei Biennial, Taipei, 2008

《你我共同之處》於 2010 歐洲文化之都德國魯爾
區多特蒙德市聖雷諾迪教堂展出
Things We Have in Common, as installed at Reinoldi
Kirche, Dortmund, European Capital of Culture
Ruhr, 2010

《一個公共空間提案——電影院》於阿拉伯聯合大公國沙迦藝術基金會展出
A Proposal for A Public Space – A Cinema, as installed at Sharjah Art Foundation, Sharjah, 2012

吳建瑩

Wu Chien-Ying

1983 年台灣台中生；在巴黎、台北居住和工作。

2000 年代末開始從事創作的吳建瑩，自國立台灣藝術大學畢業後赴法國國立高等美術學院就讀，在個人的藝術實踐中，他採用的方法是藉由他人的介入導向開放式結局。他常運用錄像媒體將自己關注的議題化為作品，透過對他人的訪談，挖掘出各人情感和心理深層，或是人們彼此之間的關係和連結。

本次展出的《我的朋友》(My Friends, 2013)，是從小學五年級的少年亞瑟開始，由他來介紹自己的朋友，再由那位朋友繼續介紹下一位朋友。在過程中可以發現，連綿接續的熟人、朋友關係不斷編織，同時也在他們的信賴之下，得以拍攝到一般市井小民的影像。從「關係美學」的提倡至今已過了大約 20 年，思考人類彼此之間，或是與多元化社會、政治、歷史脈絡間的關係，這些觀點現在看來都已不罕見，然而吳建瑩超越世代和地域，不斷探尋關係的建構，再次提出對不可見的連結之認知，已成為思索人類存在的普遍性價值觀。

Born in 1983 in Taichung, Taiwan. Lives and works in Paris and Taipei.

Wu Chien-Ying began making art in the late 2000s. He is a graduate of National Taiwan University of Arts and the École Nationale Supérieure des Beaux-Arts in France. In his personal artistic practice, Wu uses the interposition of others to effect an undetermined conclusion to his works. He often employs video to transform issues of personal concern into artworks, interviewing others to unearth the deeper layers of their feelings, or the mutual relations and connections among people.

The work *My Friends*, featured in this exhibition, begins with the fifth-grade student Arthur, who introduces his friend, and then his friend introduces a friend of his own. Through this process we discover a continuous web of companionship constantly woven, and through their sense of trust, images of ordinary people are captured. Nearly twenty years have passed since the rise of "relational aesthetics," which ponders the mutual connections among human beings or the relationships of pluralistic societies, governments or historical milieus. These perspectives now seem unexceptional, yet Wu Chien-Ying has moved beyond era and place. Constantly searching for the constructs of relationships and re-expressing perceptions of these invisible connections has become a means to muse on the universal values of humankind.
Work caption and description

我的朋友
2013
單頻錄像，23 分 48 秒

My Friends
2013
One single channel video, 23 min. 48 sec. loop

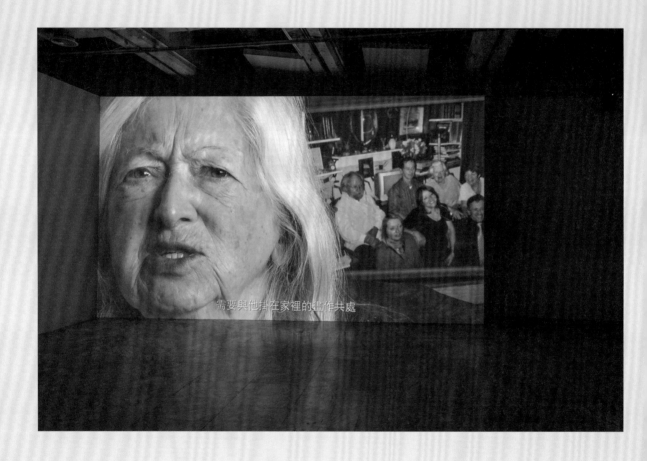

《我的朋友》於台北市立美術館「2013 台北美術獎」展出
My Friends, as installed at "Taipei Arts Awards 2013," Taipei Fine Arts Museum, Taipei, 2013

Appendix

作品清單

凡例

- 作品清單分為「李明維作品」與「思考『關係』的作品」二大類。
- 各作品的資料依藝術家姓名（李明維的作品除外）、作品名、創作年份（部分李明維的作品一併記載「首次發表年份」與「在臺北市立美術館的發表年份」）、媒材、尺寸（長 × 寬 × 深 公分／影像作品以時間長度計算）、收藏家、版權所有的順序記載。並根據圖版，將照片版權資訊刊在作品清單後半的「圖片來源」。
- ◆──在展覽中展示複製印刷品

List of Works

Notes

- The List of Works is divided into two categories, "Works by Lee Mingwei" and "Works for Relationality."
- For each work, the basic information provided is: the author's name (except works by Lee Mingwei), the title of the work, the year of its production (double dating of the original year / the current exhibition copy in case of works by Lee Mingwei when applicable), material(s) / media, dimensions (height × width × depth cm / duration in case of films and videos) of the work, the lenders and owners of the work, credits and courtesies. Photographic credits are also provided in the "Photo Credits" Section in the latter part of the List of Works where appropriate.
- ◆── Indicates works reproductions of which are on view in the exhibitions.

李明維作品
Works by Lee Mingwei

織物的回憶
2006 / 2015
複合媒材互動裝置
木作平台、木盒、24 件織物
Fabric of Memory
2006 / 2015
Mixed media interactive installation
Wooden platform, wooden boxes, 24 fabric items

聲之綻
2013 / 2015
參與式表演裝置
椅子、台座、服裝、藝術歌曲
Sonic Blossom
2013 / 2015
Ongoing participatory performance installation with chair, music stand, costume, and spontaneous song

如實曲徑
2015
參與式表演裝置
米、穀粒、種子、服裝、舞蹈
Our Labyrinth
2015
Ongoing performance installation with rice, grains, seeds, costume and dance

補裳計畫
2009 / 2015
複合媒材互動裝置
桌、椅、線、織物
曾文泉先生收藏
The Mending Project
2009 / 2015
Mixed media interactive installation
Table, chairs, threads, fabric items
Collection of Rudy Tseng

女媧計畫
2005
竹、絲、綿線、壓克力顏料
350 × 112 公分
Nu Wa Project
2005
Bamboo, silk, cotton thread, acrylic
350 × 112 cm

石頭誌
2010
複合媒材裝置
冰河石、銅、木台座
11 組，各 10.5 × 50 × 15.5 公分
曾文泉、吳興達、施俊兆、陳榮泉、Sophia & Leon Tan, Cesar Reyes, Harvey Molotch & Glenn Wharton 收藏
Stone Journey
2010
Mixed media installation
Glacial stone, bronze, wood
11 sets, 10.5 × 50 × 15.5 cm each
Collection of Rudy Tseng, Simon Wu, Leo Shih, Rong-Chuan Chen, Sophia & Leon Tan, Cesar Reyes, Harvey Molotch & Glenn Wharton

魚雁計畫
1998 / 2015
複合媒材互動裝置
木作驛亭、信紙、信封
三座，各 290 × 170 × 231 公分
The Letter Writing Project
1998 / 2015
Mixed media interactive installation
Wooden booth, writing papers, envelopes
3 pieces, 290 × 170 × 231 cm each

去留之間
2007 / 2015
複合媒材裝置
沙、燈、聲音
Between Going and Staying
2007 / 2015
Mixed media installation
Sand, lamp, sound

晚餐計畫
1997 / 2015
複合媒材互動裝置
木作平台、榻榻米、黑豆、米、錄像
335 × 335 × 85 公分
忠泰美術館籌備處收藏
The Dining Project
1997 / 2015
Mixed media interactive installation
Wooden platform, tatami mats, beans, rice, video
335 × 335 × 85 cm
Collection of JUT Museum Pre-Opening Office

客廳計畫
2000 / 2015
複合媒材互動裝置
The Living Room
2000 / 2015
Mixed media interactive installation

水仙的一百天
1995
影像輸出
五件，各 166.5 × 115 公分
100 Days with Lily
1995
Silver dye bleach prints
5 pieces, 166.5 × 115 cm each

睡寢計畫
2000 / 2015
複合媒材互動裝置
木床、床頭櫃
The Sleeping Project
2000 / 2015
Mixed media interactive installation
Wooden beds, night stands

如沙的格爾尼卡
2006 / 2015
複合媒材互動裝置
沙、木作小島、燈光
1300 × 643 公分
忠泰美術館籌備處收藏
Guernica in Sand
2006 / 2015
Mixed media interactive installation
Sand, wooden island, lighting
1300 × 643 cm
Collection of JUT Museum Pre-Opening Office

傳移摹寫
2004
複合媒材互動裝置
11 位藝術家臨摹所作
34 × 26.7 公分（× 11）
國立臺灣美術館收藏
Through Masters' Eyes
2004
Mixed media interactive installation
Creative reproductions by 11 artists, 34 × 26.7 cm
each
Collection of National Taiwan Museum of Fine Arts

傳移摹寫
2014
展覽版本
34 × 26.7 公分
Through Masters' Eyes
2014
Exhibition copy albums
34 × 26.7 cm

◆

石濤 (1642-1707)
山水
1694，清代
八頁冊頁之一；紙本設色
原作由洛杉磯郡立美術館收藏
Shitao
Landscape
Qing dynasty, 1694
One leaf of an eight-leaf album; ink and color on
paper
27.9 × 22.2 cm
Collection of Los Angeles County Museum of Art

移動的花園
2009 / 2015
複合媒材互動裝置
花崗石、水、鮮花
1200 × 134 × 60 cm
施俊兆先生與夫人收藏
The Moving Garden
2009 / 2015
Mixed media interactive installation
Granite, water, fresh flowers
1200 × 134 × 60 cm
Collection of Amy & Leo Shih

內經圖
清代
拓本複製
120 × 51 公分
View of the inner dimensions (Nei-jing-tu)
Qing dynasty, China
A replica of a Qing dynasty rubbing
120 × 51 cm

白隱
Hakuin

◆
動中工夫
日本江戶時代中期，18 世紀
原作為紙本水墨、掛軸
私人收藏
Meditation in activity
18th century
Original work: hanging scroll, ink on paper
Private Collection

鈴木大拙
D.T. Suzuki

◆
重重無盡
明治—昭和時代，20 世紀
原作為紙本水墨、掛軸
日本神奈川東慶寺收藏
Endless interrelationship
20th century
Original work: hanging scroll, ink on paper
Collection of Tokeiji, Kanagawa, Japan

伊夫·克萊因
Yves Klein

《周日》1960 年 11 月 27 日——僅發行一天的
報紙
1960
報紙
55.6 × 37.9 公分
私人收藏
*Dimanche, 27 novembre 1960 — le journal d'un seul
jour*
1960
Newspaper
55.6 × 37.9 cm
Private collection

《周日》1960 年 11 月 27 日——僅發行一天的
報紙〔英文版〕
1960 年原作之英文版
報紙
55.6 × 37.9 公分
私人收藏
*Dimanche, 27 novembre 1960 — le journal d'un seul
jour [English version]*
Re-creation of 1960 piece
Newspaper
55.6 × 37.9 cm
Private collection

◆
邀請參加伊夫·克萊因「將原料狀態的感性特化
成為穩定的圖像感性（虛空）」展覽開幕典禮
巴黎艾瑞絲·克勒特藝廊，1958 年 4 月 28 日
1958
印刷品
7.2 × 17 公分
私人收藏
*Invitation to the opening of Yves Klein's exhibition, The
Specialization of Sensibility in the Raw Material State
of Stabilized Pictorial Sensibility [The Void], Galerie Iris
Clert, Paris, April 28, 1958*
1958
Printed paper
7.2 × 17 cm
Private collection

銷售「非物質圖像感性區」收據簿，序號：0
1959
印刷品
8.7 × 29.8 公分
私人收藏
*Receipt book for the sale of the Zone of Immaterial
Pictorial Sensibility, Series No. 0*
1959
Printed paper
8.7 × 29.8 cm
Private collection

◆
將《非物質繪畫感性區》讓渡給麥可·布蘭克福
的收據
雙倍橋、巴黎、1962 年 2 月 10 日
照片、紙、手寫訊息〔複製品〕
33 × 42 公分
私人收藏
*Pressbook documenting the transfer of the Zone of
Immaterial Pictorial Sensibility to Michael Blankfort,
Pont au Double, Paris, February 10, 1962*
1962
Photographs on paper with additional handwritten
notes [Reproduction]
33 × 42 cm
Private collection

單調－寂靜交響曲
1949-1961
數位錄音檔案
45 分 30 秒
私人收藏
Monotone-Silence Symphony
1949-1961
Sound recording digital file
45 min. 30 sec.
Private collection

◆
單調－寂靜交響曲
1949-1961
樂譜
41.8 × 29.5 公分
私人收藏
Monotone-Silence Symphony
1949-1961
Printed score
41.8 × 29.5 cm
Private collection

◆
擔任指揮的伊夫·克萊因，於德國蓋爾森基辛歌
劇院
1959
黑白照片
16 × 22.5 公分
私人收藏
Yves Klein as orchestra conductor, Gelsenkirchen
Opera House, Germany
1959
Black and white photograph
16 × 22.5 cm
Private collection

約翰·凱吉
John Cage

4 分 33 秒
1952
樂譜
27.5 × 21 公分
日本山梨縣清里現代美術館收藏
4'33"
1952
Printed score
27.5 × 21 cm
Collection of Kiyosato Museum of Contemporary
Art, Yamanashi, Japan

0 分 00 秒（4 分 33 秒第二號）
1962
樂譜
27.5 × 21 公分
日本山梨縣清里現代美術館收藏
0'00" (4'33" No.2)
1962
Printed score
27.5 × 21 cm
Collection of Kiyosato Museum of Contemporary
Art, Yamanashi, Japan

龍安寺
1983-1985
LP 唱片
31.3 × 31.5 公分
日本山梨縣清里現代美術館收藏
Ryoanji
1983-1985
LP record
31.3 × 31.5 cm
Collection of Kiyosato Museum of Contemporary
Art, Yamanashi, Japan

易之樂
1951
LP 唱片
31.3 × 31.5 公分
日本山梨縣清里現代美術館收藏
Music of Changes
1951
LP record
31.3 × 31.5 cm
Collection of Kiyosato Museum of Contemporary
Art, Yamanashi, Japan

R²3 (Where R=Ryoanji)
1983
銅版畫
18 × 54 公分
川村龍俊收藏
R²3 (Where R=Ryoanji)
1983
Drypoint
18 × 54 cm
TP, ED. 25
Collection of Kawamura Tatsutoshi

R³ (Where R=Ryoanji)
1983
銅版畫
18 × 54 公分
川村龍俊收藏
R³ (Where R=Ryoanji)
1983
Drypoint
18 × 54 cm
TPB, ED. 25
Collection of Kawamura Tatsutoshi

Ryoku, No.1
1985
銅版畫
45.7 × 61 公分
川村龍俊收藏
Ryoku, No.1
1985
Drypoint
45.7 × 61 cm
AP5, ED. 10
Collection of Kawamura Tatsutoshi

亞倫·卡布羅
Allan Kaprow

舒適地帶
1975
16mm 影片轉換成數位檔案（DVD）、黑白、
聲音
17 分 49 秒
活動於馬德里凡德烈藝廊
亞倫·卡布羅資產及豪瑟暨維爾斯藝廊借展
Comfort Zones
1975
16mm film transferred to digital files (DVD), black
and white, sound
17 min. 49 sec.
Activity at Galería Vandrés, Madrid
Courtesy of Allan Kaprow Estate and Hauser &
Wirth

261

舒適地帶
1975
活動手冊
32.5 × 22.1 公分
馬德里凡德烈藝廊出版
亞倫‧卡布羅資產及豪瑟暨維爾斯藝廊借展
Comfort Zones
1975
Activity booklet
32.5 × 22.1 cm
Published by Galería Vandrés, S.A., Madrid
Courtesy of Allan Kaprow Estate and Hauser &
Wirth

如何創作偶發藝術
1964
LP 唱片
31.3 × 31.5 公分
日本山梨縣清里現代美術館收藏
亞倫‧卡布羅資產及豪瑟暨維爾斯藝廊借展
How to Make a Happening
1964
LP record
31.3 × 31.5 cm
Collection of Kiyosato Museum of Contemporary
Art, Yamanashi, Japan
Courtesy of Allan Kaprow Estate and Hauser &
Wirth

假日：偶發藝術日曆
1970
日曆
38.6 × 27.4 公分
日本山梨縣清里現代美術館收藏
亞倫‧卡布羅資產及豪瑟暨維爾斯藝廊借展
Days Off: A Calendar of Happenings
1970
Calendar
38.6 × 27.4 cm
Collection of Kiyosato Museum of Contemporary
Art, Yamanashi, Japan
Courtesy of Allan Kaprow Estate and Hauser &
Wirth

◆
歐洲旅行前寄給友人的信
1981
信件
尺寸不明
亞倫‧卡布羅資產及豪瑟暨維爾斯藝廊借展
The Getty Research Institute, Los Angeles (980063)
Letter to the friends before the European tour
1981
Typed letter
Dimensions unknown
Courtesy of Allan Kaprow Estate and Hauser &
Wirth
The Getty Research Institute, Los Angeles (980063)

◆
去／留
1981
歐洲旅行中的活動指示書
尺寸不明
亞倫‧卡布羅資產及豪瑟暨維爾斯藝廊借展
The Getty Research Institute, Los Angeles (980063)
Going / Staying
1981
Score for activity for European tour
Dimensions unknown
Courtesy of Allan Kaprow Estate and Hauser &
Wirth
The Getty Research Institute, Los Angeles (980063)

七種共鳴
1976
活動手冊
27.9 × 21.5 公分
維也納二十世紀美術館出版
亞倫‧卡布羅資產及豪瑟暨維爾斯藝廊借展
7 Kinds of Sympathy
1976
Activity booklet
27.9 × 21.5 cm
Published by Museum des 20er Jahrhunderts,
Vienna
Courtesy of Allan Kaprow Estate and Hauser &
Wirth

「偶發」
1967
目錄
25.6 × 22 公分
日本山梨縣清里現代美術館收藏
帕莎蒂納美術館出版
亞倫‧卡布羅資產及豪瑟暨維爾斯藝廊借展
"Happening"
1967
Catalogue
25.6 × 22 cm
Collection of Kiyosato Museum of Contemporary
Art, Yamanashi, Japan
Published by Pasadena Art Museum
Courtesy of Allan Kaprow Estate and Hauser &
Wirth

兩種鐵律
1974
活動手冊
34 × 24.5 公分
日本山梨縣清里現代美術館收藏
瑪爾塔諾出版
亞倫‧卡布羅資產及豪瑟暨維爾斯藝廊借展
2 Measures
1974
Activity booklet
34 × 24.5 cm
Collection of Kiyosato Museum of Contemporary
Art, Yamanashi, Japan
Published by Martano Editore
Courtesy of Allan Kaprow Estate and Hauser &
Wirth

甜牆
1976
活動手冊
22.7 × 15.1 公分
日本山梨縣清里現代美術館收藏
亞倫‧卡布羅資產及豪瑟暨維爾斯藝廊借展
Sweet Wall
1976
Activity booklet
22.7 × 15.1 cm
Collection of Kiyosato Museum of Contemporary
Art, Yamanashi, Japan
Courtesy of Allan Kaprow Estate and Hauser &
Wirth

常規
1975
活動手冊
28 × 21.5 公分
日本山梨縣清里現代美術館收藏
亞倫‧卡布羅出版
亞倫‧卡布羅資產及豪瑟暨維爾斯藝廊借展
Routine
1975
Activity booklet
28 × 21.5 cm
Collection of Kiyosato Museum of Contemporary
Art, Yamanashi, Japan
Published by Allan Kaprow
Courtesy of Allan Kaprow Estate and Hauser &
Wirth

迴響—遲鈍
1975
活動手冊
30.5 × 22.6 公分
日本山梨縣清里現代美術館收藏
達爾克出版
亞倫‧卡布羅資產及豪瑟暨維爾斯藝廊借展
Echo-Logy
1975
Activity booklet
30.5 × 22.6 cm
Collection of Kiyosato Museum of Contemporary
Art, Yamanashi, Japan
Published by D'Arc Press
Courtesy of Allan Kaprow Estate and Hauser &
Wirth

滿意
1976
活動手冊
28.3 × 21.9 公分
日本山梨縣清里現代美術館收藏
紐約 M.L. 達爾克藝廊出版
亞倫‧卡布羅資產及豪瑟暨維爾斯藝廊借展
Satisfaction
1976
Activity booklet
28.3 × 21.9 cm
Collection of Kiyosato Museum of Contemporary
Art, Yamanashi, Japan
Published by M.L. D'Arc Gallery, New York
Courtesy of Allan Kaprow Estate and Hauser &
Wirth

約翰‧凱吉備用盒
1987
膠版印刷紙、橡皮筋、幻燈片
21.6 × 21.6 × 3.2 公分
日本山梨縣清里現代美術館收藏
Prepared Box for John Cage
1987
Offset lithograph on paper, rubber bands, slide
21.6 × 21.6 × 3.2 cm
Collection of Kiyosato Museum of Contemporary
Art, Yamanashi, Japan

里克力‧提拉瓦尼
Rirkrit Tiravanija

無題 2007（free / still）
2007
16mm 影片、無聲、黑白
60 分 36 秒
東京 SIDE 2 藝廊及紐約蓋文‧布朗藝廊借展
Untitled 2007 (free/still)
2007
16mm film, silent, black and white
60 min. 36 sec.
Courtesy of GALLERY SIDE 2, Tokyo and Gavin
Brown's Enterprise, New York

吳瑪悧
Wu Mali

從妳的皮膚甦醒 2000-2004──皇后的新衣
2004
影片，12 分 28 秒
與台北市婦女新知協會合作
*Awake in Your Skin, 2000-2004—The Empress's New
Clothes*
2004
Video, 12 min. 28 sec.
Collaboration with Taipei Awakening Association

樹梅坑溪環境藝術行動
2011-2012
影片，11 分 33 秒
與竹圍工作室合作
*Art as Environment—A Cultural Action at Plum Tree
Creek*
2011-2012
Video, 11 min. 33 sec.
Collaboration with Bamboo Curtain Studio

林明弘
Michael Lin

文件
2015
9 分鐘
Documentation
2015
9 min.

- 1998
 共生共存 37 日
 Complementary

- 1998
 進口
 Imported

- 2008
 又甜又涼
 Cool and Sweet

- 2008
 無題
 Untitled

- 2013
 空位
 Place Libre

楊俊
Jun Yang

提案計畫與真實
2015
錄像，9 分 48 秒
Proposals and Reality
2015
Video, 9 min. 48 sec.

- 2010
 你我共同之處
 Things We Have in Common

- 2006 -2011
 GFZK 花園
 GFZK Garden

- 2012
 一個公共空間提案——電影院
 A Proposal for A Public Space – A Cinema

- 2012
 DAM——一本雜誌／一份有關／大仁藝術市場
 DAM – A Magazine / A Paper About / With Daein Art Market

- 2008
 一個當代藝術中心，台北
 A Contemporary Art Centre, Taipei (A Proposal)

吳建瑩
Wu Chien-Ying

我的朋友
2013
單頻錄像，23 分 48 秒
My Friends
2013
One single channel video, 23 min. 48 sec. loop

圖片來源
Photo Credits

Photo: Blaise Adilon
[pp.72, 84, 126]

Photo: Anita Kan
[pp.92-93, 140, 179, 184-185, 192-193]

Photo: Lee Studio
[pp.100-103, 106-107, 127, 133, 152-153, 170, 178]

Photo © 2015 Museum Associates / LACMA
[p.113]

Photo: Gary Lee
[p.141]

Photo: Kioku Keizo
[pp.206, 209, 211, 221-224, 226-228, 231-232, 236-238, 240]

© Yves Klein, ADAGP, Paris & JASPAR, Tokyo, 2015
E1766
[pp.213-214, 216-219]

Photo: Charles Wilp / BPK, Berlin
[p.219]

© John Cage Trust
[pp.226-228]

© J. Paul Getty Trust
[pp.233-234]

Photo: Bee Ottinger
[p.235]

© 2015. Digital Image, The Museum of Modern Art, New York / Scala, Florence
[p.242]

李明維

1997　耶魯大學藝術研究所碩士
1993　加州藝術與工藝學院藝術學士

2015　「李明維與他的關係：參與的藝術」，台北市立美術館，台北，台灣
　　　「李明維：聲之綻」，波士頓美術館，波士頓，美國
2014　「李明維與他的關係：參與的藝術」，森美術館，東京，日本
　　　「李明維：聲之綻」，尤倫斯當代藝術中心，北京，中國
2013　「客廳與四重奏」，華人藝術中心，曼徹斯特，英國
　　　「浮光之淵」，新加坡土生華人博物館，新加坡
2012　「客廳計畫」，嘉德納美術館，波士頓，美國
　　　「澄·微」，資生堂畫廊，東京，日本
　　　「石頭與水仙」，路易·威登文化空間，台北，台灣
2011　「移動的花園」，布魯克林美術館，紐約，美國
　　　「旅人」，美國華人博物館，紐約，美國
2010　「聲音三部曲」，曼特·史都華，蘇格蘭，英國
　　　「萬神殿」，巴爾的摩當代藝術館，巴爾的摩，美國
　　　「流動的形式」，奧沙畫廊，香港，中國
2009　「祖父之坡」，蒙塔瓦藝術中心，薩拉托加，美國
　　　「補裳計畫」，朗伯菲畫廊，紐約，美國
2008　「如沙的格爾尼卡」，昆士蘭現代美術館，布里斯本，澳洲
　　　「菩提計畫」，昆士蘭現代美術館，布里斯本，澳洲
　　　「非常感知」，戈維博斯特美術館，新普利茅斯，紐西蘭
　　　「四重奏」，雅爾本畫廊，倫敦，英國
2007　「李明維個展——無常」，芝加哥文化中心，芝加哥，美國
　　　「複音——李明維、謝素梅雙個展」，台北當代藝術館，台北，台灣
2006　「旅驛計畫」，雪曼畫廊，雪梨，澳洲
　　　「如沙的格爾尼卡」，雅爾本畫廊，倫敦，英國
　　　「萬神殿」，紐伯格美術館，紐約，美國
2005　「傳移摹寫」，科隆東亞美術館，科隆，德國
　　　「傳移摹寫」，懷古堂，紐約，美國
2004　「傳移摹寫」，洛杉磯郡立美術館，加州，美國
　　　「水頭傳說」，金門碉堡藝術館，金門，台灣
2003　「旅驛計畫」，紐約現代美術館，紐約，美國
　　　「靈媒計畫」，哈佛大學公共藝術案，劍橋，美國
2002　「旅驛計畫」，萊斯大學，休士頓，美國
　　　「對影」，誠品畫廊，台北，台灣
2000　「客廳計畫」，嘉德納美術館，波士頓，美國
　　　「睡寢計畫」，朗伯菲畫廊，紐約，美國
　　　「共鳴經濟」，衛斯理學院岱維斯美術館，衛斯理，美國
　　　「共鳴經濟」，勞德岱爾美術館，勞德岱爾，美國
1999　「李明維 1994-1999」，克里弗蘭當代藝術館，克里弗蘭，美國
1998　「驛站」，惠特尼美術館，紐約，美國
　　　「魚雁計畫」，紡織工房博物館，費城，美國
1997　「相互交換」，朗伯菲畫廊，紐約，美國

聯展

2015　「藝術與需求」，肯塔基藝術與工藝博物館，路易維爾，美國

　　　「國巨基金會收藏展」，京都國立近代美術館，京都，日本

　　　「盛宴：當代藝術中的徹底接待」，魏斯曼美術館，明尼亞波利斯，美國

2014　「綑代理」，詹姆斯・科恩畫廊，紐約，美國

　　　「國巨基金會收藏展」，廣島市現代美術館，廣島，日本

　　　「國巨基金會收藏展」，名古屋市立美術館，名古屋，日本

　　　「盛宴：當代藝術中的徹底接待」，根德美術館，甘比爾，美國

　　　「國巨基金會收藏展」，東京國立近代美術館，東京，日本

　　　「盛宴：當代藝術中的徹底接待」，SITE 聖塔菲，聖達菲，美國

2013　「串連_開展」，韓國國立現代美術館，首爾，韓國

　　　「盛宴：當代藝術中的徹底接待」，布萊佛美術館，休士頓，美國

　　　「超級關係——2013 國際科技藝術展」，國立台灣美術館，台中，台灣

　　　「Little Water」，2013 堂島川雙年展，堂島川論壇，大阪，日本

　　　「城市塑造——2013 人工製品節」，STUK 藝術中心，魯汶，比利時

2012　「REAKT ／觀點與過程」，歐洲文化之都，吉馬良斯，葡萄牙

　　　「盛宴：當代藝術中的徹底接待」，斯馬特美術館，芝加哥，美國

　　　「偶然的信息」，第七屆深圳雕塑雙年展，深圳，中國

　　　「我們所有的關係」，雪梨雙年展，雪梨，澳洲

　　　「開放學院」，海沃德藝廊，倫敦，英國

2011　「眾生平等」，海德林藝廊，西雅圖，美國

2010　「21 世紀十年藝術展 」，昆士蘭現代美術館，布里斯本，澳洲

　　　「交易再思維」，2010 利物浦雙年展，利物浦，英國

　　　「城市嬉遊」，錫恩美術館，法蘭克福，德國

2009　「啟蒙」，愛丁堡藝術節，愛丁堡，英國

　　　「每一天的視點」，2009 里昂雙年展，里昂，法國

　　　「如此靠近、卻又如此遙遠」，2009 仁川女性藝術雙年展，仁川，韓國

2008　「全相」，錫恩美術館，法蘭克福，德國

　　　「泡沫紅茶：台灣藝術・當代演繹」，摩拉維亞美術館，布爾諾，捷克

　　　「人群」，紐伯格美術館，紐約，美國

　　　「中國加油站」，葛洪達尚現代美術館，盧森堡

　　　「家——22008 台灣美術雙年展」，國立台灣美術館，台中，台灣

2007　「1.5 世代」，皇后美術館，紐約，美國

　　　「食飽未？」，2007 亞洲藝術雙年展，國立台灣美術館，台中，台灣

2006　2006 利物浦雙年展，泰德利物浦美術館，利物浦，英國

　　　2006 越後妻有大地藝術三年祭，新潟，日本

　　　聖莫妮卡藝術中心，巴塞隆納，西班牙

　　　「湖與湖間」，麥迪遜當代藝術館，威斯康辛，美國

　　　捷克科學院，捷克

2005　「秘則為花」，森美術館，東京，日本

　　　「偷天換日」，台北當代藝術館，台北，台灣

　　　「人群」，巴爾的摩當代藝術館，巴爾的摩，美國

　　　「意向的香氣」，猶太當代博物館，舊金山，美國

	「四海一家」，蘇菲亞皇后美術館，馬德里，西班牙
	「以『當代』為名——威尼斯雙年展台灣參展回顧，1995-2003」，台北市立美術館，台北，台灣
2004	2004 惠特尼雙年展，惠特尼美術館，紐約，美國
	「四海一家」，雀兒喜美術館，紐約，美國
	「虛擬的愛」，台北當代藝術館，台北，台灣
2003	「心感地帶」，第 50 屆威尼斯雙年展台灣館，威尼斯，義大利
	「遠離家園」，魏克斯納藝術中心，克里夫蘭，美國
	「開幕特展」，辛辛那提當代藝術中心，辛辛那堤，美國
	「魔術師」，德摩尼斯藝術中心，德摩尼斯，美國
	「方寸之間」，湖巖美術館，首爾，韓國
	「禮物」，布朗克斯美術館，紐約，美國
	「禮物」，西北大學布洛克美術館，芝加哥，美國
2002	「街頭劇院」，艾迪生美國藝術畫廊，安多佛，美國
	「禮物」，史考特戴爾當代藝術館，史考特戴爾，美國
	「歡樂迷宮」，高雄市立美術館，高雄，台灣
2001	「歡樂迷宮」，台北當代藝術館，台北，台灣
	「混合配方」，美國酒饌藝術中心，那帕，美國
	「禮物」，帕翡思宮當代館，席耶那，義大利
	「只要我長大」，潘理緒美術館，南漢普敦，美國
2000	「無法無天」，2000 台北雙年展，台北市立美術館，台北，台灣
	「無價」，盧布爾雅那市現代畫廊，斯洛維尼亞
	「希望的獻禮」，東京現代美術館，東京，日本
1999	「1999 亞太三年展」，昆士蘭美術館，布里斯本，澳洲
	「你在何方？」，巴德學院策展中心，紐約，美國
1998	「異語」，白盒子藝廊，紐約，美國
	「紙上藝術」，韋勒思朋美術館，格林斯伯勒，美國
1997	「給我你的錢」，芮弗沙龍，舊金山，美國
	「世界觀點」，德意志銀行，紐約，美國
	耶魯大學美術館，紐哈芬，美國

典藏紀錄

惠特尼美術館，紐約，美國

國立台灣美術館，台中，台灣

耶魯大學美術館，康乃迪克州，美國

昆士蘭美術館／現代美術館，布里斯本，澳洲

德意志銀行，紐約，美國

韋勒思朋美術館，格林斯伯勒，北卡羅萊納州，美國

歐柏林學院艾倫紀念美術館，俄亥俄州，美國

國巨基金會，台北，台灣

榮嘉藝術文化基金會，新竹，台灣

波士頓美術館，波士頓，美國

Lee Mingwei

1997	Yale University, Graduate School of Fine Arts, Master of Fine Arts in Sculpture
1993	California College of Arts and Crafts, Bachelor of Fine Arts with Honors in Textile Art

Solo Exhibitions

2015	*Lee Mingwei and His Relations: The Art of Participation*, Taipei Fine Arts Museum, Taipei, Taiwan
	Lee Mingwei: Sonic Blossom, Museum of Fine Arts, Boston, MA
2014	*Lee Mingwei and His Relations: The Art of Participation*, Mori Art Museum, Tokyo, Japan
	Lee Mingwei: Sonic Blossom, Ullens Center for Contemporary Art, Beijing, China
2013	*A Quartet and A Living Room*, Chinese Arts Centre, Manchester, UK
	Luminous Depths, Peranakan Museum, Singapore
2012	*The Living Room*, Isabella Stewart Gardner Museum, Boston, MA
	Visible, Elusive, Shiseido Gallery, Tokyo, Japan
	Tales of Flower and Stones, Espace Louis Vuitton, Taipei, Taiwan
2011	*The Moving Garden*, Brooklyn Museum, New York, NY
	The Travelers, Museum of Chinese in America, New York, NY
2010	*Trilogy of Sounds*, Mount Stuart, Scotland, UK
	Pantheon Project, Museum Contemporary Baltimore, Baltimore, MD
	Lee Mingwei: Liquid Forms, Osage Gallery, Hong Kong, China
2009	*Grandfather's Incline*, Montalvo Art Center, Saratoga, CA
	The Mending Project, Lombard-Freid Projects, New York, NY
2008	*Guernica in Sand*, Queensland Gallery of Modern Art, Brisbane, Australia
	Bodhi Tree Project, Queensland Gallery of Modern Art, Brisbane, Australia
	Uncommon Senses, Govett-Brewster Art Gallery, New Plymouth, New Zealand
	The Quartet Project, Albion Gallery, London, UK
2007	*Lee Mingwei: Impermanence*, Chicago Cultural Center, Chicago, IL
	Duologue, Museum of Contemporary Art Taipei, Taipei, Taiwan
2006	*The Tourist*, Sherman Galleries, Sydney, Australia
	Guernica in Sand, Albion Gallery, London, UK
	Pantheon Project, Neuberger Museum of Art, New York, NY
2005	*Through Masters' Eyes,* Museum für Ostasiatische Kunst, Cologne, Germany
	Through Masters' Eyes, Kaikodo Gallery, New York, NY
2004	*Through Masters' Eyes,* Los Angeles County Museum of Art, Los Angeles, CA
	Shueito Legends, Bunker Museum of Contemporary Art, Kinmen, Taiwan
2003	*The Tourist*, Museum of Modern Art, New York, NY
	Harvard Seers Project, Harvard University Office for the Arts, Cambridge, MA
2002	*The Tourist Project*, Rice University Art Gallery, Houston, TX
	The Shadow and Its Double, Eslite Gallery, Taipei, Taiwan
2000	*The Living Room Project,* Isabella Stewart Gardner Museum, Boston, MA
	The Sleeping Project, Lombard Freid Fine Arts, New York, NY
	Empathic Economies, Davis Museum, Wellesley College, Wellesley, MA
	Empathic Economies, Ft. Lauderdale Museum of Art, Ft. Lauderdale, FL

1999	*Lee Mingwei 1994 to 1999*, Cleveland Center for Contemporary Art, Cleveland, OH
1998	*Way Stations*, Whitney Museum of American Art, New York, NY
	The Letter Writing Project, The Fabric Workshop & Museum, Philadelphia, PA
1997	*InteractExchange*, Lombard Freid Fine Arts, New York, NY

Selected Group Exhibitions

2015	*Food, Shelter, Clothing: Art and Need*, Kentucky Museum of Art and Craft, Louisville, KY
	Guess what? Hardcore Contemporary Art's Truly a World Treasure: Selected Works from the YAGEO Foundation Collection, The National Museum of Modern Art, Kyoto, Japan
	Feast: Radical Hospitality in Contemporary Art, Weisman Art Museum, University of Minnesota, Minneapolis, MN
2014	*By Proxy*, James Cohan Gallery, New York, NY
	Guess what? Hardcore Contemporary Art's Truly a World Treasure: Selected Works from the YAGEO Foundation Collection, Hiroshima City Museum of Contemporary Art, Hiroshima, Japan
	Guess what? Hardcore Contemporary Art's Truly a World Treasure: Selected Works from the YAGEO Foundation Collection, Nagoya City Art Museum, Nagoya, Japan
	Feast: Radical Hospitality in Contemporary Art, Gund Gallery, Kenyon Gallery, Gambier, OH
	Guess what? Hardcore Contemporary Art's Truly a World Treasure: Selected Works from the YAGEO Foundation Collection, The National Museum of Modern Art, Tokyo, Japan
	Feast: Radical Hospitality in Contemporary Art, SITE Santa Fe, Santa Fe, NM
2013	*Connecting_Unfolding*, National Museum of Modern and Contemporary Art, Korea, Seoul, Korea
	Feast: Radical Hospitality in Contemporary Art, Blaffer Art Museum, Houston, TX
	TEA/Super-Connect—2013 International Techno Art Exhibition, National Taiwan Museum of Fine Arts, Taichung, Taiwan
	Little Water, Dojima River Biennale 2013, Dojima River Forum, Osaka, Japan
	A City Shaped, Artefact Festival, STUK arts center, Leuven, Belgium
2012	*REAKT / Views and Processes*, European Capital of Culture, Guimarães, Portugal
	Feast: Radical Hospitality in Contemporary Art, Smart Museum of Art, Chicago, IL
	Accidental Message: Art is Not a System, Not a World, 7th Shenzhen Sculpture Biennale, Shenzhen, China
	All Our Relations, 18th Biennale of Sydney, Sydney, Australia
	Wide Open School, Hayward Gallery, London, UK
2011	*All Things Equal*, Hedreen Gallery, Seattle University, Seattle, WA
2010	*21st Century: Art in the First Decade*, Gallery of Modern Art, Brisbane, Australia
	Re:Thinking Trade, Liverpool Biennial 2010, UK
	Playing in the City II, Schirn Kunsthalle Frankfurt, Germany
2009	*The Enlightenment*, Dean Gallery, Edinburgh International Festival, UK
	The Spectacle of the Everyday, Lyon Biennial 2009, France
	So Close Yet So Far Away, 2009 Incheon Women Artists' Biennale, Incheon, Korea
2008	*All Inclusive*, Schirn Kunsthalle Frankfurt, Frankfurt, Germany
	Art of Taiwan and its Contemporary Mutations, The Moravian Gallery, Brno, Czech Republic
	Person of the Crowd, Neuberger Museum of Art, New York, NY

China Power III, Musée d'art moderne Grand-Duc Jean, Luxemburg

Home-Taiwan Biennial 2008, National Taiwan Museum of Fine Arts, Taichung, Taiwan

2007 *1.5 Generation*, Queens Museum of Art, New York, NY

Have You Eaten Yet?, 2007 Asian Art Biennial, National Taiwan Museum of Fine Arts, Taiwan

2006 *International 06*, Liverpool Biennial 2006, Tate Liverpool, UK

Echigo-Tsumari Art Triennale 2006, Niigata, Japan

Arts Santa Monica, Barcelona, Spain

Between the Lakes: Artists Respond to Madison, Madison Museum of Contemporary Art, Madison, WI

Czech Academy of Sciences, Czech Republic

2005 *Elegance of Silence*, Mori Art Museum, Tokyo, Japan

Trading Places, Museum of Contemporary Art, Taipei, Taipei, Taiwan

Man of the Crowd, Contemporary Museum Baltimore, Baltimore, MD

Scents of Purpose: Artists Interpret the Spice Box, Contemporary Jewish Museum, San Francisco, CA

We are the world, El Museo Nacional Centro de Arte *Reina Sofía, Madrid, Spain*

Contemporary Art from Taiwan at the Venice Biennale, Taipei Fine Arts Museum, Taipei, Taiwan

2004 *Whitney Biennial 2004*, Whitney Museum of American Art, New York, NY

We Are the World, Chelsea Art Museum, New York, NY

Fiction Love, Museum of Contemporary Art, Taipei, Taipei, Taiwan

2003 *Limbo Zone*, 50th Venice Biennale, Taiwan Pavilion, Italy

Away from Home, Wexner Center of Art, Cleveland, OH

Inaugural Exhibition, Cincinnati Center for Contemporary Art, Cincinnati, OH

The Magic Makers, Des Moines Center of Art, Des Moines, IA

Mind Space, Ho-Am Art Museum, Seoul, Korea

The Gift, Bronx Museum of Art, Bronx, New York, NY

The Gift, Mary and Leigh Block Museum of Art, Chicago, IL

2002 *Sitelines*, Addison Gallery of American Art, Andover, MA

The Gift, Scottsdale Museum of Contemporary Art, AZ

Labyrinth of Pleasure, Kaohsiung Museum of Fine Art, Kaohsiung, Taiwan

2001 *Labyrinth of Pleasure*, Museum of Contemporary Art Taipei, Taiwan

Mixed Ingredients, American Center for Food, Wine and the Arts, Napa, CA

The Gift, Centro Arte Contemporanea Palazzo delle Papesse, Siena, Italy

About the Bayberry Bush, Parrish Art Museum, Southampton, New York, NY

2000 *The Sky is the Limit,* 2000 Taipei Biennial, Taipei Fine Arts Museum, Taipei, Taiwan

Worthless (Invaluable), Museum of Modern Art, Ljubljana, Slovenia

The Gift of Hope, Museum of Contemporary Art Tokyo, Japan

1999 *The 3rd Asia Pacific Triennial*, Queensland Art Gallery, Brisbane, Australia

Where Are You?, Center for Curatorial Studies, Bard College, New York, NY

1998 *Plural Speech*, White Box, New York, NY

Art on Paper, Weatherspoon Art Gallery, Greensboro, NC

1997 *Gimme all your money*, Refusalon, San Francisco, CA

The World View, Deutsche Bank, New York, NY

Yale University Art Gallery, School of Architecture, Yale University, New Haven, CT

Public Collections

Whitney Museum of American Art, New York, NY

National Taiwan Museum of Fine Arts, Taichung, Taiwan

Yale University Art Gallery, New Haven, CT

Queensland Art Gallery / Gallery of Modern Art, Brisbane, Australia

Deutsche Bank, New York, NY

Weatherspoon Art Gallery, Greensboro, NC

Allen Memorial Art Museum, Oberlin College, Oberlin, OH

YAGEO Foundation, Taipei, Taiwan

Yeh Rong Jai Culture & Art Foundation, Hsinchu, Taiwan

Museum of Fine Arts, Boston, MA

参考書目
Selected Bibliography

展覽圖錄
Exhibition Catalogues

- 『リー・ミンウェイ展 澄・微』資生堂 企業文化部，2012 年
 （*Lee Mingwei Visible, Elusive*, Tokyo: Shiseido Corporate Culture Department, 2012.）
- *18th Biennale of Sydney: All Our Relations*, Sydney: The Biennale of Sydney, 2012.
- *Touched: Liverpool Biennial*, Liverpool: Liverpool Biennial of Contemporary Art, 2011.
- *Lee Mingwei: The Moving Garden*, New York: Brooklyn Museum, 2011.
- *The Enlightenments*, Edinburgh: Edinburgh International Festival, 2009.
- *Generation 1.5*, New York: Queens Museum of Art, 2009.
- *All-Inclusive: A Tourist World*, Frankfurt: Schirn Kunsthalle, 2008. 〔德 / 英 | German/English〕
- *Duologue: Exhibition by Lee Mingwei and Tse Su-Mei*, Taipei: Contemporary Art Foundation/Museum of Contemporary Art, 2007. 〔中 / 英 | Chinese/English〕
 （《複音：李明維、謝素梅雙個展》，台北：當代藝術基金會 / 台北當代藝術館，2007）
- *Liverpool Biennial International 2006*, Liverpool: Liverpool Biennial of Contemporary Art, 2006.
- *Between the Lakes: Artists Respond to Madison*, Madison, WI: Madison Museum of Contemporary Art, 2006.
- 『秘すれば花：東アジアの現代美術』森美術館，2005 年
 （*The Elegance of Silence: Contemporary Art from East Asia*, Tokyo: Mori Art Museum, 2005.）
- *Trading Place: Contemporary Art Museum*, Taipei: Contemporary Art Foundation/Museum of Contemporary Art, 2005. 〔中 / 英 | Chinese/English〕
 （高千惠策展，《偷天換日：當・代・美・術・館》，台北：當代藝術基金會 / 台北當代藝術館，2005）
- *Lee Mingwei's Through Masters' Eyes*, Los Angeles, CA: Museum Associates, Los Angeles County Museum of Art, 2004.
- *Projects 80: Lee Mingwei, The Tourist*, New York: The Museum of Modern Art, 2003.
- *Lee Mingwei: The Tourist Project*, Houston, TX: Rice University Art Gallery, 2003.
- *Away from Home*, Columbus, OH: Wexner Center for the Arts, 2003.
- *Magic Markers: Objects of Transformation*, Des Moines, IA: Edmundson Art Foundation, 2003.
- *Mind Space*, Seoul: Samsung Museum of Modern Art, 2003. 〔韓 / 英 | Korean/English〕
- *Labyrinth of Pleasure*, Taipei: Contemporary Art Foundation/Museum of Contemporary Art, 2001. 〔中 / 英 | Chinese/English〕
 （賴瑛瑛、王嘉驥策展，《歡樂迷宮》，台北：當代藝術基金會 / 台北當代藝術館，2001）
- *About the Bayberry Bush*, Water Mill, NY: Parrish Art Museum, 2001.
- *Active Ingredients*, Napa, CA: COPIA: The American Center for Wine, Food and the Arts, 2001.
- *Lee Mingwei: The Living Room*, Boston, MA: Isabella Stewart Gardner Museum, 2000.
- *Beyond the Future: The Third Asia-Pacific Triennial of Contemporary Art*, Brisbane: Queensland Art Gallery, 1999.
- *Way Stations*, New York: Whitney Museum of American Art, 1998.

專書
Books

- Finkelpearl, Tom, *What We Made: Conversations on Art and Social Cooperation*, Durham, NC: Duke University Press Books, 2013.

- Hsu, Yunkang, *In the Name of Art*, Taipei: Goodness Publishing House, 2009.〔中｜Chinese〕
 （徐蘊康，《以藝術之名──從現代到當代探索台灣視覺藝術》，台北：博雅書屋，2009）
- *Studies on 20th Century Shanshuihua*, Shanghai: Shanghai Shuhua Chubanshe, 2006.〔中｜Chinese〕
 （《二十世紀山水畫研究文集》，上海：上海書畫出版社，2006）
- Baas, Jacquelyn; Jacob, Mary Jane (eds.), *Buddha Mind in Contemporary Art*, Berkeley, CA: University of California Press, 2004.
- Stroud, Marion Boulton, *New Material as New Media: The Fabric Workshop and Museum*, Cumberland: The MIT Press, 2003.
- Anderson, Maxwell L., *Whitney: American Visionaries — Selections from the Whitney Museum of American Art*, New York: Whitney Museum of American Art, 2002.
- Zimmer, Carol, "Two Artists: Gerhard Richter and Lee Mingwei," *Ninety: Art in the 90's*, Paris: Flohic Editions, No.29, 1998.〔英／法｜English/French〕

期刊文章與專文
Periodicals

- Solanki, Veeranganakumari, "Flash Art Asia 3: Lee Mingwei & Charwei Tsai," Flash Art, November-December 2012, pp.90-93.
- Kent, Rachel, "Threads of Connection: Lee Mingwei," *ArtAsiaPacific*, Issue 80, September-October 2012, pp.100-109.
- 西岡一正「服の思い出、人々を結ぶ リー・ミンウェイ日本初の個展」、『朝日新聞』2012 年 9 月 19 日夕刊
- 岡部あおみ「リー・ミンウェイ展 人とつながる独自アート」、『東京新聞』2012 年 9 月 7 日夕刊
- 後藤繁雄「後藤繁雄の来日アーティスト・ショートインタビュー：リー・ミンウェイ」、『ARTcollectors（アートコレクターズ）』生活の友社、No.44、2012 年、p.103
- Dyer Amazeen, Lauren, "Critics' Picks: Lee Mingwei — Mount Stuart," *Artforum*, July 2010.
- Mansfield, Susan, "Lee Mingwei: Trilogy of Sounds," The Scotsman, May 16, 2010.
- Aristarkhova, Irina, "Man as Hospitable Space: The Male Pregnancy Project," *Performance Research: A Journal of the Performing Arts*, March 30, 2010.
- Lequeux, Emmanuelle, "Six artistes, six agitateurs du quotidien," *Le Monde*, September 15, 2009.〔法語｜French〕
- McGlone, Jackie, "Interview: Lee Mingwei — 'I really wanted to give birth'," *The Scotsman*, August 12, 2009.
- Temin, Christine, "Lee Mingwei: Beyond Labels," *Sculpture*, Vol.27, No.7, September 2008, pp.24-31.
- Sorensen, Rosemary, "Artist shifts sands in tribute to Picasso's Guernica," *The Australian*, May 2, 2008.
- Clarke, Suzanna, "Venerable Tree for Enlightened Project," *The Courier-Mail*, 2008.
- Sand, Olivia, "Lee Mingwei and his practice," *Asian Art News*, 2008.
- Hawkins, Margaret, "'Impermanence' Full of Life — and Death," *Chicago Sun-Times*, May 18, 2007.
- Schwendener, Martha, "Art in Review; Generation 1.5," *The New York Times*, August 24, 2007.
- Weinberg, Lauren, "Sweet Dreams," *Time Out Chicago*, 2007.
- Huang, Iris, "Duologue: Osmosis between Lee Mingwei and Su-Mei Tse," *Artist Magazine*, 2007.
- Wang, Pinhua, "Encountering the Ephemeral," *ARTCO*, 2007.

- Lee, Yulin, "Lee Mingwei: Artists as Residents," *ARTCO*, 2006.
- Wan, Chiren, "Lee Mingwei," *La Vie*, 2006. 〔法語 | French〕
- Hampson, Alice, "The Tree of Man," *Monument*, 2006.
- Cotter, Holland, "Art in Review; Asia Week Is Here, There, Everywhere," *The New York Times*, April 1, 2005.
- Iwakiri, Mio, "Shioda Junichi view on Contemporary East Asian Art," *Artist Magazine*, 2005.
- Chan, Suwen, "The Challenges of Contemporary Art Collectors," *Artist Magazine*, 2005.
- Cheng, Scarlet, "A master revisited," *Los Angeles Times*, May 9, 2004.
- Tsai, Eugenie, "Lee Mingwei: The Tourist," *ArtAsiaPacific*, Issue 40, Spring 2004.
- Cotter, Holland, "Art in Review; Lee Mingwei — Projects 80," *The New York Times*, November 21, 2003.
- Gewertz, Ken, "Is this art?: Lee Mingwei says, 'Trust me.'," *Harvard University Gazette*, May 1, 2003.
- Temin, Christine, "Seeing, believing are put to the test at Harvard," *The Boston Globe*, April 25, 2003.
- Goldstein, Brian D., "Art Installation to Bring Seekers, 'Seers' to Memorial Hall," *The Harvard Crimson*, April 25, 2003.
- Tsai, Eugenie, "Projects 80: Lee Mingwei, The Tourist," *Time Out New York*, 2003.
- Edwards, Alison, "The Harvard Seers Project," *Arts Spectrum*, 2003.
- Weisgall, Deborah, "ART/ARCHITECTURE; Lust in the Gallery, Larceny in the Heart," *The New York Times*, August 18, 2002.
- Temin, Christine, "In Andover, New Project Lines Main Street with Art," *The Boston Globe*, May 2, 2002.
- Kee, Joan, "Resting with Mingwei: Subversive Cosmopolitanism in the Conceptual Project of Lee Mingwei," *Yishu*, Vol.1, No.1, May 2002.
- Thea, Carolee, "Focus: Lee Mingwei," *Sculpture*, Vol.21, No.2, March 2002.
- Moore, Janet, "Rebel without a Genre," *The Wall Street Journal Asia*, January 18, 2002.
- Karson, Kay, "To Take Part in the Art, You Sleep with the Artist," *The New York Times*, November 5, 2001.
- Clifford, Katie, "Please Touch!," *ARTnews*, May 2001, pp. 180-183.
- Long, Charles, "Top Ten," *Artforum*, March 2001.
- Kastner, Jeffrey, "LOOKING AHEAD; MoMA to MoCA, Storm King to Fogg," *The New York Times*, September 10, 2000.
- Chang Ju-ping, "The Men Behind the Installations," *Taipei Times*, September 3, 2000.
- Phillips, Patricia C., "Critique & Compliance: Artists on Display," Vol.19, No. 4, *Sculpture*, May 2000.
- Weisgall, Deborah, "ART/ARCHITECTURE; Please, Make Yourself at Home in the Art," *The New York Times*, April 23, 2000.
- Zimmer, Carol, "Art in Experience," *Greater Boston Arts*, WGBH, April 19, 2000.
- Temin, Christine, "Postal Modernism Exquisite Works by Installation Artist Lee Mingwei Attempt to Bridge the Gap between Art and Life," *The Boston Globe*, April 7, 2000.
- Hopkins, Randi, "Ritual Exchange," *Boston Phoenix*, March 24, 2000, p.12.
- Hu, Yung-fen, "'I am a Magician!' Lee Mingwei, A Fantasy-Creating Artist," *ArtChina*, No.18, March 2000, p.44.
- Boyce, Roger, "The Art of Lee Mingwei," *Art New England*, February-March 2000.
- Brown, Alan, "Lee Mingwei," *Out Magazine*, February 2000, p.34.
- Marcoci, Roxana, "The Anti-Historicist Approach: Brancusi, 'Our Contemporary'," *Art Journal*, Vol.59, Issue 2, 2000.
- Green, Charles, "The Third Asia-Pacific Triennial of Contemporary Art," *Artext*, No.68, 2000.
- Namba, Sachiko, "Review: The Third Asia-Pacific Triennial of Contemporary Art," *Art Monthly*, October 1999.
- Sozanski, Edward J., "Five Artists Take On The Problems Of Language," *Philadelphia Inquirer*, April 2, 1999.
- Stein, Judith E., "Lee Mingwei," *ArtAsiaPacific*, Issue 22, April 1999, p.91.
- Zimmer, Carol, "The Best Museum Shows of 1998," *Time Out New York*, December 31 – January 6, 1999.

- 難波祐子「"観客参加"問いかける "アジア太平洋現代美術トリエンナーレ"を見て」、『中国新聞』1999 年 11 月 13 日
- Rice, Robin, "Between Heaven and Hell," *Philadelphia City Paper*, November 20, 1998.
- Larson, Kay, "The Healing Power of Art," *The New York Times*, November 15, 1998.
- Kino, Carol, "My Dinner With Mingwei," *Time Out New York*, July 1998.
- Schwabsky, Barry, "Subject X: Notes on Performative Art, Part 1," *Artext*, No.60, 1998.
- Myles, Eileen, "Mingwei Lee," *Art in America*, November 1997.
- Lebre, Elayne, "Surprises," *ELLE Magazine*, September 1997.〔フランス語版｜French edition〕
- Gardiner, Beth, "Museum Preserves Dinner Dialogue," *Associated Press*, July 30, 1997.
- Doran, Anne, "Interact Exchange," *Time Out New York*, June 18, 1997.
- Levin, Kim, "Voice Choices," *The Village Voice*, June 10, 1997.

感謝誌
Acknowledgements

本展得以順利完成，我們要對下列機構與個人（依姓氏筆畫）的熱忱支持與協助表達誠摯的謝意。
We would like to express our heartfelt thanks to the following individuals, organizations, and corporations whose generous support and cooperation made this exhibition possible.

機構
Organizations

國立台灣美術館
National Taiwan Museum of Fine Arts
忠泰建築文化藝術基金會
JUT Foundation for Arts and Architecture
清里現代美術館
Kiyosato Museum of Contemporary Art
嘉德納美術館
Isabella Stewart Gardner Museum
洛杉磯郡立美術館
Los Angeles County Museum of Art
昆士蘭現代美術館
Queensland Art Gallery | Gallery of Modern Art
田中溫古堂
東慶寺
Allan Kaprow Estate
GALLERY SIDE 2
HAUSER & WIRTH ZÜRICH
John Cage Trust
Yves Klein Archives

個人
Individuals

吳建瑩 Wu Chien-Ying
吳瑪悧 Wu Mali
吳興達 Simon Wu
李明維 Lee Mingwei
林明弘 Michael Lin
施俊兆與夫人 Amy and Leo Shih
陳榮泉 Rong-chuan Chen
曾文泉 Rudy Tseng
楊俊 Jun Yang
Cesar Reyes
Daniel Moquay
Harvey Molotch and Glenn Wharton
Rirkrit Tiravanija
Sophia and Leon Tan
川村龍俊 Tatsutoshi Kawamura
井上陽司 Youji Inoue
田中大三郎 Daizaburo Tanaka
田中春喜 Haruki Tanaka
伊藤信吾 Shingo Ito

特別感謝
Special thanks to

丁心如 Hsin-ju Ting
王佩瑤 Peiyao Wang

王增勇 Frank Wang
朱雨平 Daphne Chu
李佳玲 Chia-ling Lee
李為仁 Wei-ren Lee
李堯堃 Yau Kuen Lee
李貴蘭 Kui-lan Li
林子晴 Elly Lin
林貴美 Kuei Mei Lin
洪致美 Joyce Hung
范月華 Yueh-hua Fan
翁伊珊 Issa Weng
高子衿 Tzu-chin Kao
陳眂怡 Kuang-yi Chen
黃煦倩 Sandy Wong
John Rivett
Mori Art Museum Best Friends
土屋隆英 Takahide Tsuchiya
中島美々 Mimi Nakajima
片岡真實 Mami Kataoka
広瀬麻美 Mami Hirose
吉田彩子 Ayako Yoshida
熊倉晴子 Haruko Kumakura
鷹箸絵麻 Ema Takanohashi

《如實曲徑》演出者 Performers of *Our Labyrinth*
平彥寧 Yan-ning Ping
吳成龍 Cheng-lung Wu
汪秀珊 Hsiu-shan Wang
林睿育 Jui-yu Lin
徐偉 Wei Xu
簡妍臻 Yan-chen Chian

《聲之綻》演唱者 Singers of *Sonic Blossom*
林義偉 Yi-wei Lin
宮天平 Thien-phin Kung
梁又中 You-jhong Liang
陳玟潔 Wen-chieh Chen
陳集安 Chi-an Chen
黃盈慈 Ying-tzu Huang

《客廳計畫》主人 Hosts of *The Living Room*
王允端 Yun-duan Wang
王佩瑤 Peiyao Wang
王柏偉 Po-wei Wang
何湘葳 Hsiang-wei Ho
余思穎 Sharleen Yu
吳世全 David Wu
林育淳 Yu-chun Lin

林宗興 Tzung-hsing Lin
柯佳佑 Chia-yu Ko
許惠琪 Hui-chi Hsu
陳倖靜 Hsing-ching Chen
詹彩芸 Tsai-yun Chan
盧瑞珽 Jui-ting Lu

《晚餐計畫》主人 Hosts of *The Dining Project*
林平 Ping Lin
林忠憲 Chung-hsien Lin
倪重華 Chung-hwa Ni
張麗莉 Lily Chang
蔣雨芳 Yu-fang Chiang
蕭淑文 Jo Hsiao

《睡寢計畫》主人 Hosts of *The Sleeping Project*
王柏偉 Po-wei Wang
何湘葳 Hsiang-wei Ho
吳世全 David Wu
陳泳任 Yung-jen Chen
羅鴻文 Hung-wen Lo
饒德順 Der-shun Rau

《織物的回憶》參與者 Participants of *Fabric of Memory*
王允端 Yun-duan Wang
吳美玲 Mei-ling Wu
吳莉慧 Li-hui Wu
吳道沄 Tao-yun Wu
吳麗珠 Li-chu Wu
沈怡寧 Yi-ning Shen
周麗蘭 Li-lan Chou
孟華 Hua Meng
拉拜依・尤耀 Labay Yuyan
林小戀 Hsiao-lian Lin
翁翎詠 Ling-yung Weng
馬嘉琪 Chia-chi Ma
高秋玉 Chiu-yu Kao
莊麗蓉 Li-jung Chuang
陳永煜 Yung-yu Chen
陳冠竹 Kuan-chu Chen
陳昭儀 Chao-yi Chen
游秋蘭 Chiu-lan You
蔡有芬 Yu-fen Tsai
鄭詩蘋 Shi-ping Cheng
鄭寶妹 Pao-mei Cheng
黎芮伶 Jui-ling Li
顏芝芸 Chih-yun Yan
羅淑玉 Shu-yu Lo

李明維與他的關係：參與的藝術
——透過觀照、對話、贈與、書寫、飲食串起和世界的連結

本書為「李明維與他的關係：參與的藝術」展覽專輯，展覽日期為 2015 年 5 月 30 日至 9 月 6 日

展　　覽

展覽組長　方美晶
展覽前置　蕭淑文
展覽策辦　雷逸婷　蘇子修
展覽助理　林以婕
展務協助　嚴玲娟
視覺設計　胡若涵
展覽佈置　支涵郁　林宗興　王麗莉　陳宏圖　李佳霖
作品拍攝　陳泳任　陳志和
機電燈光　蔡永昶　蔡鳳煌　簡偉洲　張裕政
教育活動　張芳薇　林宣君　施淑宜　蕭淑惠　吳世全　盧瑞珽　莊麗雅
公關宣傳　林忠؟儒　廖健男　呂學卿
總　　務　饒德順　廖芸娜

專　　輯

發 行 人　林　平
著作權人　台北市立美術館
執行編輯　雷逸婷
助理編輯　林以婕　蘇子修
校稿協助　劉玉貞　張曉華
翻　　譯　日譯中：劉子倩　詹慕如
　　　　　英譯中：繆詠華
　　　　　中譯英：韓伯龍　陳靜文
美術設計　胡若涵
圖像授權提供　台北市立美術館　森美術館　李工作室

發 行 處　台北市立美術館
　　　　　台灣 104 台北市中山北路三段 181 號
　　　　　電話：886 (2) 2595 7656
　　　　　傳真：886 (2) 2594 4104
出版日期　2015 年 9 月 初版
印　　刷　佳信印刷有限公司

國際標準書號｜ISBN 978-986-04-6012-4（精裝）
統一編號｜1010401783
定價｜新台幣 900 元

展售門市
台北市立美術館藝術書店
104 台北市中山北路三段 181 號｜電話：886 (2) 2595 7656 分機 734
國家書店松江門市
104 台北市松江路 209 號 1 樓｜電話：886 (2) 2518 0207
五南文化廣場台中總店
400 台中市中山路 6 號｜電話：886 (4) 2226 0330

國家圖書館出版品預行編目 (CIP) 資料

李明維與他的關係：參與的藝術：透過觀照、對話、贈與、書寫、飲
食串起和世界的連結 / 雷逸婷執行編輯.
-- 初版. -- 臺北市：北市美術館, 2015.09
280 面；19x24 公分
ISBN 978-986-04-6012-4(精裝)

1. 現代藝術 2. 作品集

902.33　　　　　　　　　　　　　　　　104019007

Lee Mingwei and His Relations: The Art of Participation
—Seeing, Conversing, Gift-giving, Writing, Dining and Getting Connected to the World

Published for the representation of Lee Mingwei and His Relations: The Art of Participation at the Taipei Fine Arts Museum,
Taipei, Taiwan from 30th May to 6th September, 2015.

Exhibition Team
Curator in chief: Mei-ching Fang
Planning: Jo Hsiao
Curators in charge of the exhibition: Yi-ting Lei, Tzu-Hsiu Su
Exhibition Assistant: I-chieh Lin
Exhibition Affairs: Sabrina Yen
Graphic Design: Rohan Hu
Exhibition Display: Han-yu Chih, Tsung-hsing Lin, Lily Wang, Hung-tu Chen,
 Chia-lin Lee
Photographers: Yung-jen Chen, Chih-ho Chen
Technical Staffs: Yung-chang Tsai, Feng-huang Tsai, Wei-chou Chien,
 Yu-cheng Chang
Education Program: Fang-wei Chang, Hsuan-chun Lin, Shu-yi Shi, Shu-hui Hsiao,
 David Wu, Jui-ting Lu, Li-ya Chuang
Public Relations: Chung-hien Lin, Chien-nan Liao, Hsue-ching Lu
General Affairs: Der-shun Rau, Yun-na Liao

Catalogue
Publisher: Ping Lin
Published by: Taipei Fine Arts Museum
Editor: Yi-ting Lei
Editing assistance: I-chieh Lin, Tzu-Hsiu Su
Proofreading assistance: Yu-chen Liu, Olga Chang
Translators: Japanese to Chinese / Tzu-chien Liu, Mu-ju Chan
 English to Chinese / Yung-hua Miao
 Chinese to English / Brent Heinrich, Christine Chan
Graphic Design: Rohan Hu
Photos provided by: Taipei Fine Arts Museum, Mori Art Museum, Lee Studio
Publisher: Taipei Fine Arts Museum
© Taipei Fine Arts Museum
181 Zhongshan N. Road Sec. 3 Taipei 104 Taiwan
Tel + 886 (2) 2595 7656, Fax + 886 (2) 2594 4104
Publishing date: September, 2015, First print
Printer: Chia Shin Printing Co., LTD

ISBN: 978-986-04-6012-4
GPN: 1010401783
Price: TWD 900

RETAIL OUTLETS
Taipei Fine Arts Museum, Art Bookstore
 181 Zhongshang N. RD. Sec.3, Taipei 104, Taiwan
 Tel + 886 (2) 2595 7656 ext: 734
Government Publication Bookstore, Songjiang Store
 1F No.209 Songjiang RD., Taipei 104, Taiwan
 Tel + 886 (2) 2518 0207
Wu-nan Book Inc., Taichung Main Store
 No.6 Zhongshan RD., Taichung 400, Taiwan
 Tel + 886 (4) 2226 0330